Red Threads

'I loved this book, it was thrilling to learn about these radical rebels and revolutionaries, and to feel that this is a history we can all connect with and be inspired by.'

—Josie Long, comedian

'Intense and gripping, *Red Threads* tells a grand history of hope, disappointment and potential rejuvenation through the drama of the people and movements who flew and still fly the red flag.'

—Ewan Gibbs, University of Glasgow, author of *Coal Country*

'From Paris to Petrograd, Delhi to Detroit, Merthyr Tydfil to Mexico City, Cairo to Cape Town, Henry Bell deftly traces the shifting meanings of the red flag to the people who flew it and to those who sought to tear it down through revolutions, rebellions and revolts. An internationalist tour de force of revolutionary history encompassing stunning victories and crushing defeats, *Red Threads* will also serve as a source of inspiration to those who wish to keep the red flag flying today.'

—Hannah Proctor, historian and author of *Burnout: The Emotional Experience of Political Defeat*

'A great read. The red flag flying, a flame that can never be extinguished. The epic story of this universal symbol, so stirring, vivid, vital, its beautiful and humane ideals so often blood-soaked and betrayed, here told with passion and erudition, not flinching from a single terror or contradiction. You'll find herein thrilling histories of so many individuals, women and men, heroes, martyrs, communards and comrades, bonny fechters, the workers and writers lavishly quoted, the artists and activists worldwide throughout the last two centuries who have been, and still are, part of the ongoing imperfect – because human – struggle. I learned so much from this book.'

—Liz Lochhead, poet

Red Threads
A History of the People's Flag

Henry Bell

First published 2024 by Pluto Press
New Wing, Somerset House, Strand, London WC2R 1LA
and Pluto Press, Inc.
1930 Village Center Circle, 3-834, Las Vegas, NV 89134

www.plutobooks.com

Copyright © Henry Bell 2024

The right of Henry Bell to be identified as the author of this work has been asserted in accordance with the Copyright, Designs and Patents Act 1988.

British Library Cataloguing in Publication Data
A catalogue record for this book is available from the British Library

ISBN 978 0 7453 4769 1 Hardback
ISBN 978 0 7453 4772 1 PDF
ISBN 978 0 7453 4770 7 EPUB

Every effort has been made to trace copyright holders and to obtain their permission for the use of copyright material in this book. The publisher apologises for any errors or omissions in this respect and would be grateful if notified of any corrections that should be incorporated in future reprints or editions.

This book is printed on paper suitable for recycling and made from fully managed and sustained forest sources. Logging, pulping and manufacturing processes are expected to conform to the environmental standards of the country of origin.

Typeset by Stanford DTP Services, Northampton, England

Simultaneously printed in the United Kingdom and United States of America

For Maili, Frankie and Soren,
and all their comrades

Contents

Introduction: The Signal of the Emergency ... 1
1. War ... 11
2. Defiance ... 34
3. Revolution ... 45
4. The International ... 69
5. The Commune ... 75
6. The Workers ... 92
7. Peace ... 118
8. Utopia ... 130
9. Tyranny ... 145
10. The Dispossessed ... 171
11. Subversion ... 200
12. The Peasants ... 229
13. Chinese Characteristics ... 250
14. The Present ... 266
15. The Future ... 282

Acknowledgements ... 292
Notes ... 293
Index ... 328

Introduction: The Signal of the Emergency

Beneath a sky black with the smoke of burning boulevards and palaces, red flags are torn from the barricades as the French army slaughters more than 20,000 revolutionaries in the streets.[1] The autonomous radical government that has ruled Paris for just two months of 1871 has come to a final bloody end. The red flag, the symbol of the revolution, a symbol which has represented people in revolt for nearly a century, had been raised for the first time as a flag of government. It shall not be the last time it is flown as a symbol of worker rule, nor the last time it is torn down and dragged through blood by the forces of empire and capital.

As the barricades of the Commune fall, thousands of Communards are captured and sentenced to exile. Among them is Louise Michel, the 'Red Virgin of Montmartre'. This radical schoolteacher, feminist and anarchist has been a leading figure in the revolutionary government of the Paris Commune. She had thrown herself into the armed struggle against the French national government. As the revolution is crushed, Michel takes a red flag from the debris of battle and hides it on her person; she keeps it with her through her arrest, trial and deportation. In exile on the Pacific islands of New Caledonia, 10,000 miles from her home, she wears the red flag of the Commune around her neck as a mark of her commitment to the struggle for liberation.[2]

Five years into Michel's exile, the united tribes of the Kanak – the indigenous people of New Caledonia – rise up against the colonial oppression of the French state. Subject to brutal repression, enclosure, indenture and forced labour, the local tribes band together against the ruling minority of white French settlers.[3] Of the 4,000 Communards who have been deported to the islands, almost all side with the French Empire, fighting alongside the army that had murdered their comrades, destroyed their homes, and deported them to the South Pacific. They help to crush the tribal resistance.

Louise Michel does not. Seeing her own struggles as a woman and revolutionary reflected in the anti-imperialist struggle of the Kanak people, she tears her red neckerchief in two and hands a piece to a Kanak fighter as they head into battle.[4] The red flag of the Paris Commune, that symbol of insurrection and martyrdom, has been transported across the world in chains, only to find itself again in the hands of those fighting for freedom. For a moment – not the last – it is transformed from the flag of French workers into a symbol of solidarity, indigenous resistance and anti-colonialism: the red flag of internationalism.

Less than a decade later, a red flag is in the hands of Lucy Parsons as she and her family lead 80,000 people through Chicago in early May 1886.[5] Born into slavery in Virginia, Lucy, then Lucia Carter, grew up in Texas. After her emancipation, she fell in love with Albert Parsons, a former confederate soldier turned left-wing political firebrand.[6] The two of them became anarcho-communists and leaders of the workers' movement. The red flag is their standard as they lead the movement of industrial workers, migrants and formerly enslaved people who throng to Chicago in the late nineteenth century. Lucy, famous for her powerful speeches and pamphlets, declares that: 'the red flag, the horrible red flag, what does that mean? Not that the streets should run with gore, but that the same red blood courses through the veins of the whole human race. It means the brotherhood of man.'[7]

The Chicago police are determined to stop the movement that the Parsons and the red flag stand for. A police riot follows their peaceful march, and in the melee a bomb explodes at the Haymarket. A policeman is killed by the explosion and six more are shot dead by fellow officers in the confusion.[8] Lucy and Albert and their children have already left the demonstration at the time of the violence, but nevertheless, Albert is among those who are rounded up and framed for the attack. In his cell on death row, he writes: 'Though fallen, wounded perhaps unto death, in the battle for liberty, the standard ... which my hands bore aloft in the midst of the struggle is caught up by other hands, and will be again and

INTRODUCTION: THE SIGNAL OF THE EMERGENCY

again, if needs, till the crimson banner waves in triumph over the enemies of peace, brotherhood, and happiness.'[9]

On the morning when Albert is hanged, Lucy Parsons and their children are arrested, stripped and searched for bombs. Albert asks to be able to speak at his hanging, but is denied the privilege.[10] The following day, when his coffin is brought to the Parsons' apartment, Lucy drapes it in that 'crimson banner' which had flown on the 4 May march.[11] Albert, the three men executed alongside him and a comrade who took his own life in his prison cell become the 'Haymarket Martyrs'. The global outrage at their execution drives the international workers movement to commemorate their deaths. That commemoration becomes May Day, the international day of the workers.

The red flag that shrouded their coffins in 1886 had become a flag of mourning, defiance and martyrdom. The sacrifice of those early martyrs of the working class colours the flag, but it remains also a beacon of hope. In May of every year Lucy and Albert Parsons' flag of peace, brotherhood and happiness now flies in every major city in the world.

Sixty years later in Berlin, a red flag is raised over the shattered remains of the capital of the German Reich. Marked with a battalion number and a hammer and sickle, it stands not for a small and desperate band of revolutionaries, nor a guerrilla island of resistance against empire, nor for lone and noble defiance at the gallows, but rather for a millions-strong mechanised army that has defeated fascism in Europe. The red flag stands once again for martyrdom, but this time it also represents the triumph of communism, and the might of an army and nation that has fought against the most destructive war machine humanity has ever seen. When Ernest Hemingway wrote that 'anyone who loves freedom owes such a debt to the Red Army that it can never be repaid',[12] he was summing up the feelings of millions across Europe, the Americas and Asia who saw the red flag as the symbol of liberation, resistance and endurance. But in the months and years that follow, the idealism and hope associated with the Red Army will shift and fade, and further meanings will be overlaid on the red flag.

In 1989, in that same city, two red flags are lowered on either side of the Brandenburg Gate. The fall of the Berlin Wall marks the beginning of a cascade of events that will see the red flag lowered across all of Eastern Europe and, eventually, Russia. It has stood for liberation, anti-colonialism, and shared humanity, and at the same time it has been the flag of oppression, gulags, devastating war and the workers' bomb. This standard, raised wherever tyranny has reigned, came at the same time to represent famine, subjugation and the might of the state. It is a flag of victory and defiance, but also a flag of grand errors, compromise and defeat.

Yet still in the twenty-first century the red flag can be found flying high above the market-socialism of China or amongst the rocket launchers of the Gazan resistance. It flies above Cuban doctors as they rush to the front lines of each new epidemic, and it is raised at industrial disputes and acts of solidarity across the world. The red flag flies at May Day rallies from Bogotá to Cape Town, and remains the symbol of the Naxalites fighting their guerrilla war in the jungles of Eastern India, and of the Kurdish battalions facing the armies of Turkey and the Islamic State.

These red flags, augmented with writing and symbols, words, numbers, maps and stars, are all the same flag claimed by different causes, traditions and nations. This is the story of that red flag. Borne by workers, revolutionaries and idealists, it has travelled through the centuries: claimed and reclaimed, always contested, always bearing the seeds of its former meanings. A plain block of solid colour, sometimes overlaid with a star, sometimes a hammer and sickle, at times improvised, at times mass produced, in all its forms and wherever it flies, the flag of revolution – the flag of the left – has a single origin. And yet within its folds dwell many histories, and a multitude of meanings: a flag of revolution and utopia, of tyranny and subversion, of the dispossessed and of empire. To some the red flag is a relic of a grim past, and to many others it is the beacon leading to a bright future.

From the hands of French kings and Atlantic pirates to German bourgeois revolutionaries, from European industrial workers to Brazilian peasants, Chinese intellectuals and South African freedom

INTRODUCTION: THE SIGNAL OF THE EMERGENCY

fighters, this history of the red flag takes us to every corner of the globe where one class has struggled against another. There is no symbol, other than the crucifix and the crescent moon, that so many people have lived under and died for. The red flag remains both a promise and a warning, a demand and a threat, soaked in the blood of its friends and foes alike.

This is the story of that flag: both as a material object and as a dialectical symbol. It is the story of how it found its meaning, how it came to represent the workers against the propertied class, and how it has been fought over, betrayed and raised high again. It is a story about those who kept the red flag flying, and why.

The past is never safe from a victorious enemy, and capitalist histories continue to define the red flag. This book is intended to echo the voices of those who made, raised and fought under the red flag, and to listen to those who fly it today, whilst also recording those who have suffered beneath it. But it will not do so dispassionately. The red flag has much to offer us, and we have something to offer it. This is a history that aspires to be a contribution to the class struggle the red flag represents.

Like most flags, the red flag has represented peoples, places and nations, but at its core it has a more specific symbolism. Noam Chomsky describes the meaning of the red flag as 'a call for radical social change'.[13] Though it has been appropriated by different rulers and parties since its conception, the red flag today, as it always has been, is a flag of instruction; it is a refusal to surrender, a call to the oppressed to rise up, a demand to the ruling class to stand down. It countermands the white flag, declaring a willingness to fight to the end no matter what.

Karl Marx suggested that revolutions were the locomotive of world history,[14] while Walter Benjamin claimed the opposite, that 'it may be that revolutions are the act by which the human race travelling in the train applies the emergency brake'.[15] If Benjamin is right, then the red flag may be the signal of the emergency, the red light that commands the forces of history to stop, a warning calling for the armies of reaction and oppression to halt. It is the opposite not just of the white flag of surrender, but also of the green flag that

dispatches trains from Central Station. It says to the worker: stop, do not lift a finger in aid of your own oppression. Stop the wheels of the factory, stop the traffic charging down the motorways, stop the cargo ships pulling into port, lay your body upon the gears. Stop the circulation of capital, bring these social relations to a halt, and instead build a new and better world. A world held in common.

Walter Benjamin also gave us the image of the 'Angel of History':

> A Klee painting named Angelus Novus shows an angel looking as though he is about to move away from something he is fixedly contemplating. His eyes are staring, his mouth is open, his wings are spread. This is how one pictures the angel of history. His face is turned toward the past. Where we perceive a chain of events, he sees one single catastrophe which keeps piling wreckage upon wreckage and hurls it in front of his feet. The angel would like to stay, awaken the dead, and make whole what has been smashed. But a storm is blowing from Paradise; it has got caught in his wings with such violence that the angel can no longer close them. The storm irresistibly propels him into the future to which his back is turned, while the pile of debris before him grows skyward. This storm is what we call progress.[16]

The red flag is a human plea to stay and make things whole, a Communard's prop to which we cling because it has the power to call history to a halt, and to change its direction. Has there ever been a time when changing the direction of history, and demanding a change to the social order has been more vital than now, as the seas rise and the earth heats? The red flag stands against a society based on extraction and exploitation, against the degradation of the people and the planet. The red flag of revolution is history's stop sign by which we may awaken the dead.

Those dead, of course, travel with it. Like any object, the red flag is imbued with the meanings and values of the workers who designed it and made it, those who carried it high, and those who dragged it in the mud, the revolutionaries and reactionaries who have helped shape what it has meant through history. In 1889 the Irish docker

INTRODUCTION: THE SIGNAL OF THE EMERGENCY

and labour leader Jim Connell wrote the socialist anthem 'The Red Flag'.[17] In its first eight lines he writes:

The people's flag is deepest red,
It shrouded oft our martyred dead
And ere their limbs grew stiff and cold,
Their hearts' blood dyed its every fold.

So raise the scarlet standard high,
Beneath its shade we'll live and die,
Though cowards flinch and traitors sneer,
We'll keep the red flag flying here.

That cast of martyrs, cowards and traitors, all named in relation to *us*, the singers of the song, the bearers of the red flag, show the symbol's power as a forger of mass identity, a physical shibboleth, a boundary, that signifies affinity, loyalty and betrayal. It is the mass movements, the armed groups, the radical factions that it has stood over which have given the red flag its most powerful metaphorical attributes. For those committed to flying the red flag, there is nothing more contemptible than the people who betray this flag of internationalism and solidarity. It is the ultimate symbol of us against them, of class warfare. It is no small wonder, then, that even the singing of this song has been a contentious issue among the English left.

From its earliest appearance in the hands of the workers, the red flag has not just been wielded against the bourgeoisie, but has also been fought over by Marxists, socialists, communists and anarchists, and appropriated by liberals. While it has always represented radical social change, the questions have remained: What form should that social change take? Who does the red flag take power from and who does it hand it to? Is the red flag the symbol of democracy or dictatorship, liberation or repression?

In The Hague in 1872, in the wake of the defeat of the Paris Commune, the anarchists split from the First International Workingmen's Association after a dispute over Marx's proposal that

the workers must build their own state. The great divide between Marxists and anarchists that occurred in 1872 saw the red flag take on an identity that would eventually lead it to Kronstadt and the Bolshevik suppression of an anarchist rebellion. Under the red flag of the Soviet Union, communists murdered anarchists who had brought them and their flag to power. The flag that had belonged to Louise Michel became the flag of an army which massacred her ideological heirs. What flag should those revolutionaries fly now? These meanings remain in contention. The red flag has long been a flag of war flown by state against state, and by worker against worker.

Yet, in its purest distillation, the *us* of the red flag is always *the people*, and the *them* it rails against is always our rulers. One hundred and fifty years ago, in his pamphlet on the Commune, Marx wrote that: 'the old world writhed in convulsions of rage at the sight of the Red Flag, the symbol of the Republic of Labour, floating over the Hôtel de Ville'.[18] The red flag is a red rag to the bull of capital, a provocation that cannot be borne, and although at the Paris Commune, as before and since, those who flew the red flag were brutally murdered by the bourgeois state, the red flag remains the flag of the future, a symbol that for many radicals represents the future utopian society and its inevitable victory against the old world. The flag has pointed to the future for centuries now, and we find it stained, or consecrated, with blood. Yet it still leads us to a new world.

The red flag in Europe is only now stirring again after the long liberal years between the fall of the Soviet bloc and the great recession of 2007–9. In a world where the statues of Lenin and Stalin have come crashing down, the red flag is heavy with the weight of history – a history written so often by the capitalist victors that many who carry the red flag in the nations where it first emerged cannot agree even with each other about what past the red flag represents. And yet across Asia, Africa and South America, the red flag has never been lowered, and in the eyes of millions there, its meaning as a flag of liberation and worker control is beyond dispute, while, at the same time, over a billion people in China look on as

INTRODUCTION: THE SIGNAL OF THE EMERGENCY

Hongqi *Red Flag* limousines transport Communist Party officials and multi-millionaire entrepreneurs alike.

Elsewhere, the red flag flies over the battlefields of the Levant. In the Syrian civil war elements of the Western left threw their support behind the brutal nationalist government of Bashar al-Assad as he resisted imperialist regime change, while others on the left backed the Free Syrian Army even as it allied with increasingly reactionary forces from Islamists to NATO. But, at the same time, a third force emerged, flying the red flag on its front lines, declaring a people's revolution, and resisting the forces of imperialism and Islamo-fascism. The radical, democratic, feminist experiment of the Rojava revolution in Syrian Kurdistan layers a new meaning upon the red flag and upsets the old divides between Marxists and anarchists. In the hands of the Kurdish Women's Protection Units, the red flag finds new meanings and new futures as a symbol of hope and of liberation in the twenty-first century.

The object of this book is the history of all these red flags. It is neither a sterile eulogy nor a sentimental hagiography. It is the history of a living symbol that is reviled and adored. The argument of this book is that the red flag continues to serve as a vital conduit for our radical history, and an essential portal to our liberatory future. As a symbol, the red flag generates self-knowledge, it raises class consciousness and helps produce the movement it symbolises. It ignites passions and reinforces collective belonging and lineage. It is the material incarnation of a shared goal and memory. The red flag is a communication between the dead and the living, a transmission belt of radical politics, identity and history. When we take up the red flag of the past in order to enact the future, it does not just represent a movement, it plays an active role in our ability to create it.

There is no one tradition that can claim that red flag as its own, or define the future that it calls for, but in exploring its history and in examining the revolutionaries who have flown the flag and the workers who have lived beneath it, we can discover something essential about the struggle for a better world, its triumphs, its trag-

edies and its farces. In seeking to uncover that history, I hope that this book is a contribution to keeping the red flag flying.

Wherever you stand on the left, however you feel about the socialism of the twentieth century, the loss of faith in the symbol in the 1980s and 1990s, the picking up of that flag by young revolutionaries today, the red flag remains your flag, and its victories and defeats, its triumphs and betrayals belong also to you.

In grappling with the meanings of the red flag, we might find that we better know what we must do with it next. Like Benjamin's Angel of History, we can see the debris of humanity growing skyward, but we have the chance to stop and pick amongst that debris to find the shattered barricades, each of them with a red flag flying, each of them representing an attempt to stop and make things whole. The red flag remains caught in that storm blowing from paradise, which we call progress. Where we take it next must be informed by its past. Which red flag we choose to raise will define the future.

I
A Flag of War

Countless times throughout history people have raised a red sign, died a cloth with ochre or marked an emblem in blood. There is no first red flag, just as there is no first rebellion or first oppression – both the symbol and the struggle it has come to represent have been with humanity longer than history or written language. But they have only travelled together for a few hundred years.

Before that, unattached to the cause of socialism, the red flag has been a deep archetype, driven forward by its apparent simplicity and its internal contradictions: a flag of resistance and of dictatorship, of the individual human and of the great mass of humanity, of war and of peace. The red flag, the blood flag, like the crucifix, is a symbol of life and of death.

But in its original, ancient incarnation the red flag exists first and foremost as a flag of authority and of war. Wielding some symbol by which to identify yourself in battle, to assert territory or community, or to express a warning is a fundamental part of human interaction. Such objects through their use take on a meaning and become symbols. Ideas and values are attached to concrete objects, and their presence becomes symbolic. The massive collective system of these symbols, representing identity, thought and action, is the system of signs that allows society to exist.

Each polity – be it political, religious or national – comes into being when a group names itself and rallies around a symbolic object. Remove the symbol, and the group becomes invisible. These many symbols of identity form the boundaries of belonging and ideas. Each totem, each symbolic focal point, is essential to the existence of each group and how they understand themselves and the world. These symbols are not incidental, they are vital, they both create and communicate thought and being. The feeling of membership

is at its most intense when the symbol becomes active in a collective project.

When engaged in action or ceremony – at a battle, a barricade, a coronation or a martyr's funeral – the symbol of the red flag becomes embodied with tremendous power. It is a totemic object that affirms a faith. It allows those who fly it to understand themselves as part of a group and lineage.

Over millenniums the groups that fly the red flag have transformed beyond recognition. It is a symbol that has been repeatedly inverted and yet which carries with it something of all its former roles. It exists as one of humanity's oldest symbols, and one of its oldest flags.

Flags themselves have a pre-human ancestry. Primates' use of sticks as an extension of their arms to wave and to beat their chests is a precursor to the flag.[1] And as such it combines two common roles of the flag – as a symbol and, with its pole, as a potential weapon. This symbol-cum-weapon leads us to one of the red flag's earliest incarnations.

Soldiering and seafaring are the direct origins of almost all flags. Both sea and battle are locations in which communication by other means is difficult. Both reinforce the proximity of flags and weapons. While the red flag has many ancestors, and their meanings have arisen sometimes independently, sometimes interdependently, and often in contradiction to one another, it is in the ancient world where we find the first clear evidence of the red flag, a red flag of war that we will track across land and sea.

The earliest flags of war, now faded, dented and discoloured, served as battle ensigns. In ancient Persia and pre-dynastic Egypt, armies would march beneath leather, wood or metal symbols and representations of animals on poles, markers of identity intended to inspire loyalty and fear. But it was in China some 50 centuries ago that the technology – the spinning and dyeing of silk – emerged to create the first true flags. The lightweight material could catch the wind, be easily transported and be unfurled to signal across great distances. It could also be dyed red. The red flag quickly spread along the Silk Road to India, the Arab world and later to the

Roman Empire. Roman legions used Chinese silk to fashion red *vexilla* – flags that flew above them as they conquered Europe.[2] We know, for instance from the writings of Sidonius Apollinaris in the fifth century CE, that Roman legions marched beneath red flags bearing the images of wolves and eagles.[3] These were derivatives of the earliest flag-type objects. By the sixth century CE the Roman military had developed the *flammula*, a red streamer that was attached to the lances of legionaries as they marched.[4]

Though the earliest red flags do not survive, we find evidence of them in verse and in illuminated manuscripts, from both the Roman Empire and the Indian subcontinent. Atop chariots and elephants in battle, alongside bells and umbrellas, these flags signalled the readiness to fight.[5] Spreading from the Muslim to the Christian world through the violent encounters of the Crusades, such flags of war became the antecedents of mediaeval heraldry in Europe. In almost all cases, the red flag served as a battle flag.

Red was chosen across the ancient world: in Africa, India, Arabia, China and in Europe, to signify battle. But what is the origin of red's association with war? Goethe remarked that 'a bull becomes furious only if he is presented with a red cloth, a philosopher on the other hand goes into a rage as soon as the colour is mentioned'.[6] Much ink has been spilled trying to establish the meaning of this primal and passionate colour. Whilst subtler understandings of colour are culturally specific, there are universal experiences of colour, and few colours are as universal as red. We all first encounter red in our mothers' blood, in that act of sacrifice and generation, often even martyrdom. In the instant of every human's first encounter with red is the generation of life and the risk of death. It is the first and only colour that a foetus sees. In each language red is the colour concept that emerges first, after light and dark.[7]

Red is the colour of life. It is the colour we see when we close our eyes tight, the dark red of our own blood coursing through our eyelids. It is the colour we all have access to if we want to slice open our hand and make a mark. It is the colour seen by all people, whether they live in the desert, the jungle, the city or the tundra. Against the brown, green, grey or white of their lives, two things

are certain: all humans see the red of blood, and all humans see the red of fire. Because that primal and essential element is also red. And, like birth, it is double-edged; fire is key to subsistence, yet it also carries the threat of destruction. A mother colour and a martyr colour.

Alongside these bodily meanings, red is also a colour of warning, danger and anger. It occurs in the natural world as a signal of poison, and, as blood, it represents not just life, but killing too. Think of Tennyson's line 'nature, red in tooth and claw' and its rhyme 'Love, Creation's final law'.[8] Just as the red flag itself is marked by its own internal contradictions, so too are our own earliest encounters with the colour red. That it became a flag of war is no accident, and that the workers then took it as their standard and that it retains that role today stems most essentially from its ability to represent both life and creation as well as death and destruction. This plain red flag has carried its associations of blood and war through the millennia. Even the god of war wears red, and the red planet, Mars, is named after him because of its colour. As we follow the red flag through history, watching it define and be defined by countless struggles and revolutions, its signification of both destruction and creation will come to the fore again and again.

But there are other early signs of the red flag we know today amongst the Roman world of fabric and colour. Because red was not just the colour of battle; it was the colour of power. Emperors and generals wore fabulously dyed red and purple cloth to represent their status. While the tunics and togas of plebs and citizens might be dyed with iron salts and oak gall, the clothing of rulers and priests was coloured with rare and exotic dyes extracted from flowers, insects and molluscs. The reds of these togas give us much of the colour's symbolism today. We inherit a red that is associated with power and might: the ceremonial redcoats of the British army, the purple-reds of royalty and judiciary, the cardinal reds of papal pomp. These colours became symbols of power and authority not just through their use on the battlefield, but also for material reasons, due to the expense of their dyes. The red dye kermes is made from the crushed bodies of the female kermes scale insects that live on

the oak trees of the Mediterranean, the dye gives wool and cotton a crimson colour; the word 'crimson' itself is derived from the name of the insect.[9] To wear something dyed crimson confirmed status and wealth. But no dye did this more spectacularly in ancient Rome than Phoenician Red. Made from the crushed shells of a predatory snail found in the eastern Mediterranean, it can, when correctly prepared, produce either a vivid purple or, at its most desirable, a dark dried-blood red.[10] Twelve thousand crushed snails yield little more than a gram of purple or red dye, enough to stain just the hem of a garment.[11] The vast amount of labour required to produce these dyes, and their consequently high exchange value, led textiles of these colours to become synonymous with power and authority. It is this power and status of the colour red that gives us a, perhaps unlikely, antecedent of the red flag. A red that is about luxury and displays of wealth, and the ability to command workers. From this springs one of the red flag's most key meanings, that of power, and later, of power inverted, luxury reclaimed.

In antiquity, red cloth represented an intertwining of luxury, power, war and authority. But even in its early days this red was sometimes turned against the rulers. In 778 CE the 'Red-clothed ones' rose up in Gorgan, Persia against the Abbasid Caliphate. The rebels were led by a man named Qahir, and were likely to have been a sect of Zoroastrians who believed in freedom, pleasure and the non-harm of others: spilling blood was strictly forbidden – unless their red flag of revolt was raised.[12] Volume 13 of *The Great Soviet Encyclopaedia* of 1973 lists this as the first time the red flag was raised as an emblem of a people's revolt against their oppressors.[13] Others claim that, still earlier, Spartacus raised the red flag in his slave revolt. In other instances red flags crop up in descriptions of medieval peasant risings. But in all cases, although red was seized upon by rebels because it was a symbol of power and war, its associations with revolution and class struggle can only be projected backwards onto these early flags.

Nevertheless, we find red in the pre-modern era prefiguring its connections to rebellion and betrayal. Over the first millennium of the Common Era many attempts were made by artists to distin-

guish Judas from the other disciples, but by the thirteenth century the convention had been established that Judas was distinguished by his red hair.[14] Following from this initial convention, the use of red hair and red clothing to represent rebels and traitors spread in iconography, having been used in particular to distinguish Cain, that traitor in the Garden of Eden, and Mordred, the traitor in the Arthurian myths. Red is used to catch the eye in classical painting and to single out antagonists. The colour red's role with provocateurs and its signification of betrayal and rebellion, battling authority, are part of its journey towards becoming the flag of the left.

Despite the connection with betrayal, red remained the preserve of power, and was associated with the threat of death in the Middle Ages. In the Holy Roman Empire special sentencing courts, known as blood courts, sat in order to dispense capital punishment. The judges of such courts wore red as a symbol of their power, a power that was devolved to them by the *Blutfahne*, or blood flag, a square red flag that was the sole preserve of the monarch and which showed the right to blood jurisdiction: the right to decree execution, assumed by feudal kings.[15] For this reason, peasant risings would appropriate the red flag in an act of feudal mutiny. In both the Lubeck rising of 1408 and during the German Peasant War of 1524, the red flag was flown by the rebels. Engels would write 300 years later: 'the peasant war in Germany pointed prophetically to future class struggles, not only by bringing on to the stage the peasants in revolt – that was no longer anything new – but behind them the beginnings of the modern proletariat, with the red flag in their hands and the demand for common ownership of goods on their lips'.[16]

In the feudal class struggle between peasants and lords, the red flag was already in contention. As the peasants were slowly forced into a proletarian relation with their rulers, the red flag would remain only insecurely in the hands of kings. A colour on the verge of being captured.

The association of red cloth with both royalty and the threat of death leads us to the first direct parent of the red flag of revolution: the Oriflamme, or golden flame. Housed in the abbey at St

Denis, outside Paris, the Oriflamme was a long red pennant flag flown from a golden lance. Said to be stained red by the blood of the beheaded St Denis, the flag was flown by the king of France in battle and indicated to enemy nobles that they would be killed rather than captured. It was, again, a blood flag. Designed to boost the morale of the French army and to strike fear into the enemy, the Oriflamme was flown in French campaigns from the twelfth to fifteenth centuries, though its mythical origins begin with a lance that Charlemagne supposedly carried with him to the Crusades and which prophecy foretold would give forth flames and drive out the Saracens.[17] The likely truth in fact is that it was a symbol stolen from the Saracens.

It is this flag that Southey calls 'the Oriflamme of death'.[18] Medieval authors wrote that the red flag could blind infidel armies, and the thirteenth-century monk Richer de Senones wrote, in the voice of the bearer of the flag, that: 'This Oriflamme thirsts for human blood as many are witnessing. Thus today with the help of God I shall let it drink heavily of the blood of the enemies.'[19] This idea that the red flag literally consumed the blood of enemies, awakening in the French army a murderous lust for violence, was prevalent in the writings of the time. Whilst the Oriflamme itself was the standard of total war, belonging exclusively to the French king, contemporary poems, or *chansons de geste*, tell us that a red flag was also flown by barons and lesser noblemen.[20]

The red flag was, for many centuries, established as a flag of blood, both literally and figuratively: the red flag is recorded at the Globe theatre in sixteenth-century London, where flags were flown to advertise plays to a largely illiterate audience. A white flag denoted a comedy, a black flag a tragedy, and a red flag signified one of Shakespeare's blood-drenched history plays.[21]

In order for the red flag to undergo its transformation from a blood flag to the flag of class war, to move from the hands of noblemen to the hands of the workers, it had to take two distinct journeys, one by land and one by sea. On land, from the tenth century CE the red flag, be it the Blutfahne or the Oriflamme, prescribed a death sentence, either in battle or in court. At sea it became, by the thir-

teenth century, the Baucans, which was flown from a ship's mast to signal a battle. It was a flag of 'no surrender', the opposite of the white flag, known in the English navy as the 'bloody colours'. The Baucans, cognate with beacon, was a large red streamer that indicated a fight to the death.[22] It was an international symbol of maritime war which can be traced to Norman ships raiding in the English Channel in the thirteenth century as a maritime appropriation of the Oriflamme.[23]

Whether as a naval ensign or as flag of war, it is no coincidence that the colour red is reserved for such a signal, not simply because it is the colour of blood, but also because red is in fact the colour that humans perceive most clearly; it is the colour with the longest wavelength perceptible by the human eye. Shorter wavelengths, from violet to yellow, are more quickly dissipated by interference from dust and other atmospheric conditions, meaning that they are harder to see over distance. Red is therefore the colour that appears to us first and most clearly – we literally see it more easily; we see more of red light than we see of the other colours that reach us. As a colour, red has both an inherent primacy and an inherent usefulness for signalling. This status as the first and the boldest colour gives red an almost magical power. Look across a room at a bookcase, and it is the red spines which will stand out. When we look at the sun at dawn or sunset when its light is filtered through the greatest interference, it is only its red light that we see, with its yellows and violets filtered out. As a flag of warning, demand or threat, red is the best colour to choose because our enemies and allies will see it most clearly, whether that is through the fog of war, the mist of the sea, or the smoke and fumes of the factory. The Norman ships battling the storms of the Channel and hunting English vessels could take more courage from each other and strike more fear into their prey with a flag that could be seen amidst the rain and seaspray. The fourteenth-century writer Jean Froissart declared that no sooner was the Oriflamme unfurled at the battle of Rosbecq than the clouds cleared and the sun began to shine.[24] The power of the Oriflamme is connected to this almost supernatural quality of red as the colour which we see first. When the British redcoats made their first Con-

tinental appearance, helping to put down the Fronde rebellion in France, they were praised for the fierceness of their assaults and for their key role in the battle – this was likely in part due to their having been the most visible soldiers on the field, clothed as they were in the red of war.[25]

This most visible flag, the Baucans flown at sea by European ships, or the Oriflamme flown on land by French kings, existed at first as a symbol in the hands of the propertied class. It was a flag that was used in wars between the rich, to secure territory and trade routes, and to capture enemy vessels. But over time its meaning was seized upon by the workers themselves. This occurred for the first time at sea. In the microcosm of the class system that is a ship, the red flag's symbolic meaning was able to mutate quickly. It was here that the flag arrived for the first time in history as a symbol of the power of the common man against the arrayed forces of wealth in the hands of those dubious left-wing icons, the pirates.

Though popular history has handed down to us a pirate flag that is black with a white crossbones, the flag in the seventeenth century, during the golden age of piracy, was more often red. Known in Dutch as the *Bloedvlag*, or in English as the Jolly Roger, likely a corruption of the French *Joli Rouge*, or 'pretty red', the red flag flew over pirate ships across the Atlantic and Mediterranean.[26] When pirates flew the red flag they indicated that they would fight to the death to take that which they desired. The flag was again a Baucans, taking its significance from the Oriflamme, but it had become a flag flown not by authority, but against it. In the hands of the pirates the red flag is for the first time associated with the appropriation of property by forces other than the ruling class and with a moral and social code that disrupted law, order and hierarchy. It is still, undoubtedly, a flag of power and war, a flag that takes its meaning from blood and medieval battle. But it is flown by those acting against the crown rather than for it. The red flag, flying from a pirate ship, sails into the realm of class warfare. In *A General History of the Robberies and Murders of the Most Notorious Pyrates* published in 1724 we find the words of the famous pirate Captain Samuel Bellamy:

> Though you are a sneaking puppy, and so are all those who will submit to be governed by laws which rich men have made for their own security; for the cowardly whelps have not the courage otherwise to defend what they get by knavery; but damn ye altogether: damn them for a pack of crafty rascals, and you, who serve them, for a parcel of hen-hearted numbskulls. They vilify us, the scoundrels do, when there is only this difference: they rob the poor under the cover of law, forsooth, and we plunder the rich under the cover of our own courage.[27]

Bellamy, beneath a red flag, was what Eric Hobsbawm would later call a social bandit: fighting against an unjust upper class, championing the weak against the strong, and developing and maintaining his own peasant morality against the ruling class morality which subjugated him.[28] Whilst there was concrete power held by these piratical red flag bearers, to disrupt trade and colonial projects, their true power was in their symbolism. The attraction of a life beyond the state and the family, and free from the distinctions of race, class, nationality and often sexuality, has long been the attraction of piracy in the popular imagination. It is worth noting that pirates are not merely the first people to take up the red flag against the propertied class, they are also some of the first people of colour to do so, both in the Atlantic pirate fleets and beneath the red flag of the Barbary Pirates. Among those named in Bellamy's crew are Hendrick Quintor, who was a Dutchman of African descent, and John Julian, an indigenous Miskito man from Central America.[29] Pirates such as these were not only engaged in robbing the rich, but also in attacking slave trading ships and navies engaged in the colonisation of the Americas. In a complex way, these red flag flyers were an early part of an internationalist resistance against white supremacy. Bellamy's flag ship, the *Whydah Gally*, was itself a slave trading vessel commissioned by Sir Humphry Morice, the Governor of the Bank of England, and captured by Bellamy on its maiden voyage.[30]

Pirates, of course, have always been ripe for romanticism, and all of this must be viewed in a context mired in murder and greed. But nevertheless we find here both the real use of a red flag by the

people against the powerful and a symbolic association of the flag with popular rebels, and with economic and social transgression. Pirates, beneath the red flag, posed a threat to both the economic and the social order.[31] The meanings that they layered upon the red flag would inspire admiration, terror and disgust. The red flag of the workers may often strive for respectability, but it has its roots in piracy.

Whilst pirates flying the red flag against government ships form one root of the red flag's meaning, another red flag was raised at sea by an internal enemy within national navies: one that would see the final and most significant mutation of the Baucans aboard ship. The late eighteenth century saw a wave of riots, insurrections, assassinations and mutinies sweep across the French, Dutch and English navies as the age of revolution and republicanism inspired sailors to play an active part in the reorganisation of their society.[32] On both sides of the Atlantic, the encounters between white rebels, black slaves and the indigenous resistance to colonialism spread ideas of liberty, freedom and emancipation. And it was in this milieu that the liberatory red flag was first glimpsed.

By 1800, as word of the momentous revolutions in America, Haiti and France spread, between a third and half of the 450 ships and 200,000 men of the Dutch, French and English fleets had participated in at least one mutiny in the previous decade. It has been suggested that this wave of unrest in the Atlantic should be considered as seismic a revolution as those of 1776 and 1789.[33] It was these insurgents of the lower decks who were the first to fly the red flag with its modern meaning of rebellion, revolt and a world turned upside down,[34] and it was in their transition from immediate on-board demands to broader societal campaigns that the red flag first flew as a symbol demanding radical social transformation.

Amongst the earliest of these red flag mutinies was the Liverpool Seamen's Revolt, of 1775. Directly precipitated by the American Revolutionary War which was taking its toll on the merchant and slave ships of Britain's largest port, sailors took up the red flag to fight against their employers. Scores of boats and thousands of sailors were struggling to find work, and pay was being cut for those

who were still in employment. When a group of sailors working to fit out the *Derby* found that they were to be paid 20 rather than the standard 30 shillings per month, they cut down the ship's sails and rigging and left them lying on the deck. It is this striking of the rigging which gives us the modern word 'strike', meaning the cessation of work. This strike on the *Derby* was the signal for sailors across the docks to do the same, and throughout Liverpool rigging was cut down and the red flag of 'no surrender' was raised aboard each ship.[35] A group of many hundreds of seamen set off towards the homes of the ship owners and the mercantile exchange. They took the red flag ashore, transforming it for the first time from a maritime flag of mutiny to a symbol of worker resistance. The uprising was sparked by immediate conflicts with ship owners and demands over pay and conditions. The mutineers were radical and democratic in nature, with sailors forming committees, holding elections and referring to each other as 'citizen'.[36] The strike spread, and the sailors' committees met with the Lord Mayor of Liverpool. On the fifth day of the strike it was announced that the employers would meet the sailors' demands for pay. The strikers withdrew and began to celebrate, but word soon spread that 300 men had been hired to apprehend the leaders of the strike. By nine that evening the sailors had again gathered and surrounded the mercantile exchange. When a window was broken, special constables opened fire on the unarmed crowd, killing seven men.

Next morning 1,000 sailors returned, led by the red flag, and with red cockades in their hats. They went to Parr's gunsmiths and seized 300 muskets while others dragged cannon from the ships into the city and opened fire on the mercantile exchange. From the exchange they marched to the house of Thomas Rattliffe, a 'Guinea merchant'. An eye-witness account from one of his servants survives:

> A large number of them came with a drum, a flag, and armed with cutlasses, blunderbusses, clubs etc. who fired on the said merchant's house, which stands in sight of us, where they threw out the feather beds, pillows etc, ripped them open and scattered the feathers in the air, broke open the drawers, full of clothes, lace,

linen, tore in pieces the house and bed furniture, together with the stoves, parchment, china etc, and all that was in the house. We were all in a dreadful confusion, but they behaved very well to everyone, excepting those to whom they bore a grudge.[37]

Amidst all the smoke, feathers, torn paper and smashed china, we find the red flag flying, and a group of workers avenging martyred comrades and pursuing their enemies in the ruling elite. The red flag is still a battle ensign, but in the Liverpool Seamen's Revolt it is a symbol of class war too. Though it is set down once the rising is finished, the flag of these eighteenth-century sailors may be the first red flag of revolt that we encounter, flying in the face of mercantile capital. Its relation to the sea also allows it an international character, and we find it again in Rotterdam in 1783 when dockyard workers fly it as they go from house to house demanding money from the city's wealthy elite.

In the quarter century following the Liverpool Seamen's Revolt, mutinies raising the red flag swept across the Atlantic. The flag increasingly came to represent the division of the ship into two classes – sailors and officers – and the appropriation of the ship and weapons by that lower, red flag-wielding class. The vast majority of these instances of the red flag being raised were single ship mutinies that resulted in defeat and the hanging of ringleaders. In other cases, though, the revolts went further, involving whole islands and fleets. These mutinies imbued the red flag with a practical meaning. But in parallel in the streets of Paris, a political meaning was emerging for this mutinous flag.

The red flag's journey towards becoming a French revolutionary symbol was a winding one. By the early 1790s the flag at sea was in the hands of pirates and mutineers, but on land it had only moved from the hands of kings to the hands of mayors, governors, generals and their soldiers. In France it was the symbol of martial law, a symbol opposed to revolution. The Oriflamme of Paris had become a flag of disorder. By a decree of 1789 it represented the threat of death, but that threat came from the elected officials, not the king.[38] The red flag in France was an analogue to the British Riot Act.

Thomas Carlisle describes it thus: 'this is that famed Martial law, with its Red Flag, its "Drapeau Rouge:" in virtue of which ... any Mayor, has but henceforth to hang out that new Oriflamme of his; then to read or mumble something about the King's peace; and, after certain pauses, serve any undispersing assemblage with musket-shot'.[39] The flag had retained its medieval meaning that prisoners would not be taken, but it had changed its target, from the enemy army to the people. The red flag flew in France as a warning to rioters or protesters that they must retreat or be shot. It was this red flag of repression that Wordsworth portrayed in his 'Descriptive Sketches':

Tho' now, where erst the grey-clad peasant stray'd,
To break the quiet of the village shade
Gleam war's discordant habits thro' the trees,
And the red banner mock the sullen breeze.[40]

The first connection between this red flag of order and radical politics came in June of 1791. Amidst the continued unrest in France, King Louis XVI and Queen Marie Antoinette attempted to flee Paris and to launch a counter-revolution. They were recognised and captured in the small town of Varennes. The attempted escape was a seismic shock to French politics and resulted in the National Assembly decreeing a constitutional monarchy. French republicans were horrified, and a petition was drawn up demanding the removal of the king; 20,000 people gathered on the Champ de Mars to sign the petition on 17 July.[41] Here, amongst the confusion and excitement of revolutionary Paris, the red flag would make one of its defining outings.

Some 6,000 signatures had been collected by the evening, when an alarm went up on the Champ de Mars. Two men were discovered making holes through the stage on which the petition was held. Today it is commonly believed that, as the stage held a large group of mixed genders, the men discovered beneath the wooden boards were likely peeping toms, boring through the planks to look up skirts. The crowd, however, jumped to a different conclu-

sion, believing the men to be royalists planting a bomb. The crowd quickly lynched and beheaded the two suspects.[42] In the turmoil that followed there is claim and counter-claim as to who began the disturbance, who provoked the crowd, who provoked the National Guard, and whether it was a dozen or 50 of the petition's signatories who lay dead by that night. What we do know is that the red flag was flown by the Mayor of Paris, Jean Sylvain Bailly, to signal martial law, and that the crowd threw stones at soldiers and chanted 'down with weapons, down with the red flag'.[43] The Marquis de Lafayette ordered his troops first to fire warning shots and then to shoot into the body of the crowd, killing many. The newspaper *Les Révolutions de Paris* wrote:

> Blood has just flowed on the field of the federation, staining the altar of the fatherland. Men and women have had their throats slashed and the citizens are at a loss. What shall become of liberty? Some say that it has been destroyed, and that the counter revolution has won. Others are certain that liberty has been avenged, and that the Revolution has been unshakably consolidated.[44]

The Champ de Mars massacre marked a paroxysm in the French Revolution, with Mars, that red giant, overseeing a transformation for both the red flag and for republicanism. At the massacre the red flag had flown as a symbol of conservative state violence and repression, and the public were shocked by the violence. Lafayette – previously a standard bearer for both the American and French revolutions – saw his reputation ripped to shreds,[45] and a worse fate met the mayor, Bailly, who was executed for his part in the massacre. A red flag, appropriated by the protesters and standing as an accusation of his crimes, accompanied him to the guillotine, and onlookers who called themselves avengers of the Champ de Mars dragged red flags in the gutter and whipped them in his face.[46] After he was killed, the red flag was burned in the street by the crowd.[47] It seemed the association of the red flag with bourgeois state violence would be fixed. And yet the reputation of the red flag began to transform almost at once. In the days that followed Bailly's execu-

tion the bloody flag of repression was taken up to memorialise the republican comrades who had fallen in the Champ de Mars. The red flag was for the first time a flag of political martyrdom. A year later, in 1792, as the revolution again gathered pace, the red flag was taken up as a symbol of the Jacobins. In his *Socialist History of the French Revolution*, Jean Jaurès writes: 'there was a committee where they made a red flag bearing this inscription: "The martial law of the people against the revolt of the court", under which all free men were to rally, all the republicans who had a friend, a son, a relative murdered on the Champ de Mars on July 17, 1791 to avenge.[48]

And so French radicals made the state's traditional flag of war, martial law and 'no quarter' into both a flag of mourning and a flag of revenge. It was now a flag in the hands of revolutionaries, though not yet a flag of revolution. Other flags also flew above the French radicals – the black flag of poverty in Lyon,[49] the tricolour in Paris, and the oldest known surviving flag of the revolution, a yellow flag from 1790 bearing the inscription 'Valeur et Bonne Foi, Dieu et la Patrie' ('Valour and Good Faith, God and the Fatherland').[50] But it was the red flag, symbolically subverted by the blood of the revolution's martyrs, which became the standard of the radicals. It was the red flag that flew when Jacobins, the most extreme republican faction, stormed the Tuileries Palace in August 1792 and finally overthrew the monarchy. Jaurès writes:

> And the red flag, which was the flag of martial law, the bloody symbol of bourgeois repression, was taken over by the revolutionaries of August 10. They made it the signal of revolt, or rather the emblem of a new power And so it was more than a symbol of vengeance. It wasn't the banner of reprisals: it was the splendid flag of a new power conscious of its right, and this is why since then, whenever the proletariat was to affirm its strength and its hopes, it would be the red flag it would unfurl.[51]

This association of red with republicanism came from the flag's threat of death, now inverted by the people as a symbol of martyrdom. But the association of red and radicalism also sprang from

earlier traditions of colour in French politics. During the Fronde, the Ormée parliament – a radical insurrection in Bordeaux, drawing inspiration from the English levellers – red had been used as the symbol of the people.[52] Later, in 1675, Louis XIV had raised taxes on tobacco, paper and tin to fund the war with the Dutch, and a revolt had ensued. The Breton peasants who rose up wore their traditional red caps. This led to the rising being known as La Révolte des Bonnets Rouges, and the identification of red caps with revolution.[53] By the time of the French Revolution the symbolism of these Breton bonnets had merged with the Greco-Roman symbol of the Phrygian cap worn in ancient Rome by freed slaves. A red Phrygian cap, with its distinctive floppy ears and peak, had by the 1790s in France become a symbol of resistance against the monarchy and the establishment, combining Roman and French historical events.[54] Despite Robespierre's objections in his 'Speech Against the Red Cap',[55] during the course of the Revolution the colour red jumped from caps to cockades and eventually to flags. Inspired by the brutal massacre on the Champ de Mars and the spilled blood that divided the constitutional monarchists like Lafayette from the radical republicans such as Robespierre and Marat, the red flag and cap came to embody revolutionary idealism. Because of this it was the colour red that was associated with the Jacobin terror that marked the most violent phase of the French Revolution and the most firm destruction of the old regime.

The red flag was emerging in France and across the Atlantic just at the moment when the notion of the people as a political force was being born. It is not incidental that the red flag comes to prominence as ideas of nation and public polity emerge. The question 'Who are the people?' necessitated the question 'What is their flag?' As loyalty to royal houses began to decline, new faiths and identities emerged. In the cult of the nation state the masses – now political actors in their own right – began to prioritise their own secular collective identity, or rather one produced by the intelligentsia and the ruling class.[56] The objects of veneration – the national flag, the capital, the law – became the objectification of a new popular identity, they were the symbols that stood in for the will

of the people and their common fate.[57] Concurrent with the emergence of this new nationalism is the aesthetic and symbolism of the red flag. However it is a communal and moral symbol where class antagonism rather than national borders defines its boundaries. Born from the same moment as nationalism, the cult of the red flag is not centrally directed, it has no connection to country or ethnicity, and yet it fulfils the same function as the new national flags – it is a symbolic embodiment of the will of the people, and a totemic centre for a moral and political community. It symbolically ties a community together and binds them to a shared project and a shared fate. A project and future that was only just being glimpsed in the streets of Liverpool and Paris.

Symbols bind a community together by being collectively defined, but also mutable, imprecise and subjective. In the repeated use of the red flag, in the development of the political identity around it, the flag aggregates experience and identity. There is no final 'consensus of sentiment' that the red flag represents.[58] Instead, even in these initial moments of the French Revolution and the Liverpool Seamen's Revolt the red flag itself is a dialogical object that radicals can use to think with, to communicate via, and to find solace in. Already wrenched from the hands of monarchs during the birth of the modern world, the red flag would now be taken in many directions by rebels and radicals.

When the red flag of revolution arrived in Haiti its powerful connection to revolution and the mutability of its meaning allowed this symbol of the French people to be used by a populace enslaved by France. When rebel forces fought beneath a red flag at Crête-à-Pierrot in 1802[59] a slave nation was rising up with a red flag, and ideals that went far beyond those of the French Revolution in its claim to liberty, egality and fraternity were assumed by the flag. Haiti was the first colony to free itself, the first black republic and the first national slave revolt. Its own red flag would echo through history.

The combination of a red flag of mutineers and one of revolutionaries was affirmed in Toulon in 1795, where French sailors defended the Jacobins' radical government against a slide into counter-revo-

lution in Paris. Many sailors by this time had taken part in both revolutionary and mutinous campaigns, and the red flags on sea and land began to unite in their symbolism.

However, acceptance of the symbol was not universal. In another turn of the revolution, the 1796 Conspiracy of Equals in which the revolutionary Babeuf organised a coup d'état to establish a protosocialist state, the red flag was rejected in favour of the tricolour. The revolutionaries declared that republicanism was socialism and did not need another symbol.[60] The red flag in fact was not yet wholly captured by republicanism at this stage. When it flew in 1815 at the last French forts holding out against the British and their allies following the battle of Waterloo[61] it was in some cases coupled with the white flag of the monarchy and in others with the tricolour of the republic.[62] Again, in the French Revolution of 1830 the red flag was raised, flying from the towers of Notre-Dame. But this was a flag in defence of monarchy, not the republic; not a radical or political flag, but a flag of defiance.[63] In these cases it retained a sense of 'no surrender'.

The flag's co-option by radicals and republicans came in fits and starts, and even by the time of the Bourbon restoration many still saw it as the symbol of kingly power and martial law. France's most committed radicals did not see the red flag as their standard. Indeed, even in its most famous anthem, the French Republic today maintains the red flag's identity as a symbol of royal oppression. Singers of the 'Marseillaise' declare:

Allons enfants de la Patrie
Le jour de gloire est arrivé!
Contre nous de la tyrannie
L'étendard sanglant est levé

'Against us, the bloody flag of tyranny is raised.'

This is a red flag of death, a bloodthirsty flag that is a symbol of tyranny and mercilessness, the very ability to command labour and soldiers. The flag still speaks of this reactionary murder even as it is

taken up by some in the French Revolution as a standard of radical change. In this moment it exists simultaneously as a symbol of the *ancien régime* and as the flag of a possible future. There is no single ancestor for the red flag, nor a single moment that can be called its birth. Instead, it has engaged in a long process of becoming.

Meanings of republicanism and radical change continued to mix with the flag's identity as a symbol of mutiny around the world. But in 1797 they bore fruit in England when the red flag was raised in the greatest British working-class rising of the eighteenth century.[64] The year had begun with a successful mutiny at Spithead in Portsmouth, in which sailors had negotiated a pay rise and pardon from the Royal Navy.[65] Inspired by this success, sailors moored at Great Nore, an anchorage where the Medway meets the Thames, and began to organise and elect committees aboard every ship at anchor there. On 12 May the signal was given, and the 90-gun HMS *Sandwich*'s crew gave three cheers and raised the red flag. Twenty-eight further ships joined the mutiny at once, immobilising the Royal Navy's home command and taking control of the entrance to the Thames. The mutiny's initial demands were for the equal distribution of prize monies, the removal of unpopular officers, and changes to the Articles of War which governed behaviour and punishment aboard ships. But a radicalism soon swept the mutiny, led by agitators, many of whom had witnessed or participated in the revolution in France. Herman Melville described it as 'live cinders blown across the channel from France in flames'.[66] Whilst HMS *Sandwich* became the uprising's flagship, it was the more radical crew of HMS *Inflexible* which enforced the mutiny, even firing on other ships that threatened the solidity of the action.[67]

As the month progressed, the mutinous fleet declared itself a 'floating republic' and developed a complex committee system reminiscent of revolutionary Paris. The sailors elected Richard Parker their president,[68] and the red flag continued to fly from all ships as they enforced a full blockade of the city of London.[69] In late May the North Sea Squadron, now also in mutiny, arrived at Nore and joined the floating republic, which at its height numbered 100 ships and 30,000 men. What had begun as a strike had evolved

into a political action and, amid scaremongering in national papers and claims that the leadership was largely Irish and American, the mutiny expanded its demands and President Richard Parker, 'by command of the delegates of the fleet', called for the dissolution of the English Parliament, and peace with revolutionary France.[70] Here, at the gates of London, was a vast, armed, republican, working-class movement flying the red flag and demanding the fall of the government.

A response from the state was in preparation. The Navy itself, under Admiral Gower, had amassed a large fleet in the upper Thames, fearful that the Nore mutineers would sail on the capital.[71]

The red flag in this rising was still a flag of mutiny, but as in France, its practical meaning was shifting to become the symbol of a political identity. A cult was developing around the object. One of the mutineers' communiques was signed 'red for ever', and witnesses at the time claimed to have heard sailors cheer 'huzzah for the red flag'.[72] The Baucans' transformation into a flag of mutiny now progressed further. At Nore the red flag is for the first time not just a symbol of a rising, but a representative of working-class demands, a flag flown not just in the moment of conflict, but as a symbol of a political movement, the flag of a floating republic.[73] In the following year the red flag was withdrawn by the British Navy and no longer carried on ships: officers did not wish to hand their crews the symbol of mutiny. The red flag's power was ceded from the Navy to the rebels, and the fate of the colour red was further elided with the cause of labour.

The Nore Mutiny has been called 'the largest, best organised, and most sustained working-class offensive in 18th century Britain'.[74] What began as a strike and workplace occupation had developed political characteristics, revolutionary ideals and democratic structures. Whether it was through the influence of radical socialist mutineers or the fear of Admiral Gower's force advancing down the Thames, the Nore mutiny's position solidified from being the grievance of organised workers to a demand for social transformation, and in doing so it imbued the red flag with new symbolic power – a power that echoed around the world as news of the Nore

mutiny inspired revolts beneath a red flag in the British Mediterranean squadron, Cape squadron and eventually the Indian Ocean squadron stationed at Trincomalee.[75]

In September of that same year HMS *Hermione* mutinied beneath a red flag in the Caribbean. The crew killed ten of their officers and handed the warship to the enemy, Spain.[76] These mutineers, like many of those at Nore, disappeared to foreign countries and in many cases to foreign navies, spreading their experience. The multinational nature of the maritime labour force – most warships of the period could boast a score of different nationalities amongst their crew – and the spread of mutinies in this period across navies gives us a red flag in the hands of sailors of every race and nationality; they held a flag that represented something beyond nationalism, but which, unlike the nihilism and isolationism of piracy, pointed further towards ideas of utopian democracy and internationalism, whilst, of course, at the same time the meaning of the flag was being forged by the gruelling conditions, dehumanisation and desire for revenge on their superiors that was the experience of many at sea.

The Nore mutiny collapsed in the summer of 1797, and ten men from each ship were court martialled. The red flag was lowered from HMS *Sandwich* and the yellow flag that signifies an impending execution was raised in its place. Richard Parker, the president of the floating republic, was hanged from the yard-arm. His dying wish was that his 'death may be considered a sufficient atonement' for the mutiny, 'without involving the fate of the others'.[77] His wish was not to be, and 18 more men were executed. It is likely that those hanged were neither the most active nor the most radical of the mutineers; those men were believed to have escaped to France.[78] Nevertheless, they died alongside President Richard Parker, an elected insurrectionist, who flew the red flag at the head of a rebel navy, a red flag for which he and his comrades were martyred. In the sad end of the Nore mutiny we see a foreshadowing of one of the red flag's key roles in the century to come, a death shroud for the rebel dead.

At the start of the eighteenth century the red flag had been firmly established as a flag of power and threat flown by govern-

ment soldiers and ships. But by the end of that tumultuous century it had fallen into the hands of the working class and had begun to mutate in meaning. First at sea, from the Indian Ocean to the Americas, the Bloody Colours were turned against the establishment by pirates and mutineers. Then, in the streets of Paris, red flags were taken up in revenge against the authorities and in the consecration of dead comrades. Finally, at Nore the flag stood for a floating republic of workers, demanding international solidarity. In all these instances it was the flag of war, the Oriflamme, the Baucans, transformed and transferred from the establishment to the rebels. The flag underwent what Jaurès described as 'a sudden reversal of meaning that resembled a heroic play on words'.[79] The flag's historic significance of a fight to the death was being overlaid with the red flag's symbolic future as a flag of revolt, sacrifice, martyrdom and hope. At the end of the eighteenth century the red flag projected for the first time the power of the people and their sacrifices. It was a symbol beginning to find its meaning.

2
A Flag of Defiance

The Oriflamme of St Denis Cathedral vanished during the French Revolution, likely looted or destroyed. The red flag of French kings was no more. It had moved from the hands of armies, navies and kings into the company of pirates, mutineers and rebels. But its meaning remained in flux. Even at the trial of Richard Parker, the president of the 'floating republic' was unable to answer the question of what the flag had meant to the uprising. Repeatedly, prisoners and witnesses reported seeing the red flag raised, with one prisoner calling it 'the most daring outrage I had ever seen in the course of my life'.[1] But while the prosecutors were able to suggest that it was a 'flag of mutiny' and a 'flag of defiance', none of the accused were willing or able to confirm its meaning. While the importance of the red flag was clear to both sides, the meaning of the red flag was still in the process of emerging.

Nevertheless, the red flag's fame as a symbol of defiance continued to spread from the mutinies – so quickly, in fact, that by December 1797 the Tower Hamlets Militia, a military unit garrisoned in East London, were involved in a dramatic rooftop chase apprehending rebels suspected of flying a red flag over a procession at Ludgate Hill.[2] The seeds of the flag's role as a radical symbol had been sown, and the nineteenth century would see its significance and power grow as it moved from ships of war to the ship of state. The red flag would be raised in struggle throughout the first half of the nineteenth century, shedding its nautical and martial connotations and coming instead to be associated with the world of labour. Each time the flag appeared at a site of conflict it would do so with more political intent and more class consciousness massing around it. While in these decades it had no overtly political or economic programme attached to it, we can see, in the struggles that it flies

above, the nascent meaning of the red flag. In the early nineteenth century it is still a flag of action, of emergency, a flag that declares a moment of rebellion, but it is above all a flag of defiance, moving through history towards the hands of the working class.

In Britain in the early nineteenth century this making of meaning for the flag emerged at a crucial moment in the history of the working class. The establishment of large-scale industry, steam and steel, and the consequent mass cooperation and organisation of workers, were producing the most significant change in society since the development of agriculture. Beginning in England, Wales and Scotland, and spreading out across Europe and North America, the Industrial Revolution was developing a new mode of production, new cities and ways of living, a new society, with a new morality and a new oppressed class labouring beneath it. This new class, the proletariat, would come to define the red flag. Its creation took place concurrently with the forging of its symbol.

In the crucible of the Industrial Revolution, amongst the mines and mills, twin forces were acting upon this new class and on the red flag. One was the radical ideas emanating from the French Revolution: ideas of liberty, popular government and the re-organisation of society, law and time itself. The other was the disruption, privation and sharp increases in the cost of living brought about by the long Continental war being fought against Napoléon's French Empire and its allies. These powerful immediate influences had as their canvas the long process of enclosure and dispossession that had severed the people from their land and their right to subsistence. Millions were now compelled to sell their labour in order to live. Over time peasants of England, Scotland and Wales had the ties of feudalism and kinship broken and their access to the commons withdrawn. Landowners closed off their fields in order to increase efficiency and income. In doing so they forced the rural population off the land and into centres of industry where their ability to work permitted them temporary access to the food they had previously grown for themselves. Increasingly landowners and employers worked together to drive down wages while workers organised themselves into unions and guilds to preserve their pay.

Amidst this long process of proletarianisation the early nineteenth century saw conditions for the poor worsen as the war with France and the Continental blockade that Napoléon was pursuing against the British drove the price of food ever upwards. Strikes and riots against food prices spread, and English radicals began to foment dissent amongst the workers with slogans such as 'Peace or No King' and 'Cheap Bread or No King'.[3] Fearful of the growing discontent, Prime Minister Pitt's government passed the Combination Acts to outlaw trade unionism and bring the workers in line. However, the Acts had the opposite effect, banning moderate trade unions and putting a large number of organised workers into the hands of the most politically extreme organisations – organisations that continued to disregard the new law and which advocated the destruction of machines and factories.

In response to the bill political strikes swept England's industrial heartland and soon escalated as groups of organised workers began to attack the local yeomanry: the militarised proto-police force who were enforcing the anti-worker laws. In Middleton, near Oldham, in 1811 a group of several hundred workers, some with muskets, some with coal miners' picks, marched through the village and faced down a division of cavalry. A newspaper account described the workers waving 'a sort of red flag'. The cavalry responded to the demonstration by opening fire, and five men were killed, including a 16-year-old hatter and a 53-year-old joiner.[4] A local coal owner remarked that 'the spirit of turbulence peculiar to all manufacturing counties ... has assumed a new character since Jacobinism was infused into the lower orders and has now become perfectly infernal'.[5] The red flag had found its way into the hands of militant workers, and the political radicalism that had begun in France now travelled with it.

In this early nineteenth-century conflict at Middleton the red flag's key significance is present for the first time: the flag is the standard of a rising of organised workers against the troops of a state defending capital. As the workers are slain, the red flag again takes on its ceremonial link with martyrs. As the political faith of the proletariat begins to emerge, so too does the cult of the red

flag. Nevertheless, the flag here is not representing radical change, nor the organisation of the workers, it is simply a symbol of armed defiance. It acts as a stop sign by which people seek to resist the radical social transformation of industrial capitalism.

The flag is not, in 1811, taken up more widely by the movement of radicals or striking workers, and instead it is still simply the flag of small rebellions, early battles fought by industrialised labour. A flag sensationalised in the press, but which nevertheless is gaining in popularity. In 1818 the *Champion* of London published an editorial declaring: 'Westminster has proved that, even among the poorest, the most uninformed and unaccommodated of her population, Anarchy has no party. Its red flag has been displayed, and its red bonnet has been mounted, and they, and their mountebank apostles have been despised.'[6] But by March 1819 the same paper lamented that the reform movement was indeed taking up the red flag: 'by some strange ignorance, if not some perverse design of the agitators of these assemblies, it has become the habit to mount the red cap and flag of massacre'.[7]

Just months later the red flag would indeed be associated with massacre in England, though it would not be committed by those who flew it. In 1819, in St Peter's Field, Manchester, a red flag was raised amongst the crowd of 60,000. The large demonstration had gathered to demand parliamentary representation and reform. At the time many MPs were elected by a single landowner and fewer than 4 per cent of the adult population had any vote at all. The demonstration called for full suffrage and an end to the system of rotten boroughs. Amidst the crowd were women from Royton, a small town four miles from the earlier unrest at Middleton, and distinguished by being one of the first places in the world where the factory system was instituted.[8] The women bore a red flag[9] emblazoned with the words 'let us die like men, and not be sold like slaves'.[10] Their red flag, though it flew amongst banners of many colours, was a flag of defiance, and in particular of women's defiance, with a slogan expressing a willingness to die for the cause. This willingness was all too quickly to be answered as the Manchester and Salford Yeomanry charged into the crowd to arrest the orator

Henry Hunt. The yeomen knocked down a woman and killed a child, and in the mayhem that ensued the 15th Hussars, a regular cavalry regiment, were called in to disperse the crowd. They did so with sabres drawn. Seventeen people were murdered and hundreds injured.[11] In Richard Carlile's popular colour prints commemorating the massacre the red flag made by the women of Royton can be seen flying above Hunt. Though it was neither a symbol of the rally nor of reform, the image of the red flag flying above England's most famous political massacre would help solidify its meaning. By September of that year newspapers in London refer for the first time to 'the red flag of universal suffrage' being flown.[12]

This tragic heroism of the red flag is lit upon in the same year in one of the most renowned and generative paintings of the nineteenth century: *The Raft of the Medusa*. The monumental oil painting shows a mass of sailors' bodies, some dead, some living, aboard a raft on stormy seas. They are the lower-class survivors of the French frigate *Medusa*. The ship had sailed from France for the colony in Senegal, captained disastrously by a royalist who was appointed for his political loyalty to the newly restored French monarchy. When the ship struck a sandbank most of the passengers were evacuated, but 146 souls were left on an improvised raft that was towed into open ocean and then abandoned. The painting is a view of human suffering and an allegory of the wreck of the French Revolution. An image of what France has been reduced to in the wake of the terror, the emperors and the kings. But it is also an image of hope – on the horizon the *Argus* can be sighted coming to rescue the survivors, and at the painting's focal point a black sailor raises the red flag to signal their survival, their defiance and their hope of deliverance. It is the red flag in the hands of a black man that the painter chooses to represent the defiant struggle for survival and the coming liberation of the most oppressed. The image was an instant sensation, praised for both its political allegory and its representation, through the red flag, of the painter Géricault's commitment to the abolition of slavery.

Both Carlile and Géricault's images of the red flag would be mass-produced and would come to influence the choice of the red

flag as the increasingly dominant symbol of popular resistance. This identity was further crystallised when it flew in Scotland a year later in the Radical War of 1820.[13] That year weavers took part in armed insurrection across central Scotland. Scottish weavers and other artisans were radicalised, like their contemporaries in Oldham, by falling wages, the threats posed by industrialisation, and their lack of political representation. They looked to the French and American revolutions for inspiration, and began organising for an uprising, a provisional government and the re-establishment of a Scottish Parliament. In Strathaven, Lanarkshire, radicals and striking workers armed with pikes, a broken sword and a few guns[14] were addressed by John Stevenson. The crowd intended to march north to join with a radical army rumoured to be 5,000 strong camping in the Cathkin Braes above Glasgow, and there join in an attack on the positions of power in the city. At the same time some 60,000 workers began a general strike in Central Scotland, and groups of armed radicals attacked iron works and liberated political prisoners from Greenock jail. Stevenson said to the crowd:

> Is degradation and misery to be our sole inheritance – are we to be effectually and eternally the tools of a villainous aristocracy, who have shed the blood of three millions of men in the late revolutionary wars, and who would again shed the blood of half the human race to perpetuate their cannibal and desolating usurpation of the rights of industry? Fellow countrymen, we are for peace, law, and order, but we must and shall have justice …. Rather than bow to such hateful despotism we must and will unfurl the red flag of defiance.[15]

This may be the first time anywhere in the world that the red flag was invoked by armed workers intent on establishing a government, and explicitly in defence of the rights of industry. The radicals marched beneath banners declaring 'Scotland Free or a Desert', and across the country small groups rose up against both their masters and the state. But the rumoured radical army they hoped to join never materialised, and leaders in most major towns found them-

selves betrayed by spies or drawn into ambushes by agents provocateurs. Stevenson's group marched to the Cathkin Braes, where they found no allies, and returned home to Strathaven demoralised. In the days that followed 88 of the Scottish radicals were arrested and many more escaped on boats to Canada. The leader, James Wilson, was hanged on Glasgow Green in front of a crowd of 20,000 who called out 'he is a martyr'. At Stirling Castle his comrades Baird and Hardie were executed in the last juridical beheadings to take place in the British Isles.[16] Though the radicals had been drawn into the open by government spies and were easily suppressed, they assumed a mythical status in the pantheon of Scottish rebels. The Radical War represents an early entangling of the red flag with the cause of national liberation.

The Radical War in Scotland, and the Cato Street Conspiracy in London the same year, in which agents provocateurs again exposed radicals and, on this occasion, concocted a plan to assassinate the British Cabinet, revealed the extent to which unrest was widespread in the British Isles, but also demonstrated the fears of a ruling class that saw insurrection all around it. After each uprising, radicals and agitators were rounded up, including – in London – the Jamaican-born radical preacher Robert Wedderburn. Wedderburn – the son of an enslaved African woman, Rosanna, and the Scottish enslaver James Wedderburn – was a known agitator and an early bearer of the red flag. Robert's father James, himself the son of an executed Jacobite, had sold Robert's mother when she fell pregnant with him. Robert was raised by his grandmother in Jamaica, and recalled that when he was eleven she was flogged for being a witch. Robert himself was tried for blasphemous libel on 9 May 1820 during the repression of radicals.[17] Though he had begun his career as a Methodist, Wedderburn's ideas had become increasingly politically charged, and at the time of his arrest he was known as an abolitionist and was accused of having asked his congregation if it was right for a slave to kill his master. He held a regular service in Soho,[18] where he preached in favour of revolution in Jamaica and advised the founding of a republic in England.[19] Police informants reported that in his chapel, a makeshift room with bales of hay for

seats, slogans such as 'Our Rights, Peaceably if We May, Forcibly if We Must' and 'Universal Suffrage and Annual Parliaments' were daubed on the walls. At one end of the room, where the altar would have stood, were pictures of Thomas Paine, Toussaint L'Ouverture, a skull and crossbones and a red flag.[20]

These figures, the women of Royton, the weavers of Central Scotland and the radical Jamaican preacher Robert Wedderburn are the harbingers of a mass movement for reform. They are demanding liberation and representation, and advocating violence and self-sacrifice. They are forerunners of trade unionists, chartists, socialists and anarchists who are beginning to emerge from the growing proletarian class. They are activists who are attempting to resist the new capitalist oppression. All of them fly the red flag of defiance, all of them constitute the class that that flag will come to represent. In Wedderburn's chapel the red flag stands as a prop in the fight against slavery and for free religious expression, uniting the rebellions of Maroons in Jamaica with those of workers in London; at Peterloo, the red flag flies as a demand for suffrage and for women's emancipation, and denotes a willingness to die for it; and in the Radical War it unites national and social grievances at the frontier of British industrial capitalism. Currents of worker control, democracy, feminism and anti-colonialism are present here at the birth of the red flag. In two crucial years, across the British Isles, the red flag's meaning is forming. A flag flown repeatedly as a symbol of defiance is beginning to accrue symbolic values and ideals beyond just the representation of violence and mutiny. Crucially, its meaning is being forged in the hands of women, abolitionists and armed workers.

This was a process repeated wherever industrialisation and its new forms of oppression were developing. The red flag appeared again at the Aachen Revolt in 1830.[21] Here the red flag of mutiny and Jacobinism was moving into the hands of factory workers. As with sailors moving between navies, the migration of these newly industrialised workers dragged the cosmopolitan red flag in its wake.

A year later, at the periphery of the British state, amidst an uprising by Welsh iron workers in 1831, the red flag would gain

its first firm association with industrial labour. This occasion, the Merthyr Rising, is considered the first outing of the red flag of socialism.

At the turn of the nineteenth century South Wales was transformed in a few generations from a predominantly rural society to an industrial centre. Of the 27,000 inhabitants of the market town of Merthyr Tydfil more than a third worked for just four families in the town's iron works. Many more of the surrounding population worked in the coal pits, feeders, turnpikes, quarries and canals that now marked the landscape.[22]

These sites of body-crushing labour were the backdrop to a mass uprising in the Welsh valleys. A sharp depression in the iron trade, mass unemployment and the reform crisis in London – in which both Tory and Whig governments delayed democratic reforms – led to a sudden outbreak of political rioting. The riots were extraordinary in many ways: their combined urban and rural nature; the rioters' successful seizing of weapons from the military; their defeat of both the local yeomanry and the Argyll and Sutherland Highlanders under the guidance of radical former soldiers; their complex communications arrangements; and the worker control of the town that was maintained for four days. A mass rally by miners had turned into a general strike and an armed uprising in Merthyr, and the town's gentry and soldiers were besieged in the Castle Hotel. But the Merthyr Rising would go down in history not for these achievements, but rather for the flag under which they were won. As the workers fought the government soldiers, and as the Argyll and Sutherland Regiment began a retreat from the Castle Hotel to a more defensible encampment at Penydarren House, the striking coal and iron workers slaughtered a calf and drenched a flag in its blood. As the soldiers and gentry began to tend their wounded and count their supplies, this red flag of defiance was paraded through the town. This was organised labour fighting against capital beneath the red flag.

The image of a flag dipped in blood as the symbol of violent unrest took hold at once, and in just the following months newspapers carried sensational reports from Bristol and Bath of radicals

dipping flags in blood and blocking roads.[23] The establishment was shaken by both the power and the symbolism of the rising.

Though the tenacity and organisation of the workers of Merthyr was remarkable, they were no match for the British state. Reinforcements eventually relieved the besieged soldiers at Penydarren and began to retake Merthyr, street by street. Twenty-four of the rebels were killed in the fighting, and many more were injured.[24] The British Government was determined that at least one of the rising's leaders must be executed, and so Dic Penderyn was framed for the stabbing of a soldier and hanged in Cardiff. He would become another of the red flag's earliest martyrs, still commemorated today by Welsh trade unionists.[25] In the decade that followed the Merthyr Rising the red flag, often accompanied by the slogans 'bread or blood' and 'death or liberty', would become established as the symbol of struggle from below in Britain, re-emerging in demonstrations against the Corn Laws[26] and flown by the inmates of poorhouses in protest against the Poor Law.[27]

In both the wrongful execution of Dic Penderyn and in the sacrifice of a calf in Merthyr Tydfil we find another link to the historic and cultural primacy of the colour red. Just as national flags stand in for the blood sacrifice of a nation's soldiers, so the red flag stands in for the blood sacrifice of fallen comrades. Its red speaks of a ritual around violence, creating meaning out of the lives of martyrs. Part of the power of all national flags is established through myths of sacrifice,[28] but where the national flag is part of an unending blood sacrifice that must be enacted again and again at the borders of the nation, the red flag is sanctified by its own martyrs and their call for an end to all bloodshed.

Uniting the flag with Christian imagery again, this is a blood sacrifice that gives life.

Red indeed is a colour that brings things to life, just as a flag when it catches the wind seems to have a life force. Adorno and Horkheimer wrote in 1944 that 'Animism had endowed things with souls; industrialism makes souls into things.'[29] Even in its infancy, the red flag was seeking to redress this desecration. In the first three decades of the nineteenth century the red flag had found

itself repeatedly in the thick of battle between two new classes: the proletariat and the bourgeoisie. It was the totemic symbol by which the workers sought to arrest progress, stop the capitalist machines, and turn slaves and workers from things back into souls. The red flag had now found its class and its purpose.

3
A Flag of Revolution

The year after the Merthyr Rising, the red flag would return to another of its cradles: Paris. On the morning of 5 June 1832, amidst bad weather and against a backdrop of rioting and disease, more than 100,000 soldiers, citizens, progressives and nobles gathered in the centre of the French capital for the funeral of General Lamarque. A Napoleonic war hero and republican politician, Lamarque's admirers included radicals in exile from Poland and Italy whose causes he had supported, ministers of state, republicans, satirists and the great mass of the Parisian poor.[1] Although Lamarque was a rich and famous general, he had died in the fearsome outbreak of cholera that was sweeping through the working-class districts of Paris. Cholera had first emerged a decade earlier in the Ganges delta and was now reaching pandemic proportions across Europe. Its victims were disproportionately the urban poor who were the most exposed to contaminated water and therefore the most at risk of the terrible and swift death by dehydration that cholera could result in. This novel and terrifying disease had spent 1832 sharpening the class distinctions between the poverty of the Parisian workers and the opulence of the newly dominant bourgeoisie.[2] Rumours spread that it was the aristocracy themselves who had created cholera to subdue and clear out the working class. Cholera riots had already been seen in England and in Russia. As Victor Hugo observed: 'Paris had already long been ripe for commotion. As we have said, the great city resembles a piece of artillery; when it is loaded, it suffices for a spark to fall, and the shot is discharged. In June 1832, the spark was the death of General Lamarque.'[3]

The official mourners who followed Lamarque's coffin did so in such deep and zealous devotion that they began to knock the hats off any passers-by who were not quick enough in showing their

respect.[4] But for the people of Paris the funeral represented a greater opportunity than the knocking off of hats: some mourners had the crown of King Louis Philippe in their sights. As the funeral cortege and accompanying military escort made their way toward the Pont d'Austerlitz and the driving rain bounced off the cobbled streets, a group of opposition leaders and artisans, apparently without prior planning, took control of Lamarque's coffin, hijacking the cortege, and led the mourners toward the Place de la Bastille.[5] Lafayette, the man who had raised the red flag and presided over the massacre at the Champ de Mars 40 years earlier, was one of the pallbearers. He began to make a speech praising the flags of Poland and Spain above the crowd.[6] As he spoke, and as waiting guardsmen were ordered to refrain from violence in retaking control of the funeral, a makeshift red flag appeared above the crowd. It was carried by a curious pallid figure, his skin caked in poultices of linseed flour and his eyes sombre and fixed. The poet Heinrich Heine described him as a motionless ghost unleashing the fury of battle around him.[7] His flag was inscribed 'La Liberté ou la Mort' ('Liberty or Death').[8] The sickly flag-bearer, according to police reports, rode his black horse back and forth across the square before being thrown to the ground. His black horse bolted,[9] but the message had been understood and disorder broke out. The ghostly black horseman, thrown to the ground bearing a red flag of death, seems almost too perfect an evocation of the cholera, the desperation of the poor and the threat of revenge that this Jacobin flag conveyed. The question of who first opened fire has never been answered, but shots were exchanged between workers and soldiers, and barricades were erected. The pale horseman with the red flag marked the beginning of a republican uprising against the recently installed July Monarchy. By nightfall 3,000 insurgent workers were in control of central and eastern Paris, and the bonnet rouge, that symbol of the reign of terror of 1793, could be seen everywhere in the crowds.[10] Heine wrote that 'there is something mystical about this red banner with the black fringe … like a banner of consecration unto death'.[11] And indeed it was a rebellion unto death: the rising was crushed, and more than 100 people were killed.

A sickly horseman, a bolting black horse, a doomed uprising. These are inauspicious signs. And yet it is a vital moment in the life of the red flag as it moves on its journey from strike to insurrection. Here the flag has its message written plainly on it, 'Liberty or Death'; it is the red of lifeblood and the red of martyrdom. The flag is in the hands of armed workers and students in the midst of pestilence and hunger, and flown against the government forces of a bourgeois liberal monarchy. Although the insurgents would not yet identify the flag with socialism, and despite the fact that the uprising had been crushed, the sight of the red flag flying above the Parisian barricades would come to be a defining image in radical art and politics: workers, with a political programme, rising up against the ruling class and seizing whole districts of their capital city. Though the flag still signified rebellion rather than the redistribution of wealth, its attachment to republicanism and popular government marked its arrival as a symbol of revolution. The most utopian and democratic ideas of the French Revolution were coalescing around it. Under the Orleanist July monarchy which held power from 1830 to 1848 the red flag was, for the first time, outlawed, and one man caught with a red flag on 5 June 1832 was charged with 'having displayed in a public place a sign or symbol intended to spread the spirit of rebellion'.[12] This identification of the red flag with a spirit of rebellion acknowledges its move from a flag that merely signals an uprising to one which is intended to inspire or to propagandise one.

The fear generated by this symbol was clear from the verdict handed down to the young painter Michael Geoffroy who was identified as the man on the black horse. He was sentenced to death for being the bearer of the red flag at Lamarque's funeral. However, he was released a month later when the true flag bearer was found, a man who was deemed too mentally unstable for the same sentence.[13] Though contemporary accounts question whether the flag was in fact raised by anarchists, doctrinaires, Carlists wishing to restore the Bourbon monarchy or agents provocateurs wishing to strengthen the hand of the July monarchy,[14] the meaning that the

incident imbued the flag with was clear: it had become a demand for revolution.

This key role of the red flag in 1832 unites it with another first in that year, as Pierre Leroux introduced the English term 'socialism' to the French language. He wrote that socialism was to consider society as a living, meaningful thing and that 'to recognise no other aim than individualism is to deliver the lower classes to brutal exploitation'.[15] Borrowed from English, the word 'socialist' had formed around the cooperative ideas of Robert Owen. Owen used the fortune he had made from the textile industry to pioneer utopian communities in Scotland and the USA. He constructed planned towns, campaigned for labour laws and promoted collectivist ideas of child-rearing and education. Owen believed that humans were creatures of circumstance and that the drive for profit was corrupting their humanity. He believed that social good rather than individual greed must be the guiding principle. In Paris in 1832, informed by the experiences of the Industrial Revolution in Britain, a revolutionary movement was acquiring both a name and a symbol: socialism and the red flag.

Victor Hugo, a young republican in Paris at the time, witnessed the 1832 uprising and criticised the revolutionaries, writing that: 'We shall have a republic one day, and when it comes of its own free will, it will be good. But, let us not harvest in May fruit which will not be ripe until July; let us learn to wait …. We cannot suffer vagabonds to daub our flag with red.'[16] However, it would be Hugo himself who would later elevate this minor uprising to stand as a metaphor for all revolution in his novel *Les Misérables*. Fully one fifth of the novel takes place on 5 June 1832, and it is at the barricades that the characters and themes of the novel finally confront one another, beneath the red flags of young Parisian workers and students. The flag is itself a symbol of revolution for the first time in the 1830s, but retroactively, Hugo divorces the 1832 rebellion from its context and has it stand in for the revolutions of 1830 and 1848, and also for the future revolution that Victor Hugo hopes to see.[17] The novel, the stage musical and the film continue to raise the doomed red flag of 1832 and to trade on the sense of hope and desperation, the cause of liberty or death that continues to resonate

globally. At the novel's heart, too, is a socialist proposition in the mould of Robert Owen: that no one is good or evil, but that their material conditions shape them and their actions. In *Les Misérables* the red of the convict's uniform is the same red as that of the judge's gown, the priest's robes and the flag over the barricades. It is a red of power and oppression, of life and death. This is red on its journey from kings to communism. A symbolism in the process of being captured by the people.

Hugo himself would be at the side of national guardsmen crushing a barricade defended by workers in 1848, yet he still offers up a definitive image of revolution and places at its centre the red flag. His novel was a sensation, finding its way into the hands of more workers than almost any other piece of writing that century, published simultaneously in 'Paris, London, Brussels, Leipzig, Rotterdam, Madrid, Milan, Turin, Naples, Warsaw, Pest, St. Petersburg, and Rio de Janeiro':[18]

> People from all walks of life had come with wheelbarrows and hods and were squashed up against the door of Pagnerre's bookshop, which unfortunately opened outwards. Inside, thousands of copies of *Les Misérables* stood in columns that reached the ceiling. A few hours later, they had vanished. ... Factory workers contributed money to kitties and raffled off the novel to buy what would otherwise have cost them several weeks' wages.[19]

The story Hugo gave to these workers is at once an epic of love and sacrifice, but also a statement of the inevitability of revolution, of the dignity and assured future triumph of the red flag raised prematurely in 1832. In the novel the young revolutionary Enjolras makes a speech before his death on the barricade, saying: 'this barricade is not made of paving-stones, nor of joists, nor of bits of iron; it is made of two heaps, a heap of ideas, and a heap of woes. Here misery meets the ideal. The day embraces the night'[20] Here is an essential quality of revolution, and of the red flag, a tomb flooded with the dawn, the dialectical relationship between hopes and woes, liberty and death. The speech becomes the material for the key song

in the revolutionary section of the stage musical, in which the red flag is used to unite the political fervour of the young men and the romantic desire at the centre of the story:

> We need a sign
> To rally the people
> To call them to arms
> To bring them in line!
> ...
> Red, the blood of angry men!
> Black the dark of ages past!
> Red, a world about to dawn!
> Black, the night that ends at last!
> ...
> Red I feel my soul on fire!
> Black, my world if she's not there!
> Red, the colour of desire!
> Black, is the colour of despair!

Hope, desire, love and anger are all united in the red flag of *Les Misérables*. Though the novel is often derided for its length, its digressions, its lack of radical ideas, *Les Misérables* firmly shaped the revolutionary iconography of its time. The author selected the red flag as its emblem, which he placed in the hands of revolutionaries who 'through fear and trembling if needs be, ... force the human race towards paradise'.[21]

Before its immortalisation by Victor Hugo in 1862 the red flag of rebellion had begun to spread beyond Paris. So too had socialist ideas, often moving in parallel to but not yet wrapped up in the flag. When striking silk workers in Lyon took control of the city in the Canut revolt of 1834 they flew red flags from police stations and churches,[22] but in the 1830s the *drapeau rouge* was still not the settled symbol of the people or the workers in France. The Canuts also flew a black flag emblazoned with the words 'vivre en travaillant ou mourir en combattant' ('live working, or die fighting'). The popular images of the day show the tricolour in the hands of the

rebels and the red flag above the National Guard about to massacre the workers.[23]

This state of flux for the red flag as it takes on its meaning for socialists and yet continues to be deployed as a flag of martial law by the state and a flag of war by rebels persisted throughout the decade. The famous use of the flag by the forces of the Mexican dictator Santa Anna as he raised a red flag outside the Alamo in 1836 to declare no mercy for the Texan revolutionaries[24] found its counterpoint further south, in Uruguay in 1843, when the young Italian revolutionary Giuseppe Garibaldi commandeered a consignment of red shirts meant for slaughterhouse workers and established them as the uniform of his battalion. Garibaldi's redshirts would go on to become a key symbol of national liberation in Latin America, Italy and beyond.[25] They inspired the Scottish poet Hugh MacDiarmid's ode to the red of communism:

I fight in red for the same reasons
That Garibaldi chose the red shirt
– Because a few men in a field wearing red
Look like many men –
…
and the colour of red dances in the enemy's rifle sights
and his aim will be bad – But, best reason of all,
a man in a red shirt can neither hide nor retreat.

For more than a century the red flag moved between the hands of the oppressors and the oppressed: in both instances it represented a fight to the death. But it now found its meaning in contention – did the flag signify authority, or did it stand for liberty? In 1839 at the head of a large demonstration of radicals in Glasgow a red flag was raised. On it was the image of a hand clutching a dagger, and the words 'O tyrants, will you force us to this?'[26] The red flag was the embodiment of a heroic final stand and a righteous threat of violence – this eschatological symbolism would become more prevalent with each sacrifice made beneath the flag.

In the same year the flag re-appeared briefly on the streets of Paris when Louis Auguste Blanqui, the famous French radical, socialist and vanguardist, launched a failed coup d'état, the prototype of what would come to be known as a Blanquist attack. Blanqui believed in the redistribution of wealth and the founding of new collectivist society, but he was more concerned with how to achieve such a revolution than he was with what would follow it. The 1839 putsch was organised by his clandestine Société des Saisons, which launched a surprise attack and with 500 armed revolutionaries seized the National Assembly, the Hotel de Ville and the Palace of Justice. Their intention once they had gained control of the government was to proclaim a socialist dictatorship. However, isolated from any mass movement and without the support of the public, the coup was quickly crushed. Its final stand was taken on Rue Saint-Denis. There, on the street where the medieval French kings rode to collect the Oriflamme from the Abbey of St Denis, a final band of desperate revolutionaries manned a barricade. There fortifications were so hastily improvised from a nearby market that the stacked boxes were still filled with fresh eggs and vegetables. Atop the barricade, wedged between the spokes of an upturned omnibus, was a stick bearing a scrap of red cloth. As soldiers and police fought their way along the road Blanquists fired at them from the windows lining the street, and by the time the red flag of the failed coup was seized by soldiers the barricade had been abandoned. Some 700 men were arrested, though Blanqui himself managed to escape, with his own connection to the red flag far from over.[27]

The coup may have failed, but yet again it thrust the red flag into the centre of a political moment. Blanqui remained convinced that the establishment of socialism would be possible with the capture of Paris and that bearers of the red flag should not wait for some future 'organic' uprising by the masses, but instead should organise cells of dedicated revolutionaries who could act and change history by force. The Société des Saisons coup d'état had resulted in yet another defeat, and yet it provided an image of armed radicals, and of resistance against the monarchy and the bourgeoisie. Another defiant last stand, a defeat planting the seeds of hope. Again and

again the red flag had been raised amidst worker unrest, amidst republican rising, amidst revolutionary fervour. Even though it flew in the 1830s and 1840s in the hands of both the revolutionaries and of the state, it took on new meaning each time it was seen on the battlefield of the class war, and gradually, these meanings became fixed. In England, Scotland, Wales and France workers were beginning to associate the flag not just with taking a bloody stand, but also with the future they wished to fight for. The cult of the red flag was becoming attached to a faith in socialism.

When a new workers' movement stirred in Prussian Silesia in 1844 it was the red flag that they took as their standard. The Silesian weavers had risen up against the tortures and privations of industrialisation, which included lengthening their working days, lowering their wages and lining the pockets of their masters. Again, as in Merthyr, Lanarkshire and Oldham, it was the industrial mills of capitalism that were the birth place of the red flag. Marx wrote in August of 1844: 'The Silesian rebellion starts where the French and English workers' finish, namely with an understanding of the nature of the proletariat. This superiority stamps the whole episode. Not only were machines destroyed, those competitors of the workers, but also the account books, the titles of ownership ... the Silesian workers turned against the hidden enemy, the bankers.'[28]

Whereas the revolutions of 1789 and 1830 had been bourgeois, by the 1840s, across Europe, new powerful workers' groups were forging a revolutionary idealism. For many this included a political conviction that both the rights of democracy and the fruits of industry should be enjoyed by all. This would crystallise in 1848 when the proletariat and the socialist movement, still in its infancy, would rise up. Driven from the land into the factories, these working people represented a new dispossessed, a mass whose oppression and alienation had reached dizzying proportions in the furnace of the industrial age. The revolutions that swept the Continent began, once more, with the workers of Paris. And once more the workers of Paris brandished the red flag as their banner.

In the 1840s this red flag provided a means of identifying fellow-travellers, a non-verbal communication of radical intent. It was

not just a signal to the oppressor, but also a signal to those in the crowd who shared revolutionary views and feelings. Raised not just at moments of political violence, but also at rallies, speeches and funerals, it allowed sentiments to be shared that could not be spoken aloud amidst the repression and censorship of Europe's bourgeois monarchies. As it does today, the raising of a red flag signalled both a message of defiance, but also one of solidarity and fellow feeling. It is a symbol that conjures the revolutionary masses into being. As the Italian filmmaker and poet Pier Paolo Pasolini would write a century later:

For those who know only your colour, red flag,
you must really exist, so they may exist.[29]

Beginning with the revolutions of 1848, the red flag's meaning begins to transcend specific conflicts and to attach itself, both emotionally and ideologically, to the movements for socialism, anarchism and communism, and to the proletarian class. It exists so that the workers can know themselves. Its transition from a flag of individual risings to a flag of egalitarian political movements is both gradual and convulsive, but the international spread of revolutions in 1848 settles this transition and propels the red flag far beyond France. Perhaps its latent associations with life and death helped it to translate easily to new meanings. Undoubtedly its pedigree as a flag of martyrdom, sacrifice and revenge lent it a key role in rebellions. However, its final adoption as the flag of worker revolution does not precede, but instead proceeds from its appearances at the risings, coups, radical wars and mutinies of the early 1800s.

By 1848 the July Monarchy of the Orleanists had ruled France for 18 years. Besieged at different times by republicans, socialists and Bonapartists, who wished to fulfil the promises of the revolution, they were also harried by Legitimists who strove to reinstall the Bourbon monarchy. The July Monarchy had held itself out as a liberal form of government, seeking to ameliorate the extremes of the revolution and of the more conservative monarchy that had preceded it. But in those 18 years the world had been transformed.

The Industrial Revolution gripped Europe in a vice of production and consumption. European fleets poured tens of thousands of merchants, soldiers and slavers out into Africa, India and Asia to secure and seize raw material, land and people to feed into the ever more brutalising machine of the European factory system. Workers themselves were expendable appendages to the looms, ovens, kilns and furnaces that worked day and night to extract more and more value from the shattered bodies of the urban poor and colonised subjects. In the 1840s more than 600 million tonnes of coal were hacked from the earth,[30] nearly a tonne for each living soul on the planet. And yet the majority of the world population continued to live as rural peasants, untroubled by industrial capital and still rooted to the land. The exception, of course, was western and central Europe, where peasants were forced into the cities, feudal ties were broken and agriculture and landlordism were revolutionised. These peasants competed with artisans and drove down wages, while the wealth of the capitalists piled up around them.

At the same time, steady advances in printing and communication established a first mass media, spreading news and ideas like wildfire between fast-growing urban centres. In the 1840s nationalism, socialism and communism reached a mass audience through these new technologies. An increasingly powerful liberal bourgeoisie strove to organise new democratic nation states, and the ever-growing numbers of workers sought to exert their own power through trade union and socialist organising. The same forces that had fed the Radical War in Scotland and the Merthyr Rising in Wales were now at work across Europe as repressive monarchies suppressed secret societies. In their place, communists emerged intent on a new world created by and for the proletariat. After visiting Paris in 1843 Marx wrote:

> When communist artisans associate with one another, theory, propaganda, etc., is their first end In this practical process the most splendid results are to be observed whenever French socialist workers are seen together ... the brotherhood of man is no

mere phrase with them, but a fact of life, and the nobility of man shines upon us from their work-hardened bodies.[31]

On 1 June 1847 the Communist League was founded in London. It brought together the leftist League of the Just with a circle of German émigrés centred around a young radical philosopher called Karl Marx and chose the red flag as its symbol. The Communist League believed that the emerging conflict between the proletariat and the bourgeoisie would lead to a new society free from class and oppression and based on modern machine production.[32] This was a new understanding of society, and its advocates flocked toward its flag.

In the same year the German economist and folklorist August von Haxthausen expressed what these new political and industrial tensions would mean:

> Pauperism and proletariat are the suppurating ulcers which have sprung from the organism of modern states. Can they be healed? The communist doctors propose the complete destruction and annihilation of the existing organism. ... Would this in turn give way to new national states, and on what moral and social foundations? Who shall lift the veil of the future?[33]

The veil of the future was swiftly rent as the inadequacy of a ruling class out of touch with both the new proletariat and the new industrial rich found itself confronted with the European Potato Failure and an economic panic spreading from the British banking crisis of 1847. When autonomists rose up in Sicily in 1848 it became clear that this was the opening salvo of a sustained revolutionary barrage across the Continent. The red flag, however, was not the revolution's sole banner, and nor were communism and socialism its leading ideologies. Instead, ideas of national democracy were at its forefront. Behind these demands a host of even more disruptive ideas were ready to bloom.

The wave of national revolutions did not begin among the workers on the streets, but rather at a series of banquets. With polit-

ical demonstrations banned in France under King Louis-Philippe more prosperous Parisians had begun to stage political banquets as forums for criticism of the regime and for calls for reform. Friedrich Engels attended various reformist banquets at this time and described one in Paris as 'more like a demonstration of the strength, both in number and intellect, of democracy at Paris, than anything else'.[34] The *Journal des Débats* reported rather more breathlessly:

> What! no toast to the king? and this toast not omitted by negligence, by want of a sense of propriety – no, this omission put as a condition for their support by part of the getters-up! ... Why, this is not mere republicanism – this is revolutionism, physical-forcism, socialism, utopianism, anarchism and communism! Ah, but, gentlemen, we know you – we have had samples of your bloody deeds, we have proofs of what you are contending for! Fifty years ago, gentlemen, you called yourselves the club of the Jacobins![35]

Such sensational reporting contributed to the nervousness of the ruling elite who, fearing that agitation might spread from these banquets, outlawed them. This repression only served to unite bourgeois reformists with working-class revolutionaries, both of whom now found their political activities curtailed. Marx described the monarchy of Louis-Philippe as 'a joint stock company for the exploitation of France's national wealth' and a 'finance aristocracy, [that is] in its mode of acquisition as well as in its pleasures ... nothing but the rebirth of the lumpenproletariat on the heights of bourgeois society'.[36] This dissolute ruling class was as much a leech on the bourgeoisie as it was on the proletariat. The enforced end of political banqueting brought their shared resentment out into the light.

In early 1848 Parisians took to the streets. On 23 February soldiers fired into a crowd and the city erupted. Industrial workers, artisans and shopkeepers alike overturned omnibuses, cut down trees, lit fires and barricaded the city. On February 24 radicals seized the Tuileries palace and stormed the throne room, pulling down the

red curtains and cutting the luxurious red cloth from the throne to create flags.[37] In a single act the red of French kings was re-made as the flag of revolution. The revolutionaries demanded not just electoral reform, but also the fall of the monarchy and the establishment of a new republic. What form that republic should take was unclear, and different factions called for the lowering of taxes, the improvement of living conditions and the abolition of private property. This was a revolution, but a revolution led by competing classes. On the one hand it was a continuation of the bourgeois radicalism of 50 years earlier. On the other hand it represented a new power: that of the industrial proletariat, and their ideas of socialism, communism and class conflict. In February 1848 in Paris there were two flags atop the barricades: the tricolour of the French republic and the red flag of a workers' revolution.

Within a day Louis-Philippe abdicated and fled to England, and a republic with a provisional government was declared. The Russian anarchist Mikhail Bakunin wrote in his confession to Tsar Nicholas of what he encountered in Paris:

> Everywhere there were crowds, wild shouts, red banners in all the streets and squares and on all public buildings This huge city, the centre of European enlightenment, had suddenly been turned into the wild Caucasus: on every street, almost everywhere, barricades had been piled up like mountains, reaching the roofs, and on them, among rocks and broken furniture, like Lezghians in ravines, workers in their colourful blouses, blackened from powder and armed from head to foot. Fat shopkeepers ... with faces stupid from terror, timidly looked out of the windows. On the streets and boulevards not a single carriage. And the dandies, young and old, all the hated social lions with their walking sticks and lorgnettes, had disappeared, and in their place my noble ouvriers in rejoicing, exulting crowds, with red banners and patriotic songs, revelling in their victory! And in the midst of this unlimited freedom, this mad rapture, all were so forgiving, sympathetic, loving of their fellow man.[38]

We must be careful not to accept Bakunin's testimony as a complete image of the revolution. He had his own motives in describing the joy of a new republic, and we must remember that the quarters of Paris he stayed in were the most radical and the most openly controlled by workers and communists.

Elsewhere in revolutionary Paris the red flag was subordinate to the tricolour. Other contemporary accounts and illustrations show the red flag flown alongside the red, white and blue.[39] It was a dual revolution, and in its dual use of revolutionary symbols the red flag's fate was sealed. It became not just the flag of the uprising, but the flag of the utopian workers' vision. The red flag was opposed not only to monarchy, but also to a republic forged solely in the interests of the bourgeoisie.

On the morning of 25 February the representatives of the bourgeois republicans vied for power in the new provisional government. But outside the Hotel de Ville the other half of the revolution, the workers, marched bearing red flags and handing out red strips of cloth to all who assembled. There was soon a mighty crowd, flecked with red, besieging the seat of power and demanding that the Second French Republic take the red flag as its symbol. When groups of patriotic workers would arrive flying the tricolour fighting would break out and the red flag would triumph. For the government and the propertied class the tricolour represented continuity with the first republic and the bourgeois revolution. For the massed workers it represented another revolution captured by the elite. Alphonse de Lamartine, a writer, poet and the new Minister for Foreign Affairs in the provisional government, addressed the crowd, declaring:

> Today you demand from us the red flag instead of the tricolour one. Citizens for my part, I will never adopt the red flag; and I will explain in a word why I will oppose it with all the strength of my patriotism. It is, citizens because the tricolour flag had made the tour of the world under the Republic and the empire, with our liberty, and our glories, and that the red flag has only made the tour of the Champ de Mars, trained through torrents of the blood of the people.[40]

This suggestion that the red flag was one purely of martyrdom, and not a flag of struggle or of the people, won the day. The tricolour was adopted as the flag of France. However, Lamartine himself goes further in his history of the event, writing that the red flag is the flag of 'terrorists and communists' and that 'these had set up the red flag only because that colour excites men as well as brutes. [The workers] followed the communists without comprehending them. They vociferated with the terrorists without their thirst or impatience for blood.'[41] The workers of Paris, Lamartine maintained, were seduced by the red flag, 'more misled than guilty'.[42] Lamartine feared a flag that was not so much dragged in blood, but as he perceived it, bloodthirsty. The revolutionary sentiments it represented were to him so terrifying that he denied that they were indeed held by the crowd that surrounded him. Enough doubt was sown that the red flags were lowered, though by way of compromise it was agreed that French officials would all wear a red rosette. The next day a crowd again surrounded Hotel de Ville and flew the red flag, but they were met with 5,000 guards bearing muskets and flying tricolours. The professional revolutionary Blanqui responded:

> The people raised the red colours on the barricades of '48, just as they raised them on those of June 1832, April 1834, and May 1839. They have received the double consecration of defeat and victory. From this day on, these colours are theirs.
>
> Just yesterday they gloriously floated from the fronts of our buildings.
>
> Today, reaction ignominiously casts them in the mud and dares stain them with its calumnies.
>
> It is said it is a flag of blood. It is only red with the blood of the martyrs who made it the standard of the republic.
>
> ...
>
> Reaction has already been unleashed. It can be recognized by its violence. The men of the royalist faction roam the streets, insults and threats in their mouths, tearing the red colours from the boutonnieres of citizens.

Workers! It's your flag that is falling. Heed well! The Republic will not delay in following it.

Blanqui was right. The red flag, when it fell, was swiftly followed by the defeat of the workers, and then by the defeat of the second republic itself.

But in those first months of the 1848 Revolution great gains had been made. The bearers of the red flag had re-established the republic and forced the king to flee, they had secured the creation of a right to work, with a guarantee of paid employment for all citizens, and they had established The Luxembourg Commission to address social problems and meet the demands of the workers.[43] Though Marx remarked that 'the claims of the Paris proletariat, so far as they went beyond the bourgeois republic, could win no other existence than the nebulous one of the Luxembourg',[44] the working class of Paris nevertheless inspired the world, showing for the first time the revolutionary potential of the proletariat, and doing so beneath the scarlet standard. And those demands that were met were important: the right to work, the right to free association for labourers, a commission for social works, and a National Workshop providing pay and work for the tens of thousands of unemployed. This progress would imbue the red flag with new values and meanings beyond the physical act of revolution, aligning the banner with the larger transformative process of ongoing social revolution. In the years that followed, the English Chartists who had long fought for political rights under the green flag now adopted the red flag.

The Father of French anarchism and politician of the Second Republic Pierre-Joseph Proudhon wrote in March 1848:

Every time that the people, defeated by suffering, has wanted to express, outside of that juridical legality that murders it, its wishes and complaints, it has marched under a red banner. The red flag, it is true, has still not made the tour of the world, like its fortunate rival, the tricolour Poor red flag! Everyone abandons you! Well! I embrace you. I clutch you to my breast. Cheers to fraternity! The red flag is the sign of a revolution that will be the last.

> The red flag! It is the shroud of Christ, the federal standard of the human race.[45]

Spring 1848 represented a twin fate for the red flag. It had, for the first time, flown from a thousand barricades and toppled a government, but it had failed to complete that journey and rule Paris. It was now a flag of defiance and revolution, and also a flag of a politics and a class: socialism and the proletariat. It was fitting, then, that the flag had not been adopted by the state: the state was not yet in the hands of the workers. The 'us' signified by the red flag was confirmed as the working class against the 'them' of bourgeois nationalism. Had the provisional government adopted the red flag, the flag would have been immediately de-fanged and co-opted. Had it flown as the flag of France it would have been the red flag of a brief bourgeois republic, or worse still it might have served as the red flag of the decadent second empire that quickly followed the revolution. The red flag, however, did not come to power in 1848, and neither did the workers who bore it. Instead, they learnt a clear lesson in the impossibility of compromise with their oppressors, and they consecrated the meaning of their flag in its stand against the coming counter-revolution. The rejection of the red flag by the French bourgeoisie was the confirmation of the workers' symbol.

The proletariat and the bourgeoisie had delivered a revolution together, and they attempted to impose their conflicting wills on France. It is in this crucible of class conflict that the red flag is finally settled upon as the symbol of the global proletariat. The red flag affirmed the identity of the radical and allowed them to distance themselves from the reactionary. Ever since the 1790s Paris had been a repository of such radicals. In 1848 thousands of Poles, Italians, Hungarians and Germans who had long sought shelter in Paris now flowed out from the revolution and back to their homelands, seasoned by the barricades and waving the red flag.[46]

Inspired by the uprising in Paris a wave of revolutions spread across the continent, uniting workers, peasants and capitalists, and bringing down feudal and monarchical establishments that had ruled for a millennium. The birth of capitalism over the preceding

centuries had created two unstoppable forces: one was a bourgeoisie who no longer wished to bend the knee to their lords, and the other was the proletariat, separated from the land and newly conscious of their exploitation. The temporary alliance of the red flag with a host of national flags brought ruler after ruler tumbling down. First Sicily and France, then Germany, Denmark, Hungary, Switzerland, Austria, Sweden, Poland and Belgium were thrown into upheaval by a coalition of urban workers, bourgeois reformers and a hungry rural poor.

The red flag was raised above the door of the Berlin Assembly,[47] while elected deputies in Vienna plucked the colours of Austria and Hungary from their caps and flew a red flag,[48] In Venice, following riots and the brief establishment of the revolutionary Venetian Republic in 1848–1849, a red flag was hung from the bell tower of St Mark's.[49] In England the Chartist leader George Julian Harney proclaimed that: 'The tricolour is now as obsolete as the colourless rag of worn-out Legitimacy. Henceforth for the democracy, the red flag is the symbol of struggle, the emblem of hope, and the presage of victory.'[50]

The Italian activist Giuseppe Mazzini argued that the Jacobin revolution of the eighteenth century was one of 'individualism' and personal liberty, but that this new nineteenth-century revolution was characterised by 'association' – that is to say, communal liberty.[51] Two objects came to symbolise that truth in 1848 more than any others: the red flag and the newly published *Communist Manifesto* of Karl Marx and Frederick Engels. The red banner of proletarian revolution and its foundational text rose up together in 1848 and shook all of Europe: 'Let the ruling classes tremble at a Communistic revolution. The proletarians have nothing to lose but their chains. They have a world to win. Working men of all countries unite!'[52]

These words of Marx and Engels encompass the emergent meanings of the red flag: as a blood flag it declares that those who fly it have nothing to lose; as a battle standard it proclaims class war; and as a transnational flag it demonstrates that the workers have no country, that they are united in pursuit of a better world.

Marx and Engels were themselves active beneath the red flag in the revolution in Prussia, organising workers' associations, launching a left-wing newspaper, *Neue Rheinische Zeitung*, and dispatching communists to the provinces.[53] In 1849 Engels participated in the workers' Elberfeld Rising and led raids on Prussian arsenals.[54] Red flags flew from the barricades, and the revolution spread throughout the various German-speaking states.[55] Engels wrote: 'Is there a revolutionary centre anywhere in the world where the red flag, the emblem of the militant, united proletariat of Europe, has not been found flying on the barricades during the last five months? The fight in Frankfurt against the Parliament of the combined landowners and the bourgeoisie was likewise waged under the red flag.'[56]

Though the red flag flew from barricades, it flew alongside the tricolours of European nation states. The alliance of moderates, radicals, workers and bourgeois liberals who had brought about the wave of revolutions quickly began to fall apart. In Germany the bourgeoisie feared the radicalism of the workers and sided with the old regimes. In Paris the conflicting demands and partial achievements of the united workers and the bourgeois reformers paved the way for the collapse of the republic. In Baden the red flag itself came to mean nothing more than bourgeois reform.[57] All revolutions that are left unfinished find themselves the prey of reaction and counter-revolution, and the winter that followed the 1848 revolutions offered profound evidence of this. Across Europe progress was rolled back, despots came to power and the demands of the workers were suppressed. Whilst it had been the red flag that had flown at the barricades, it was the flag of the nation state that emerged triumphant from the flames of 1848.

In France the counter-revolution was swift and brutal. By mid-1848 the conservative and capitalist classes had reorganised themselves as the Party of Order, and their main target was the National Workshops. Some 100,000 French workers received their pay from this government organisation engaging them in public works. Workers were paid two francs for each day's work and one franc if no work could be found for them.[58] This system, won by the bearers of the red flag, was anathema to the aristocrats and to

the bourgeoisie alike. How could wages be forced down, how could workers be forced to toil, if the threat of destitution were removed by this organised welfare? Worse still, workers who have a secure livelihood regardless of their labour have time to read, to think and to organise. On 21 June the Party of Order forced the closure of the National Workshops, undoing in a single move the one great concession that labour had won from the state in France. Unemployed workers aged 18–25 were conscripted to the army, and those older were to be sent out of the city to work draining swamps. On 23 June the workers of Paris – this time unsupported by the liberals who had joined them in February – began methodically constructing barricades across the city. They demanded the restoration of the National Workshops and also the right to remain in Paris. Their enemies, such as the German economist Moritz von Mohl, declared that 'those who refuse to work raise the red flag and seek to murder those people who do work'.[59] Communists declared that there was now a chance to complete the February 1848 Revolution. Everywhere there was talk of civil war.

However, the Party of Order and its executive commission were prepared. They entrusted full military control to their Minister of War, General Cavaignac, and instructed him to put down any uprising. He wrote: 'I am charged with crushing the enemy and I shall act ruthlessly against him as though at war.'[60] Cavaignac was true to his word, and in a three-day battle in which 170,000 Parisian workers fought against the state the rebels were routed and their barricades and red flags were torn down. Fighting street by street in their own neighbourhoods, the workers fell at barricade after barricade, proving no match for an army and its artillery. Commanders had learnt from experience how important it was to prevent the fraternisation that in February had led to soldiers being contaminated by the insurgency and taking up the red flag themselves. The vengeance of the Party of Order was total, with huge numbers of armed workers killed and many more hunted down and executed in cold blood. It is estimated that at least 10,000 insurgents were thrown in the Seine or buried in mass graves.[61]

Karl Marx wrote:

The defeat of the June insurgents, to be sure, had now prepared, had levelled the ground on which the bourgeois republic could be founded and built, but it had shown at the same time that in Europe the questions at issue are other than that of 'republic or monarchy'. It had revealed that here 'bourgeois republic' signifies the unlimited despotism of one class over other classes.[62]

In their brutal defeat the workers of Paris and their red flag demonstrated what a bourgeois republic could mean for workers defending their rights: rivers of blood. Paris was kept under siege, and France under the dictatorship of Cavaignac, until a new constitution was put in place and elections were held in December.[63] The country continued its counter-revolutionary fall to the right. Proudhon wrote: 'The government is white; we are red. It no longer wants the tricolour; neither do we. That is clear.'[64]

The lightning triumph of the February revolution which lit up Europe was followed by the crushing defeat of the workers in June, and the humiliating election and subsequent enthroning of Emperor Louis-Napoléon III, a man Marx described as 'the adventurer who hides his trivial and repulsive features behind the iron death mask of Napoleon'.[65] The Second Republic was replaced by the Second Empire.

The vast Continental counter-revolution, although it threw radicals out of power and crushed workers movements, nevertheless acted to further radicalise both the proletariat and the bourgeois reformers and to unite their resistance around the red flag. With the failure of liberalism, the extremism of the socialists and communists won still more support. As Marx wrote: 'So swiftly had the march of the revolution ripened conditions that the friends of reform of all shades, the most moderate claims of the middle classes, were compelled to group themselves around the banner of the most extreme party of revolution, around the red flag.'[66]

While reaction triumphed in post-1848 Europe, the significance of the red flag both in terms of the failed revolution it symbolised and the ongoing resistance it represented continued to spread its fame. In the decades that followed, the red flag and the *Communist*

Manifesto would march hand in hand through the slums of Europe and beyond. As resurgent monarchies sought to persecute the failed revolutionaries, tens of thousands of political refugees fled across the Channel to Britain and across the Atlantic to the Americas. Others found refuge in European cities where they were not known. They brought with them the symbolism of the red flag. Marx and Blanqui both settled in England, dejected but determined to stoke the flames of future socialist uprisings. On 10 November 1850 a group of socialist exiles in London renounced their national flags and pledged allegiance to the red flag of revolution, foreshadowing the internationalism that was to come.[67] German revolutionaries such as Carl Schurz headed for New York, writing: 'The ideals of which I have dreamed and for which I have fought I shall find there, if not fully realised, but hopefully struggling for full realisation. In that struggle I shall perhaps be able to take some part.'[68]

It is estimated that at least 4,000 of the Germans who arrived in the United States of America in the 1850s had participated directly in the revolutions of 1848–1849. They joined many more revolutionaries from Italy, France, Austria and beyond. In 1854 a group calling themselves the Universal Democratic Republicans held a mass rally in New York marking the sixth anniversary of the February Revolution in Paris. The marchers carried the US flag, alongside the 'European rouge, or red flag, of the universal democracy'.[69] These thousands of political refugees began to fight for the red flag across the United States. The crushing of the red flag in Paris planted seeds throughout the world.

In 1850 Walt Whitman wrote 'Resurgemus', his poem of the 1848 revolutions. In it he celebrates the thrilling force that swept Europe:

> SUDDENLY, out of its state and drowsy air, the air of slaves,
> Like lightning Europe le'pt forth,
> Sombre, superb and terrible,
> As Ahimoth, brother of Death.
> God, 'twas delicious!
> That brief, tight, glorious grip
> Upon the throats of kings.

Whitman goes on to describe the betrayals and counter-revolutions that destroyed the new revolutionary society:

> The People scorned the ferocity of kings.
> But the sweetness of mercy brewed bitter destruction,
> And frightened rulers come back:
> Each comes in state, with his train,
> Hangman, priest, and tax-gatherer,
> Soldier, lawyer, and sycophant;
> An appalling procession of locusts,
> And the king struts grandly again.

Amidst the fog of reaction Whitman senses a mysterious being rising up:

> Vague as the night, draped interminably,
> Head, front and form, in scarlet folds;
> Whose face and eyes none may see.[70]

The red flag incarnate rises out of the revolutions of 1848. Whether it is a golem or a seraph, a hobgoblin or a spectre is uncertain, but the bodily form of the proletarian revolution is a fact. In Whitman's poem, as in reality, the people are only temporarily defeated. The red flag has been confirmed as the flag of the people, and its promise of revolution will be fulfilled.

4
A Flag of the International

In the years that followed the revolutions of 1848 rapid technological advances created huge cities of mansions and slums, and an unending array of new commodities. The vast capitalist progress was built on a global campaign of war, genocide and colonial adventure that subjugated the world to the empires and markets of Europe. As the European bourgeoisie appropriated an ever-greater mountain of wealth, they dispossessed an ever-greater army of labourers, peasants and colonial subjects. As the flags of Britain, France and the United States of America flew from the fortresses of capital, the red flag of labour spread at first clandestinely and later openly around the world, finding itself in the hands of myriad revolutionaries. The years that followed 1848 saw the steady progress of the bourgeoisie and the national flags of their regimes. This created an equal and opposite motion for the red flag. The conflict between the two was inherent and inevitable.

Over the centuries in which slave rebelled against master, serf against feudal lord, bourgeois against aristocrat and worker against capitalist, we have seen that the red flag emerged again and again at the moment of open conflict, sometimes in the hand of the oppressor, sometimes in the hand of the oppressed, but always carrying with it its use for signalling and its blood symbolism. The flag was that primal colour, red, the easiest to pick out from the chaos of the barricades, the clearest marker of comrade or enemy. Red with the blood of life and the threat of death.

Following the revolutions of 1848 the meaning of the red flag continued to change. It still bore the ideas of democracy and republicanism, of mercilessness and revolt, but these ideals were now a part of a proletarian politics, it was now a flag of the workers against the propertied class. Jean Jaurès wrote that the red flag had in its

history oscillated between the past and the future, between the ruling class and the people, but that, little by little, its new meaning, both popular and revolutionary, had by 1848 become settled.[1] The symbol was firmly entwined with the workers during the revolutions of that year, and in the ensuing suppression of their demands the meaning of the symbol became fixed. Anarchists, syndicalists, socialists and communists, followers of Bakunin, Blanqui, Marx and Proudhon – now forced into exile and underground – continued to rally beneath the folds of the scarlet standard.

It is no surprise that by 1849 the red flag was banned in France, with the new minister for the interior Léon Faucher writing that 'the red flag is a call for insurrection … a seditious symbol'.[2]

As both a socialist symbol and as a symbol detested by governments, the red flag's fame spread quickly during the 1850s and 1860s as communications, commodities, labour, profits and ideas moved quickly across borders. This globalisation would come at a price, and in 1857 the economic system witnessed its first truly global crisis. In what became known as the Panic of 1857, modern systems of communication meant that for the first time word of over-expansion in the US market and bank failures in the United Kingdom was able to spread almost instantly and to damage confidence in the global economy. The ensuing recession of 1860 and the American Civil War that followed it brought further shocks to capitalists, and as their businesses faltered this created sharp incentives for the lowering of wages, the firing of workers and the hiring of cheaper foreign labour.[3]

In response to this crisis of international capital there was an opportunity for the working class, if it could get organised. Workers' associations, trade unions and left-wing groups sought to establish a formal international organisation to maintain links and protect wages, chiefly across France and England, but also in combination with revolutionary movements more widely. In 1864 this desire was realised with the founding of the International Workingmen's Association. Its first meeting in London was attended by Proudhon, Blanqui, Marx and key figures representing the Owenites and trade councils, Italian republicans, German socialists and Irish and

Polish nationalists.[4] The First International, as it was later known, was soon joined by Engels, Bakunin and its first female member, Harriet Law.

In 1866 the International's first congress was held at Geneva. Delegates met for six days and made two key decisions which would dominate the cause of labour for the remainder of the century. The first was the adoption of the red flag. The delegates were led into the congress hall behind a red flag bearing the words 'no rights without duties, no duties without rights'. This was a flag, not of battle or revolution, but of ceremony, displayed with the same reverence as flags of state – on either side of it were the flags of Switzerland and the United States of America.[5] Like those flags, the flag now made a claim on a collective identity, on a people and a class. Outside the conference the red flag was raised from a yacht – to the horror of the Genevan bourgeoisie, who feared it as the symbol of violent revolution.[6]

The meeting of the International took place behind closed doors and saw long theoretical and tactical debates regarding the merits of cooperatives, communes, anarchism and socialism. However, under the red flag a key and concrete demand, supported strongly by Karl Marx, was established: in an industrial system where ten-, twelve- or fourteen-hour days in the factories had become the norm, the International would fight for an eight-hour working day. In *Capital* Marx wrote: 'In its blind unrestrainable passion, its werewolf hunger for surplus-labour, capital oversteps not only the moral, but even the merely physical maximum bounds of the working-day. It usurps the time for growth, development, and healthy maintenance of the body.'[7]

For Marx and the International the demand for an eight-hour day was not just a reformist demand which would improve the conditions of the workers toiling in relays of night and day shifts, sharing beds and eating at their looms and furnaces. Far more than that, an eight-hour day would create both time and energy for working-class education, organisation and indeed for planning revolution. Beyond these aims a limit on the working day would lay bare the truth of where value came from: the workers. By adopting the

red flag, and in making a single simple demand, the International set the stage for a century of revolution.

The red flag was now associated with a political programme which could be fought for by trade unionists, political parties and revolutionaries alike. The congress declared: 'The legal limitation of the working day is a preliminary condition without which all further attempts at improvement and emancipation of the working class must prove abortive.'[8] This unity of reform and revolution, of different movements and tendencies in one struggle for an eight-hour day, took place under the international banner of the working class: the red flag. By foregrounding a demand that seemed to be a simple reform, but which was understood by revolutionaries as a corollary to liberation, the International sowed the seeds of a conflicted identity for the red flag. It united two ideological and tactical camps: those who worked for the slow and dignified progress of the working class, and those who fought for the total destruction of the current economic and political system.

Increasingly, the red flag symbolised anarchist, socialist and communist demands and associations, flying at demonstrations as a threat to the ruling classes. The flag continued to meet with suppression, but it also began to slowly separate itself from the barricades and to take on a new role in the everyday political life of the working class. At meetings, strikes and processions the many guild and union banners that had long been raised at such occasions were now joined across Europe and North America by the red flag.

In the same years the Industrial Revolution itself was spreading inexorably. Underway already in England, Scotland, Wales, Belgium, the USA and Northern France for decades, it now stretched to all the major cities of Western Europe and began to establish an industrial proletariat across Europe and the Americas.

In the spring of 1868, in cities all over France, this burgeoning new class demonstrated against the Second Empire by singing the revolutionary French anthem, 'The Marseillaise' and flying the red flag. *The Christian Observer* remarked of the demonstrations in Bordeaux, Toulouse and Nantes: 'They [the public] know that the raising of the red flag is a matter of extreme importance inasmuch

as it indicates the working men of the towns in question are weary of the present regime.[9] The French workers were in truth not just weary of the regime, but were internationally organised as well. In Paris workers flocked to the new International as it arranged for monetary support for striking French bronzeworkers to be transferred to them from comrades in London.[10] The prestige of the red flag grew as it showed itself capable of practical as well as political action.

In 1869 a further watershed for the red flag occurred with the foundation of the Sozialdemokratische Arbeiterpartei Deutschlands (the Social Democratic Workers' Party of Germany). This radical left-wing party formed the political front of the labour movement in Germany, and was controlled by friends and allies of Marx. Representing a new strategy for gaining power for the workers – the ballot box – the party hoped to organise the proletariat into a parliamentary force to combat the reactionary government that had followed the 1848 revolutions. In Germany Otto von Bismarck had emerged as the imperial ruler to match France's Emperor Napoléon III, both in terms of repression at home and ambitions for conquest abroad.

It was against this conservative backdrop that the Social Democratic Workers of Germany became the first political party in the world to adopt the red flag as its symbol and banner.[11] Immediately, the party's internationalism was tested as Bismarck and Louis-Napoléon's armies clashed and the Franco-Prussian war began. The Social Democratic Workers' Party's leaders, Wilhelm Liebknecht and August Bebel immediately sued for peace and demanded in the Reichstag that all French territory be returned to France.[12] In a parallel peace demonstration in Paris in 1870 the red flag flew at the head of a vast procession. Parisians filed past the Bastille behind the *drapeau rouge* with shouts of 'Vive le Pax' and 'the people are our brothers, the tyrants are our enemies'.[13]

While the movement of international workers resisted war beneath their shared rebel banner, the tyrants pressed on. Both seeing the opportunity to expand their own Continental empires, Napoléon III and Otto von Bismarck led France and Prussia to war

in the summer of 1870. Prussia's superior forces swiftly won a series of key battles, and by the autumn the French emperor had been captured and Paris was under siege.

The city fell after four months, and in March 1871 the Prussians held a victory parade through Paris.[14] Quickly withdrawing from the newly formed French Republic, the Prussians extorted a vast sum as a war indemnity and assumed control of most of the territories of Alsace and Lorraine. This first clash between the great industrialised powers of the Continent would foreshadow the terrible world wars of the next century, but in that long slaughter's first battle the red flag emerged as a new beacon, a symbol of peace pointing to another world. Throughout the siege and the defeat of Paris a radical mood had gripped the city as soldiers elected their own officers and thousands of bourgeois citizens left for the countryside, leaving the cities and factories under worker control. In the shadow of war the red flag, the internationalist symbol of peace, flickered across France. For the first time the flag was not just a standard of revolution, but the symbol of the united workers of the world.

5
A Flag of the Commune

In each revolution, at each factory gate and in each election the red flag had accrued new meaning. Every time it had been cut down or betrayed, whether by allies or by enemies, reformers or reactionaries, its meanings had hardened. The flag represented workers, their defiance, their uprisings and their demand for change. But in 1871, a century after it began to fly as a symbol of labour, the red flag would take on a new form: as a flag of government, the flag of the Commune.

That year in Paris the red flag would find itself at the heart of a defining struggle. For two brief months workers ruled the French capital. The red flag was hoisted to the topmast of this unprecedented world event. For the first time the people had consciously taken power into their own hands. The Paris Commune was the opening act in a drama that would see the red flag, and communism itself, unleashing class warfare around the world, sowing the seeds of both liberation and tyranny.

The red flag's debut as a flag of government arrived in the spring of 1871 after the Prussians had captured Paris. The French government of the newly formed Third Republic had withdrawn to Versailles, and much of the Parisian bourgeoisie had fled to food and safety in the countryside. The capture of Napoléon III, the humiliating defeat of the French army and the gruelling Prussian siege of Paris produced a new political foment amongst the heady mix of republicans, socialists, communists, industrial workers, servants, Polish exiles and disaffected soldiers who made up the remaining population of Paris.[1] Secret societies, veterans of 1848 and members of the Workingmen's International all agitated and organised across Paris, hoping to capitalise on the sudden vacuum of power as the previous social order collapsed. Amongst the city's proletarian pro-

tagonists were the many secret supporters of Blanqui. Police reports claimed that there were as many as 3,000 Blanquists in Paris, armed and organised into secret cells of ten members each. The cells themselves had no knowledge of each other, used codenames, received their orders only verbally and were committed to an armed uprising to bring down the state.[2]

Paris itself had already seen months of unrest under the siege and occupation. The Prussian military attaché reported that 'Every night isolated barricades were thrown up, constructed for the most part out of disused conveyances, especially omnibuses, a few shots were fired at random, and scenes of disorder were taken part in by a few hundreds of persons.'[3] At the same time the National Guard in Paris became increasingly radical; soldiers refused to wear uniform, they elected their own officers and began organising by arrondissement, thus ensuring that soldiers of the same class and background served together.[4] A general election was held by the new republic in January of 1871 and was won decisively by monarchists, but the results were starkly different in Paris, where 37 of the 42 seats were won by republicans and socialists.[5] The new government in Versailles signed an armistice with the Prussians and set about the task of restoring order to Paris. Its first target was to remove 400 muzzle-loading cannons that Parisian citizens had raised funds for during the defence of the capital against the Prussians. The local battalions of the National Guard believed the cannons should remain in the city's parks, while the government sought to remove them from the hands of potential dissidents.

On 18 March the regular army marched into the city, intent on wresting the cannon from the insubordinate National Guard. Arriving early, the army was initially successful at Belleville and Buttes-Chaumont, but in Montmartre it faced resistance and, after a brief exchange of fire and the death of one local guardsman, citizens began to flood into the streets and to surround the soldiers. The government's General Lecomte ordered soldiers three times to fire into the crowd, but on each occasion they refused, and many defected to the National Guard. The crowd seized the army officers and took them to the local Guard station.[6] With word spreading

of the government's failed attempt to seize the cannons, and with barricades being built in every working-class district in the city, the Central Committee of the National Guard ordered their men to occupy the Hotel de Ville that evening. By nightfall 20,000 national guardsmen filled the centre of Paris, a red flag was raised from the city hall and all government forces were again withdrawn to Versailles.[7] *The Economist* reported that although peace had briefly returned to Europe, the financial world's hopes had turned into despair: 'The Red Party have obtained the mastery, and have set up a government of their own fashion. Representing and composed of men of the lowest classes.'[8]

Adolphe Thiers, as chief executive of the provisional French government, was in ultimate charge of the French forces and able to enact the strategy he had advised for Louis-Philippe in 1848: they would temporarily retreat from the capital, re-build the army and return to crush the radical proletariat once and for all.[9] The stage was set for both class war and civil war. The red flag flew once again against the tricolour.

A moment of revolution had arrived, the 'lowest classes' controlled the city beneath the red banner. The world watched in hope and fear: what did the red flag mean, and what would this people's army do with the power that it had seized? A generation earlier in the same city Lamartine had rejected the red flag, calling it a symbol dragged in the blood of the people, but in 1871 it had been chosen again by the people, and this time it flew with the force of an army in control of the whole of Paris.

Radical figures in the National Guard's Central Committee argued for an immediate march on Versailles to take control of the whole of France, but their views were moderated by the majority who wished not to appear as the aggressors. It was decided that the National Guard should consolidate its control of the city, hold elections with full male suffrage and hand power to a new, directly elected Commune.[10] The decision to delay proved to be too tentative. Had the National Guard pursued Thiers' forces, who were retreating in a disarray so chaotic that many regiments had been left stranded within Paris, it is possible it could have taken Versailles

within days and the red flag of the republic of labour might have flown over all of France.[11]

Instead, the red flag flew above a radical and noble experiment in Paris alone. But, despite its symbolism, and the revolutions it would go on to inspire, the Paris Commune was not the industrial workers' revolution that it may sometimes appear from our historical vantage point, and nor were the delegates of the Commune, once elected, explicitly communist, or indeed from the working class. Of the 92 seats contested in the hastily organised elections, some 20 remained untaken as moderate republicans elected to them by Paris's bourgeois districts refused to take their seats. In more working-class neighbourhoods Blanqui was elected in more than one arrondissement, despite at the time being in jail in Brittany. Of the remaining delegates, most were artisans, followed by intellectuals such as artists and journalists, and professionals such as teachers and lawyers; a small minority were industrial workers. Politically too, the delegates were diverse. The largest grouping were neo Jacobins, who believed in a revival of the politics of Robespierre. These were followed by Proudhonist social anarchists. There were just ten Blanquists elected, and a mere handful of delegates belonging to the International were chiefly influenced by Marx.[12] It is the history of those who today claim the lineage of the Paris Commune and the red flag which causes us to project backwards the image of a communist revolution in Paris. Indeed, the word 'commune' itself does not stem from 'communism', but instead simply from 'council' in French.

The Paris Commune ruled the city for 60 days from 28 March 1871. From its very inception it was destined to face a civil war with the national government. However, just as quickly as it poured its energies into the defence of the city, so too did it concentrate on the emancipation of its citizens and the spreading of revolution beyond the city. The Paris Commune immediately chose the red flag as its natural symbol and made the first laws to be established beneath that flag. Marx wrote:

> It was essentially a working class government, the product of the struggle of the producing against the appropriating class, the political form at last discovered under which to work out the economical emancipation of labour ... the Commune intended to abolish that class property which makes the labour of the many the wealth of the few. It aimed at the expropriation of the expropriators ... – the old world writhed in convulsions of rage at the sight of the Red Flag, the symbol of the Republic of Labour, floating over the Hôtel de Ville.[13]

The Commune's delegates immediately abolished the death penalty and conscription, ordered the wages of any political figure or public servant to be no greater than that of a worker, outlawed child labour, night-work and the fining of workers, cancelled all rent for the period of the Prussian siege, ordered all pawn shops to return work tools and household items to workers, and gave employees the right to take over and run any enterprise abandoned by its owners. The Commune also declared Blanqui its honorary president and appropriated all the property of the church.[14] The police were disbanded. As Marx put it: for the first time since 1848 the streets of Paris were safe.[15] These policies aimed to achieve the economic emancipation of the workers and they solidified the meaning of the red flag. As Marx had observed, here was the cult and faith of the red flag finding its political form. These were the first practical experiments in the politics of Proudhon, Bakunin, Marx and Blanqui. Those political theorists of the previous generation now saw their disciples rise up.

The symbolism of the Paris Commune revolved heavily around the red flag and the colour red, leaning on both its connotations of internationalism and proletarian rule. The National Guard swore an oath to the red flag, declaring a willingness to die defending the red banner. *Le Père Duchesne*, a radical newspaper printed in the 1790s, 1848 and again during the two months of the Paris Commune, wrote that:

We want nothing more to do with the fraudulent flag of your shameful – allegedly moderate and respectable – republics When a nation's standard has been dragged through such shameful quagmires, its fabric has to be changed and so its colour. The red flag ... is red only because it is drenched in the blood of the people spilled by the forces of reaction.[16]

For the first time the red flag was a symbol not just of revolution, not just of radical politics, but also the symbol of a government and a people. The Paris Commune achieved a symbiosis that united the revolutionary socialist imagination for the first time with political reality. It represented this project aesthetically with the red flag. And it is no small detail that many of those who fought beneath the red flag, and even many military commanders in the Commune, were not just internationalists, but internationals, and their rejection of the French flag also represented a new cosmopolitan identity in Paris.[17] The red flag adopted by the Commune was 'the wordless international declaration of independence',[18] and its protagonists were at work creating images and icons that would disturb capitalists around the world, not just the French government plotting a few miles away in Versailles.

Despite knowing that a rival national government was solidifying its position and preparing to invade, the Commune – Parisian as it was – remained committed to aesthetics. It was filled with joy, laughter, singing and theatre.[19] On 15 April the Commune sanctioned the formation of the Paris Federation of Artists, an organisation of sculptors, painters, architects, engravers and decorative artists who met to establish control of the city's arts by artists. They aimed to secure a right to culture and beauty for all citizens, to organise education and exhibitions, and to decide on the stewardship of the city's galleries, museums and monuments. This was but one small example of worker control in the city, but it led to a major spectacle when the Federation of Artists proposed the removal of the Vendôme Column and statue of Napoléon. The painter Gustave Courbet, the president of Federation of Artists, proposed the motion: 'In as much as the Vendôme column is a monument

devoid of all artistic value, tending to perpetuate by its expression the ideas of war and conquest of the past imperial dynasty, which are reproved by a republican nation's sentiment, citizen Courbet expresses the wish that the National Defence government will authorise him to disassemble this column.'[20] The Commune agreed, and Courbet hoped to see it reassembled in a museum. But the Council of the Commune had other ideas, and perhaps intent on fulfilling Marx's prophecy that the statue of Napoléon would come crashing down, they proposed a great spectacle of iconoclasm in which the column would be destroyed. In May a crowd gathered to watch the symbolic toppling of the emperor. A band played, spectators chanted 'Vive la Commune' and wedges were driven into the base of the column as a group of 50 men pulled at ropes tied to the statue. A witness wrote:

> There was no concussion on the ground, the column broke up almost before it reached its bed, and lay on the ground, a huge mass of ruin. An immense dust and smoke from the stones and crumpled clay rose up and an instant after a crowd of men, National Guards, Communards, and a sight-seeing Englishman flew upon it ... the excitement was so intense that people moved about as in a dream.[21]

Speeches were made, guardsmen smashed at the bronze with their rifle butts and collected pieces to be melted down for coins, while red flags were draped over the broken base of the column.[22] The square itself was renamed Place Internationale.[23] This was political performance art, the re-imagining of the city of Paris with a radical, internationalist perspective that centred the red flag at every turn: the cross atop the Pantheon had its two arms cut off and they were replaced by a red flag,[24] the first Communards to die facing French government forces were paraded through the cities in black hearses flying red flags,[25] the red flag flew from the column of the Bastille,[26] and at the Palais Garnier the statue of Apollo no longer bore a lyre, but instead the people's flag.[27] The god of poetry, truth and prophecy now proclaimed to the world a message of liberation.

The immense proliferation of red flags in the few months of the Commune did not occur by happenstance; it is no coincidence that it was at this moment that red became the ubiquitous colour of the workers. In the late eighteenth century alizarin was created – the first synthetically produced natural dye, making red cloth suddenly simpler to mass produce. The raw material of the Commune's red flags was no longer the cloth of the elite, but chemically dyed cottons and linens that could be easily and cheaply acquired. Where in 1848 red flags had been made from the curtains of the throne room, in 1871 they could be made from the shirts of the people.

But it was not only crucial that the Paris Commune had access to an abundance of red material, more than that it had a government which understood the red flag's symbolic and aesthetic power. As a movement under siege and yet in possession of many of the greatest treasures of France – the iconic buildings and artworks of Paris – it set about utilising the red flag not just as the symbol of its uprising and new democracy, but also as the universal symbol of appropriation and martyrdom in the cause of the workers. Understanding how a people identify with and are inspired by a national flag, it used the red flag as the central totem of its collective project. The Communards saw that as a symbol the red flag generates self-knowledge, it raises class consciousness and thus produces the movement it symbolises. They used it to ignite passions and reinforce a sense of collective belonging and lineage. The red flag had become the material incarnation of a shared goal and a shared memory.

The spark that was lit in Paris spread first to other French industrial cities. Blanquists and members of the International, including Bakunin, seized the town hall of Lyon and declared a short-lived Commune there, recognising the Central Committee in Paris as the legitimate government of France and flying the red flag over the city. Communes were declared and red flags raised over Toulouse, Marseille and St. Etienne, where the prefect was murdered and his murderer executed by the Commune.[28] These short chaotic risings were quickly put down by the regular army, and tricolours restored on the spires and city halls. A spasmodic civil war began in the spring of 1871, faltering quickly, and the last red flag to be lowered

outside of Paris was that flying over the town hall at La Guillotière in Lyon, which held out until the start of May.[29]

Once the red flag had been torn down in each of these cities the French army at Versailles began an assault on Paris. In an act of elite support for the provisional government, Bismarck freed thousands of French soldiers to take part in the destruction of the Commune, and sent the Prussian army in for good measure. The red flag was the symbol of the working class, and the national flags were arrayed against it. The international ruling class prepared to exact a terrible vengeance on the Commune. Marx wrote:

> The civilization and justice of bourgeois order comes out in its lurid light whenever the slaves and drudges of that order rise against their masters. Then this civilization and justice stand forth as undisguised savagery and lawless revenge. Each new crisis in the class struggle between the appropriator and the producer brings out this fact more glaringly. Even the atrocities of the bourgeois in June 1848 vanish before the infamy of 1871. The self-sacrificing heroism with which the population of Paris – men, women, and children – fought for eight days after the entrance of the Versaillese, reflects as much the grandeur of their cause, as the infernal deeds of the soldiery reflect the innate spirit of that civilization, indeed, the great problem of which is how to get rid of the heaps of corpses it made after the battle was over![30]

Artillery bombardment, burning houses, pools of blood, corpses on the city's streets: the revenge of the Versaillese was merciless. Revolutionaries fought valiantly, but without organisation or tactics, their democratic structure and arrondissement-based loyalty becoming their fatal undoing. The Communards were slaughtered neighbourhood by neighbourhood by the invading government forces,[31] who would begin pillaging one end of a street before they had even captured the other. As news of the massacre spread, the soldiers of the Commune became committed to a fight to the death. The final words of a communard named Louvet were recorded:

We only have a few moments left, you hear the rumours, secure our flag, burn it rather than let it fall into the hands of the Versaillese; if you manage to escape, keep it like a treasure, so that it might once again fly at the head of the defenders of rights of humanity, should a new revolution unfold.[32]

The leading delegate and member of the International Eugene Varlin provided the image for the final stand: leading 50 men on the final day of battle beneath a huge red flag, he was captured and shouted "Vive La Commune" as he died in a hail of bullets.[33]

When the battle was over and the Commune was defeated, the government's forces became a vast battalion of executioners. Anyone loyal to the Commune, anyone bearing a red flag, anyone in possession of arms, anyone dwelling in a house that fired upon the soldiers – and in some neighbourhoods anyone in possession of so much as a watch – was summarily executed.[34] Between 10,000 and 20,000 Communards were killed in what became known as the Bloody Week.[35] A further 43,000 people were taken prisoner by the French army, including 1,000 women and 600 children. They were held in desperate and unsanitary conditions, and thousands were sentenced to death, prison or exile.[36] In June 1871 London's *Standard* reported that prisoners were being executed at a rate of 500 each day.[37] Emile Zola, who had arrived in Paris as a journalist unsympathetic to the Commune, wrote: 'Paris is tired of murders. It seems to Paris that they're shooting everyone …. When the echoes of the last shots have ceased, it will take much gentleness to heal the million people suffering nightmares, those who have emerged, shivering from the fire and slaughter.'[38] It is no small irony that the red flag which began as a symbol of mercilessness in the hands of the French monarchy should now be the symbol that provoked such ruthlessness in the enlightened French Republic.

The unprecedented fury visited upon the Commune was enacted not just against the men, women and children of the city, but also against their ideas and their symbol. Even as the fighting went on, soldiers on both sides risked their lives for and against the red flag. Communards dragged flags from barricade to barricade in retreat,

and hid them on their person despite the certain death they would face if the flag were found. On the opposing side officers tore down red flags and stamped them in the dirt. One soldier climbed to the top of the opera house, bullets whistling around him, and with both hands tore the battle-scarred red flag down from the lyre of Apollo.[39] So vile and so perverse was the spirit and symbol of the Commune to Paris's re-established government, and so determined were many of the surviving public to escape the vengeance of the soldiers that a kind of mania against socialism, and in particular against the red flag, swept the city. One witness wrote that during the Commune there had been a passion for everything that was red: 'clothes, flags, ideas and language itself', but that, following defeat, 'red had become a fatal disease, one that must be studied so that it can be prevented, just as one does with the plague or cholera'.[40] The red flag itself was a pathogen.

Not all Communards were captured. Among the many women who organised and fought for the Commune, Louise Michel's name occurs the most often in the history of the uprising. She was there speaking at the political clubs and factories ahead of the revolution, and on 18 March she was in Montmartre inspiring the workers to defend the cannons and take up arms with her in the revolution. When the Commune itself could not decide whether or not to pursue Thiers' retreating army, she travelled alone to Versailles to demonstrate how easy it would be to assassinate the rival head of state. She took an active part in the political life of the Commune, remarking that 'It is true, perhaps, that women like rebellions. We are no better than men in respect to power, but power has not yet corrupted us.'[41]

During the Bloody Week in Paris, Michel fought on barricade after barricade. As the Commune fell she managed to escape with a red flag hidden on her person and retreated into the shadows of the ruined city. She became one of the most wanted figures in Paris, but was never betrayed. It was not until six months later, when the government took her mother hostage, that Michel surrendered. At her trial she told the judges: 'Since it seems that every heart that beats for freedom has no right to anything but a little slug

of lead, I demand my share. If you let me live, I shall never cease to cry for vengeance.'[42] In Michel, as with Varlin, the Commune and the red flag found martyrs more radical and more clearly ideological than those of previous revolutions. The writings of Marx, Bakunin, Proudhon and Blanqui – themselves inspired by the red flags of 1848 – now gave voice and power to the new revolutionaries. Although the character of the Paris Commune may in fact have been less socialist, less proletarian than that of 1848, the icons and allies who emerged from the Commune ensured that its essence would be remembered as one of anarchism, socialism and communism, as communicated by the red flag.

The massacre that marked the end of the Paris Commune would strip from the red flag any semblance of liberalism or of reconciliation that had remained during the Commune, where socialists and anarchists governed alongside moderate and liberal republicans, and where capitalists were allowed to retain their property. Instead, in the shadow of the counter-revolution the red flag would be established as a flag of unremitting class war. The International declared:

> When the red flag of the working class shall float again victorious we shall remember the real meaning of these deceiving words, 'Conciliation, reconciliation'. They have cost us too much to forget it. For a century the working class has been used as a tool by the bourgeois in its pursuit of state power. Repeatedly has the working class on the day of victory forgotten its past sufferings, and forgiven its bitterest enemy, the bourgeoisie. History shows by what treacheries this confidence has been repaid. The hideous hecatombs of June, 1848, and May, 1871, will form, for ever, an abyss between the proletariat and the bourgeoisie.[43]

As Trotsky put it, the French Third Republic was founded on the bones of the Communards.[44] In Montmartre, on the site of the state's greatest massacre, a huge basilica, the Sacré-Cœur, was constructed to expiate the crimes of the Commune, its white marble asserting itself as the symbol of bourgeois so-called morality against the red of proletarian struggle.

A FLAG OF THE COMMUNE

Across the channel the English ruling class looked to Paris in horror and sought to root out Communard sympathisers in London, where some 7,000 workers had met beneath a red flag on Clerkenwell Green to show their solidarity.[45] The establishment press found its obvious target in the General Council of the International Workingmen's Association, who shared the same symbol as the Commune – the red flag – and whose French members had participated in the civil war in France.[46] British members of parliament suggested that the International itself had directed the Commune according to the designs of that resident of Kentish Town 'the red terror doctor', Karl Marx.[47] The *New York World* reported that 'the English people have got a scare, and smell International in everything as King James smelled gunpowder after the famous plot'.[48]

Suggestions that the International had planned or directed the Commune or that it might repeat the experiment in London were feverish delusions. But the bourgeoisie were correct to fear contagion from the Paris Commune and to fret over its dangerous influence. As Engels wrote, 'the entire socialist proletariat, from Lisbon to New York and Budapest to Belgrade has assumed the responsibility for the actions of the Paris Commune without hesitation'.[49] The image of the red flag and the revolutionary gospel that emerged from the Commune proved a powerful propaganda tool, newly glamorised by the fear that the flag struck in the hearts of the capitalists and landlords who saw it fly. What would occur through the 1870s was not another great confrontation or revolution, but the slow and steady creep of the red flag, with its meaning newly clarified and its esteem newly raised.

In this decade the red flag first appeared in Sweden, Norway and Denmark. In Madrid it flew for the first time, emblazoned with the ominous words: 'the people are hungry'.[50] The press hysteria around the red flag further spread its fame. On 14 March 1872, when 7,000 unemployed New Yorkers rallied beneath red flags in Tompkins Square, the newspapers breathlessly reported that New York had its own Commune.[51] Similar rallies were organised by the International in Washington and in Chicago, where German,

English, Swedish and French-speaking workers united beneath a red flag.[52] In fact, in North America's largest cities the International saw a huge growth in membership in the 1870s, with socialists, communists, communalists, land reformers and suffragists, black, white and native workers, wealthy intellectuals and even spiritualists flocking to the red flag. Marx had hoped that in the USA it would be German and Irish workers who took up the red flag and led the international movement there, promoting Marxist principles and sowing the seeds of a workers' party. But, instead it quickly became clear that the red flag had a far broader appeal. Yankee radicals, immigrant anarchists and formerly enslaved people were all inspired by the stand taken by the Communards, and they soon formed the majority in the US branch of the International. When the International marched in New York it opted symbolically for African-American civil war veterans to march at the front of the crowd.[53] While the establishment press vehemently denounced the Commune as murderers and savages, the abolitionist newspapers of North America heralded the Communards and featured poems and dispatches from the Commune on its front pages.[54] The cultural makeup and history of the US working class was a world away from France and would take the red flag into the hands of a new oppressed. But the disenfranchised of the USA saw clearly that it was their cause that had been fought for in Paris too.

By 1881 the martyrs of the Commune and the spirit of their flag were fast becoming sacred to the working class. Sympathy for the Communards and reverence for the red flag had reached such a degree that the body of Théophile Ferré, the lover of Louise Michel and the first of the Communard delegates to be executed by the government, was exhumed. He was re-buried in a ceremony in which friends and comrades cut lockets from the hair that still clung to his broken skull, wrapped him in a red flag and entombed him in the family grave.[55] Such memorials were not uncommon, and by 1883 Ilya Repin was completing a painting of a memorial service at the Wall of the Communards in which a large red flag flies in front of a crowd that stretches beyond the frame. Édouard Manet produced

a painting of the Communard Rochefort escaping from exile, and William Morris wrote in his popular poem 'The Pilgrims of Hope':

> Year after year shall men meet with the red flag over head,
> And shall call on the help of the vanquished and the kindness of the dead.[56]

In the memorialising of the Communards, and in the part the red flag played in these ceremonies, a sanctity and ritual were created, establishing a left tradition around holiness and reverence that would find later expression in communism's battles with the church, and in the movement's focus on anniversaries, death and martyrdom. William Morris himself, along with George Bernard Shaw and others, expressed disquiet about the reverent and sacred approach that was emerging in relation to the Commune and the flag. They felt that it placed limits on the possibility of moving forward and of naming the Commune's mistakes. They felt that such reverence for the past was a brake on imagining the future. Ahead of the 1887 commemoration Morris wrote candidly to his daughter: 'I have to speak, which I don't quite like; because although it is proper & right to celebrate the day, one has by this time said all one has to say on the subject.'[57] But conversely, red flag rituals around noble defeats also allowed possible futures to emerge. Enzo Traverso has suggested that such memorialising has a part to play in a dialectics of defeat, in which martyrdom and commemoration are way markers on a journey of expansion and development. He wrote of the Commune: 'The dimension of such a defeat was overwhelming, but did not shake the faith of Marx in the historical growth of socialism. Three decades later, mass socialist parties existed in all European countries.'[58]

Presaging this, Louise Michel wrote: 'The Commune, surrounded from every direction, had only death on its horizon. It could only be brave, and it was. And in dying it opened wide the door to the future. That was its destiny.'[59] The red flag again flew over a tomb flooded with sunlight.

In Germany the door to that future was already opening in the most unlikely way. Wilhelm' Liebknecht and August Bebel, the leaders of the small Social Democratic Workers' Party that had called for an immediate peace with France in 1870, were tried for treason in 1872 as part of Otto von Bismarck's determination to stamp out the seeds of socialism in Germany.

The trial lasted two weeks, and although both defendants were found guilty, it created a storm of interest, giving both politicians a national platform. In a curious twist, numerous banned revolutionary texts were cited in evidence by the prosecutor – including the, at the time out of print, *Communist Manifesto* – and so they now became legal to print in the public interest. The trial led to a huge increase in the publication and sales of the works of Marx and others.[60] After their prison sentences both Bebel and Liebknecht were re-elected to the Reichstag with increased majorities, and their party began its transition from a minor left-wing grouping to becoming the first mass party of the European working class. An article of Liebknecht's was read out to the court:

> You too have chosen the flag of the proletariat, the people's colour, the sacred red! It is not the colour of innocence, nor of sadness, nor of hope, nor of penance: it is the colour of philanthropy, of the flame of enthusiasm that blazes up from the embers of the heart, it is the colour of our heart's blood that we must be willing to give for the liberation of mankind!
>
> So hold up the flag of work, the flag of equality, freedom and brotherhood!

The article closed with a poem

> For too long tears have stained
> the hard bread of work;
> now a fiery protest rages;
> raise our red flag!
> The bourgeoisie crash into us
> and suck our blood:

the worker dies in hunger,
they starve his brood.
Too long have they extorted
our cries of pain.
Now we stand true, now we stand firm,
now our flag is red![61]

The President of the Court claimed that these words were treasonous. It seemed to the court that by 1872 allegiance to the red flag was a threat to the German state. Liebknecht protested that the red stood not for murder, but for equality. But the president of the court concluded: 'everyone in this room whose voice is of value knows what the red flag means, it is an incitement to rape the bourgeoisie'.[62]

The case began a series of attempts to suppress the red flag both in Germany and across the Continent. In the 50 years that followed the Paris Commune the red flag would be defined by the power it wielded in Paris and the hatred it evoked in the ruling class. Nevertheless, the bloody conclusion of the Paris Commune would see those who flew the red flag retreat from revolutionary and communist positions, framing themselves instead as the bearers of a humanistic, democratic and scientific socialism. The Commune confirmed the meaning of the red flag, but in the debris of a failed revolution those who raised it moderated their aims. The tendency of radical change gave way to that of gradual reform. The violence of the bourgeoisie created a period in which armed revolution was shunned.

6
A Flag of the Workers

Though the Paris Commune presented a caesura in capitalist dominance, Europe emerged from the Franco–Prussian War and the rubble of Paris with a fanfare of steel. Combustion engines, flying machines, steam ships and imperial wars pulled wealth to the capitalist centre and reshaped the world. The Industrial Revolution bore dramatic fruit in a wealth of new technologies. In and amongst the remarkable advances of the Belle Epoque was an ever-growing class of the oppressed, both in Europe and in the colonised world. This was echoed in the USA as the civil war gave way to what Mark Twain referred to as the Gilded Age, a thin façade of economic progress that covered the suffering of a vast, downtrodden underclass. Amidst these contradictions the red flag began to develop new meanings, finding itself for the first time at the head of a movement that was asserting its will not at the barricades of Western Europe, but across the globe at the ballot box, the factory gate and even in the corridors of power.

The connotations of the red flag as a symbol of warning and danger continued to grow in parallel and in tension with the red flag of socialism. In Britain, as fears of the dangerous new motor cars began to spread, parliament passed the Red Flag Act, which decreed that motor vehicles could travel at no more than 4 miles per hour and must be accompanied by two men waving red flags, one in front and one behind the carriage.[1] The red flag retained a meaning outwith politics. In the Red Flag Act, in parallel to the symbol's political uses, we have that symbol marching ahead of modernity, ushering in a new era, whilst warning of carnage to come.

The years between the fall of the Paris Commune and the outbreak of the First World War saw immense growth in the membership of socialist parties in Europe and its colonies. But in these

decades too, in cities around the world, anarcho-syndicalism began to take an ideological and strategic foothold. The artisanal workers who had formed the backbone of Chartism, the French revolutions, and the 1848 Springtime of Nations were now largely subsumed into a vast industrial proletariat. The scale of production, cooperation and the geographical extent of the factory system increased exponentially and led to the development of huge new urban centres where workers came under the influence of radical trade unions, and where voters joined socialist political parties. Between 1870 and 1913 Germany went from producing 1 million tons of pig iron a year to producing more than 16 million tons a year. Even this number was dwarfed by the 31 million tons produced annually by the United States.[2] These figures belie a vast new industrial and urban population finding itself not only in the grip of mechanised capitalist exploitation, but also within the sphere of socialist and anarchist influence. In this period, broadly speaking, socialists favoured a slow, democratic takeover of the state and anarcho-syndicalists believed in an immediate seizure of the factories. Despite different strategies, both had as their aim the foundation of an egalitarian society and both had as their symbol the red flag.

Socialists and anarchists had, until the Paris Commune, both maintained membership of the First International and shared not just a flag, but a movement. However, this alliance was unable to survive the disputes between the two factions during the 1870s. By 1872 Marx and Bakunin, the pre-eminent socialist and anarchist theorists respectively, were engaged in an internecine struggle for the minds of the workers' movement, the International, and the red flag. Both men opposed capitalism, and both believed that a new communist society would abolish private property and economic class. They hoped to free all people to develop their creative, intellectual and social capacities. Both men also agreed that it was the state itself that policed, enforced and propped up the capitalist orthodoxy. For Marx and Bakunin, the future communist world would have no need for states. The question that divided them was strategic: how to get to this future world. For Bakunin, a revolution was the opportunity to return to an idyllic natural state of harmony

between humankind. For Marx, a revolution was an opportunity to drive humanity on to its next stage of development, building on the incredible advances of capitalism, but casting the oppression it produced aside. For this Marxist future a transitional state was required, a dictatorship of the proletariat that would lead society on to its communist existence in which the state would wither away.[3] Marx advocated a proletarian party that could lead this new state and fight against the dictatorship of the bourgeoisie under which all of Europe continued to suffer.

Bakunin could not accept this, fearing that a dictatorship of the proletariat would be merely a replication of the current oppression in different hands. He wrote: 'we think that the necessarily revolutionary policy of the proletariat must have for its immediate and only object the destruction of states'.[4] Marx saw Bakunin's position as bucolic and naïve – did Bakunin think that the bourgeoisie would vanish overnight, that industrial capitalists would accept their defeat, see the red flag raised and release their slaves? For Marx, the workers' party and the dictatorship of the proletariat would not be there to rule over the workers, they would exist as a weapon to use against the ruling class. The state apparatus would be used to crush the bourgeoisie and would then wither away.[5] For Bakunin, the means were the ends: the state had to be abolished along with capitalism.

These philosophical and practical tensions led to a bitter ideological struggle between the adherents of these two theorists and resulted in the eventual destruction of the First International. The red flag was divided. It stood at the head of two great political movements. In the wake of the International's collapse two new organisations emerged. The Second International gathered together the socialist and labour parties of the world, and the Anarchist International became the organisation of those who sought the destruction of all political power.

The red flag in these years, however, was not principally a flag of theory and political concept, but rather a flag of action. Although the split between Bakunin and Marx would come to define the red flag in the twentieth century, it was in the nineteenth century merely the

background to the huge overlapping progress of both the socialist and anarchist movements. Neither Marxism nor Bakuninism were the dominant modes of thought for the millions who flew the red flag in these decades. Instead, they were only elements of a radical and revolutionary red flag politics that promised a new future to the working class. In each society, according to its own material conditions and its own cultural legacy, a distinct red flag tradition developed, and all of these traditions took ideas and inspiration from both the anarchist and the socialist left. One of the great benefits of a universal symbol is that it may stand in for theory, even for a political programme, uniting a people around a set of beliefs that seem to be generally held by all who adhere to the flag, but which in fact subtly mutate by era, population and individual. The red flag allowed space for alliances and cross-pollination within an umbrella movement that included different working-class politics that at different times would be united and dispersed. The red flag in the final years of the nineteenth century found itself at the head of many different rivers of humanity, with a vast array of subtly different political visions and programmes, all with a shared emancipatory goal. The question was merely which of these currents would be the first to see the red flag fly triumphant.

In Britain, where the process of industrialisation and urbanisation had happened earliest, the workers' movement professed a municipal socialism: cooperatives, associations and parliamentary motions would work to peacefully transfer control of land, factories and the means of distribution into the hands of the workers. In France, conversely, where artisanal labour and handicraft persisted more stubbornly, a syndicalism developed that concentrated on the mass strike and control of the factories and workshops as political tools for social change; capitalism and the state would be simply paralysed and forced to comply with the political aims of the working class. Elsewhere, the scientific socialism of Marx led to a current which, through theory and study, intended to remove the scales from the eyes of the workers and to allow them to see not only the exploitation of one class by another which was inherent in capitalism, but also the fact that this exploitation could end only

in the ruin of both classes, or in the establishment of socialism. Finally, some anarchists in this period developed the propaganda of the deed: a programme of insurrectionary violence, bombings and assassinations aimed at catalysing revolution and providing an example to fellow workers of the oppressive nature of the state's monopoly of force. Anarchist violence took hold most profoundly in countries such as Russia, where socialist organisation, popular education and trade union organising were most fully suppressed.

In these years nascent labour parties, economics lectures, socialist Sunday schools, syndicalist trade unions and assassins hunting the crown heads of Europe all took up the red flag, and left their mark upon it. But nowhere was the red flag's ascent more dramatic than in the United States of America. This new superpower was emerging with individualism and the free rein of capital as its foundational core, and a vast native and immigrant population of oppressed and dispossessed workers as its raw material. Although utopian socialist and anarchist movements had developed in the United States in the early nineteenth century, it was the second half of the century when the red flag first began to fly in America.

From its earliest arrival in America competing elements of the socialist press were attempting to define the flag. In *Fortnightly Review* in 1878 Frederic Harrison wrote that 'the color red, which for decorative purposes is capable of magnificent effects, represents to French workmen not, as some have absurdly said, violence in any way, but the peaceful republic of industry'. In 1885 the Chicago paper *Vorbote* added that the red flag is 'the emblem of the universal brotherhood of man ... the symbol of the frequently shed blood of the proletariat, and at the same time the sign of the salvation of the suffering and starving people'. The Kansas Bureau of Labour Statistics wrote: 'The red flag signifies the gospel Paul preached on Mars Hill, that God had made of one blood all nations, and that it is the banner of one blood, the emblem of fraternity.'[6]

Blood, violence, brotherhood, aesthetics, the history of the French workers all are present as Americans take up the symbol, as is an increased ritual and spiritual symbolism of the flag.

In the United States, as elsewhere, non-conformist preachers were often the first recruits of the socialist movement, and the imagery and ideas of the Bible became interwoven with the aims of the working-class movement. At Mars Hill, the Areopagus of that red god of war, Paul proclaimed an early internationalism, with all nations in the image of God, but in the quote above the symbol of the red flag is moved beyond that in order to signify the underlying unity of races, the common blood of all workers – the blood of struggle and of labour. In the United States the division of labour and society along colour lines was the greatest asset of American capitalism and the greatest weakness of American labour. The red flag, though, was utilised by many of those engaged in symbolic and practical attempts to unite workers across race lines. Marx had argued in the 1860s that 'the veiled slavery of the wage workers in Europe needed, for its pedestal, slavery pure and simple in the new world'[7] and that 'Labour in the white skin can never free itself as long as labour in the black skin is branded.'[8] Yet despite this central understanding of modern capitalism's dependency on racialised exploitation, and the necessity of solidarity across the colour line, in the US, more starkly even than in the Old World, the stamp of white supremacy fell upon the working-class movement and found its expression in parts of the movement that flew the red flag. W.E.B. Du Bois wrote that: 'Despite the fact that the nineteenth century saw an upsurge in the power of the laboring classes and a fight toward economic equality and political democracy, this movement ... lagged far behind the accumulation of wealth, because in popular opinion labor was fundamentally degrading and the just burden of inferior peoples.'[9]

In the USA the end of the Civil War and the abolition of slavery saw a vast new black proletariat arrive in the cities and the fields. Instead of being greeted with solidarity, they were viewed as a threat to wages and to society and were met with a wall of racist thought and violence that punished and subjugated black workers and warped the ideals and understanding of white workers. Similarly Chinese and Latin American labourers were excluded from white trade unions and socialist parties. As Du Bois put it: 'it was

easy to transfer class hatred so that it fell on the Black worker'.[10] At the same time it was possible for the bourgeoisie to offer petty or theoretical privileges to white workers, ensuring their division from workers of colour. Yet, although for the majority racism was the norm, the quotations above indicate that the red flag was also a symbol used to unite across colour lines, as well as to organise workers of colour throughout the United States.

In 1877 a 69-day strike by non-unionised railroad workers spread across the north-eastern United States. Some 100,000 workers downed tools in response to pay cuts and set fire to stations and hundreds of engines in action that led the government to fear a repetition of the Paris Commune. Up and down the country black workers joined the strike. In Louisville hundreds of black sewer-diggers marched through white neighbourhoods.[11] In many towns such demonstrations were met with force and crowds were fired upon by local militia and guardsmen, More than 100 workers were killed by police at massacres in Grafton, Baltimore and Pittsburgh.[12]

Under a red flag Peter H. Clark, a black former schoolteacher, addressed a mass rally in support of the workers who had fought the police and the army and destroyed millions of dollars' worth of private property in this first national strike in the USA. Local newspapers denounced Clark and the strikers as 'fools' and 'destructives',[13] but the effectiveness of his speech and the power of his position as a black socialist was clear in the Socialist Labour Party's decision the following year for Clark to stand as their first ever congressional candidate.[14] At that time no African-American had ever been elected to the US Senate or to the House of Representatives.

However, in the United States of America during the reconstruction era, and particularly in the Southern states, the red flag was a conflicted symbol for African-Americans. For decades the red flag had flown outside the offices of slave traders to indicate that they were open for business. The painter Eyre Crowe described seeing in the 1850s 'small garish flags of blood red upon which are pinned small manuscript descriptions of the negroes to be successfully disposed of'. The practice continued until the South's defeat in the American Civil War in 1865.[15] The red flag was deployed by slave

traders with its symbolism of blood and flesh to represent dehumanisation instead of liberation. And yet – just as the flag had been reclaimed by the Jacobins in 1792 – at Charleston in 1865 when slavery was abolished, black men rang bells and flew red flags in the march marking their liberation.[16]

Black American history is furnished with examples of the red flag of defiance. Like many escaped or freed slaves, the Black Seminole tribe of Florida, which banded together natives, maroons and freed slaves, stood against the American army beneath a red flag in the early nineteenth century.[17] Red flags were frequently flown by escaped slaves, and emancipated people in the Americas. This symbolism comes in part from the workers' movement and in part from the lineage of Jacobinism – particularly the Haitian revolution. But Historian Robbie Shilliam also notes the many powerful pan-African antecedents to the red flag: 'Red is the spiritual colour of Africa in many Caribbean faiths. In Trinidad, the colour of Shango – the agency of thunder and lightning – is red. And, for the Converted faith in St Vincent, red is the colour of Africa. In Guyana Comfa, red also represents Africa, as well as St Judas.'[18] Red is also the colour of the battle flag of Igbo warriors.[19] The red flag of African-American Marxism and the black radical tradition represents a synthesis of politics, faith and identity, combining African and European red flags. It incorporated and modified the red flags before it and used them in the many risings against both capitalism and white supremacy that black fighters led in the western hemisphere. Shilliam also highlighted how this black radical red flag crystallised around the united anti-colonial and anti-racist struggles in the Americas and Africa, and particularly around the red flag that opposed Mussolini's invasion of Abyssinia. In this later period black peasant risings were increasingly accompanied by rumours of communist infiltration. In Demerara in 1935 two plantation overseers were beaten by workers and forced to carry red flags, in step with strikers, on the sugar estates. Another Guyanese striker declared: 'I am an Abyssinian General.'[20] These valuable sources are evidence of a black internationalist red flag uniting struggles, connecting the workers of the factories and the plantations of the Americas and Africa.

For many on the US left the red flag had the potential to unite black and white workers. In no tradition was this more true than in the anarchist movement. Whilst organised socialist and communist parties never reached a mass membership in the United States, the power of trade unions, and particularly anarchist trade unions, was considerable. Unions had the ability to paralyse transport and factories in the major eastern cities and secured significant gains for their members. Across the United States two key trade union organisations led workers, one vehemently opposed to the red flag and the other raising it high. The first was the Knights of Labor, a massive federation of workers with more than 800,000 members;[21] they fought for an eight-hour day, cooperatives and the cultural uplift of workers, although they spurned strike action and campaigned actively to exclude Chinese workers from both organisation and jobs. In 1886 the Knights of Labor declared:

> Let it be understood by all the world that the Knights of Labor have no affiliation, association, sympathy or respect for the band of cowardly murderers, cut-throats and robbers, known as anarchists, who sneak through the country like midnight assassins, stirring up the passions of ignorant foreigners, unfurling the red flag of anarchy and causing riot and blood-shed.[22]

The midnight assassins that the Knights condemned were the anarchists and syndicalists who would go on to found the Industrial Workers of the World, affectionately known as the Wobblies. They would do more to shape the meaning of the red flag in the United States than any socialist, Marxist or communist organisation during this period. In the USA the red flag of the workers was significantly the red flag of anarchism. Although the US had a long history of individualist and indigenous anarchisms, the association between anarchists and the red flag took hold chiefly among immigrants to the USA during the 1870s and 1880s. The first anarcho-communist publications in North America were in Yiddish, German and Russian, and in these publications new arrivals to the US propagated the symbols and tactics of the Old World. Emma

Goldman from Lithuania, Johann Most from Germany and Alexander Berkman from Russia were among the most effective and reviled left-wing campaigners the USA has ever seen. Attracting crowds in their thousands, they discussed the socialisation of labour, the destruction of authority, the emancipation of women, free love and the merits of political violence.

Frustrated by the reformism, racism and anti-strike positions of established trade unions, anarchists used the red flag in the USA to symbolise a total break with the old society. They advocated one big union of workers, freely associating and willing to lead a violent revolution for the abolition of private property. Goldman, whom one paper described as 'a mysterious young woman on a truck who had waved a red flag and urged revolution, her high-pitched voice putting the horse to flight',[23] would often lead processions of workers beneath the flag. She would arrive in cities and conduct radical baptisms in which children were initiated in the spirit of anarchism and their parents were educated in the rights of the child.[24] The red flag in Goldman's hands was the symbol not just of direct worker organisation, but also of radical social change. In the late nineteenth century she distributed birth control, supported sex workers and campaigned for gay liberation.[25] The press response to anarchists such as Goldman was as excitable as it was fanciful, claiming that she baptised babies in liquor and carrying descriptions of her such as this from the *Detroit Journal*:

> Emma Goldman, Anarchy Agitator, Shrieks for the Blood Red Flag. One Dynamite Bomb and One Death, She Says, Are Worth Ten Years Talking and Preaching. This High Priestess of Anarchy Declares the Doctrine of Destruction and Discontent. And she has blue eyes. Silky, Soft Hair, and Pretty Feet in Neat Shoes. Became Noted by Her Wild Speeches Under the Banner of the Red Flag.[26]

The *New York World* described her as: 'a great raw-boned creature, with short hair and bloomers, a red flag in one hand, a burning torch

in the other; both feet constantly off of the ground and "murder!" continually upon her lips'.[27]

Goldman's fiery speeches and radical social and economic positions led the newspapers to describe her in terms one minute piratical and the next supernatural, and often with vivid ideas of sex and power. Her influence is hard to overestimate, and her positioning of the red flag as a symbol of anarchism and radical, often violent, demands was widespread in the United States in the 1880s and 1890s, although ideas of extremism often came more from bourgeois paranoia than from actual political organisers themselves. Goldman was less concerned with fire-raising and riots, and more with 'the black man's right to his body and woman's right to her soul'.[28] It was these ideals as much as the fevered imaginings of journalists that propelled anarcho-communism and the red flag to the forefront of the US working-class movement.

There were, however, significant acts of political violence committed beneath the red flag in the United States in the late nineteenth and early twentieth century: the assassination of US President William McKinley by the steelworker and anarchist Leon Czolgosz, bombings in Union Square, Wall Street and Lexington Avenue, and Alexander Berkman's attempt to murder the industrialist Henry Frick. But the most famous anarchist bomb, and the one that would spread the fame of the red flag the furthest, exploded in Chicago's Haymarket in 1886.

Agitation for the eight-hour day had been gaining momentum across the United States ever since the end of the Civil War. Rapid industrialisation and urbanisation had led to increased militancy on behalf of both capital, which employed thugs, spies, scabs and lockouts, and labour, which ranged in its tactics from those of the conservative anti-socialist worker associations such as the Knights of Labor to armed revolutionaries and socialist propaganda groups. In Chicago alone there were several thousand – mostly immigrant – anarchists who were organising workers in the city and publishing the *Arbeiter-Zeitung*, a radical newspaper.[29] In 1884 the Federation of Organized Trades and Labor Unions passed a resolution setting 1 May 1886 as the date by which an eight-hour day would become

standard, replacing the ten-hour day that was then near universal. As May 1886 approached, workers across the United States planned mass meetings and strikes. At a time when some 10 per cent of white workers and 70 per cent of black workers were illiterate,[30] it was slogans, songs and symbols as much as newspapers and resolutions that moved the public to action. In this instance, the red flag and the 'Eight Hour Song' were key tools of propaganda. The red flag flew above factory gate meetings and the agitators sang:

> We are summoning our forces from the shipyard, shop and mill, Eight Hours for work. Eight hours for rest. Eight hours for what we will.[31]

The extent to which the red flag was a central tool for rallying the anarchists in the city is confirmed by the efforts of the police to suppress the symbol. Captain Michael J. Shaack, who led the 1886 Chicago police investigation into the anarchists, wrote:

> In the numerous arrests and raids made, the police became thoroughly acquainted with the most notorious Anarchists in the city, the ins and outs of their resorts, and even the interior arrangement of their dwelling-places. Not only were suspects arrested, but search was made for contraband articles. A varied collection of arms, bombs, etc., and a large assortment of red bunting thus found their way to the Chicago Avenue Station. In all the public demonstrations made by the Anarchists in the city they had carried many flags, banners and transparencies as emblems of defiance, and whenever such were found they were carefully taken in charge. When the investigations were concluded, the inner room of my private office was well filled with a most curious display of these time-worn and weather-beaten ensigns, and the collection is very interesting as a reminder of a critical period in the history of Chicago. There are flags of a very primitive and cheap description, and flags more or less elaborate and expensive. They varied in size and differed in the degree of their crimson colors. Those belonging to groups were large and

plain, showing frequent handling by dirt-begrimed hands, and were mounted on plain pine staffs. Those carried by the Lehr und Wehr Verein were of finer texture and larger in size, its principal standard, of silk, being a present from the female revolutionists and gorgeous in the amplitude of its folds. This silken standard was the pride and joy of the whole fraternity, and at one time it served to relieve the motley collection with its bright vermilion, but in some unaccountable manner it disappeared one day from a West Side police station. The reds had evidently set their hearts on recapturing it, and by some sort of legerdemain they succeeded. Who it was that accomplished the deed has never been disclosed, and in whose custody it is now is a profound secret, carefully kept by the Anarchists[32]

The red flag had a significant propagandist value to both anarchists and police in this decade-long game of 'capture the flag', culminating in the Haymarket bombing and the first political May Day.

On 1 May 1886 a strike began across the USA. There were picnics and parades in Milwaukee, Cincinnati and Detroit, and in New York Italian labourers tied red handkerchiefs to their pickaxes and marched through the city.[33] As many as half a million workers struck across the United States, and Chicago was the centre of the storm.[34] On the third day of the strike Chicago police fired into a crowd of workers as they rushed towards strike-breakers at the McCormick Reaper Works. Two striking workers were shot dead, and organisers feared that the murders by police were a deliberate attempt to demoralise the strikers.[35] On the same day in Milwaukee nine unarmed workers bearing red flags with clock faces painted on them – a symbol of the eight-hour movement – were shot dead by national guardsmen.[36] A demonstration was called for the next day in Chicago, and tens of thousands of fliers were distributed in the city bearing words such as 'Revenge', 'Working Men to Arms', 'Arbeiter zu den Waffen' and 'Your masters sent out their bloodhounds – the police – they killed six of your brothers at McCor-

mick's this afternoon ... destroy the hideous monster that seeks to destroy you.'[37]

On 4 May an anxious Chicago police force assembled to face a potentially riotous demonstration. The assembly passed quietly. Albert Parsons and other anarchists addressed a few thousand workers in the rain as the evening drew on. By ten that night the heavily policed crowd was slowly dispersing. But as the demonstration petered out, the dark evening was suddenly lit by an explosion. A bomb on a short fuse was thrown into the lines of police and exploded, killing one officer and leading other policemen to fire into the crowd and at each other.[38] An anonymous police official told a local newspaper: 'A very large number of the police were wounded by each other's revolvers. ... It was every man for himself, and while some got two or three squares away, the rest emptied their revolvers, mainly into each other.'[39]

At least seven officers and four workers were killed in the Chicago Haymarket on the night of 4 May. Desperate to retaliate and to prevent further anarchist attacks, the police rounded up leading organisers: Albert Parsons, George Engel, Adolph Fischer, Louis Lingg, Michael Schwab, Oscar Neebe, Pastor Samuel Fielden and August Spies. They were tried as conspiracists to the bombing. All were prominent anarchists, public speakers and writers. The police produced no other evidence against them.

In his indictment of the accused, Judge John G. Rogers declared: 'what is a red flag or a black flag in a procession but a menace and a threat? It is understood to be emblematic of blood and that no quarter shall be given.'[40] All eight defendants were found guilty. Seven were sentenced to death by hanging, and one to 15 years in jail. The international outrage was instant, with defence rallies and campaigns for the sentences to be appealed held in London, Paris and New York. George Bernard Shaw, Eleanor Marx, Oscar Wilde, William Morris, members of the French Chamber of Deputies, US Congressmen and governors, and the labour leader Daniel De Leon all argued for the anarchists to be pardoned. If the bombing itself had not attracted the attention of workers around the world, then the retribution of the US justice system certainly had.[41] This in itself

was the aim of the propaganda of the deed: to create outrages that forced the capitalist state to reveal its true nature. The throwing of a bomb provoked the state into showing its brutal dedication to capital.

But it was the words of the defendants themselves that most clearly caught the ear of the workers' movement around the world and came to most fully encapsulate the ideas of martyrdom, self-sacrifice and dedication to the cause of liberation that the red flag had come to represent.

Louis Lingg told the court: 'I despise you, your order, your laws, force-propped authority. Hang me for it.'[42]

August Spies declared that:

Seven policemen have died …. You want a life for a life, and have convicted an equal number of men. … [Anarchism,] these are my ideas. They constitute a part of myself. I cannot divest myself of them, nor would I, if I could … if death is the penalty for proclaiming the truth, then I will proudly and defiantly pay the costly price! Call your hangman![43]

Oscar Neebe, the eighth man who was sentenced to jail rather than death, protested:

Well, these are all the crimes I have committed. They found a revolver in my house, and a red flag there. I organized trade unions. … There is no evidence to show that I was connected with the bomb-throwing, or that I was near it, or anything of that kind. So I am only sorry, your honor – that is, if you can stop it or help it – I will ask you to do it – that is, to hang me, too; for I think it is more honorable to die suddenly than to be killed by inches.[44]

Adolph Fischer added: 'by our death have we advanced our noble cause more than we could possibly have done had we grown as old as Methuselah'.[45]

And Albert Parsons concluded: 'Do you think that this trial will be settled by my strangulation and that of my colleagues? I tell you that there is a greater verdict yet to be heard from. The American people will have something to say.'[46]

The sentences of Fielden and Schwab were commuted to life. Lingg killed himself in his cell. And four anarchists were hanged: Parsons, Spies, Fischer and Engel. The executed men – none of whom had thrown the bomb – became the Haymarket Martyrs. Their bodies were returned to their mourning families and a committee began planning the funeral. Their stand against an unjust judiciary, and their unflinching defence of their political programme made them icons far beyond the anarchist movement. Their families desired that the red flag should be flown in the funeral procession, but the Mayor of Chicago intervened, declaring: 'the American flag is good enough for us and it is good enough for you. If that flag don't suit you I am sorry. No red flag shall ever take its place while I am Mayor of Chicago.' Thousands traipsed through the Parsons' small apartment to see his body and to pay tribute to the martyr. Some 20,000 people joined a funeral procession in respectful silence,[47] and in defiance of the mayor's order, red flags were laid across the coffins of the Haymarket Martyrs.[48]

These funereal red flags and the words of the men whose coffins they were draped over would lend a new solemnity and sacredness to the red flag. The anarchist bomb makers and syndicalist unions that had become synonymous with the flag in the USA had now made the symbol famous beyond their movement. The bomb in Haymarket Square brought it to the US mainstream, where it now stood for the nobility of those workers unjustly murdered by the state. The flag did not just become associated with the bomb in Chicago, nor did it become fixed as the symbol of the anarchists who were hanged for the crime, instead it was confirmed as the standard of an entire workers' movement.

The revolutionary anarchist movement in Chicago, with its leaders killed, dispersed or jailed and its organisation shattered, was successfully destroyed by the Chicago police. But that very destruction and martyrdom became a foundational myth for the red flag and

the global labour movement. Albert Parsons' widow Lucy lay the red flag over her husband's coffin and infused it with a new power.

It was Lucy Parsons who would go on to be the iconic bearer of the red flag in the USA. A mixed-race Southern woman in the industrial North, a freed slave, and the widow of a wrongly executed revolutionary, she was a complex expression of contradictory respectable and radical experiences of the United States. The hanging of her husband in no way quietened her radical commitment to anarchism, but his heroic death did give her a national and international platform from which to publish and speak. She toured Paris, London and Glasgow in 1888 as well as speaking in cities across the US.[49] And in that same year the American Federation of Labor recommended that May Day should be marked by an annual strike in support of the eight-hour day and in memorial to the Haymarket Martyrs. In 1889 the proposal was taken up by the newly formed Second International in Paris, which called for May Day 1890 to be a great international demonstration for the eight-hour day, and to honour the memory of the Haymarket tragedy.[50]

The international workers' movement now had a united cause, a day agreed by the representatives of labour in the two most industrialised continents of the world, a revolutionary example in the Paris Commune, and powerful martyrs in the form of the hanged American anarchists. This triumvirate of political bonds was gathered together in the red flag. Through ceremony, battle and sacrifice, the red flag was consecrated.

Though bourgeois reformists had flown the flag in 1848 and artisanal republicans had flown it in 1871, by May Day 1890 the red flag was inarguably the symbol of the international proletariat. It represented Marxists, social democrats, trade unionists and anarchists, and within every political faction it was the massed workers who owned the symbol of the red flag. In 1890 it found its permanent and settled place. On 2 May that year *The Times* of London reported that workers had marched beneath red flags in London, Paris, Madrid, Barcelona, Valencia, Seville, Lisbon, Copenhagen, Brussels, Budapest, Berlin, Prague, Turin, Geneva, Lugano, Warsaw, Vienna, Marseille, Reims, Amsterdam, Stockholm and Helsinki.

Beyond Europe mass demonstrations beneath the flag were seen that year in Cuba, Chile and the USA.[51] In London crowds were addressed by leading socialists such as Paul Lafargue, and red flags and banners proclaiming worker unity in English, French and German were flown.[52] *Commonweal* reported that 'over all floated the red flag, the emblem of revolted labour in every land'.[53] The spectre that Marx had declared was haunting Europe in 1848, that vague shape that Whitman had seen, 'Head, front and form, in scarlet folds', now moved across the whole world.

The new ubiquity of the flag as the symbol of labour also found expression in song. 'The Red Flag' by the Irish dockworker Jim Connell appeared in the socialist paper *Justice* in December 1889 under the heading 'A Christmas Carol'. The song was published in London on a Thursday, and by that Saturday it was being sung by workers in Liverpool and Glasgow.[54] Originally intended to be sung to the Jacobite tune 'The White Cockade', it quickly attached itself to the tune of 'O Tannenbaum', which Connell detested: 'Tannenbaum, an old German Roman Catholic hymn. I never intended that The Red Flag should be sung to church music to remind people of their sins!'[55]

Albeit fixed to the wrong tune, 'The Red Flag' spread around the English-speaking world as an anthem of defiance and unity. It would be sung at mass rallies across the English speaking world and recorded by performers as varied as Robert Wyatt, Dick Gaughan and Shakin' Stevens. The song confirmed the flag's dominance as the international symbol of the left, adored by all:

Look round, the Frenchman loves its blaze,
The sturdy German chants its praise,
In Moscow's vaults its hymns were sung
Chicago swells the surging throng.
So raise the scarlet standard high.
Beneath its shade we'll live and die.

Connell explained: 'I was inspired to write The Red Flag by the Paris Commune, the heroism of the Russian nihilists, the firmness

and self-sacrifice of the Irish Land Leaguers, the devotion unto death of the Chicago Anarchists, and other similar events. I felt my mind exalted by all these.'[56]

The song, like the flag, embraced the many ideas and tactics of the working-class movement. Around the world the nobility of the Haymarket Martyrs began to undo the slanders that had been spread about the violence and anarchy of the murdered Communards. In the decade following the defeat of the Commune the red of socialism moved beyond revolutionaries and crept back into public life. In France the rehabilitation of the red flag happened most slowly, but by the end of the decade it could be seen in buttonholes, carnations and red scarves. It was, appropriately enough, at the funeral of Blanqui on 5 January 1881 that the red flag again flew in the streets of Paris, at the head of a procession of tens of thousands of mourners.[57] But this in many ways marked the end of the Parisian primacy as bearers of the red flag. For 50 years the symbol had belonged to Parisian revolutionaries, and in the present moment it was the anarchists of the USA who bore the flag most famously, but there was every reason to expect that the coming 50 years would see the red flag flying over a Socialist Berlin. For it was there that the workers' movement was gaining the most support.

It was German delegates who were dominant in 1889 when the Second International – announcing itself as the successor to the International Workingmen's Association – was formed in Paris, 100 years after the storming of the Bastille. Socialists of many traditions were brought together from more than 20 different countries beneath a huge red flag in a packed ballroom.[58] Paul Lafargue told the assembled crowd:

> We gather here not under the banner of the tricolour or any other national colours, we gather here under the banner of the red flag, the flag of the international proletariat. Here you are not in capitalist France, in the Paris of the bourgeoisie. Here in this room you are in one of the capitals of the international proletariat, of international socialism.[59]

Lafargue's intention was that the red flag would, for the workers, supplant all national symbols. He believed that the Second International, in response to the destruction of the Paris Commune and following the ideas of Karl Marx, would appropriate the trappings of the capitalist state, with its flags, its capitals and its government, and would turn them red, for use against the bourgeoisie. The International brought together mass socialist parties, burgeoning trade union movements and radical intellectuals, all of whom believed that the scientific and technological advances around them would be taken up by a desperately oppressed working class, inevitably transforming society. As the nineteenth century piled luxuries and commodities ever higher in the hands of the well-off, so too did the other side of the capitalist equation endlessly increase the suffering of the workers. The Second International would rally these forces behind the red flag on every continent. Unlike the First International, which had been purely European, this organisation included parties from South Africa, India, Japan, Turkey and Chile.[60]

However, as it spread to each corner of the world, the form that this internationalist spirit would take practically, tactically, ideologically and philosophically was far from resolved.

In Russia the red flag had first been raised in 1861 by liberated serfs in the Kandievka uprising. They saw that their freedom was meaningless if they were not given land and were instead condemned to sell their labour to their former masters. Eleven serfs were killed when soldiers fired on the demonstrators.[61] Their existence on the threshold between slavery and peasantry made them natural heirs to the red flag of revolution, and yet rural peasants were not considered a revolutionary class by the radicals in Paris. The red flag was a symbol of industrial workers, not peasants. Under the despotism of the Tsar no extensive urban proletariat had formed and no socialist party been allowed. The red flag in Russia instead belonged to anarchists, nihilists, students and small secret revolutionary groups. In 1876 it had seen its first industrial demonstration when workers and students had taken to Kazan Square in St Petersburg in protest at the death of a comrade in jail. Jakov Potapov, one of the protesters, had raised the red flag 'of land and liberty', and the protestors

had been violently arrested by the police and deported to Siberia. It was an isolated moment for a scattered movement, but the image of the red flag cut down by the state in St Petersburg garnered significant public sympathy. Potapov himself was a minor player, and so was given a less severe sentence and transported not to Siberia, but to a monastery where he was ordered to practise the Orthodox religion. The last record of Potapov has him finally deported to Siberia for striking a religious superior. It is believed he died there.[62]

It seems strange, but sporadic risings such as these by peasants and students were often condemned by those socialists at the centre of Industrial Europe, in particular by the mouthpiece of German Socialism, *Vorwärts*. The Second International did not believe in violence or in confrontation, but rather in organising and electioneering: in respectability. One of its greatest critics, Kropotkin, wrote:

> If ... the Russians' patience was finally exhausted and the students and a few workers staged a demonstration on Kazan Square, or the workers in some small town of Italy or Spain burned the customs booths or rioted against the salt tax; ... or a strike took place in which hungry workers beat up a manager or simply marched through the streets with a red flag and staged a demonstration; if a revolutionary prank was played somewhere – hanging a red flag from a bell-tower on the night of 18 March, for example; on every occasion, *Vorwärts* would spew out all its venom and its entire vocabulary of authentic German invective The once respected occupation of revolutionary was now represented as a useless relic, a kind of buffoonery or provocation.[63]

Here was the tension of the red flag in the Second International. The symbol of bloody revolution had been repurposed as the banner at the head of a slow parliamentary march towards liberation. It was the representatives of the German Social Democratic Party who dominated. Behind the scenes Engels worked hard to secure the legacy of Marx and to bring Marxist thought to the fore in socialist parties worldwide.[64] But the International's defining characteristic was a sober, consensual and nonviolent social democracy. The

red flag in Europe was moving from the hands of Blanquists, Communards and Jacobins to the walls of the meeting rooms of the Sozialdemokratische Partei (Social Democratic Party) in Germany, the Parti Socialiste (Socialist Party) in France, and eventually the British Labour Party. Frequently these parties opposed the use of strikes and direct action, and they always shunned talk of violent revolution. In 1886 the West End Riot in London had seen unemployed workers smash windows throughout the English capital's most fashionable neighbourhoods and clubs, with the press seizing upon the image of the Social Democratic Federation's John Burns, who had brandished a red flag and told the crowd that if they could not get bread, they must take it. The action would represent the last left-wing riot in London for generations, and Burns himself would follow the social democratic line of his party, eventually being elected to parliament as a Liberal and becoming famous both for voting against poor relief and the vociferous antisemitism of his speeches.[65] In Victorian London the red flag was on a journey towards respectability, in which the riot of 1886 was an aberration. Reform was in the ascendancy and revolution in eclipse.

But the social democrats of the Second International had no monopoly on the red flag; it was by this point too fecund a symbol. In every era in which it has been claimed by moderates and reformers it has at the same time been pulled to the left by more desperate revolutionaries. In Russia in 1905 and in Mexico in 1910 the banner of labour flew above spontaneous armed revolutions. In Mexico the anarcho-communist Partido Liberal Mexicano (Mexican Liberal Party) released a 1911 manifesto stating that its members had 'unfurled the red flag in the field of action in Mexico, against Capital, Authority, and Church All that is produced will be sent to the community general store, from which everyone will take according to his needs.'[66]

Although they were a radical minority in a complex revolution that teetered on the edge of civil war, the anarcho-communists of Mexico returned the flag of the workers to the barricade. The revolution also produced two of the movement's great artists, Diego Rivera and Frida Kahlo. In their art and their lives they synthesised

tradition, indigeneity and communism to produce new socialist icons. In Diego Rivera's fresco *The Blood of the Revolutionary Martyrs Fertilising the Earth* two dead comrades are buried, wrapped in red flags. Above them grows a cornfield, and a great yellow sun that is itself a window. In the mural we see the blood of death becoming the blood of life. Wrapped in their red flags, the martyrs themselves are the seeds of a better future. The blood of the red flags allows this sun, this window, to appear. Rivera united the conflicting ideas of revolutionary death and revolutionary life, painting a fable for the red flag itself. The image would be echoed at Frida Kahlo's funeral, when a red flag was draped over her coffin. Such blending of art, life and revolution in Mexico was itself a window, a portal, showing a different way forward for the red flag, far from the European municipal socialism and the restrained Edwardianism of the Second International.

Similarly, the Russian revolution of 1905 had presented a challenge to the reformist mode of flag waving. The revolution was a sequence of disparate uprisings and attacks on authority that spread across the Russian Empire following the Tsar's ongoing humiliation in the Russo–Japanese War. Strikes demanding a minimum wage and an eight-hour day spread from St Petersburg and were violently suppressed. Russian troops fired on striking workers, killing hundreds in Riga, Warsaw and outside the Winter Palace in St Petersburg. Elsewhere, from Ukraine to Siberia, peasants rose up and attacked their masters. The closing of universities sent radical students out to march with workers, and naval mutinies further threatened the Tsar's autocracy. June 1905 produced the iconic image of the revolution when the sailors of the battleship *Potemkin* mutinied and sailed towards Odessa with the red flag flying. In Odessa's theatre the city's military command was meeting to organise the suppression of the general strike in the city.[67] The revolutionary sailors fired their guns. The steel battleship shelling its own military command from beneath the red flag was the first time that the workers took the tools of modern warfare into their own hands. The 1905 revolution affirmed to revolutionaries around the world the potential for radical social change brought about by

armed struggle. It also contained lessons on the power of keeping the red flag flying. Lenin wrote that during the revolution of 1905, in Presnya District, two working girls, carrying a red flag in a crowd of 10,000 people, rushed out to meet the Cossacks, crying: 'Kill us! We will not surrender the flag alive!' The Cossacks fled.[68] The flag had the power of those with nothing to lose. Lenin reflected later that 1905 was the dress rehearsal for the Bolshevik Revolution.[69]

The flag grew differently in different soils. In Western Europe a reformist social democracy spread a conservative vision of the red flag, popular in particular with the most securely employed elements of the working class – the labour aristocracy. However, in the United States of America, as in Mexico and Russia, the red flag of the workers remained in the hands of revolutionaries, and in particular in the hands of the anarcho-syndicalist heirs of the Haymarket tragedy. The settlers on the American continent most often came from the poorest layers of the European periphery: southern Italians, Eastern Europeans, Russian Jews and Irish peasants. These desperate masses brought with them more radical and anarchist ideas. An array of anti-suffrage laws in the USA that created colour, language and citizenship bars to voting meant that the Second International's democratic road to socialism could not easily be preached. In the Northern United States those flying the red flag centred their struggles not on bourgeois democracy, but rather on the factories, railroads and cities that sucked in low-paid and dispossessed workers from Europe, Mexico, Asia and the Southern United States.

Whilst the majority of these new workers were non-unionised or members of conservative trade unions, millions nevertheless flocked to the newly formed Industrial Workers of the World (IWW), founded in 1905 by socialists and anarchists including Big Bill Haywood, James Connolly, Lucy Parsons, Mother Jones, Daniel De Leon, Eugene Debs, Joe Hill and Ralph Chaplin. The IWW was an international industrial revolutionary union that sought to organise all workers together. Its banner was, of course, a red flag. Bill Haywood declared that the union would nail the red flag to the mast and make the bosses get down on their knees to it

every morning.[70] Members including Joe Hill had had 'the pleasure of fighting beneath the red flag' in the Mexican Revolution and brought their experiences back north.[71] In the early years of the twentieth century the red flag flew in the USA above bitter struggles between capital and labour. As the gross domestic product of the United States grew to outstrip Britain, France and Germany combined, the rate of exploitation reached untenable levels. Tens of thousands of US workers took part in more than 400 strikes beneath the red flag of the IWW.[72] As well as securing huge victories across the states, with support particularly strong amongst immigrant labourers, IWW members faced brutal repression, with thousands arrested and more than 150 killed in police custody, in lynchings, in state executions, and by company thugs in the first two decades of the organisation's existence.[73] Most notoriously, the Colorado National Guard killed eleven children and nine adults in 1914 when it set fire to an encampment of striking IWW miners.[74] Whilst the red flag in Europe moved towards respectability, in America it was firmly associated with revolutionary trade unionism, migrant labour and violent conflict with authority. In 1912 the *New York Times* published an editorial entitled 'The Contemptible Red Flag' which read:

> The flag is the symbol of lawlessness and anarchy the world over, and as such is held in contempt by all right-minded persons.
> The bearer of a red flag may not be molested by the police until he commits some act which the red flag justifies. He deserves, however, always to be regarded with suspicion. By carrying the symbol of lawlessness he forfeits all right to respect and sympathy.[75]

And yet the association of revolutionary anarcho-syndicalism with the red flag persisted and spread, not just in the USA, but around the world as workers and texts moved from America across the Pacific to China, Australia, New Zealand and Japan. In 1908 the Red Flag Incident in Japan, a police riot that took place when supporters bearing red flags gathered to mark the release of their

A FLAG OF THE WORKERS

comrade Koken Yamaguchi, marked the start of a long government suppression of the red flag there, and it was anarchists, not socialists, who were jailed and executed.[76]

Elsewhere the red flag of anarchism held appeal for colonised workers who searched for a movement that, unlike elements of the Second International, did not excuse colonial oppression. In the vast expanse of the world that was colonised, exploited and subjugated by Europe the politics of the Second International held a problematic appeal. In the early twentieth century, socialist groups made their first appearance in South Africa, in China and in the Middle East. But these revolutionaries had to share the same red flag with the Social Democratic Party and Labour Party politicians who sat in relative comfort in the parliaments of their national oppressors. The Second International itself was split between anti-imperialists and those whose contrived readings of Marx suggested that 'colonial policy could have a civilising effect under a socialist regime'.[77] Within the International an uneasy compromise was made between those who opposed colonialism and those reformists and liberals who thought it could be a means to an end.

Beyond Europe the red flag could not bear such a compromise with imperialists, and the tension between the red flag of democratic socialism and the red flag of anarchic revolution continued to widen. The red flag was now a worldwide symbol of the workers, but that world itself was divided. Despite the continued association of the red flag with anarchism in the USA, Mexico, Russia, China and Japan, at the centres of empire – Berlin, Paris and London – the red flag had become tied to parliamentarism and reformist socialism. In France, which had seen the most recent workers' uprising in Europe, in Germany, which had the most powerful socialist party in the world, and in Britain, where Marx had first anticipated the communist revolution, the holders of the red flag had secured a place in parliament in exchange for peace with the establishment. By compromising they sowed the seeds of their own destruction as the First World War approached. At the political heart of Europe the moderate red flag was to face, in 1914, the most terrible extremes and violences of capital. War would make the flag anew.

7
A Flag of Peace

On the evening of 31 July 1914 Jean Jaurès, the leader of the French Socialist Party, walked along the Rue Montmartre. His recent days had been spent in tense national and international discussions, organising the workers of France and Germany against the war. His steadfast anti-militarism and loyalty to the red flag over the tricolour cast him as the embodiment of the hope that labour could avert the bloodshed. At 9.40 p.m. Jaurès was sitting in the window seat of the Café du Croissant dining with friends when a young nationalist stood at the window and shot him through the glass. Within five minutes Jaurès was dead. His assassination proved to be the final break in the chain of international anti-militarism. French socialists voted in favour of the war. They were followed by the British Labour Party and the German Social Democrats, both of which reversed their anti-war stance.

Twenty-five years earlier, on the same street as the Café du Croissant, Paul Lafargue had declared at the first meeting of the Second International that the red flag would replace all national colours as the flag of an international proletariat. Even the most miserable pessimist could not have foreseen that within a generation his comrades would vote so enthusiastically for the mechanised slaughter of the First World War.

It had been the hope of many in the International that the workers of Europe would rally around the red flag and refuse to fight a war for the markets of their rulers. One by one, though, the leading parties of the Second International betrayed their class in favour of their country. All painted the conflict as a defensive war, and workers flocked to sign up and fight. The Scottish communist Willie Gallacher remarked: 'what terrible attraction a war can have!

The wild excitement, the illusion of wonderful adventure, and the actual break in the deadly monotony of working-class life.'[1]

With Jaurès dead, French, German and British socialists suspended all strikes and demonstrations. The only major party of the European left to stand firm against war were the Russian Bolsheviks. They found support from isolated comrades across the world: John Maclean in Scotland, James Connolly in Ireland, Rosa Luxemburg in Germany and the IWW in the USA.[2] In the early months of the war these anti-war socialists flew the red flag in the wilderness, suppressed both by governments and by socialist parties.

As the unprecedented slaughter became apparent, and as whole streets of working-class neighbourhoods in Moscow, Marseille, Glasgow and Hamburg saw their young people returning in coffins, the red flag began to take on a new significance. Ceded by the reformist parties of Europe, it was the most radical and revolutionary elements of the left that kept the red flag flying. The revolutionary socialists and anarchists who had for a generation been kept at the fringe now moved to the centre. Just as in 1848, when the red flag's compromise with the bourgeoisie had resulted in the slaughter of the working class, the reality of the Second International's betrayal moved the red flag and its movement into the hands of its most radical elements.

In each country anti-war activists began to hold rallies and to plan action to disrupt the war. The red flag sprang up again and again as the symbol of international unity, of no war except the class war. The more that the national flag were deployed to recruit for the war, the more that the red flag stood out as their antithesis.

As the war dragged on, diverse challenges to the ruling classes emerged across Europe. It became apparent that the capitalist fight for markets had left capitalism and the state exposed at home. In Dublin the Easter Rising re-lit the flames of militant Irish republicanism. Before it was brutally crushed James Connolly wrote that 'we can only hope to carry our flag to victory by securing the aid of all those workers everywhere who desire to see an effective force carrying the green flag of an Irish regiment whilst unconditionally under the red flag of the proletarian army'.[3] In Scotland,

during 1915 the leaders of the Glasgow Rent Strike and the Clyde Workers Committee organised tens of thousands in opposition to landlords and bosses. In Turin a general strike against the war only ended when more than 50 workers were shot dead and over 1,000 were arrested and sent to the front.[4] Morale in the munitions factories and in the trenches sunk ever lower, and the European powers began to fear a broader resurgence of working-class organisation. Lenin famously declared that the imperialist war must be turned into a civil war in every country against the ruling class.

Such a dream would be realised first in Russia in March 1917. Women textile workers struck on International Working Women's Day. Their demands for peace and bread soon engulfed the whole city in strikes and protests, and red banners were raised in every corner of St Petersburg. Trotsky would later remark, that even by nightfall of that day the women workers could not imagine what they had accomplished. By next morning the number of striking workers had doubled and soldiers were joining their ranks. The calls for bread and peace were coupled with the demand for democracy. Within a week the Tsar had abdicated and a provisional government had, for the first time, given women the vote.[5]

A revolution had begun in Russia, and its radical, red-flag bearing, demand for peace would help make it one of the most dramatic achievements in human history. The provisional government would be rocked by further protests against the war in July, and would in October finally fall to a Bolshevik insurrection. Led by the Soviets, the October Revolution would install the red flag above the Winter Palace and the Kremlin, and establish the first worker-controlled nation in the world. Its impact on world history and the history of the red flag in particular would be profound and long-lasting. Among its most powerful actions would be its first: ending the war on the Eastern Front.

In March 1918 the Treaty of Brest-Litovsk was signed, ending the First World War for Russia. After three years and 3 million deaths the red flag of communism had finally brought to a close the war on the Eastern Front. There – amidst the forests and frost of eastern Europe – disease, poor supply lines and the constant loss and gain

of territory had left Russia with the highest number of civilian and military deaths in the world. The treaty created eleven new independent states and fulfilled the first of the Bolshevik promises of Peace, Land and Bread. Across Western Europe the example of the Soviets was watched closely as socialists and communists in every country sought to raise the red flag and enforce an end to the war.

The revolution in Russia would immediately have its echo in the Finnish Civil War, where the Finnish Socialist Workers Republic fought beneath the red flag against landlords backed by the German Imperial Army. The conservative forces were victorious, and amidst the bloodshed more than 12,000 of the Red Finns died from malnutrition in the prison camps of White Finland.[6] Following the civil war the red and yellow state flag of Finland was changed to a blue and white cross. The defeat of the reds in Helsinki was so total that even the colour red, used as the colour of the Finnish coat of arms since the sixteenth century and as the country's flag since its independence, had to be replaced. The red flag was now the settled symbol of communism.

Although the German Kaiser had helped defeat Finnish socialism and secured huge concessions in the Brest-Litovsk Treaty with Russia, morale and discipline in the German armed forces was unravelling at a rate not seen in the years of bloody stalemate in the trenches. The German command pushed on regardless and planned a huge and decisive maritime offensive on Britain. But when the orders came in November of 1918 to set sail for the English Channel, German sailors mutinied. An estimated 40,000 sailors, soldiers and workers took control of the public and military institutions at the key Baltic port of Kiel. The red flag flew from the castle, the town hall and every ship in the fleet.[7] Apart from the captain and two officers of the battleship *König* who were shot trying to prevent the revolutionary symbol being raised, there was no resistance to the total revolt of the German fleet. Grand-Admiral Prince Heinrich, the Kaiser's brother and Commander in Chief of the Baltic Fleet, fled the city disguised as a truck driver in a vehicle disguised with a red flag.[8] As with the mutiny at Nore 120 years

earlier, a floating republic, beneath the red flag, now threatened an empire.

In panic, the Imperial Navy Office tried to close Kiel off from the rest of the country, even proposing to send in loyal torpedo boats to sink all vessels that flew the red flag, as pirates.[9] It was, however, too late. Convoys of mutinous red-flag-bearing soldiers and sailors had already begun pouring out into the rest of Germany and sailors' and soldiers' soviets took control of key infrastructure around the country. By 9 November they occupied the streets of Berlin, and a republic was declared. All of Germany's many princes and kings abdicated. Revolutionary soldiers controlled the capital, with their uniforms unbuttoned, weapons and red flags in hand, and demands for peace and democracy on their lips.[10] A red flag was hoisted above the Royal Palace in Berlin, ending 400 years of its occupation by the monarchy. The communist revolutionary and later leader of the Spartacist movement Karl Liebknecht took to the balcony and declared that 'The rule of capitalism, which has transformed Europe into a morgue, is broken.'[11] In Germany, as in Russia, the war was ended by the workers. The brutal reality of imperialism and capitalism had been exposed in the slaughterhouse of the war, and the soldiers had returned from the front flying the red flag: the natural symbol of an international working class, and their demand for peace.

Wild rumours spread in Germany that the British Fleet also sailed beneath the scarlet standard. Many believed that the revolution was to be global. But no equivalent earthquake took place in the British armed forces. One contemporary noted: 'a victorious army doesn't engage in revolution'.[12] With Germany and Russia pulled out of the war by their own troops, Britain and the US secured victory by default. Nevertheless, the revolutions in Berlin and St Petersburg still reverberated through the British working class, and their rulers struggled to maintain order in the military and at home. In 1918 nearly 700 British soldiers were sentenced to death for mutiny, with many more summarily executed by their officers. Large-scale British mutinies took place at Etaples, Pirbright and Shoreham,[13] with tens of thousands of soldiers refusing orders. In early 1919, with the war

over but a treaty not yet signed, HMS *Kilbride* mutinied and the red flag was raised from the topmast. Its crew were court-martialled.[14]

With Russia and Germany already in foment and with the red flag flying above both their capitals, a third revolution shook Europe in March of 1919 when Béla Kun raised the red flag over Budapest and established a second soviet state. The short-lived Slovak Soviet State and Munich Soviet State followed. Across Central Europe the red flag was flying as the symbol of workers' governments, the nationalisation of industry, the redistribution of land, the stripping of aristocratic titles and the abolition of money. All of these new revolutionary states looked toward Bolshevik Russia for inspiration.

In Munich and in Budapest armies backed by capitalist and allied powers quickly defeated the nascent socialist states, with street fighting, flame throwers and even aerial bombardment.[15] However, in Russia a different story was unfolding. The Red Army, commanded by Trotsky and primarily composed of peasants, was managing to defeat the White Russians, a loose confederation of anti-communist forces. The British, in a bid to help reinstate the Tsarist regime, had sent 30,000 troops to Russia and, on Churchill's orders, had engaged in chemical warfare, firing tens of thousands of shells containing the toxic gas diphenylchlorarsine.[16] US troops too were fighting Trotsky's Red Army in the North of Russia, and the French had deployed battleships to the Black Sea from where they were to support attacks on Bolshevik troops.

In the Russian Civil War the red flag again showed its dangerous propensity to leap enemy lines. On 12 April two French battleships, the *Jean Bart* and the *France*, both mutinied. In unison the red flag was raised on both ships and hundreds of sailors gathered on deck to sing the *Internationale*. Composed by the Communard Eugène Pottier, it was now adopted as the anthem of the Soviet Union. French sailors refused to fight against the Russians, and by June the mutinies had spread throughout the French Navy to the North African coast, the Eastern Mediterranean, the Baltic and even to Toulon.[17] These French sailors, by showing their loyalty to their class rather than to their country, instilled fear in their officers and hope in the Red Army. They exemplified the red flag's direct chal-

lenge to the flags of all nation states. In presenting a transnational ideology capable of unifying the working class, the flag of the Red Army was unique in its ability to inspire defection and disloyalty amongst enemy forces.

This red flag contagion continued across 1919. Around the world millions of soldiers returned home to joblessness, homelessness and rising prices, and they met with an increasingly politicised industrial class that had faced anti-strike and forced-labour laws throughout the war. Everywhere workers looked to the red flag for inspiration.

In Glasgow, where British industrial action had been concentrated during the war, a new campaign for a 40-hour week emerged. Just days after the armistice with Germany, the Scottish revolutionary John Maclean had been released from jail due to huge public pressure. He was greeted by tens of thousands of supporters when he reached the city. The communist suffragette Dora Montefiore reported that:

> Maclean called for three hearty cheers for the German Social Revolution; and ... the shouts that rent the air made a volume of sound that the capitalists of Clydeside will often remember in the near future, when they are troubled with bad dreams ... the fight will go on, and will never cease, until the Red Flag waves, not only over the City of Glasgow, but from the Clock Tower of Westminster, as a symbol that the People have entered into their inheritance.[18]

The unrest in Scotland reached its height when a general strike and the raising of a red flag in Glasgow's George Square resulted in a police riot and a military occupation of the city. The Scottish Secretary told the cabinet: 'it is a misnomer to call the situation in Glasgow a strike – it is a Bolshevist rising'.[19]

In Australia, where the War Precautions Act banned the flying of the red flag, a series of disturbances known as the Red Flag Riots broke out, with street fighting between trade unionists flying the red flag and returned servicemen. The disturbances ended in scores of injured police and protestors, and a police horse shot dead.[20] In

response the Victoria Trades Council voted to raise the red flag from its halls in Melbourne, and the red flag has flown there every day since 1918. Nowhere in the world has the red flag flown continuously for as long.

In New York 150,000 longshoremen struck, with thousands marching over the Brooklyn Bridge beneath red flags.[21] The radical mood turned into the Red Summer of 1919 when white supremacists attacked increasingly socialist- and communist-led civil rights movements. In Harlem the radical poet Langston Hughes was beginning the black Marxist education that would lead him to proclaim to young black prisoners that 'the red flag too speaks for you!'[22]

Elsewhere the great national upheavals that took place after the First World War created new governments across Europe, as emergent states such as Ireland, Finland and Hungary sought to assert themselves in the ashes of a fractured imperial Europe. These new national struggles also revealed the essential internationalism of capital, as new nations found themselves immediately within the cultural and economic sphere of their former rulers. The internationalism of labour was the necessary answer.

Nowhere glimpsed the possibility of a new society beneath the red flag, nor the dark reality of capitalist power, more clearly than Italy. There for two years – the *Biennio Rosso* – the red flag flew from factories and farms across the country. Hundreds of thousands of workers, particularly in the industrial north of the country, joined radical anarchist and syndicalist unions, formed factory councils, took control of their places of work and provided food for the people through communist kitchens. Armed strikers formed a Red Guard, and some car factories under worker control even began to build bombs,[23] with railway unions ensuring the continued supply of raw materials, and the disruption of government troop movements around the country.[24] Reporting from the centre of the Red Rising, Antonio Gramsci saw the possibility of a revolution that was not led by a vanguard or a party, but which emerged from the democratic institutions of the proletariat – a movement where factory councils, kitchens and social centres evolved together

to take control of the means of production and to meet the needs of the people; in this Italian revolutionary moment the red flag represented the solidarity and social life of the exploited workers finally emerging as the driving force of communism. A state within a state was formed, with socialist control of all major sites of production, trade unions running cooperatives, bars and sports associations, and red flags hanging from town halls. The socialist anthem 'Bandiera Rossa' ('Red Flag') was sung in the streets, factories and fields:[25]

Avanti o popolo, alla riscossa
Bandiera rossa, bandiera rossa

('Forward people, towards redemption
Red Flag, Red Flag')

Panicked by the surge in working-class power, and particularly by the spread of the red flag from the cities to the countryside in the Italian agricultural strike of spring 1920, the landlord class decided to take matters into their own hands. No longer trusting that the institutions of the state could prevent a proletarian revolution, they gave their support to the newly formed Fasci. These reactionary blackshirt militias spread from town to town, beating up elected socialist officials, aiding in the breaking of strikes, destroying scores of social centres, peasant league headquarters and left-wing newspaper offices, rooting out communists and anarchists, and tearing down the red flag.[26]

The red flag had emerged from the First World War with its symbolism radicalised. It was a flag of promise to the workers, and of threat to the propertied class. Everywhere its meaning was understood and it became the central symbol of global class war.

In Germany, as in Italy, the bourgeoisie turned to nascent fascism to defeat the revolution. Foreseeing the disaster, Rosa Luxemburg, a key theorist and revolutionary in Berlin, had written in the Spartacist newspaper *Rote Fahne* ('Red Flag') that the police and all military units returning from the war should be disarmed and proletarian soldiers should be re-formed into a Red Guard.[27] The supreme

command instead moved demobilised soldiers into a voluntary anti-communist force called the Freikorps, where conservative and monarchist soldiers kept their weapons and were directed against the German revolution. Attacking civilians and executing communists on the spot, the Freikorps moved through German cities with impunity, eventually torturing and murdering Rosa Luxemburg and Karl Liebknecht. Although it was directed by military command, the Freikorps had the support and cooperation of the chancellor, Friedrich Ebert, and the leader of the Sozialdemokratische Partei Deutschlands (SPD) – Liebknecht and Luxemburg's former party – the social democratic party *par excellence* of the Second International.[28] Fearing defeat from the left, the moderate social democrats had torn down the red flag of communism and sown the seeds of fascism in Berlin. The bitter recriminations between the SPD and the communists after the murders of these revolutionary leaders would play a key role in undermining any red front against the rising tide of Nazism in the years ahead.

Though state-sanctioned counter-revolutionary terror brought down the red flag across Germany and forever separated the SPD from a claim to left-wing support, the final days of the German revolution created icons in Liebknecht and Luxemburg. Both had opposed the war, had brought down the German Empire, and had died beneath the red flag. Luxemburg, a communist intellectual, international, Jewish fighter, would come to represent everything that the Germany of the coming decades would seek to crush. Luxemburg's stand against the Freikorps and the German state was to be a foreshadowing of the red flag's battle with fascism and the next world war. She herself had felt the force with which two possible futures were approaching Germany, writing in 1919:

> The beast of capital that conjured up the hell of the world war is incapable of banishing it Socialism alone is in a position to complete the great work of permanent peace, to heal the thousand wounds from which humanity is bleeding Peace must be concluded under the waving banner of the Socialist world revolution.[29]

Oppression was victorious in Germany, Italy, Finland and Hungary. By 1920 the red flag had almost everywhere been defeated by Fasci and Freikorps backed by capitalist governments. The world war, as Lenin had predicted, had been replaced by countless civil wars, and on opposing sides were the propertied class and the workers – one flying the many symbols of capital and empire, and the other, wherever it rose up, flying the red flag, the singular standard of peace and communism.

Reformist democratic socialism survived in the victorious nations of Britain and France, which were able to preserve their empires and the illusions of the Second International, and where even the King of England, George V, was able to play with the red flag of peace, stating towards the end of his life: 'I will not have another war. I will not. The last one was none of my doing and if there is another one and we are threatened with being brought into it, I will go to Trafalgar Square and wave a red flag myself sooner than allow this country to be brought in.'[30]

But in the rest of the world a more radical red flag was flying. Gone was any faith in a compromise with bourgeois liberalism, or patriotic chauvinism; those red flags of the Second International were so powerless they could now be invoked by kings. Their meaning had been destroyed in the trenches, and finally betrayed in the destruction of the German revolution.

In their place, an indomitable radical communism began to take up the red flag and was able to claim, with legitimacy, that whatever blood it shed was as nothing compared to the terrible violence that capitalism had wrought on the world in the preceding half-decade, let alone the preceding century. This was the red flag of peace, land and bread, and before it the crowned heads of Europe were falling one by one. The diverse communisms of Germany, Hungary, Finland and Italy succumbed to the forces of conservatism, but they had nevertheless reshaped the Continent and in doing so had redefined the red flag. The flag had ended wars and destroyed empires. Through worker democracy, factory occupation and armed revolution it pointed towards a new modernity for the proletariat.

Even as the French, Americans and British scrambled to join the Russian Civil War and tear the red flag down in Moscow, Lenin was organising a new international, the Comintern, which would define the red flag for a half-century to come and would spread it to every corner of the world. Its adherents were proclaiming everywhere that either the red flag must be victorious across the globe, or else capitalism would lead humanity inexorably towards a second, even more catastrophic, world war.

8
A Flag of Utopia

There are few events in the history of the red flag, indeed in the history of the world, more momentous than the storming of the Winter Palace in 1917. With this act the communist era arrived and the first full experiment with the ideas of the red flag took place. In St Petersburg in that cold autumn 500 years of autocracy and oppression came crashing down. What had been rehearsed in the Paris Commune was now performed across Russia as workers and soldiers toppled the government and took control of the Winter Palace. Machine gun fire rang out from the Tsar's wine cellar, where there were too many thousands of bottles hoarded to break by hand. Red wine flowed in the gutters of the old city, and the red flag was raised above the Imperial Palace as the Russian tricolour was torn down.[1]

In a series of nearly bloodless revolutions – begun by the working women of Russia and completed by the Bolsheviks – Tsarism, imperialism and capitalism were swept from Russia and replaced by a programme of bread, land and peace for all. The promise of communism was finally to be realised. Although it had been brutally crushed in the streets of Paris in 1871 and abandoned in the trenches of 1914, the red flag and all it stood for was now resurrected in St Petersburg and Moscow. Its promise was to lead humanity towards a utopian age of equality, leisure and peace. The radical socialist regime immediately ended the war with Germany, emancipated women, decriminalised abortion and homosexuality, instituted an eight-hour working day and a minimum wage, began the redistribution of land from the rich to the poor and brought in worker control of the factories. Lenin proclaimed that 'the interests of socialism, the interests of world socialism, rank higher than the national interests, higher than the interests of the state'.[2] This

was an earthquake that reverberated around the world. Everyone who had ever fought beneath the red flag now looked in the same direction, towards Russia, and at Russia's centre, in the discordant grandeur of what had been the Tsar's palace, they looked towards the Bolshevik leader, Vladimir Lenin.

That the Russian Empire's tricolour was replaced by the red flag was neither an accident nor a *fait accompli*. The red flag was the standard of the Russian revolutions, and had since 1898 been the flag of the Russian Democratic Socialist Labour Party and the Bolshevik faction. But the decision as to which flag would fly over the new revolutionary Russian republic was not a simple one. The red flag had flown alongside the Russian tricolour since the March revolution, and the bourgeois provisional government had even used it to denote its leader Kerensky's comings and goings from the Winter Palace.[3] Its symbolism had also been deployed by the army, with red flags pinned to their jackets by soldiers who had supported the deposing of the Tsar. While generals at first fought against this addition to the uniform, by May of 1917 they were deploying it to build morale and the red flag was coming to symbolise not just the hope and vitality of revolution, but a love of Russia; a special Revolutionary Red Flag was proposed as an award for gallantry. Supreme Commander Brusilov called on 'all Russian troops of all ranks and positions to rally around the red banner', and in July 1917 soldiers even went into battle on the Eastern Front beneath red flags.[4] As the symbol of the provisional government and of the continued war with Germany, the red flag had taken on moderate and nationalistic meanings in Russia.

This co-opting of the revolutionary symbol could have been the red flag's death had it replaced the tricolour during the provisional government. However, the old flag continued to fly, and for many the two flags represented the tension between the Duma and the Soviet, the politicians and the workers, reform and revolution. During the street fighting in the unrest of the July Days and later in the final coup of the October Revolution it was the red flag that flew against the bourgeois state and its provisional government. Through action its revolutionary identity was retained.

The red flag was confirmed as the official flag of Russia in April 1918.[5] It became the flag of the wider Soviet Union in December 1922.[6] Various versions followed, with a variety of lettering, symbols, hammers, sickles, wheatsheaves and globes, as the Soviet Union sought to make the red flag its own and to project an image of a distinct new communist future of worker control, peasant liberation and strident internationalism. The final design was a red background, overlaid with a gold hammer and sickle representing the unity of peasants and industrial workers, and a gold-bordered five-pointed star representing the Bolshevik party and the guiding leadership of a Marxist vanguard. Like the red flag itself, the hammer and sickle are both harbingers of life and of death. They take their place as the symbols of work, but also as potential weapons. Throughout the existence of the Soviet Union the reverse of the official flag remained a plain red field[7] – the famous hammer and sickle of Bolshevism backed up by the plain red flag of international revolution.

In this form, at the top-mast of a revolutionary state, the red flag now came of age. As a symbol it had for a century represented mutiny, defiance, revolution and radical possibility; but now it was raised as the standard of the actualisation of communist ideas. This was the red flag's encounter with a future that was concrete, the red flag as a world power.

The flag, the star and the hammer and sickle would from this moment become the definitive symbols of communism – a communism which in the 1920s offered a utopian vision of the future, inspiring and radicalising people from every country and every walk of life. Indian farmers, American steelworkers, British aristocrats, French artists, South African freedom fighters, Japanese Christians and European Jews all flocked to the image of modernity: the electric possibility of this new red flag. It still maintained its plural identity; after all, anarchists and social democrats as well as Bolsheviks had won the October Revolution; but the flag was also newly re-animated as a symbol of Marxist ideas. For movements such as the British Labour Party or the US trade unions the red flags that they carried now had a new power; they were the flags of

the workers, but also the flags of the world's first workers' state. A movement and a flag that had oscillated between democratic socialism and revolutionary anarchism now found its colour pinned to a party and a state that intended to hold fast to Marx, and enact his vision of the future.

That future arrived at unimaginable speed. In 1917, when the Bolsheviks came to power, 80 per cent of the Russian population were peasants, famine was common, disease widespread and three-quarters of the population were illiterate. Most of those who were not peasants lived in unsanitary slums, working 12- and 14-hour days in factories. In the decades that followed the revolution, this situation was turned upside down: the right to work, the right to healthcare, the right to education and the right to housing saw the soviet population transformed from one of the most backward to one of the most advanced in the world.[8] An eight-hour working day, adult education and leisure and vast networks of transport, heating and electricity improved the lives of millions beyond measure. Woman gained equal pay and full access to education and public life, as well as pain relief during childbirth. Child support was paid for the first time, and all mothers were granted 18 months' paid maternity leave.[9] Free access to sport and culture was extended nationwide, and achievements in cinema, music, theatre and athletics rivalled any nation in the world. Universal healthcare, full employment, full adult literacy and an end to starvation were achieved within a generation. The Soviet Union was at the forefront of the eradication of smallpox and inoculation against tuberculosis, and it pioneered the development of organ transplants, skin grafting and blood transfusion.[10] Life expectancy in the Soviet Union doubled within a generation of the revolution. No capitalist country achieved as much for its population at this time, and few countries today can claim to offer such benefits to their citizens. In almost every field of human life the red flag marked the expansion of rights, health and leisure – not only inside the Soviet Union, but in Western Europe too, where governments were forced to construct equivalent welfare provision in order to pacify workers who raised the threat of the Soviet red flag at home.

These human and humane achievements were more than matched by the incredible technological, scientific and economic development of the Soviet Union. In 1942 Albert Einstein wrote: 'For many years our press has misled us about the achievements of the Russian people and their government ... from rudimentary beginnings, the tempo of her development in the last 25 years has been so tremendous that it has scarcely a parallel in history.'[11]

In the first two decades of the Soviet Union state investment in science and technology increased 27-fold.[12] The centralised, planned economy delivered industrialisation, electrification and scientific progress faster than anywhere in the world. Over the period of Stalin's leadership production of steel and coal increased more than eight-fold and the country became the world's leading producer of cement, gold and natural gas.[13] Within a single lifetime the country was transformed from one in which people travelled by horse and cart and worked by candlelight to a nation that had developed nuclear power and put a man in space. The massive hydro-electric plants, the luxurious chandeliers of the Moscow metro and the Stalinist skyscrapers that now graced the skyline all demonstrated that the red flag had propelled the Soviet Union 100 years into the future in mere decades.

Red in Russian, *красный*, means not just red, but beautiful. It is a word redolent with grandeur. Red Square itself is perhaps better translated as Beautiful Square or Great Square. The association of red with power, beauty and decoration run deep in the Russian language and psyche. For the peasants and workers of 1917 the utopian beauty that the red flag had engendered was dazzling. It was now a colour to be placed above all others, representing the state, its progress and its ideology, Marxist-Leninism. The momentous social and industrial progress that was made followed closely from the ideas of dialectical and historical materialism, but also from the centralisation of power and the belief in a political vanguard. The Soviet Union would be a revolutionary state in transition, discovering the final steps that might enable it to lead the world to communism – an electrified communism that supplied modernity to the people. It would do so in the tight grip of a ruling party. Russia

A FLAG OF UTOPIA

and its people would be guided towards communism by the party, the leader and the red flag.

The Soviet adoption of the red flag made Marxism the foremost ideology of the flag for the first time. Across the world its meaning shifted from the pre-war democratic socialism of Europe and the anarcho-syndicalism of the USA to the committed Marxism of the Russian communists. The red flag was now not simply a symbol of the struggle against oppression, but a proxy for the ideology that would guide this new republic. Mayakovsky wrote:

> Years of trial
> and days of hunger
> ordered us
> to march
> under the red flag.
> We opened
> each volume
> of Marx
> as we would open
> the shutters
> in our own house;
> but we did not have to read
> to make up our minds
> which side to join,
> which side to fight on.[14]

In Russia the association of the flag with political theory and the concept of the flag as a repository of global revolutionary hope were present from the first days of the Soviet Union. The challenge of communicating political and philosophical concepts to the vast and largely illiterate working and peasant class meant that Bolsheviks began immediately to rely upon iconography, aesthetics and veneration of the flag to spread their message.

Aware of the country's history and of the socio-religious hierarchy they were seeking to replace, the Bolshevik government did not simply outlaw ritual and superstition; rather, it sought to man-

ufacture its own, using the sacred objects of class struggle. Where in pre-revolutionary Russia the entire social order and the autocracy of the Tsar were predicated on divine right and the logic of the Orthodox church, in the Soviet Union the social order proceeded from the party and from revolution, its scientific ideas and eventually its saints and icons.[15] When supplanting Tsarism, the Bolsheviks had to supplant Orthodox Christianity too, replacing religion with Marxism and the crucifix with the red flag.

Even today, in Red Square, in the mausoleum of Lenin, that ossified temple of Soviet ritual, the first Soviet leader lies in state next to one of communism's most precious relics: a red flag from the Paris Commune.[16] The steps and tribune of the tomb are the political incarnations of the stepped pyramid at Saqqara and the Temple of the Inscriptions in Chiapas. Beneath their red and black marble the body of a saviour and the shroud of the Communards lie side by side. Interred next to each other, this body and flag make a bold statement about the unified history of class struggle. This is an international monument to the lineage of the red flag.

The centrality of the Commune to the soviet project can be seen in the fact that, on the 72nd day of the Bolshevik Revolution, when the Russian Revolution had outlasted the Paris Commune by a single day, Lenin left his office in the Smolny Institute and danced in the snow.[17] He was leader of the longest-lived workers' state in human history, and owed a debt symbolically, ideologically and spiritually to the Paris Commune. The Communard flag presented to the Soviet Union by French communists in the early 1920s is a material link between these two revolutions, but it also marks a step in the transformation of the red flag from an object of urgent and actual revolution into an artefact in the production of a new culture, a new tradition and a new way of being. Whilst revolutionary Russia was mired in civil war and invaded by all the major capitalist countries, the workers and politicians at its core set about forging a new revolutionary identity.

This was the symbolic process that would accompany the astonishing economic and productive transformation of society. The modernisation of Soviet Russia would be total, and this radical

political, industrial and utopian process would itself revolutionise the meaning of the red flag. In film, in constructivist modern art, in experimental ballet and in radical modern architecture the red flag would itself be made modern, an electrified holy icon worthy of replacing the virgin mother in the now emptied Orthodox cathedrals of Soviet Russia. Proletkult – proletarian culture – was the new working-class aesthetic that Russian artists and writers created. Futurists, constructivists and idealists of the avant-garde, along with worker-poets numbering in the tens of thousands, produced radical new art, mass actions and proletarian literature. The romantic and humanist qualities of Marxism were re-imagined and thrust to the fore. Where the modernisation of the Western European economies had seen industrial capital reduce humans to mere economic units, replaceable parts in a modern machine, this explosion of new revolutionary culture offered Russian workers a chance to develop themselves fully, to became artists and aesthetes themselves. The artistic forms of the old regime – the gothic cathedral, the naturalistic portrait, the costume drama – were anathema to this aesthetic expression of the red flag.[18] This was a demand for a total moral, economic and visual break with the structures of capitalism. It called forth new forms and ideas, alien and ugly to the aristocrat and the bourgeois. It sought to create a new way of living, a new life.

Among the many Bolshevik utopias that scandalised the old ruling class was a sexual revolution. For some Bolsheviks experiments with feminism, free love and the abolition of the family formed key pillars of the new society under construction. Aleksandra Kollontai, the revolutionary, theorist, diplomat and first People's Commissar for Welfare in the Soviet Union used her position to liberate women from domestic, familial and sexual slavery.[19] In Kollontai's writing and policies communal childcare, cooking and living not only freed woman to work, but also gave rise to new forms of sexual relationship. Kollontai wrote of 'winged eros' and 'free love' beyond the confines of the family, in which female sexual desire was as natural as hunger and thirst.[20] She criticised the double standard of morality, and wrote that the bourgeois institution of the family with its subjugation of women was destined to wither away under

communism.[21] Her writings on freedom of sexual choice, collective childrearing, access to divorce and abortion and the naturalness of female sexuality formed a startling break with the past and a glimpse of a feminist politics that remained a distant possibility in capitalist countries. Red is, of course, a sexual colour, but one that carries with it the misogyny of the old world: the red of lips, the rouge and red lights of sex workers. Kollontai and her comrades worked for a utopia in which the new red woman was freed from shame and lived in every way as the equal of the new soviet man.

In all of the red flag's previous revolutions women had participated as workers and peasants and revolutionaries, they were the equals of men beneath the red flag – but that flag had not made room for their especial liberation. The red flag has no shortage of women holding it aloft – Louise Michel, Rosa Luxemburg, Countess Markievicz, Dolores Ibárruri, Leila Khaled, to name a few of its icons. And yet their relation to the flag has been as speakers, thinkers, fighters – often armed and in uniform – but rarely explicitly as women. And yet in these roles feminist victories have been won. Palestinian revolutionary Leila Khaled said: 'Before the communist struggle women couldn't choose their partner, or whether to establish a family. Now it's something ordinary. These rights, this respect, wasn't given to women, it was won by them taking part in the struggle.'[22] In 1917 the world saw what women had gained beneath the red flag, but also saw the red flag engage directly in the struggles of women.

Progressive and collectivist ideas of how to organise life were mirrored in soviet projects to organise art. Among the utopian experiments of 1917 was the People's Art School of Vitebsk. The painter Marc Chagall returned from Paris, and alongside fellow revolutionary artists Kazimir Malevich and El Lissitzky founded a new soviet art school. In a mansion appropriated for them by the Bolsheviks these modern artists and their students began a radical aesthetic imagining of the new art that would spring forth from the red flag, forging imagery, composition and symbolism anew. In Chagall's paintings from the time workers and peasants skip, stride and fly above the villages, exulted by their new power; in Malevich's

work limited shapes, forms and colours themselves fly and clash, seeking to free art from the dead weight of the old world. In his painting *Beat the Whites with the Red Wedge* El Lissitzky imagined the red flag as a dynamic abstract force defeating the enemies of the people and breaking into the future. Both the Vitebsk People's Art School and Proletkult were attempts at new aesthetics, new types of art, deserving of the workers. In El Lissitzky's picture the revolutionary red wedge pierces the reactionary forces symbolised in the circle of the white army; the angular reds shatter the curving black and white of the old regime. El Lissitzky's red wedge was a modernist expression that was part of a world-wide movement to remake art and culture after the shattering experience of the First World War. But the sharpness and the violence of this red wedge both revealed the thrilling modernism of a utopian socialist project and the real threat of the civil war that raged around them, presaging the hardness of the red flag under Lenin. The red wedge was the manifestation of a red flag that was reshaping life and art along the most radical and utopian lines.[23]

Bolshevism was from its outset interested in aesthetics and spectacle not just as a tool for propaganda and expression, but also as a system of living and of ruling. At the heart of this aesthetic was both the projection of power into a glorious future and also the commemoration of a noble past. Soviet identity would become synonymous with the production, on a vast scale, of cultural and material objects affirming and enforcing the unity of the workers and the ideas of their leaders, and commemorating every possible anniversary and date. A seemingly endless accumulation of badges, flags, banners, scarves, watches, cigarette cases and uniforms covered Russia and its people in the red of the flag and marked an ever-growing pantheon of communist holidays, replacing the saints' days of the Orthodox past. The destruction of the old feudal, familial, religious and imperial ties that had bound Russia saw the Bolsheviks replace them with a cult of identity that stemmed from the revolution itself. In 1920, on the third anniversary of the October Revolution, a mass spectacle was staged in St Petersburg in which more than 8,000 ballet dancers, circus performers, actors, members of

proletkult clubs, students, soldiers and workers – some of whom had participated in the revolution itself – re-enacted the storming of the Winter Palace.[24] More people took part, more ammunition was fired and more injuries were suffered during this mass spectacle than in the revolution itself.[25] A vast red stage occupied by the people faced the huge white stage of Kerensky and the provisional government across the square, and the full action of the February and October revolutions took place in a festival of fireworks, red flags and spotlights:

> Action on the Red stage was in a monumental style; performers wore no make-up. Acting was done in 'collectives': characters were groups, not individuals like Kerensky, a device that demonstrated the collective character of the Reds. A few hundred workers come onstage from the factories Annenkov built for his city. While about half the group stand forestage and hold statuesque poses, the other half rhythmically strike anvils with their hammers. More people flood onstage and gather round a large red flag. The ever-increasing crowd falls silent, as if straining to hear something. The Internationale becomes faintly audible; then cries of 'Lenin, Lenin!' echo from the audience until the word is caught up by the chorus. The Red stage has been changing throughout this scene. Beginning as a grey mass, the workers grow brighter as the searchlights illuminate them ever more intensely. As the masses, which have been pouring onstage chaotically, become increasingly more organised, they gather around the flag and take up the chant. When the Internationale breaks out at full volume to end the episode, the grey mass has completed its transformation into the Red Guard.[26]

This was total theatre, a vast blurring of the lines between reality and fiction, spectator and audience, art and life; it was a mass democratic experiment in the performance of revolution and the production of societal consensus. What Courbet had begun in the Paris Commune with the destruction of the Vendôme Column was now taken to new heights.

Amidst these mass rituals, personal rituals too became imbued with the colour red. Trotsky wrote: 'The workers' state already has its festivals, processions, reviews, and parades, symbolic spectacles – the new theatrical ceremonies of state ... the revolutionary symbolism of the workers' state is novel, distinct, and forcible – the red flag, red star, worker, peasant, comrade, International.'[27]

Oktyabriny ('Octobering') became the official naming ceremony for Soviet children. Before an altar of red flags, and in front of comrades rather than priests, babies would be welcomed into their new revolutionary society. Taking place in the parent's place of work, at an Octobering the child would be blessed not with holy water and prayers, but with 'our red flag of struggle and labour shot through with bullet holes and ripped by bayonets'. Sometimes a poll was taken and the child would be named democratically.[28] Names such as Vladlen, Ninel (Lenin backwards), Rosa and Octoberina became common.[29] The Soviet Union represented the first attempt by a nation to create an atheist society in the modern period, and the red flag was its central icon: a focal point beyond the darkness and sin of the church. This use of the red flag to replace religious iconography was seen too in the Socialist Sunday Schools of Glasgow, Lancashire and London, where new comrades were named in front of the red flag and atheist couples were married within their socialist communities.[30] Elsewhere, projects such as the Labour Church blended the iconography of the red flag with that of Christ. The Red Vicar of Thaxted Parish Church in Essex, Conrad Noel, was so convinced that the central message of Christ was best expressed in socialism that after the Easter Rising and the Russian Revolution he began to hang the red flag and the flag of Sinn Fein in his English church. Despite it being repeatedly torn down by students from Cambridge, it took until 1922 for the Church of England to rule that the red flag was not appropriate Christian iconography.[31]

In Russia too the lines between revolution, science and religion were being redrawn in the shadow of the red flag. Alongside Bolsheviks were idealists who were taking the victory won over the bourgeoisie to its next logical steps. Once humanity had triumphed over exploitation it would naturally triumph over gravity and even

death.[32] These were groups and individuals known as Cosmists who believed that in the future communist society eternal life and limitless space would be added to the gains of peace, land and bread.[33]

As with all futuristic movements, though the science to support such ideas did not exist, the movement itself inspired the minds that would go on to work on making such advances possible. One of the greatest thinkers inspired by Cosmism was Konstantin Tsiolkovsky, a physics teacher, auto-didact and visionary who spent his life writing and studying in a log cabin in Kaluga Oblast. Tsiolkovsky became the godfather of the Soviet space programme, developing the theoretical underpinnings of rockets, space stations, airlocks, multi-stage boosters and human space flight.[34] On May Day 1935, at the age of 77, Tsiolkovsky addressed the whole Soviet Union in a broadcast in which he outlined the distant future of interplanetary travel and the dawning age of rocketry which had been his dream and life's work. As the speech played on screens in Red Square, with red flags two and three stories high flying above the crowds and Stalin looking on, Soviet planes flew overhead, and Tsiolkovsky heralded these 'steel dragonflies' as the first stage in communism's gravity-defying future.[35]

Cosmic and technological visions and discoveries would drive the unprecedented rate of industrialisation in the Soviet Union and become central to its propaganda machine, all the time intertwining themselves with the meaning of the red flag. A flag that now moved not just from the barricades and into the factories, not just from the streets and into the Kremlin, but also from Russia out into space. Having already launched the world's first artificial satellite, Sputnik, and sent Laika, the first dog in space, the Soviet rocket Luna 2 became the first manmade object to reach the moon on 14 September 1959. Inside the rocket was a titanium pennant containing a small flag, the first flag on the moon: the red flag of communism.[36] The technological triumphs of the Soviet space programme inevitably shaped global understanding of the red flag. These triumphs projected to the world the primacy of the communist system. A system that was able, faster than capitalism, to propel humanity into the future. In 1964, when the Voskhod rocket became the first space

flight to take a scientist into space, it carried in its cargo a small part of a flag from the Paris Commune, uniting the promise of the red flag of revolution as it had been raised in 1871 with the projected communist utopia that seemed within reach a century later: liberation not just from class, but from gravity. In less than a century the red flag had travelled from the barricades of Parisian slums out into the solar system.

The red flag on the moon, the red flag raised in the hand of the steelworker turned cosmonaut Yuri Gagarin – the red flag of the Soviet Union leading the world in space – gave irrefutable proof that without capitalist profit and bourgeois exploitation the most incredible scientific achievements were possible. The Soviet Union's abiding impact on the history of the red flag may have been this, to project onto it a futuristic vision of humanity beyond just the restructuring of property and society, and into the restructuring of our place in the universe. Billions around the world saw the red flag in space as a utopian symbol newly made modern.

Even as the Soviet Union's rate of industrial advance began to slow, and in the face of the USA putting a man on the moon in 1969, other communists, in the spirit of Cosmism, were taking up the progressive possibilities of the red flag: be it practically in the incredible scientific, healthcare and literacy initiatives of Communist Cuba or fantastically in the wild and futuristic ideas of extra-terrestrial contact, sentient cetaceous comrades and the workers' bomb of Posadism.

From the outset the Bolsheviks had looked to extend the power of the working class internationally, and they sought to do so in their own image. The iconography of Leninism, and later Stalinism, became the de facto aesthetic of international communism, and the red flag was its chief object of veneration. This aesthetic took in elements of heavy industry, space exploration and warfare to produce a symbolic universe that continues to define the flags, badges, newspapers and websites of the international left. Hammers and sickles may be replaced with doves, cogs and machetes, wheatsheaves, suns, stars and globes, but the aesthetic message remains

the same: the red flag is a banner for all humanity that stretches out into a utopian future.

The legacy of the Soviet red flag is to pile high these ideas of space travel, workers palaces, peasant power, mass industrialisation, electrification and human progress. It is a red flag of a material progress. The Soviet Union did not just renew the ideals of revolt, hope and martyrdom that the red flag encapsulated; it layered them with realities of progress, electrification and Cosmism that still resonate today. It would, however, do all of this in the shadow of a darker truth that moved across the red flag, delivering these victories at a brutal cost.

9
A Flag of Tyranny

The iconic image of the end of the Second World War is that of the red flag flying above the Reichstag on 2 May 1945. In the background we see the shattered remains of central Berlin, with the granite statues of the Reichstag staring out at ruined tenements. In the foreground, echoing the steadfastness of the statues, one soldier flies the red flag over the city, while another, with arms raised, holds him up. This is one of the most well-known depictions of any flag in human history. It summed up the unbelievable resolve of those who fought against fascism. For two weeks the Red Army had fought the Battle of Berlin, one of the bloodiest battles of the war. For nearly 14 days the Soviet forces faced the German Army, the Waffen-SS, and hastily organised Volkssturm and Hitler Youth units that fought street by street in a futile bid to prevent the liberation of the capital. More than 100,000 people perished in the fighting.[1] The people's flag atop the German parliament was conclusive proof that communism had vanquished fascism, that the red flag was triumphant in Europe.

The capture of the Reichstag, the symbolic centrepiece of the German government, although bitterly fought for, was nevertheless a piece of theatre. The Reichstag itself had lain empty for more than a decade since the fire that had gutted it in 1933. For the Nazis it symbolised the weakness of democracy. But for the world it remained the conceptual seat of German power. Stalin himself had ordered that it be captured in time for 1 May, International Workers' Day, and on that day, during the battle for the building, red banners had been dropped by parachute over its domes.[2] The photograph, staged the day after the battle, of two Soviet soldiers raising a red flag from its roof was the symbolic end of the battle for Berlin. Photographer Yevgeny Khaldei, having seen the image

of American soldiers raising the Stars and Stripes at Iwo Jima, had a family member sew two table cloths together to create a red flag especially.[3]

In the photo one soldier flies the flag, the other man, supporting the flag-bearer, was a young Dagestani soldier called Abdulkhakim Ismailov. Ismailov had been born beneath the minarets of Aksai, close to the Caspian Sea, and fought with the red army from the Battle of Stalingrad to the Battle of Berlin, being hospitalised seven times in those three years.[4] Ismailov was crucial to the composition, but on returning to Moscow the photographer found a problem with his subject. The soldier was clearly wearing two watches: one on each wrist. The thought occurred that he might have looted one from an enemy corpse.[5] The photo was immediately doctored, the second watch scratched out of the negative. This tiny detail, removed from a negative, points us to the flag of revenge, untruth and tyranny.

In 1945, as much as the Red Army and its flag symbolised hope and liberation, so too did it represent terror and looting. In the final days of the war brutalised soldiers unleashed a terrible and vengeful campaign on the German population. Looting and rape were commonplace.[6] Many generals considered all Germans guilty for the Nazis' terrible crimes. Others simply felt that soldiers deserved a reward. The red flag at the heart of a destroyed Nazi Germany was both a symbol of hope and revenge. Just as nations across Eastern Europe freed from Nazism by partisans or by the Red Army began to raise the red flag over their own seats of government, either willingly or under Soviet control, the red flag, even in the moment of final victory over Nazism, was on one side a flag of liberation, and on the reverse a flag of tyranny. This dual identity played its part in the incredible resolve and sacrifice of the Red Army, an army that was at the same time fighting under a flag of utopia while also being disciplined by a flag of tyranny, and enacting its own terrors.

The red flag flew over the Reichstag in 1945 both because of the liberatory and emancipatory violence of its revolutionary message, but also because of the stultifying and terrifying institutional violence of famine, state control and purges that had forged the

Soviet army. A flag stained with the blood of martyrdom and the blood of murder.

And that there is murder should come as no surprise: the red flag has always been a symbol of violence. It is a symbol of class war, a class war which no one would dispute is bloody. In order to uncover the meaning and history of the red flag it is crucial that we look clearly at its revolutionary violence, and at the ossification of that violence into tyranny.

Equally it is a flag that has – often even in its most tyrannical form – sought to end violence. The tyranny of the red flag is always complex. The Guyanese revolutionary Walter Rodney wrote:

> We were told that violence in itself is evil, and that, whatever the cause, it is unjustified morally. By what standard of morality can the violence used by a slave to break his chains be considered the same as the violence of a slave master? ... Violence aimed at the recovery of human dignity and at equality cannot be judged by the same yardstick as violence aimed at maintenance of discrimination and oppression.[7]

The brutality of the red flag is not an initiating violence, it is the response to the violence it faces. Walter Benjamin wrote of a 'law-destroying violence', a type of violence that destroys the regime and opens up the potential future.[8] The mutiny, the revolt, the coup, the strike, these are law-destroying violences of the red flag. And yet too often they morph into the law-making violence of terror and tyranny, of purge and gulag and famine.

From the earliest days of Bolshevik rule the seeds were sown for anti-democratic government, secret police brutality, trade union suppression, prison camps, starvation of the peasants and murder of political opponents. Threaded amidst communism's triumphs, these seeds grew to become a forest of terror and repression that, whilst not synonymous with the red flag, have become a part of the flag's history and character.

This repression, however, was rooted in particular material conditions. In the red flag's first two manifestations as the symbol of

state power – the Paris Commune and the Bolshevik Revolution – red forces were immediately surrounded by the violence of their enemies. Both revolutions were besieged by a hostile force. Forged in crucibles of war and conspiracy, both revolutions looked to that first political red flag, the Jacobin Reign of Terror, as a precursor to their own struggle. Leon Trotsky wrote in 1920 that 'the iron dictatorship of the Jacobins was evoked by the monstrously difficult position of revolutionary France'.[9] In 1917 the merciless character of the capitalist armies that Trotsky faced was equal to if not greater than that faced by the revolutionaries of 1792. The reign of terror enacted by the Jacobins provided a prototype for future radical governments. Echoing through history, amidst the cries of 'liberté, égalité, fraternité' was the sound of the guillotine.

In Paris in 1871, as the Communards were slaughtered in the streets, those flying the red flag began to retaliate with brutality in kind. In the final days of fighting, the Committee for Public Safety decided to execute a group of hostages that had been held for the full two months of the Commune. Among those killed was the Archbishop of Paris. His murder would shock the world and stain the reputation of the Commune. However, Marx sought to contextualise it, writing that the taking of hostages itself had been an attempt by the revolutionaries to save lives, to place some halt on the fury of the French government led by Adolphe Thiers:

> Was even the last check upon the unscrupulous ferocity of bourgeois governments – the taking of hostages – to be made a mere sham of?
>
> The real murderer of Archbishop Darboy is Thiers. The Commune again and again had offered to exchange the archbishop, and ever so many priests in the bargain, against the single Blanqui, then in the hands of Thiers. Thiers obstinately refused. He knew that with Blanqui he would give the Commune a head; while the archbishop would serve his purpose best in the shape of a corpse.[10]

Marx was right; the murder in cold blood of 64 hostages, among them an archbishop and priests, was a propaganda gift to the red flag's enemies. It would also serve as a precedent and as a warning to future revolutionaries. The Commune committed its atrocity without purpose, amidst the massacre of its own people. The Bolsheviks would not make the same mistake. While throughout the Second International the red flag flew as a symbol of democracy and peace, the blood that it had shed in 1871 foreshadowed the coming of a greater red terror.

For the Bolsheviks in the early days of the Soviet Union its use of the red flag as a national symbol posed a problem. To what extent could the Soviet Union control its own flag, to what extent could the red flag still be used against it? If the red flag remained the symbol of revolution and the standard of international socialists and anarchists, then did it really belong to the Soviets? Such questions would be answered with both hope and terror. In order to consolidate power, the Bolsheviks not only needed to win the civil war, they needed to win a propaganda war. Much of the spectacle and propaganda of the early 1920s was aimed at reinforcing the idea that Lenin and his comrades were the sole progenitors of and natural heirs to the Russian Revolution and all of its symbols. And yet the anti-Bolshevik movement continued to fly the red flag in Russia.[11] Peasant uprisings such as the Tambov Rebellion of 1920 flew the red banner as the symbol of their revolt against authority – albeit a Bolshevik authority fighting beneath the same flag.[12] The early 1920s in Russia saw strikes, rebellions and uprisings that are sometimes known as the 'third revolution'. In these years diverse forces of the left took up the red flag against Bolshevism, and Bolshevism itself sought to take control of the flag.

The tyranny of these early years is epitomised by the crushing of Kronstadt in March 1921. The island fortress of Kronstadt, surrounded by the ice of the Gulf of Finland, is the naval base that defends St Petersburg from assault across the Baltic Sea. The dome of its cathedral and its many ramparts and battlements speak of hundreds of years of naval occupation. In 1917 the red sailors of Kronstadt had played a key role in both revolutions, forming the

Kronstadt soviet in the February Revolution and sailing the cruiser *Aurora* which fired on the Winter Palace during the October Revolution. In 1921, as strikes broke out across Russia in protest against the Soviet regime, the lack of free elections and the suppressing of opposition leftists, the same sailors described by Trotsky as 'the revolution's pride and glory' took up the red flag again and mutinied against the Bolshevik command.[13] They demanded freedoms for anarchists, independent trade unionists and peasants, and new, directly elected soviets.[14] The sailors themselves formed a new soviet with two members from each naval unit. A third of the elected delegates ran as Bolsheviks and the majority were non-party: almost all affirmed the ideals of communism, and yet they found themselves the enemy of a Bolshevik party that was determined to maintain total control of the revolution.[15] Beneath red and black flags the anarchist commune at Kronstadt held out for 16 days until the Red Army charged across the ice and crushed the one-time heroes of the revolution. Bolshevik propaganda sought either to paint the sailors as the dupes of a capitalist counter-revolution or to claim that the true red sailors of 1917 had died in the Civil War or had risen up through the Bolshevik party, and that the sailors of 1921 were the feckless children of landlords.[16] But the opposite was true. In 1921 the sailors of Kronstadt who raised the red flag of revolution were the same men who had done so four years earlier. Disillusioned by the bureaucracy and brutality of Lenin's war communism, the sailors strove to reclaim the revolution and the red flag for the people. The Bolshevik authorities reacted with fury. The sailors were told that if they did not surrender they would be 'shot like partridges', and their families were arrested in St Petersburg as hostages.[17] They held out, and fought an unimaginably bloody battle in which some 1,000 Kronstadt sailors and as many as 10,000 Red Army soldiers were killed.

The rising was finally suppressed on 18 March 1921, the fiftieth anniversary of the Paris Commune. Posters went up across the nation declaring that 'the Martyrs of the Paris Commune were Resurrected under the Red Flag of the Soviets!', but in the background the death cries of the martyrs of Kronstadt could be heard. As the

Bolsheviks celebrated their Parisian forebears, the sailors and residents of Kronstadt who had ushered in the Soviet era were either imprisoned, executed or fled abroad. The dead were so numerous that the Finnish authorities petitioned the Soviets to clear the bodies from the frozen sea, fearing a public health disaster in the Baltic when the ice thawed.[18]

The early spirit and hope of the revolution died at Kronstadt, and the character of the Soviet flag had been changed for ever. The red flag was not just torn from the hands of anarchists who had flown it for a century, but torn also from the hands of those revolutionaries who were avowed Bolsheviks, but who nevertheless represented a threat to the power of the new state. Anarcho-communist supporters of the Bolsheviks reacted in horror. Emma Goldman wrote that 'at Kronstadt the dictatorship of the proletariat was slaughtered by a political dictatorship of the party'.[19] For anarchists the red flag was now tainted with the blood spilled at Kronstadt. For Bolsheviks the shock of the massacre at Kronstadt and the strikes across Russia, coupled with the suppression in the same year of a further German revolution in that country's industrial heartland, led to a period of inward-looking compromise and a shaken confidence in the future of their project. The red flag that had become synonymous with hope in 1917 now became an icon of brutality and betrayal.

The Soviet veneration of the red flag was a bureaucratic cult that upheld the ideals of the original revolutionaries, spreading equality and liberation around the world, whilst simultaneously making revolution and freedom impossible within its direct sphere of control. The staggering progress and achievements of the Soviet Union came at an enormous cost to its people, in a paradox of freedom and suppression. The Soviet Union was the great international liberator, governed with a stranglehold from an imperial centre. The red flag of the Soviets was at once the miraculous beacon of a possible working-class future and the bloody standard under which hopes, such as those of the Kronstadt sailors, would be crushed.

Kronstadt was just one moment in the Red Terror of 1918–22. This defence of the Soviet project against internal and external enemies was the first wave of mechanised revolutionary violence

in the world. Amidst the devastation of the Russian Civil War tens of thousands of political opponents were executed by the Bolsheviks. As Lenin struggled to fight an internal and external war, the violence of the regime became set. The Soviet secret police, the Cheka – later to be called the NKVD and finally the KGB – estimated that they executed some 12,000 dissidents. Modern scholars have suggested that the number might be five times that.[20] Writing in the midst of the bloodshed, Trotsky looked back to the Commune and the words of Marx: 'Concerning the destruction of which the Commune is accused, and of which now the Soviet Government is accused, Marx speaks of "an inevitable and comparatively insignificant episode in the titanic struggle of the newborn order with the old in its collapse". Destruction and cruelty are inevitable in any war.'[21]

Trotsky argued that the dictatorship of the bourgeoisie must be met with an equal and opposing violence. There would be less blood spilled in a month of communist revolution than in one weekend under capitalism.

But this hazy equivocation, this suggestion of the means justifying the ends, set no upper limit on the bloodshed that the red flag stood for. Trotsky and Lenin, like Marx, believed that the violence of the Commune was justified. But they went further than Marx, insisting that, for the revolution to be successfully defended, its violence must be pre-emptive.

Maria Spiridonova was a Socialist Left Revolutionary, a sometime ally of the Bolsheviks, and a key figure following the October Revolution. She was no stranger to political violence, having assassinated a landlord in the 1905 revolution. The journalist John Reed had called her 'the most powerful and the most loved woman in all Russia'[22] in his classic *Ten Days That Shook the World*. But by 1918 she had turned against the Bolsheviks, horrified by the massive territorial concessions to Germany and by Soviet mistreatment of the peasants. She was imprisoned, and would live the final two decades of her life in jail or exile. As a witness to the Red Terror, she wrote an open letter to the Bolshevik Central Committee from prison:

These nightly murders of fettered, unarmed, helpless people, these secret shootings in the back, the unceremonious burial on the spot of bodies, robbed to the very shirt, not always quite dead, often still groaning, in a mass grave – what sort of Terrorism is this? ... So far the working classes have brought about the Revolution under the unblemished red flag, which was red with their own blood. Their moral authority and sanction lay in their sufferings for the highest ideal of humanity. Belief in Socialism is at the same time a belief in a nobler future for humanity – a belief in goodness, truth, and beauty, in the abolition of the use of all kinds of force, in the brotherhood of the world. And now you have damaged this belief, which had inflamed the souls of the people as never before, at its very roots.[23]

Spiridonova saw that, in the Red Terror, political violence had morphed into a system of government. And that with it this terror had altered the fabric of the red flag.

The Red Terror was a ruthless campaign of suppression aimed at defending the revolution. The red flag in the hands of the Bolsheviks was intentionally a flag of terror. The hope it was inspiring in workers was intended to have its dark reflection in the terror that it represented to kulaks and capitalists. To both sides the red flag became a banner of revenge. A flag always represents an *Us* and consequently a *Them*, and the red flag was no different.

In the case of the terror of 1918–22 such revenge was met by an equal and opposite violence. Everywhere in Russia the White army, the capitalists and their US, British, French and Japanese allies were committing atrocities against communists and civilians. This was the White Terror, a genocidal campaign targeting Jews and communists across the Soviet territories. Disparate anti-communist forces conducted pogroms and summary executions that left more than 100,000 dead.[24] Victor Serge, the dissident Russian communist, remarked that had the counter-revolution triumphed, the death toll would have been immeasurable.[25] Major William S. Graves, who commanded US forces in Siberia during the Russian Civil War, wrote: 'There were horrible murders committed, but they

were not committed by the Bolsheviks as the world believes. I am well on the side of safety when I say that the anti-Bolsheviks killed one hundred people in Eastern Siberia, to every one killed by the Bolsheviks.'[26]

The red flag of the Soviet Union came into the world amidst violence on a colossal scale, a violence perpetrated by all sides. The oft-quoted passage from Gramsci that 'the crisis consists precisely in the fact that the old world is dying and the new world is struggling to be born: this is the time of monsters'[27] dealt specifically with the horrors of these times. Monsters both red and white forged an unbreakable link between the red flag and tyranny, a link that existed in the lived experience of those in the communist world, and powerfully in the minds of those outwith the Soviet Union.

The association between the red flag and tyranny would reach its apogee during the rule of Joseph Stalin. For 30 years, from when he became General Secretary of the Communist Party of the Soviet Union in 1922, until his death in 1953, international communism and the meaning of the red flag were defined by Stalin and Stalinism. The red flag itself still exists in the minds of millions as a flag tied to the rule of Stalin.

Under Stalin the red flag became the standard of a communist ideology that prized modernity and industrialisation, and which was comfortable with the use of violence in order to maintain control. In the decade prior to the Second World War industrial output in the Soviet Union tripled and production of armaments increased an astonishing 25-fold, while unemployment disappeared completely.[28] The Soviet nations were transformed from chiefly agrarian economies into the component parts of an electrified world power, and all of this took place as the capitalist economies stumbled to their knees following the great depression. But this economic miracle was achieved not only by way of greatly improved efficiency, technology, planning and centralisation; it was also the result of uncompromising political leadership. All resources were concentrated on the project of industrialisation, at the cost of consumption. The living standards of most citizens declined, grain was exported to pay for technology from the west, as those in the cities faced ration-

ing, and millions in the countryside starved to death. Simultaneously, a vast secret police force exercised increasing control over the day-to-day lives of the people. This was an ideology of the grand plan and the greater good which neglected the needs of individuals.[29] The red flag's association with sacrifice and collective action now saw it preside over a system in which millions of lives could be sacrificed for the good of the cause. Forced collectivisation and relocation tore through the peasantry and uprooted lives. This was not a dictatorship of the proletariat, but a dictatorship both for and over the proletariat, a synthesis of totalitarian repression and emancipatory politics. Stalin created what Brecht would refer to as a 'workers' monarchy'.[30] In his book *The Furies: Violence and Terror in the French and Russian Revolutions* Arno Meyer usefully defines Stalinism as 'An uneven and unstable amalgam of monumental achievement and monstrous crimes'.[31] Under Stalinism the red flag for the first time became the symbol of a massive and entrenched system under which the momentary violence of the blood flag was able to ossify into the greater organised brutality of a flag of a repressive state.

Collectivisation ravaged the countryside in a chaotic frenzy of violence, coercion and famine. But it was not led by Stalin, or even centrally directed. Instead, a disparate mix of bureaucrats, zealots and utopian communists initiated a wild mix of reforms and collectivisations, each imagining and producing their own idea of what a collective farm should look like and each seeking to outdo the excesses of other regions: to be more Soviet, to procure more grain, to collectivise more peasants and more resources. In one district in the Urals even clothing was collectivised, with peasants picking items from a common pile before heading out into the fields.[32]

This rural demonstration of devotion to the red flag and the willingness to dehumanise those who stood in its way found its expression on a national level in the Great Purge which took hold of the Soviet Union in the 1930s. Violence and paranoia were the means of control that would come to be associated with the flag under Stalin. Mass arrests, show trials and executions eliminated vast swathes of the political, bureaucratic and military command, unveiling an array of conspiracies and plots, some real and some imagined.

Key figures from the revolution, including Trotsky, Zinoviev, Kamenev and Radek, were arrested, expelled from the party, pardoned, re-admitted, re-arrested, murdered or exiled. A popular joke from these tumultuous years has three men in a cell beneath the secret police headquarters in Moscow. They are discussing what they have been arrested for. One says, 'I am here because I defended Karl Radek.' The other responds, 'But I am here for criticising Karl Radek!' The third man sighs and says: 'Comrades, I am Karl Radek.'

The atmosphere of suspicion and denunciation pervaded all of society. Sixteen per cent of the military command were purged, and hundreds of thousands of workers, soldiers and state officials were killed.[33] Trotsky wrote that 'The Red Terror is a weapon utilised against a class, doomed to destruction, which does not wish to perish.'[34] But under Stalin this vengeful power was turned against the very people who raised the flag, even against those who were themselves responsible for the Red Terror. Trotsky was assassinated by a Stalinist agent in 1940. And by the end of Stalin's reign six of the eight original members of the first Bolshevik politburo had been killed. Only Lenin and Stalin died natural deaths. The tyranny of the red flag had always been intended to be a tyranny against the ruling class. The US socialist organiser and presidential candidate Eugene Debs wrote that 'The red flag is an omen of ill, a sign of terror to every tyrant, every robber, and every vampire that sucks the life of labor and mocks at its misery.'[35] Under Stalinism the political leadership turned that terror into a key constituent of government and used it mercilessly against its own people.

The Spanish Civil War provided a first-hand encounter with the red flag of tyranny for thousands of anarchists, socialists and Trotskyists from around the world. The Civil War was fought between republicans, loyal to the elected Popular Front government which was a coalition of leftists, and the nationalists who supported a fascist military coup led by General Franco. For three years republicans fought a desperate war against fascism, with the Soviet Union and Mexico as their only allies. Their ranks were bolstered by the International Brigades: 40,000 foreign radicals from 53 countries who fought alongside the republican forces.[36] They encountered a

besieged but beguiling left communist revolution. George Orwell wrote:

> When one came straight from England the aspect of Barcelona was something startling and overwhelming. It was the first time that I had ever been in a town where the working class was in the saddle. Practically every building of any size had been seized by the workers and was draped with red flags Every shop and cafe had an inscription saying that it had been collectivised; even the bootblacks had been collectivised and their boxes painted red and black.[37]

As the Civil War dragged on, however, the Marxist and anarchist fighters found themselves not just threatened by Franco's army, but also betrayed by the Stalinists they fought alongside. Agents of the Soviet secret police sought to control the left factions in Spain, and in doing so they arrested and executed not just fascists and spies, but also anarchists, Trotskyists and anyone they deemed fit to call an enemy of the republic. NKVD agents such as Alexander Orlov tortured fascist spies and promised them their lives would be spared if they admitted connection to anti-Stalinist left-wing groups. One such group was POUM, the left-Marxist faction of which Orwell had been a member.[38] The red flags were torn from POUM's buildings and Red Aid Centres, its leaders were captured, tortured and executed, its party was suppressed, and all the while its militias – which were still on the frontlines, fighting against fascism – were kept ignorant of the purge that was taking place against them.[39]

The defeat of the Spanish republic and the sectarian fighting led by Russian and Spanish Stalinists would complete the break between anarchists and the red flag that began at Kronstadt. Among the tens of thousands of International Brigade fighters who returned home were many who now saw the red flag and the popular fronts it represented co-opted by an uncompromising and tyrannical communism. Anarchists in particular would take a new symbol from the Spanish Civil War: the red and black flag. The CNT, an anarchist union, had adopted the bisected red and black flag as its symbol in

1910, distinguishing itself from the followers of the Second International. The flag had originally symbolised a unity between those activists who focused on economic and labour issues and those with a broader anarchist world view, both in opposition to the reformism of contemporary socialism.[40] Its unity with the red flag was now inverted and it became a symbol used by those who wished to distance themselves from a flag that belonged to Stalinism. Since the 1880s the likes of Louise Michel had flown a black flag, stressing its identity as a flag of mourning for humanity, an anti-flag, and a signifier that all flags are black when they are burned. She wrote:

> The red banner, which has always stood for liberty, frightens the executioners because it is so red with our blood. The black flag, with layers of blood upon it from those who wanted to live by working or die by fighting, frightens those who want to live off the work of others. Those red and black banners wave over us mourning our dead and wave over our hopes for the dawn that is breaking.[41]

If the black flag was increasingly established as an anarchist symbol, the red and black flag became the standard for anarcho-communism. It became the global symbol of anti-authoritarians and anarchists.

The anarchists and Trotskyists who fled fascist Spain after the defeat of the republic would take the red and black flag to every corner of the world, particularly to Latin America, where they would have a profound effect on politics, reinforcing the strong anarcho-syndicalist tradition on the continent and affirming red and black as its colours.[42] In the decades that followed, the Sandinistas, the Zapatistas and Castro's Movimiento 26 de Julio would all join the struggle beneath red and black flags, signalling their non-alignment with the pure red flag of Soviet communism[43] – a red flag which for many was now coloured by tyranny.

Denunciations, purges and terrors would become key aspects of how revolution was defended beneath the red flag in the twentieth century. And yet even amidst the depths of its violence loyalty to the red flag and its vision endured. In the gulags, throughout the

Second World War news of Soviet victories was greeted with celebration, and many inmates volunteered to fight with the Red Army, in contrast in the Nazi concentration camps where it was allied victories and bombing campaigns that were celebrated.[44] Many Gulag survivors returned to society with their commitment to communist ideology renewed, having viewed their horrific experiences either as a perversion of red flag politics or as an opportunity to offer up physical labour to the cause. Such returnees could be welcomed back as heroes and found work and status. It has been speculated that these experiences confirm both the function of communism as a secular religion, and the power of a trauma bond between the worker and the party. In both interpretations the bloody red flag has a talismanic role.[45]

Where the Commune provided Lenin with the lesson for the Red Terror, then the authoritarian communism of Stalin, the mercilessness of the purges and the popular frenzy of collectivisation would provide the lessons for perhaps the most powerful figure ever to fly the red flag: Chairman Mao.

Just as Lenin had, Mao would begin the long Chinese revolution by raising the red flag in the midst of a White Terror, this time led by Chinese nationalists. The Soviet-backed First United Front Government of China came to an abrupt end in 1927 when nationalists led by General Chiang Kai-shek massacred 5,000 of their communist allies.[46] The killings in Shanghai precipitated years of murderous repression of Chinese communists, with an estimated 1 million left-sympathising civilians and members of peasant organisations killed and mutilated by nationalists. This was the background from which the Maoist red flag arose – amidst an orgy of anti-communist brutality. Isolated, demoralised and in hiding, Mao saw the iron will of Stalin transforming Soviet Russia.[47] In the face of the brutality of nationalist movements, capitalist governments and feudal warlords, the red flag of tyranny seemed to be the correct tool for freeing China from oppression and raising its millions of peasants and workers out of poverty. Mao's famous assertion that 'political power springs from the barrel of a gun' is a celebration of force and political violence that would echo around the world. The red flag

that had been chiefly a symbol of utopian socialism at the end of the nineteenth century was, in the twentieth century, a banner of political violence.

In the 1930s, however, communists were far from having a monopoly on either state violence or the colour red. In Germany the Nazi Party of Adolf Hitler came to power through street fighting and intimidation. The struggling capitalist economies of the West had seen huge rises in support for communists and socialists in the wake of the Great Depression. Fear of revolution was once again running high amidst the European ruling class, and Nazism presented capitalists with twin answers to the problem; it would win working-class votes whilst at the same time murdering those leaders who flew the red flag of communism. Capitalism, with its back against the wall, gave birth to fascism, a totalitarian anti-communist racist force conjured up as if on a monkey's paw by those who feared for the security of their property and their place in society. Though supported and funded by the bourgeoisie, the Nazi Party courted the workers by wrapping itself in the trappings of their movement and promising power to the working class. The Nazi Party substituted the language of capitalist oppressors for a conspiracy against Jews, foreigners and other undesirables they held to be to blame for the suffering of German culture and society. As well as including the words 'socialist' and 'worker' in its names, the Nationalsozialistische Deutsche Arbeiterpartei (National Socialist German Workers' Party, or Nazi Party), co-opted the colour red.

Hitler wrote in *Mein Kampf*:

> We chose red for our posters after particular and careful deliberation, our intention being to irritate the Left, so as to arouse their attention and tempt them to come to our meetings – if only in order to break them up – so that in this way we got a chance of talking to the people.[48]

Impressed by the forceful images of tens of thousands of Marxists, and buildings draped in red flags during the German Revolution of 1918, Hitler set out to imitate and invert these images, claiming

red as a colour not of equality and hope, but of power and violence. Here was the red flag of tyranny divorced entirely from socialism, hope or revolution. Red's inherent visual qualities and its association with blood and power trumping any claim to humanity.

Whilst fascism may have adopted some of the aesthetics of the red flag, it at the same time mercilessly crushed the red flag's adherents, who were amongst its first victims. The Nazi concentration camp system was inaugurated in 1933 with the internment of political opponents in makeshift camps, warehouses and empty factories. But even in these first moments of Nazi terror, communists and socialists found sustenance in their movement and their flag. At Gotteszell women's prison on 1 May 1933 new inmates celebrated International Workers' Day with songs and flowers. In the midst of the demonstration the communist prisoner Lotte Weidenbach leapt onto the table to reveal a red petticoat beneath her uniform and declared, 'This is our red flag!'[49]

Of the estimated 50,000–100,000 people held in camps by the Nazis in the first two years of Hitler's rule, 80 per cent were communists.[50] These political prisoners, some of whom would spend more than a decade in the camps, were subjected to mass starvation, forced labour and summary executions. They were identified on their concentration camp uniforms by a red triangle – a small red flag signifying their identity, their crime and their punishment. For the many thousands of Jewish communists amongst the millions who died in the Holocaust a red triangle incorporated into a star of David was their double identifier.

The small red flag on their uniform was a mark of their crime and their identity. Hundreds of thousands of communists and socialists were murdered in the Nazi camps. Prior to their deaths many of these reds played a key role in the prison resistance movements. Across the camps communist prisoners took up positions as clerks, functionaries, elders and capos – involving themselves in the day-to-day running of the camp. This suited the SS, who limited contact between Nazis and prisoners and who could rely on the organisational abilities, international network, multilingualism, literacy and prison experience of the communists. But it also suited the commu-

nists, giving them positions of power and influence. Where most camp elders and capos were despised by their fellow inmates for their sadism and selfishness, the communists had an ideology and a faith that helped many to navigate the disturbing position of power over other prisoners, to refuse orders to beat and kill fellow prisoners, and to instil solidarity among inmates. The polish Auschwitz survivor and resistance fighter Władysław Fejkiel wrote that it was because communists could count on the support of the international resistance organisations and a broad community of prisoners regardless of their nationalities that they were able to accept the burden of becoming a camp elder and see clearly the good that could be done with the position – redistributing food and labour and sheltering the most vulnerable. It was the internationalism and their commitment to humanity that helped these communists and socialists to navigate the camps and resist the SS.[51] And yet it was also the single-mindedness, ruthlessness and acceptance of political violence that made roles as capos acceptable to communists. Many of those marked with a red triangle in the camps were prominent figures in concentration camp life, and in memoirs from the camps there are frequent mentions of the noble actions of those marked with a red triangle.

In Auschwitz communist inmate Hermann Langbein was a clerk in the camp infirmary and an active member of the resistance. His testimonies give us a record of many of his comrades in the death camp. Langbein was a veteran of the Spanish Civil War, Dachau and Auschwitz. He was later declared Righteous Among the Nations by Yad Vashem. He wrote about Orli Wald, a German lesbian communist who became camp elder and used her position to save countless people from the gas chambers, becoming known as the Angel of Auschwitz. He wrote of Orli that 'she never forgot that National Socialism was the common enemy of all detainees'.[52] He also recorded the life of Hans Neumeuer, a Bavarian communist and camp elder at Dachau who was well known for taking punishments himself rather than following an order to flog his fellow inmates. For this insubordination he was transferred to an infection block at Auschwitz. Neumeuer continued his work there, trying to

alleviate the suffering of others, saying 'if the SS couldn't get us down in Dachau, we won't let the lice do it here'. The lice, however, did get him and he died of typhus. Herman Langbein remarked that 'for me he will always remain the model of a good comrade'.[53]

But these red triangle-bearing camp elders were not all benevolent; the willingness to wield power within the camps also produced brutal and feared capos from within the communist movement. It was remarked by survivors that the cruelty and violence of these fellow prisoners was more disturbing even than the violence of the SS. Langbein witnessed one such communist prisoner, Sepp Heiden, an infirmary capo, beating a sick prisoner and then trampling him when he finally fell. Such abuses were commonplace.[54] Again the red flag all too easily morphed into a flag of tyranny. The willingness to engage with power, to try to enact change, are the hallmarks of the red flag – and in the concentration camps, as in the rest of the world, these qualities were double-edged.

Above all, though, the red flag in the Nazi camps was a symbol of hope. In 1944 this hope produced a singular and extraordinary image. On 1 May that year, in a basement at Buchenwald concentration camp, anti-fascist comrades from Germany, Holland, Czechoslovakia, France, Luxembourg and the Soviet Union raised a red flag and sang the 'Internationale'.[55] They were marking International Workers' Day by raising the red flag privately in the dark heart of fascism. Their faith in the symbol and the movement provided the focus of their resistance in the concentration camp. The Buchenwald resistance functioned for the final years of the war, saving the lives of children, sabotaging the Nazi war effort, and in the final days of the war, liberating the camp.

After liberation, on 19 April 1945 the survivors of Buchenwald gathered in national blocks in the courtyard and stood to attention before a wooden monolith built in the camp workshop. The Buchenwald resistance marched beneath the red flag. This was the funeral service for the estimated 51,000 inmates who had been murdered by the SS at Buchenwald. All those present made an oath:

We, the Buchenwald anti-fascists, are reporting today in honour of those murdered by the Nazi beast and its helpers' helpers at Buchenwald …. we swear in front of all the world in this concentration camp, in this city of fascist greyness: We will cease our fight only when the last guilty person stands before the judges of the people. The eradication of Nazism as well as its roots is our guiding principle. The rebuilding of a new world of peace and freedom is our goal.

The red triangle on concentration camp uniforms, that small and cruelly intended red flag, survived as a symbol of resistance, solidarity and hope. In the moment of liberation the red flag flew openly, and now at Buchenwald as a standard of vengeance against fascism. The striped uniforms, emaciated bodies and defiance of the Buchenwald resistance demonstrate the bearers of the red flag as Nazism's first victims and its final vanquishers. Anyone attempting to associate the red flag with fascism should recall Pastor Niemöller's famous words: 'first they came for the communists'.

Across occupied Europe it was the red flag that was the key symbol of opposition to fascism. The partisans of Italy and Yugoslavia, the French resistance, the Andartes of Greece all flew the red flag in their heroic stand against Nazi occupation. Unknown thousands of them were murdered. And while socialists and communists led every major national resistance group in Europe, their comrades in the Red Army fought against Nazism on the Eastern Front in the most total war the world has ever seen. There can be no question that the decisive force in the Second World War was that which fought beneath the red flag. In Yugoslavia and Greece, and in Poland, France and Italy, this war had the character of a worker and peasant insurgency against a fascist and aristocratic elite. In the East it was a vast bureaucratic workers' state defending itself against invasion.[56] The relation of the bourgeois government of the United Kingdom to these red allies varied from the production of Soviet tanks in England, built in capitalist factories by enthusiastic workers who flew the red flag and attended solidarity events that saw the Albert Hall draped in a 50-foot red banner in a salute to the

A FLAG OF TYRANNY

Red Army,[57] to the under-supplying of arms to Italian communist partisans and the persecution and murder of Greek communists by the British army.[58] The complex divides between these many armies shouldn't blind us to the fact that it was the red flag more than any other symbol that stood for the defeat of Nazism.

Some 27 million soldiers and civilians of the Soviet Union died in the war against Nazi Germany.[59] The final result of Soviet sacrifice was the defeat of fascism, and the red flag liberating Eastern Europe. The Red Army itself was an embodiment both of the utopian camaraderie and self-sacrificing liberatory politics of the red flag, and of the brutal terror and revenge that had come to be associated with it – that amalgam of monumental achievement and monstrous crime. When it flew from the roof of the Reichstag it proclaimed a red dawn after the long fascist night. But it was a dawn that would bring its own terrors. The evils of Nazism had been defeated and the Swastika came down, but the red flag that replaced it was one backed by purges, forced labour and gulags.

Yet the flag remained a symbol of shared humanity and hope. In 1945, as Red Army soldiers occupied the small town of Gerbstedt in eastern Germany, they were greeted by Otto Brosowski – a former local secretary of the German Communist Party – bearing a red flag embroidered with a red star, miners' picks and Russian writing. The flag had been a gift to German communists from the miners of Krivoy Rog (Kryvyi Rih) in Ukraine in 1929. Often flown at left-wing rallies during the Weimar Republic, the flag had become dangerous when the Nazis came to power. Minna Brosowski, Otto's wife, had sewn it between two tablecloths and placed it secretly on their living room table. In 1934, after returning from a year's imprisonment in the Lichtenburg concentration camp, Otto moved it to the back of a rabbit hutch. In 1945, in a newly liberated Gerbstedt, he retrieved it in order to greet the occupying communists.[60] In eastern Germany the red flag was inarguably a symbol of hope, survival and friendship regardless of the tyranny of the preceding decades.

That tyranny, however, followed the flag into government in East Germany. Today the flag that liberated Europe is illegal in some of

the countries it freed, associated not with its noble sacrifice against fascism, but with Stalinist policies of the 1950s and with the dictatorship in modern Russia. The flag's further inversion would occur after the fall of the Soviet Bloc, when the red victory banner that flew over the Reichstag would be appropriated by Russian nationalists and associated with the 2022 invasion of Ukraine. That year, at the commemoration of the surrender of Nazi Germany, the Berlin Senate banned the display of red flags at the memorials, commemorative sites and historical buildings where survivors of the Holocaust and their relatives traditionally hold events.[61] A symbol of remembrance and liberation equated with a symbol of hate and invasion.

Such conflicting and conflicted red flags of violence emerged repeatedly during the twentieth century. The red flag's encounters with power, both its own proletarian power and the power of the capitalist forces massed against it, produced contradictions that would inevitably result in and resolve themselves with violence. As Fidel Castro put it, 'revolutionaries didn't choose armed struggle as the best path, it's the path the oppressors imposed on the people'. The destruction of the Paris Commune, the collapse of the Second International, the brutality of the Russian Civil War – these were the ground in which the red flag of tyranny took root, but it is the violence of capitalism, imperialism and fascism all around which forced the shoots of the flag upwards.

The Russian state paper *Pravda* once proclaimed that 'The anthem of the working class will be a song of hatred and revenge!'[62] No matter how justified such a class hatred may be, the frenzied terror it unleashes has time and again proven uncontrollable. The excesses of the Red Terror, the Great Purge and the Cultural Revolution were so debased and so uncontrollable that even the figures of Lenin, Stalin and Mao struggled to bring the killing to a halt once they had sanctioned it. If just 1 per cent of the population are incapable of empathy, this is enough for atrocities to spread like wildfire. So the Cheka perpetuated itself, and the Cultural Revolution led in its final excess to cannibalism,[63] just as the peasants of Hautefaye in Northern France had dipped their bread in the dripping of

a burnt noble in 1870.[64] The bitterness and anger of the oppressed can easily be converted into shocking action. In the gothic imaginary of Marxism, the vampire capitalist that sucks the blood of living labour and the spectre of communism that haunts the dreams of the bourgeoisie are both all too familiar. But the werewolf of the Red Terror that is unleashed to defend the revolution, but which then begins to devour the revolutionaries themselves is less often discussed. The dictatorship of the proletariat, the republic of labour, even the anti-hierarchical anarchist commune are all able to conjure up a violence that solidifies into the red flag of tyranny.

In 1956 the Soviet Premier Nikita Khruschev made a speech in which he denounced Stalin. Khruschev launched a policy of de-Stalinisation, seeking to destroy Stalin's cult of personality and to acknowledge the wrongful violence and repression that had taken place over the previous decades, particularly during the Great Purge. And yet mere months later, partly as a result of de-Stalinisation and the reformist movements it ignited, Khruschev would preside over his own red flag of tyranny. Under his orders Soviet tanks rolled into Budapest and arrested the communist revolutionary leader of Hungary, Imre Nagy. Two years later Nagy was executed. In front of the whole world the forces that flew the red flag were seen crushing a revolution and murdering communists. Countless comrades broke with communism, and many distanced themselves from the red flag.

In a response to one of his own critics, the anarchist Kropotkin, Lenin wrote: 'you cannot make a revolution in white gloves'.[65] The blood that stained those gloves continues to separate people from the red flag.

There is no doubt that today the red flag carries authoritarianism within its folds. In the shadow of secret police forces such as the KGB and the Stasi the flag itself became associated not just with violent revolution, but also with the tyrannical statecraft and paranoia which followed. The Berlin wall became the physical embodiment of a system that made prisoners of its people.

Yet it is a paradoxical violence, always seeking to end the violence of oppression that it simultaneously perpetrates. The secret police

forces of Moscow and Berlin fought real as well as imagined enemies. And these real enemies had long proven their own disregard for human life, though the innocent victims caught out in the machinery of the Stasi and the KGB were countless.

Writing of the Jacobins, Mark Twain said:

> There were two 'Reigns of Terror', if we would but remember it and consider it; the one wrought murder in hot passion, the other in heartless cold blood; the one lasted mere months, the other had lasted a thousand years; the one inflicted death upon ten thousand persons, the other upon a hundred millions; but our shudders are all for the 'horrors' of the minor Terror, the momentary Terror, so to speak.[66]

As incomparable in their extent as the two terrors may be, the red flag was, in its first incarnation, a blood flag. And a blood flag it remains. The purges led by Stalin and Mao, and the countless other acts of violence committed beneath the red flag continue to imbue it not just with the quality of a demand for another society, but with a threat against those who threaten its power. Such a terror-ending-terror was an integral element of the Red Army's defeat of Nazi Germany. Both the violence enacted upon the surviving Germans and the purges, privations, Stalinist industrialisation and violent control that had led the Red Army to fight such an astounding and self-sacrificial war against Nazism were examples of the ferocious power of the red flag's tyranny.

In 2019 the European Parliament passed a resolution condemning communism and equating it with totalitarianism, including Nazism. As early as 2008 the European Parliament had proclaimed 23 August as Black Ribbon Day, the day of remembrance for victims of communism and fascism. Such liberal equivocations turn the history of the red flag against itself, twisting the red flag of the Buchenwald resistance into an image of tyranny.

This propaganda from the right, however, finds its answer in the neo-Stalinism of elements of the left who glory in the brutality with which opposition has been crushed in the name of the red flag,

1 *Arrest of Christ: The Kiss of Judas*. Illustrated manuscript, 1450

2 *The Battle of the Sound with the Dutch Navy Engaging Two Swedish Warships*, by an anonymous painter from the Low Countries, c. 1670

3 *To Henry Hunt, Esq., as chairman of the meeting assembled in St. Peter's Field, Manchester, sixteenth day of August, 1819, and to the female Reformers of Manchester and the adjacent towns who were exposed to and suffered from the wanton and fiendish attack made on them by that brutal armed force, the Manchester and Cheshire Yeomanry Cavalry, this plate is dedicated by their fellow labourer, Richard Carlile, 1819*

4 *The Raft of the Medusa*, by Jean Louis Théodore Géricault, 1818–19

5 Depiction of the Merthyr Rising, by Hablot Knight Browne, 1841

6 *Lamartine in front of the Town Hall of Paris rejects the red flag on 25 February 1848*, by Felix Philippoteaux, nineteenth century

7 *The Barricade at Place Blanche, defended by women communards during the bloody end of the Paris Commune*, by B. Moloch, 1871

8 *The Anarchists of Chicago*. Woodcut by
Walter Crane, 1894. Coloured by Tyler Clemons

9 The Red Flag raised in George Square, Glasgow, 1919

10 *Hamburg wharf worker*, by Heinrich Vogeler, 1928

11 *The Bolshevik*, by Boris Kustodiev, 1920

12 *Beat the Whites with the Red Wedge*, by El Lissitzkey, 1919

13 *Long Live the USSR! Blueprint for the Brotherhood of all Working Classes of all the World's Nationalities!*, by Gustav Klutsis, 1935

14 Anarchist comrades pose in revolutionary Barcelona, 1936

15 *Raising a Red Flag over the Reichstag,* by Yevgeny Khaldei, 1945

16 Concentration camp identification badge denoting a Jewish political prisoner. This object was donated to the Montreal Holocaust Museum by Mark Schick, whose father, Zigmund Schick, endured forced labour in a coal mine, and was transported to Auschwitz

17 A group of Telangana Rebels in formation, 1948

18 SACP members rally with Joe Slovo and Nelson Mandela at the decriminalisation of the Communist Party, by Paul Weinberg, 1990

19 Fidel Castro and Amílcar Cabral at the Tricontinental Conference in Cuba, 1966

20 May First, Unity of the working-class organizations guarantees the continuation of the revolution, by Jihad Mansour for the Popular Front for the Liberation of Palestine, 1987

21 *May 68, The Beginning of a Long Struggle*, by Atelier Populaire, 1968 (Bibliothèque nationale de France)

22 Yippies storm a statue in Grant Park in protest against the arrest of their leaders at the Democratic Convention, Chicago, by Art Shay 1968

23 A woman naxalite waits before her performance at a protest rally in Kolkata, by Jayanta Shaw / Reuters Pictures 2007

24 Kisan Long March, Maharashtra Farmers Protest, 2018. (Image courtesy of the All India Kisan Sabha)

25 Red Guards hold up the Little Red Book of Chairman Mao in Tiananmen Square during the Cultural Revolution, 1967

26 The Revolution, by Marc Chagall, 1963.
(Copyright ADAGP, Paris and DACS, London 2024)

arguing that any and every violence in the defence of revolution is justified by its context. Still others simply deny that crimes were committed beneath the red flag, seeking to rehabilitate tyrants and to cast their detractors as traitors and plants.

The bearers of the red flag have been avengers, tyrants, murderers and torturers. Hundreds of thousands have been murdered by communists, millions have died as a result of their actions. Many were royals, aristocrats, landlords, traitors and spies. Others were preachers, intellectuals, artists, peasants, fellow workers and fellow revolutionaries. The vast death toll attributable to the red flag cannot be ignored in the history of the symbol, and nor can it be wished away. The red flag itself cannot be raised without also raising the ghosts of those who have been murdered in its name. If we do not record how a symbol of life and liberation became warped into a standard of destruction, how the hopeful liberators of Russia and East Germany morphed into the institutions of torture and execution that were the Stasi and the KGB, then we surely cannot imagine new and better futures for the red flag.

But equally we should not allow such futures to be erased by capitalists who seek to denigrate the red flag. We cannot shy away from examining the violence of the red flag's enemies. The number murdered in the name of capitalism and imperialism is incomprehensible. Tens of millions were killed in wars fought between capitalist nations in the twentieth century. Millions more died of hunger or of poverty or of despair. More still were killed in prisons or perished in factories, were beaten to death in the street by police or rounded up and killed for their anti-capitalist beliefs. Beyond them are the billions whose lives have been benighted and usurped by greed. It would be impossible to tally the victims of capitalism, not least because the number grows daily.

Everywhere that socialism has sprung up, its training ground has been mired in blood. No sooner do workers seek to take control of their lives and destinies than they find themselves besieged by the forces of finance, the militias of the landlords, the bombs of the imperialists. The Parisian slaughters of 1848 and 1871, the Russian and Spanish Civil Wars, countless coups and counter-revolutions

have answered the red flag. Most times that the people's flag has flown it has been cut down with bullets by the bourgeoisie. It is that same bourgeoisie that goes on to finance the writing of history and seeks to define the meaning of the red flag in each period of struggle, to record the flag's dead and to cast it as a flag of tyranny.

The people killed by communist revolutions and regimes were not the victims of preternatural serial killers; they were not murdered by colossal monsters nor by great men of history. Instead, there were movements of millions of people who, in specific material circumstances, amidst revolution and counter-revolution, came to enact terrors. And who then allowed terror to become institutional. Many did so whilst loyal to the red flag and dreaming of a fairer world. These terrors that grew into systems of violence and control were not the aberrations of the power-hungry or manifestations of personal evil; they were structures developed by humans. As such these violences have formed part of the fabric of the red flag. A fabric that came to resemble what Domenico Losurdo calls 'the dialectic of Saturn' in which the revolution devours its children.[67] A flag of blood shared, and of blood shed.

10
A Flag of the Dispossessed

In 1865 in Morant Bay, Jamaica a large crowd bearing a red flag surrounded the courthouse and demanded their land and their rights. These were black peasants and formerly enslaved people, denied the right to vote, persecuted by British police, and kept landless and in poverty. The ruling white minority attempted to suppress their protest, and a hastily assembled colonial militia fired on the crowd, killing six and inciting a rebellion. The crowd burnt down the courthouse and school and seized the local police station, killing a further eleven people, most of them white. This was an anti-colonial uprising beneath the red flag, and it sent shockwaves throughout the British Empire. When order was restored, the retribution of the colonial authorities was terrible, with more than 400 Jamaicans killed and the nearby village of Stony Gut burnt to the ground by soldiers.[1]

Since its earliest incarnation the red flag had flown amidst the horrors of empire, both as the battle flag of imperial navies and privateers as well as the symbol of sailor, slave and worker risings. It had been one symbol among many in the Haitian revolution, but at Morant Bay and Stony Gut it flew for the first time as the chosen symbol of the dispossessed against their colonial oppressors. It was here that the people's flag began a historic shift, becoming not just the symbol of class liberation, but also the banner of anti-colonial struggle.

A decade later, in 1876, when two brothers named Dottin – one bearing a sword and the other a red flag – began a rising in Barbados that became known as the Confederation Riots, their use of the red flag as a symbol of anti-colonial struggle was well understood.[2] The red flag now appeared in the hands of the transported, the enslaved and the colonised peoples of the Caribbean, and would

spread across the Americas, Africa and Asia. It was in these continents that its most vital moments would arrive. Not as a flag of tyranny or utopia, but as a flag of liberation. The red flag was to become a flag of the global dispossessed, its revolutionary potential launched afresh in the subjugated nations of the earth.

These subjugated nations were what Walter Rodney called the deliberately underdeveloped parts of the world, the parts of the world that are 'naturally rich but actually poor'.[3] Thomas Sankara described the people who took up the red flag here as 'that mass of people who are disinherited and maliciously dubbed the Third World'.[4] In the century that followed the Morant Bay Rebellion they took centre stage, red flag in hand.

But that red flag's journey to these exploited nations had been long and winding.

The red flag had become established in Europe in the nineteenth century as a revolutionary symbol at the same time as the European empires themselves were becoming formalised. The proletariat that raised the red flag in Europe in those years was intimately tied up in the violence of slavery and empire; they were at once crushed by the capital that empire pulled to its centre and at the same time enjoying the privileges that being even a wage slave at the imperial centre could bring. The capitalism that forged this red flag was wedded to the imperial and racial violence that had facilitated it. Some who flew the flag engaged directly with the struggle of those colonised and enslaved people. Marx wrote in 1867:

> The discovery of gold and silver in America, the extirpation, enslavement and entombment in mines of the aboriginal population, the beginning of the conquest and looting of the East Indies, the turning of Africa into a warren for the commercial hunting of black-skins, signalised the rosy dawn of the era of capitalist production. These idyllic proceedings are the chief moments of primitive accumulation. On their heels treads the commercial war of the European nations, with the globe for a theatre.[5]

Marx was clear that primitive accumulation by imperial robbery had been the engine of capitalism. And yet until the First World War, and despite uprisings in the colonies, few flying the red flag made the defeat of empire a central aim of their movements. The failure of the Second International was in part the failure of socialists to fully comprehend the overlapping nature of colonisation, capitalism and war. For many the red flag remained a flag of white labour.

In the settler-colonial states of Canada, Australia and the USA this was particularly true. These imperial conquests, for the most part temperate in climate, operated as neo-Europes, and their rulers sought to recreate the class structure and economic conditions of the imperial centre. Here the indigenous population was not just exploited, but slaughtered. In these states the red flag had at times been the revolutionary symbol of a shared struggle between an indigenous, immigrant, formerly enslaved and transported proletariat, and at other times a banner of white workers securing their rights in opposition to a colonised and immigrant population. In the USA much of the trade union movement forced black workers out. Trotsky lamented this American white working class 'who refuse to recognize fellow workers and fighting comrades in the Negroes'.[6]

But the red flag was also raised in partial or incomplete settler-colonial states such as South Africa, Algeria and Rhodesia and in colonies of exploitation, such as Jamaica and India, where a native or transported and indentured non-white population made up the labour force. It was in these latter two types of colony that key ideological battles for the red flag would take place.

In many cases the red flag was transported to these colonies by the government itself in the hands of exiles from the imperial core. It was in this way in the 1870s that the red flag had arrived on the Pacific islands of New Caledonia with the deported Communards. Thousands of working-class Parisians who survived the massacre in France were transported to the South Pacific. When the native Kanak people of these islands rose up, many former revolutionaries fought against the indigenous freedom fighters and preserved minority white rule, just as the French government had preserved minority bourgeois rule and had filled the streets of Paris with blood.

In contrast, the Communard Louise Michel passed the red flag on to the Kanak fighters and supported their armed resistance. In this act a direct link was forged between the class struggle and the national anti-imperialist struggles. This was a moment when the flag passed from the dispossessed of Europe to the dispossessed of the world, a moment which unleashed the many tensions between national and class liberation whilst pre-empting the events that would propel the red flag far beyond the urban and industrial world and out into every corner of the earth. In Jamaica and New Caledonia, in the Atlantic and the Pacific, the red flag was becoming the symbol of a new global struggle. However, it would take the inspiration of the Russian revolutions to firmly establish the red flag as a symbol of anti-colonial revolution.

The October Revolution of 1917 and its spectacular creation of the first workers' state, flying the red flag began a contagion that, although it first threatened Western Europe, would in fact spread most dramatically in the global East and South. The defeated revolutions of Central and Western Europe in the decade following the First World War saw Lenin and the Bolsheviks refocus their internationalism, moving from Europe to Asia. In an interview in 1920 Lenin said: 'the West lives at the expense of the East; the imperialist powers of Europe grow rich chiefly at the expense of the eastern colonies, but at the same time they are arming their colonies and teaching them to fight, and by so doing the West is digging its own grave in the East'.[7]

The Third International – known as the Comintern – had as its focus the organisation not solely of the European proletariat, but also of the subjugated peoples of Asia, Africa and the Americas. It saw imperialism as a bloody stage of capitalism and a prelude to revolution. The Comintern's chairman Grigory Zinoviev was deliberate in his phrasing when he called for a 'jihad against imperialism'.[8] Karl Radek added: 'Nothing can stay the torrent of the workers and peasants of Persia, Turkey, India, if they unite with Soviet Russia ... we are bound to you by a common destiny.'[9]

The Asian revolutions that the Bolsheviks hoped for flowered first in Mongolia and Iran, two countries that existed on the frontier

between empires. The short-lived Soviet Republic of Iran on the Caspian Sea lasted less than a year before the Shah's coup broke it up. However, the Mongolian revolution that began in 1921 saw the Mongolian People's Republic raise the red flag in 1924 to become the world's second socialist state. It renamed its capital Ulaanbaatar, ('the Red Hero')[10] and adopted a red flag with the national emblem in gold. There were now two independent states that flew the red flag: one that had thrown off the shackles of Tsarism, and another that had freed itself from the imperial control of China, Russia and Japan.

Word of these revolutions and their symbol – the red flag – spread amongst colonised populations, though such news was censored and mediated by their rulers. As the enormity of what had occurred in Russia began to be known in the colonies, two key aspects of the revolution came to the fore: the unity of peasants and industrial workers, and Lenin's decree of the right of all nations to self-determination.[11] The effect of the Soviet revolution in the colonised world was electric. The future prime minister of India, Jawaharlal Nehru, wrote that 'although under the leadership of Mahatma Gandhi we followed another path, we were influenced by the example of Lenin'.[12] Gandhi himself looked towards Russia and the red flag for inspiration, writing of the 1905 Russian Revolution that 'it is not within the power of even the Tsar of Russia to force strikers to return at the point of the bayonet. ... For even the powerful cannot rule without the cooperation of the ruled.'[13] Here was the seed for Gandhi's movement: the red flag of defiance. A red flag that would play a crucial role in liberating Britain's largest colony.

In India the red flag was first flown on May Day 1923 in Madras – now Chennai. Malayapuram Singaravelu, a communist lawyer who had founded India's first trade union, addressed a crowd of labourers and told them that by marking May Day in India they were laying the foundation stone of a great labour edifice.[14] He had cut a portion from one of his wife's saris to make a red flag, which he raised on the beach.[15]

In its early years the movement around the red flag in India concentrated its energy on the urban poor of Madras, Bombay, Lahore, Delhi and Calcutta and suffered brutal repression from the British occupiers. In a series of high-profile conspiracy cases many of India's early communists were accused of working 'to deprive the King Emperor of his sovereignty of British India, by complete separation of India from Britain by a violent revolution'.[16] Singaravelu was arrested and scores of Indian communists were hanged or died on hunger strike in jail in the 1920s and 1930s. As British imperialism attempted to crush the communist independence movement, the opposite effect was achieved. Constant press coverage and sympathy with executed comrades – such as the 23-year-old revolutionary Bhagat Singh – spread the message of communism and firmly linked the red flag to the Indian independence struggle in the popular imagination.

The Communist Party of India affirmed its aims in its first constitution in 1925 as 'the establishment of a workers' and peasants' republic based on the socialization of the means of production and distribution, *by the liberation of India from British Imperialist domination*' (emphasis in original).[17] In India, as in other nations subjugated by empire, the red flag became as intrinsically anti-imperialist as it was anti-capitalist.

The red flag also represented a current of the Indian independence movement that was fiercely critical of the passive resistance of Gandhi and other nationalists. Throughout the struggle for Indian liberation demonstrations, strikes and bombings by Indian communists highlighted the British need to quit India and pushed the imperial government into negotiations with the more moderate elements of the Indian Nationalist movement. The red flag in India represented the radical wing of the independence movement both politically and tactically – a symbol of communism and of armed struggle. In the broad class coalitions that saw the anti-colonial project victorious around the world in the twentieth century this dynamic in which the red flag represented the threat and pushed the rulers into negotiation with more moderate and bourgeois nationalists was repeated.

A FLAG OF THE DISPOSSESSED

The aftermath of the Second World War and the election of a Labour government in London made a peaceful transition of power look possible in India, but communists were still able to show the danger they posed to the British should they renege on their commitments. In 1946 the Royal Indian Navy Mutiny saw the red flag raised from the Arabian Sea to the Bay of Bengal. The Indian Navy had increased ten-fold in size over the course of the war, and now, with Nazism and Japanese Imperialism defeated, it turned its guns on the British Raj: 20,000 sailors in 78 ships and bases mutinied and seized key infrastructure, including the whole of Bombay harbour.[18] They raised the red flag alongside the flags of Congress and the Muslim League, signalling their opposition to communal and religious division. The mutineers' demands included the withdrawal of Britain from India and the release of all political prisoners. Communist infiltration of the navy was mirrored in the air force and army, and the strike soon spread across the armed forces and beyond to textile and railway workers. Whilst the leadership of the Communist Party of India was hesitant in its support of the mutiny and strikes, its membership played a key role. More significant still was the Trotskyist Bolshevik-Leninist Party of India, and so the red flag of that party, with its hammer, sickle and numeral 4 representing the Fourth International, became a key symbol of the rising.[19] Communists back in Britain celebrated the coming breakup of the Empire, and in India it looked possible that the red flag would fly in government.

Just as anti-fascism had galvanised the people's flag, anti-imperialism now propelled it to the forefront of global politics, and nowhere more stunningly than in China. The Chinese Communist Party, led by Mao Tse-tung, had liberated the country after a century of colonialism and subjugation. The Chinese Revolution was an anti-capitalist, anti-colonial and nationalist project, and its symbol – the red flag – along with its tactic of a people's army encircling the cities and winning power from an agrarian and rural base would have a huge impact on the wider struggles of colonised peoples. The most populous country on earth was, for the first time in a century, sovereign over its own destiny. The red flag was

a guiding light for all those who wished to free themselves. Lenin had foreseen the growth of Asian communism beyond the Soviet Union when he wrote:

> There can be no doubt that the age-old plunder of India by the British, and the contemporary struggle of all these 'advanced' Europeans against Persian and Indian democracy, will steel millions, tens of millions of proletarians in Asia to wage a victorious struggle against their oppressors. The class-conscious European worker now has comrades in Asia, and their number will grow by leaps and bounds.[20]

The unity of those struggling against their national rulers in Britain and France, and those struggling against their colonial rulers in India and China found its expression in the shared symbol of the anti-capitalist and anti-colonial struggles: the red flag.

Just as in India and China, new communist parties and revolutionary movements were founded in almost every nation in the world. Colonialism itself provided the mechanism for the spread of the red flag, as industrial and agricultural workers, sailors, lascars, exiles, intellectuals, deportees and rebels moved around the world amidst the flow of capital. Many leading figures from the colonised world, from Ram Mohammad Singh Azad to Ho Chi Minh, worked and studied in Europe, bringing the red flag home with them. In 1919 a young Husayn al Rahul was studying in Berlin and witnessed the Spartacist revolution. In the years that followed he travelled across India, learning about their struggle for independence – and in the 1920s he returned to his native Baghdad and founded the country's first Marxist study group, and later the Iraqi Communist Party.[21] Ottoman participants in the German revolution went on to found the Workers' and Peasants' Party of Turkey. In 1925 at the Communist University for Toilers of the Orient in the Soviet Union the young Marxist Aziz Hamdi swore only to return to Egypt to raise the red flag from the pyramids at Giza.[22] Joseph Rosenthal, a Beirut-born Russian, began the work of making that happen when he led the first May Day in Cairo in 1921, and a few years later the

buildings of the Egypt Oil Company were occupied and the *rayat al-shaab*, the people's banner, flew from the rooftops.

The Palestinian Bolshevik Najati Sadqi fought in the International Brigades of the Spanish Civil War and wrote that communism was the best route to national liberation, stating that he was 'fighting for Cairo in Zaragoza'.[23] Sadqi, who had witnessed both the Arab revolt of 1916 and the Russian Civil War, helped Arabise the Palestinian Communist Party and was imprisoned by the British. He later produced the Arabic newspaper of the Comintern in Paris and knew Mao, Stalin and Ibárruri personally.[24]

The internationalism of the red flag saw revolutionary knowledge move around the world. Shapurji Saklatvala travelled from Jharkhand to England to recuperate from malaria, and there became the first Communist MP elected in Britain. Ram Mohammed Singh Azad was radicalised by the Amritsar Massacre of 1919, worked in Germany and Britain, joined the Indian Workers' Association and in 1940 assassinated Michael O'Dwyer, the former governor of the Punjab.

Such figures are emblematic of the movement of people and ideas between the Middle East, India, North Africa, Russia, Europe and the colonies, a movement that spread the red flag across the world and combined the ideas of national liberation and class struggle

However, in much of Asia the spread of socialism and communism was hampered not just by a lack of access to key texts in translation, but also because of uncertainty around how to translate concepts that had been defined in line with a European philosophical tradition and were thus lacking linguistic and philosophical cognates in the destination languages. Early Ottoman socialists, for example, transliterated 'socialism' into *sūsyālizm*, and this practice continued in Iran and Turkey, where it reinforced an association of the workers' movement with foreign intervention. In Arabic, conversely, the term *ishtirākiyyah* soon became the established translation of 'socialism'. The original root of the word in Arabic is 'to share' or 'to cooperate' or 'to associate', but other connotations of the word's derivation hampered its spread: the word is a close relative of words meaning Christian communion (*shirkah*) and idolatry

(*shirk*).²⁵ Such complex ideas around the transmission and translation of socialism were often overcome by the flag itself, a symbol that the masses could associate with action, strikes and concessions won from both imperial rulers and local landlords, and around which an indigenous national left movement could grow. The red flag, free from language and nations, was able to communicate its ideas in every vernacular.

By the 1930s the red flag was the pre-eminent symbol of national liberation around the world. One Mexican revolutionary leader at the time put the alliance between the struggle of the oppressed nations and socialism's ideas and symbols bluntly: 'I don't know what Socialism is, but I am a Bolshevik, like all patriotic Mexicans. The Yankees do not like the Bolsheviks; they are our enemies; therefore, the Bolsheviks must be our friends, and we must be their friends. We are all Bolsheviks.'²⁶

The red flag served to a communicate a message to many whom theory and rhetoric were unable to reach. It identified allies and enemies in the struggle against imperialism.

As a symbol the red flag began to stand in for an unending library of ideas untranslated, unavailable or suppressed in the colonies. Increasingly it was the symbolic stand-in for the material fact of the Chinese People's Army, the Russian proletarian victory and the Parisian Communard sacrifice. The red flag contained the democratic and socialist ideals that pointed to a future beyond both bourgeois and white oppression. It began to play an active part in scores of liberation struggles, and the leaders of those struggles began to study the red flag's victories elsewhere. In Paris Ho Chi Minh helped to found the French Communist Party; in the caves of Yan'an Mao studied the life and work of Stalin; at the University of Havana a young Fidel Castro encountered the works of Marx and Lenin. Castro wrote:

> Marxism taught me what society was. I was like a blindfolded man in a forest, who doesn't even know where north or south is. If you don't eventually come to truly understand the history of the class struggle, or at least have a clear idea that society is divided

between the rich and the poor, and that some people subjugate and exploit other people, you're lost in a forest, not knowing anything.[27]

The red flag was the beacon that pointed the way to this understanding, lighting up capitalism and colonialism so the people could see their way out of it. The proof of the red flag's power was in the fury it inspired in the ruling class. If the red flag was the enemy of the British ruling class, of the American plantation owner, of the Italian fascist, then surely it must also be the friend of the Indian worker, the Polynesian islander, the Ethiopian farmer. The generation that came under its influence in the first half of the twentieth century would go on to reshape the world.

It was these figures, overwhelmingly rural, from the global South and from peasant and tribal backgrounds, that would define the revolutionary red flag in the post-war period. In these years Maoism became a new dominant force in the meaning of the flag. Lin Biao, the vice-chairman of the Chinese Communist Party, wrote:

> Taking the entire globe, if North America and Western Europe can be called 'the cities of the world', then Asia, Africa and Latin America constitute 'the rural areas of the world'. Since World War II, the proletarian revolutionary movement has for various reasons been temporarily held back in the North American and West European capitalist countries, while the people's revolutionary movement in Asia, Africa and Latin America has been growing vigorously. In a sense, the contemporary world revolution also presents a picture of the encirclement of cities by the rural areas.[28]

Still today the places where the red flag flies from government buildings and from insurgent armies are almost all located in Asia, Africa and Latin America, the direct producers of most of the so-called First World's wealth. The increasingly globalised nature of capital and the unchangingly racialised nature of capitalism led the red flag to become central to political life on these three continents.

This centrality of the red flag to the anti-colonial struggle would also highlight the unity of capitalism and imperialism in the second half of the twentieth century as neo-colonialism, and economic and cultural imperialism increasingly replaced direct colonial rule.

The combined symbolic power of the anti-racist and anti-colonial red flag was evident in one of the first conflicts following the Second World War: the Korean War. Liberated from Japanese occupation, Korea had been divided between Soviet and US control. By 1948 two governments had been formed: a communist North and a capitalist South. Almost immediately a revolution began in the capitalist South; there the Workers Party of Korea raised the red flag and began an insurgency against the Western-backed government. The red flag provided a rallying point for those who saw US influence as a continuation of colonial rule. After two years of left-wing guerrilla fighting and brutal government retaliation the North invaded the South in an attempt to aid the communist fighters. In the three-year war that ensued the US and South Korean army fought against the Soviet and Chinese-backed North Koreans. More than 4 million people were killed in the fighting,[29] and the American bombing campaign left no building higher than a single storey standing in the entirety of North Korea.[30] US Air Force general Curtis LeMay said of the campaign that killed nearly 20 per cent of the Korean population: 'We burned down every town in North Korea and some in South Korea too.'[31] After all the killing, in the end the borders between the two Koreas were unchanged: a communist North and a capitalist South.

The massive US intervention had been the result of the United States' fears over communist contagion, seeing the role communism was taking in the dismantling of the European empires and aware of the power of the red flag to cross borders. 'Domino theory' was the American expression of this fear, holding that just as Russia had spread the red flag across Eastern Europe, so too might newly communist China lead to the red flag being raised across Asia.

It has been true since the Parisian barricades of 1848 that the red flag has a unique capacity to cross national lines and a unique ability to inspire defection. Any ruling class must send its workers

to the front lines, and there, when they face the red flag, they see a symbol and an ideology that promises to liberate them. They face an enemy that is at the same time a comrade with the potential to empower them. Such possibilities were realised in the Korean War, where Koreans, Chinese and Russians fought beneath the same red flag and brought that flag into contact with British and American soldiers. Among them was a young black soldier called Clarence Adams. He would later write of his defection to communist China:

> The Chinese insisted it was 'a rich man's war but a poor man's fight'.... When I thought about my life as a young black man, I had great difficulty in seeing what democracy and freedom had done for me Why are the rich rich and the poor poor? Why do blacks always get kicked around like animals? ... [T]he more I thought about this, the more I believed there was some truth in what the Chinese were telling us. Critics in America later called this brainwashing. But how can it be brainwashing if someone is telling you something you already know to be true.[32]

Adams would later broadcast to black American troops on Radio Hanoi, saying: 'You are supposedly fighting for freedom, but what kind of freedom do you have at home, sitting in the back of the bus, being barred from restaurants, stores and certain neighbourhoods, and being denied the right to vote? ... Go home and fight for equality in America.'[33]

Whilst a rival national flag will rarely inspire such defection, the red flag of the dispossessed was all too attractive for young working-class soldiers to adopt as their own. It is this unique universality of the red flag – its ability to represent all the dispossessed and to unite them against their oppressors – that made the flag so dangerous to British and French imperialism and to the projected US sphere of influence in Asia. The connection between African-American oppression at home and the oppression of all people of colour in the global South was made explicit by those flying the red flag. In Beijing, five weeks after Martin Luther King made his 'I have a dream' speech, 10,000 Chinese communists rallied beneath red

flags and sang 'We Shall Not Be Moved' in solidarity with black America.[34] Despite the brutal stalemate in Korea the red flag would continue to advance amongst the global oppressed.

In Malaysia the guerrilla fighter Chin Peng had been awarded an OBE by the British for his part in the struggle against Japanese occupation during the Second World War. But following the defeat of the Japanese he raised the red flag against the returning British occupation. Inspired by Maoist ideas of a radical peasant democracy, Peng led an insurgency against the colonists, one that would be mirrored by Ho Chi Minh in Vietnam, Norodom Sihanouk in Cambodia, Sukarno in the Dutch East Indies and Aung San in Burma.[35]

Fighting for twelve years in the jungles of Malaysia, the Malaysian Communist Party sought to drive out the British. In response they interned more than 500,000 indigenous, tribal and immigrant people in concentration camps across the country. The captives faced disease, overcrowding and execution by British guards if they broke curfew.[36] Those imprisoned were not communists; they were poor, immigrant and tribal people, those that the British judged had the most to gain from the red flag. The British understood all too well the power of the people's flag among those they dispossessed.

Peng wrote on his deathbed: 'It is irrelevant whether I succeeded or failed, at least I did what I did. Hopefully the path I had walked on would be followed and improved upon by the young after me. It is my conviction that the flames of social justice and humanity will never die.'[37]

When anti-colonial fighters took up the red flag in the middle years of the twentieth century they added to its theory and practice. In this process the red flag became associated meaningfully for the first time with the peasantry, with tribal people, with anti-racism, and most of all with the tactics of guerrilla warfare and military insurgency that would dominate in the post-colonial era.

The enemies of the red flag were, however, also formulating and sharing new tactics. Britain's network of concentration camps and indefinite detention in Malaysia and its policy of starving out the insurgents would be mimicked again and again from Vietnam in

the 1970s to India and Palestine in the twenty-first century. Meanwhile, MI6 and the CIA were developing new techniques for combating the spread of the red flag. The repression that the flag met with would both halt the movement and at the same time, paradoxically, would inspire further fighters to take the flag onwards.

In the 1950s the CIA spent millions of dollars attacking the Guatemalan revolution and seeking to undermine attempts to hand hundreds of thousands of acres of idle land owned by the American United Fruit Company over to landless peasants.[38] Despite the Guatemalan government's explicit rejection of communism in favour of social democracy, the USA opposed it violently, producing assassination manuals and compiling lists of leftists to be murdered once the junta the USA backed could seize power and restore US interests. It was clear that even a democratic allegiance to the red flag was unacceptable to US imperialism. In 1954, when Guatemala's left-wing president purchased weapons from communist Czechoslovakia, it proved to be the provocation required, and CIA-trained generals rolled into the country while US planes bombed the cities and towns.[39] Sheltering from the bombs, a 26-year-old Argentinian called Ernesto Guevara was there to defend the revolution. He wrote to his aunt: 'I have sworn before a picture of the old and lamented comrade Stalin not to rest until I see these capitalist octopuses annihilated. In Guatemala I will perfect myself and achieve what I lack to be an authentic revolutionary.'[40]

The coup in Guatemala was to be a prototype for US foreign intervention over the next 70 years. As the government fell, Guevara travelled to Mexico and eventually on to Cuba, where, along with Fidel Castro and a small band of fellow revolutionaries, he helped raise the red flag over Havana while Guatemala was plunged by the anti-communists into a civil war that would last until 1996.

The virulent anti-communism of the British and Americans delivered its most brutal attack on the red flag in Indonesia, one of the most populous countries in the world and home in 1964 to the largest communist movement outside Russia and China: the PKI, or Indonesian Communist Party.

The country's president, Sukarno, had led the struggle for independence from Dutch colonialism, and now, as leader, he walked a political tightrope. His project was to re-make the nation whilst balancing the interests of nationalism, political Islam and communism: the dominant political forces on the islands. Like his key allies in the post-colonial nations – Nehru in India and Nasser in Egypt – Sukarno was an anti-colonial leader of global importance, unaligned to the Soviets, but favouring a socialist future for his nation.

American diplomats were troubled by Sukarno's political reliance on the Indonesian Communist Party. They were disturbed to see the red banner and hammer and sickle pasted on every wall and tree in the capital, a metropolis in which Marxism had taken hold.[41] Sukarno himself often linked the anti-colonial struggle with the struggle against capitalism. Even today the symbol of the Indonesian Democratic Party of Struggle, led by Sukarno's daughter, is a red flag emblazoned with a bull. And this despite the fact that the anti-communism engendered following Sukarno's rule runs so deep that today the display of a plain red flag or one emblazoned with a hammer and sickle is punishable in Indonesia by up to 20 years in prison.[42]

American fears in Indonesia saw the CIA engaged in disturbing and strange schemes for influencing politics on the islands. It distributed the books of George Orwell, hired Bing Crosby to make a film that would expose an invented affair between Sukarno and a blonde Russian air hostess, and tried to foment a premature left-wing coup in the hope of army reprisals. At the same time it planned an assassination of the president and provided support and arms to anti-government rebels and religious extremists.[43] The British appointed a Director of Political Warfare in Singapore to oversee long-term covert operations aimed at turning the public against the Communist Party and spreading communal tensions.[44] Despite these programmes, the Communist Party continued its rise, winning support through confrontations with landlords. Increasingly in the early 1960s it gained the patronage of Sukarno, and many – including the CIA – were convinced that the red flag would soon fly over Jakarta.[45]

In his annual Independence Day speech in August 1964 Sukarno declared 'the year of living dangerously' and promoted a Jakarta–Phnom Penh–Beijing–Hanoi–Pyongyang axis.[46] Between them the nations that these cities represented comprised nearly a third of the world's population, all of them living under governments loyal or sympathetic to the red flag. These were the communist dominos that the United States feared.

Western powers intervened on 30 September 1965 with a botched coup that resulted in the deaths of six Indonesian army officers. Despite a total absence of evidence or motive, the coup was blamed on the communists by the local press as well as by the BBC, Voice of America and Radio Australia. False information was spread that soldiers had been brutally tortured and that members of the communist women's movement had danced naked around the bodies.[47] The slow demonisation of the communists, the mobilisation of religious fanatics against them and the mysterious botched coup bore fruit in an anti-communist pogrom. The British ambassador, Sir Andrew Gilchrist, told the Foreign Office: 'I have never concealed from you my belief that a little shooting in Indonesia would be an essential preliminary to effective change.'[48] He and the Americans continued their policy of promoting a government of generals and disseminating anti-communist propaganda, fuelling religious violence and nationalist resentment against perceived Chinese communist influence. The British falsely suggested that arms were being shipped in from Mao's China in preparation for a civil war, despite the fact that the PKI had no armed wing and was committed to a peaceful revolution.

In November the US ambassador reported that the generals were 'moving relentlessly to exterminate the PKI as far as that is possible to do', adding that 'Embassy and USG [US government] generally sympathetic with and admiring of what the army are doing'. Declassified British files revealed that by January 1966 the government in London believed that 150,000 communists and their families had been slaughtered. By March they conceded that 200,000 members of the party had been murdered in Sumatra alone. In April the US embassy wrote to the State Department to say that 'we frankly do

not know whether the real figure is closer to 100,000 or 1,000,000 but believe it wiser to err on the side of the lower estimates, especially when questioned by the press'.⁴⁹ The CIA's own analyst stated:

> in terms of the numbers killed, the anti-PKI massacres in Indonesia rank as one of the worst mass murders of the twentieth century It may well prove to be one of the most significant events of the post war period. The political repercussions of the coup have not only changed the whole course of Indonesian history but they have had a profound effect on the world political scene, especially that of Southeast Asia.⁵⁰

In 2016 judges at the Hague found that the United States and Britain had engendered a genocide in Indonesia to halt the spread of the red flag.

America's covert war against the red flag in Indonesia happened concurrently with its overt war against the red flag in Vietnam. In March 1965 Operation Rolling Thunder began – a US air and ground campaign against communist North Vietnam that would see more than 800,000 tons of explosives dropped indiscriminately and more than a million people killed. Tens of thousands more would suffer from the medical and agricultural devastation wrought by the 73 million litres of chemical weapons the USA sprayed across Vietnam.⁵¹ The eventual defeat of the US army led to the establishment of communist governments in Vietnam, Cambodia and Laos. As well as this, the poor performance of the US Air Force, which by 1972 was seeing a ratio of enemy aircraft shot down to the number of American aircraft lost to enemy fighters of less than one to one, resulted in the inauguration of Operation Red Flag, a fighter pilot training programme which uses the insignia of a red flag flying at the centre of a gunsight. Participants in the programme include the members of NATO, alongside India and Israel. Its name and anti-communist logo remain the same today: the flag of the dispossessed in the gun sights of the capitalist nations.

In the history of the red flag the events of the 1950s and 1960s in Korea, Malaysia, Indonesia and Vietnam have a dual power. They

are the seed of a new revolutionary spirit, of a guerrilla insurgency, and they are the graveyard created by an anti-communism so brutal, so violent that the flag is still haunted by the mass killings. All too often families that fly the red flag have failed to see a second or a third generation. The colonised and post-colonial people of Southeast Asia who flew the red flag in the 1950s and 1960s were killed in horrifying numbers. The brutality with which their movement and their flag were suppressed is evidence of the threat anti-colonial communism posed to the imperial powers. The repression meted out by Britain and the USA in Southeast Asia continues to shape the world. Its legacy was the forced neo-liberal globalisation of the region, decades of military dictatorship, and also the anomalies of Vietnam and North Korea, where the red flag still flies in government more than 30 years after the collapse of the Soviet Union. In fact, as the Soviet Union turned inwards in its final decades, it was increasingly the red flag-flying nations of the decolonising world and the heroism of those revolutionaries who had faced the USA that spread its message across the globe.

Following the massacre in Indonesia, Jakarta would become the model and byword for the suppression of the red flag across the world. In Guatemala in 1966, frustrated by ten years of struggle against socialists and communists, the Americans sent diplomatic staff from Jakarta to Guatemala City; there they helped form death squads and murdered key left-wing figures. It is believed that 1965 in Indonesia was the first time that political figures were 'disappeared' as a tactic of state terror in Asia. Guatemala in 1966 saw the first time people in Latin America were 'disappeared' by their government.[52] The tactic would become synonymous with South American anti-left repression in the decades that followed. In Chile the democratically elected socialist government of Salvador Allende was murderously deposed in a brutal CIA-backed coup that installed the neo-liberal regime of General Pinochet. In the months that preceded the coup and its many murders and disappearances words began to appear on the walls of Santiago's suburbs: 'Yakarta Viene' ('Jakarta is coming').[53] Three years later in Brazil in 1975 the generals would unleash Operação Jacarta, a secret police

plan to physically eliminate the peaceful Brazilian Communist party.[54] Tens of thousands were tortured and killed in a campaign that would eventually spread across almost every South American nation in an attempt to crush the ideals of worker control, popular education and land distribution that the red flag stood for. The violent suppression of the red flag in Indonesia became the capitalist world's defining tactic against worker-led governments. Still today the pattern is clear; no sooner is the red flag raised in South America than the agents of US capital arrive to crush it.

A key effect on the movement in this period was the proof that progressive parties such as those of Indonesia and Guatemala which pursued a non-violent path towards social and economic transformation, and politicians such as those in Chile and Guatemala who chose the democratic road to socialism would find themselves murdered in their thousands by the enemies of the red flag. Only those who were armed had a chance to defend themselves. The flag of the dispossessed increasingly found itself wedded to the machine gun, not by choice, but by circumstance.

At the Bandung Conference of 1955 the leaders of the colonised and post-colonial world had met to discuss the future of Africa and Asia and to defend their shared struggle against colonialism. Key figures such as Sukarno of Indonesia, Nasser of Egypt, Nehru of India and Zhou Enlai of China stated their commitments to self-determination and democratic struggle against colonialism and neo-colonialism. Almost all the key figures subscribed to a Marxist-influenced political and economic outlook for their countries, and all except China did so with the red flag either veiled or absent from their politics. The meeting even censured the Soviet Union for its own colonialism in Central Asia. This was the emergence of the Non-Aligned Movement and the formalisation of a global anti-imperialist project based in those countries. Its object was a peaceful transition and a new future where a liberated global South could counterbalance the superpowers of the USA and the Soviet Union. As Vijay Prashad has said, 'The Third World was not a place, it was a project.'

But the decade that followed had seen bloody repression in Indonesia, Guatemala, Algeria, Vietnam, Kenya and elsewhere. Lumumba, Ben Barka, Um Nyobè and other key leaders of the non-aligned movement had been assassinated. Democratic attempts at national liberation across Africa were violently suppressed by European governments and white settlers.

In 1966, a decade on from the Bandung Conference, the Non-Aligned Movement met again, but its character was wholly different. This 'Tricontinental Conference' had been initially organised by Moroccan opposition leader Mehdi Ben Barka, who had hoped to host the meeting of leaders from across South America, Africa and Asia in Geneva. However, while working to organise the conference, Ben Barka was arrested by French police, handed over to Moroccan authorities and never seen again.[55] Consequently the conference was moved to Havana, where it would be held beneath the red flag of Cuban communism. The Tricontinental Conference saw the flag of the dispossessed asserted as a symbol of armed liberation. In the ten years since Bandung, the red flag had moved from the ballot box to the Kalashnikov. The pan-Africanist revolutionary, political leader and poet Amílcar Cabral addressed the conference, stating:

> the present situation of national liberation struggles in the world (especially in Vietnam, the Congo and Zimbabwe) as well as the situation of permanent violence, or at least of contradictions and upheavals, in certain countries which have gained their independence by the so-called peaceful way, show us not only that compromises with imperialism do not work, but also that the normal way of national liberation, imposed on peoples by imperialist repression, is armed struggle.[56]

Cabral and others at the conference were committed to the idea that the violence of the imperialists and anti-communists had to be matched by the violence of guerrilla warfare. Anti-colonial leaders had evidence in China, Cuba, Korea and Vietnam that it was inde-

pendence won by armed struggle under a red flag that could deliver freedom.

The red flag now stood as a practical measure and as a commitment to liberatory violence. The revolutionary psychiatrist Frantz Fanon advocated a redemptive, therapeutic and self-defensive destruction that was an essential process for the tortured and colonised minds of the world, helping them to avenge and end the violence against them. The writing of figures such as Fanon and Cabral legitimised and reanimated a red flag committed to struggle. Just as the First World War had seen the red flag move from a predominantly democratic to a revolutionary symbol, imperialist repression now shifted its focus again from revolution to guerrilla insurgency.

The red flag's qualities as a symbol of defiance, of resistance, as a flag of war, had resurfaced. By the time of the 1966 Havana Conference Che Guevara himself had renounced his position in the Cuban government and left to fight for socialism, first in the Congo and then Bolivia. The Tricontinental Conference re-forged the anti-colonial movement, and it did so in the shadow of the red flag. It did not, however, adopt the red flag. The flag itself, imbued as it was with the power of Russia and of China, and associated with the socialist parties of France and Britain – those key global oppressors – could not be fully adopted as a flag of national liberation. Instead, the flag remained partially exposed and partially hidden in the struggles across Asia, Africa and Latin America. For all the talk of internationalism, to fly the red flag in government meant falling into the sphere of influence of either Russia or China. National liberation struggles were fearful of winning freedom from London or Paris only to then cede control to Moscow or Beijing. Here was a key contradiction for the red flag as it existed as a symbol of internationalism, but also of nations such as China and the USSR which held their own imperial possessions.

Yet despite all this the red flag continued to play a key role in the reconfiguration of the colonised nations, communicating, as it always had, the values of land, peace, bread, worker control and democracy while also serving as a banner of guerrilla warfare, and crucially, encouraging the supply of weapons and money from existing com-

munist nations. No wonder that the British press were scandalised when in 1966 a large red flag emblazoned with a hammer and sickle was raised in front of Queen Elizabeth II on her visit to Barbados.[57] It did not just speak of communism, but of armed struggle against empire.

In those nations where racist colonial governments persisted the longest the continued influence of the red flag was the greatest. In Palestine many of the icons of the resistance flew the red flag. In 1969 the communist guerrilla Leila Khaled became the first woman to hijack a plane, successfully negotiating the release of Palestinian prisoners. She was captured a year later in London after her hijack of a second aircraft failed, a grenade she threw did not detonate and her accomplice was killed by an air marshal. The image of Khaled, machine gun in hand and wearing a red keffiyeh as a headscarf, would be a defining picture of those fighting for liberation. More than half a century later Khaled remains a prominent communist, speaking around the world beneath the folds of the red flag. Today the Popular Front for the Liberation of Palestine, the party of Leila Khaled, legendary Arab author Ghassan Kanafani and international left-wing terrorist Carlos the Jackal, remains a pillar of the Palestinian resistance, and the red flag and the red keffiyeh continue to play a central role in the iconography of Palestinian liberation.

In South Africa's long struggle against apartheid, it was the red flag that represented Black South Africans' staunchest allies. The Communist Party of South Africa had been calling for black majority rule of the country since 1928, and its internationalist connections helped galvanise workers around the world against apartheid. The anti-apartheid paramilitary force uMkhonto we Sizwe ('Spear of the Nation') had its troops trained in China and Eastern Europe, and the South African Communist Leader Joe Slovo travelled to Moscow to secure military equipment. There was a global unity behind the anti-racist militants of South Africa, and the symbol of that unity was the red flag. Though proscribed by the South African government, the Communist Party provided a key organisation that allowed membership across colour lines, providing an avenue for South Africans of Indian, Jewish, white and black origin to join

the struggle for liberation. The international allies of the red flag were also central when it came to the proxy war in Mozambique, where forces supportive of apartheid in South Africa and Rhodesia carried on a civil war against the socialist government. The socialists, backed by China, Cuba, Romania and Yugoslavia, won, and this defeat at the hands of the Marxist-Leninist Liberation Front of Mozambique left South Africa isolated. The flag of liberation in Mozambique was a plain red flag with a hammer and mattock emblazoned in yellow; it remains the flag of the ruling party, though not of the nation, which now overlays that red flag with green, black and yellow stripes. In South Africa too the nation's flag on liberation became aesthetically an African flag, yet the red flag of the Communist Party, with its black five-pointed star, maintained a key position. In July 1990, just months after his release from Robben Island, Nelson Mandela stood with Joe Slovo and Winnie Mandela with their fists raised in front of a giant red flag in Soweto, marking the official legalisation of the South African Communist Party with the largest political rally South Africa had ever seen.[58] After his death the South African Communist Party and the African National Congress revealed that Mandela had joined the Communist Party in the early 1960s and had served on its central committee.[59] The red flag had been a formative inspiration for Mandela,[60] he wrote:

> Dialectical materialism seemed to offer both a searchlight illuminating the dark night of racial oppression and a tool that could be used to end it. It helped me to see the situation other than through the prism of black and white relations, for if our struggle was to succeed, we had to transcend black and white. I was attracted to the scientific underpinnings of dialectical materialism, for I am always inclined to trust what I can verify.
>
> Marxism's call to revolutionary action was music to the ears of a freedom fighter. The idea that history progresses through struggle and that change occurs in revolutionary jumps was similarity appealing. In my reading of Marxist works, I found a great deal of information that bore on the types of problems that face

a practical politician. Marxists gave serious attention to national liberation movements, and the Soviet Union in particular supported the national struggles of many colonial peoples.[61]

The politics of the red flag in Mandela's journey towards liberation is indicative of its role in many liberation struggles. Firstly it symbolises theory, a materialist structure that allows one to understand and change the world; secondly, it offers practical and financial support in the form of a connection to global solidarity; and thirdly, it offers a focal point for and legitimisation of armed struggle. In post-apartheid South Africa Communist Party members have never yet been out of government.

As the twentieth century progressed, liberation movements flying the red flag moved further to the left. By the 1970s socialism was replaced by Marxist-Leninism and democratic aspirations were firmly supplanted by armed struggle. The meaning and character of the red flag was shaped by its conditions. When Portuguese imperial rule finally crumbled, those figures who took up the red flag of the dispossessed in the former Portuguese empire did so with the fullest understanding of the elements that Mandela described. Amílcar Cabral in Cape Verde, Agostinho Neto in Angola, Samora Machel in Mozambique and Thomas Sankara in French-ruled Burkina Faso forged an Afro-Marxism that aimed not just to end imperial rule, but to reshape the social and economic order of their continent.[62] These were fighters drawing on the legacy of the red flag of the Russian Revolution, the Paris Commune and the Vietnam War. Often, though, the red flag would be obscured in these struggles, as in Burkina Faso, where the Marxist military officer Thomas Sankara came to power in 1983 and began a radical programme of land reform, literacy, public health and anti-imperialism. He slashed income for the elite, vaccinated millions, began vast infrastructure projects and planted 10 million trees.[63] But Sankara himself never flew the red flag, adopting instead a red and green flag for his country, symbolising revolution and natural plenty. He is, however, symbolically a red icon, with his famous red beret denoting the flag's cause and values. A red beret that would be taken up decades

later by Hugo Chavez and the Bolivarian Revolution in Venezuela, another country that took the red flag as the symbol for its politics, but not its state. Similarly in Angola the country's new revolutionary leaders adopted a flag in 1975 that is redolent of the red flag; the Angolan flag is two horizontal bands of red and black, bearing a yellow machete and gear with a five-pointed star. The red of the flag represented communist revolution when it was first raised. But today, after years of movement to the right, that red is said to represent the blood of the people.[64]

This morphing of the red flag from one of socialist struggle into national struggle is a recurrent theme, often resulting in the formation of a new ruling class and the abandonment of the values of revolution, equality or self-determination that the red flag initially represented. The class alliance between the proletarian and bourgeois elements of the liberation struggle is often abandoned once imperial rule is ended, and a new ruling class outlaws, imprisons or massacres those who continue to fly the red flag. In other newly liberated states the trappings of the red flag and the benefits of its iconography in terms of international and local popular support may remain intact, but at the same time they encounter disturbing deformations that push the meaning of the red flag even beyond the violence of the Red Terror.

In Kampuchea, now Cambodia, the Communist Party and its regime, the Khmer Rouge, ruled the country for five years. In these years they oversaw an unimaginable genocide committed beneath the red flag. Cloaked in the language and iconography of communism, the Khmer Rouge was a radical, agrarian, authoritarian and xenophobic regime that took power and gained popular support amidst the devastating carpet-bombing of Cambodia by the United States.[65] In the decade before the Khmer Rouge came to power, as part of US anti-communist efforts in South East Asia the US Air Force dropped 2,700,000 tons of explosives on Cambodia. More bombs were dropped in this country of 7 million people than the US used in the whole of the Second World War. Half a million Cambodians lost their lives.[66] A shattered and traumatised peasantry were drawn into the liberatory rhetoric of the Khmer Rouge,

which seized power from the ruling prince and began a campaign of mass murder that resulted in the deaths of more than 1.8 million people.[67] The red of revolution was supplanted both symbolically and actually with the red of blood. The Khmer Rouge's leader Pol Pot explained that 'a blood call has been incorporated into our national anthem'. The first lines of the new anthem were:

> The bright scarlet blood
> Flooded over the towns and plains of our motherland Kampuchea.

Before party meetings a song titled 'The Red Flag' was sung, its lyrics a celebration of blood:

> Glittering red blood blankets the earth,
> Sacrificial blood to liberate the people:
> Blood of workers, peasants and intellectuals;
> Blood of young men, Buddhist monks, and young women.
> Blood that swirls away and takes flight, twirling on high
> Into the sky,
> Turning into the red, revolutionary flag!
> Red Flag! Red Flag! Flying Now! Flying Now!

The blood red of the flag that had symbolised martyrdom now became an embodiment of violence, a physical manifestation of terror and murder that was able to take flight up into the air. Anger, sorrow, loss, racial unity and violence are all tied up in the Khmer Rouge propaganda and in its red flag. Supported by both China and the USA, its genocide was only ended in 1979, when communist Vietnam invaded. The red flag of the Khmer Rouge was a red flag of the dispossessed, but one warped and deformed by violence. A brutal and self-destroying flag, it took on the most tyrannical aspects of the flag's history and character. After 1979 the Khmer Rouge was driven into hiding, though the USA continued to endorse its seat at the United Nations well into the 1990s.[68] This was a red flag turned wholly against the people and cynically used

by larger powers. In the Khmer Rouge the red flag's potential as a symbol justifying violence reached its most terrible expression.

The red flag in Cambodia was defined by two forces, forces that sometimes moved together and sometimes stood in opposition to one another. The first was the liberatory promise of the flag, its call for radical change. The second was its call for revenge and violence. Whereas in Cuba a small group of revolutionaries around a charismatic leader had raised a red and black flag that built a society with universal literacy and a health service the envy of the world, in Cambodia a small group of revolutionaries and their charismatic leader raised the red flag as the standard of anti-intellectual and anti-urban genocide. Both were red flags of the dispossessed, and both were shaped by the ongoing imperialism of the capitalist world.

Still today the imperial powers of the USA, France, Britain and their allies are either bombing or have troops on the ground across the formerly colonised world, in Afghanistan, Pakistan, Syria, Iraq, Palestine, Somalia, Yemen, Burkina Faso, Chad, Mali, Mauritania and Niger. Their object remains the securing of markets and resources for their own capitalist governments. Some of their key enemies continue to fly the red flag, but in most cases the successful anti-communism of the twentieth century has created for itself a new enemy in Islamism.

In the battle between capitalism and the red flag-flying dispossessed of the world it is simple enough to say that capitalism won the twentieth century. It did so by indiscriminate murder. By the year 2000 the post-colonial nations had fallen almost in their entirety to capitalism. These nations are shackled to world markets, beholden to undemocratic global financial institutions and continue to experience growing poverty and insecurity: in the 30 years since 1990 the ten countries that experienced the greatest increase in extreme poverty were all former colonies.[69] They are also, in one very important but incomplete sense, free. In the last century half the world was liberated from colonial rule, and the red flag played a key part in this liberation.

A FLAG OF THE DISPOSSESSED

In this process the red flag of the dispossessed suffered unimaginable defeats, and yet it has also been the flag of undeniable triumph: defeating apartheid in South Africa, delivering universal housing and health care to Cuba, allowing hundreds of millions of people to live richer and fuller lives in China, maintaining the ongoing resistance of the Palestinian people. The fact that it took the CIA and the force of US, British and French imperial power with campaigns of anti-communist killings in dozens of countries to prevent the red flag from flying across Asia, Africa and Latin America shows the power of the symbol and its ideas.[70] Despite the murders of millions who flew the flag, it continues to fly as both a standard of communist guerrilla warfare, and of organised democratic opposition to colonialism. Today it flies from government buildings in Hanoi, Beijing, Kathmandu, Thiruvananthapuram and Havana, demonstrating the enduring power of what the red flag offers to the global dispossessed. More than 75 years after the insurgencies began, the red flag still flies over some 1.6 billion people in the formerly colonised countries of this planet.

The Cold War, a conflict between liberal democracies and planned economies, led the colonised world to become both a battleground and a graveyard. But it also provided the territory for a redefinition of the red flag. The red flag in our time exists in terms set by an international dispossessed, with new understandings of capitalist extraction and new theories and practices of resistance against it.

As decolonisation takes on an ever more metaphorical identity in our histories and institutions the practical lived experience of decolonisation continues to take place beneath the red flag. In a globalised, or Americanised, world it is clear that the choice remains one between neo-colonialism and the red flag, between socialism or barbarism. The anti-colonial red flag shows the possible future for humanity most starkly, and it is this red flag that has travelled from Africa, from Asia and from Latin America back to the capitalist centre of Europe and North America.

11
A Flag of Subversion

In late August 1968 the US Democratic Party met in Chicago to decide on their candidate for president. The weather was oppressively humid; suited politicians dripped with sweat as they made their way towards the huge steel fence that surrounded the convention centre. Many workers in the city were already on strike, and the National Guard lined the streets with their bayonets fixed as tens of thousands of anarchists, communists, anti-war protestors, black revolutionaries, hippies and students filled the streets with a carnival of protest and anger. Parks, churches and coffee shops were crammed with protesters demanding change, demanding an end to the war in Vietnam, demanding that something in the USA shift as the struggle for civil rights continued to face brutal suppression. The preceding months had seen the assassinations of Martin Luther King and Robert F. Kennedy, and riots in more than 100 US cities. The Democratic Convention of 1968 was a lightning rod for dissent.[1]

When the crowd in Chicago raised a red flag outside the convention it provided the starting signal for a police riot, and the American manifestation of a global revolutionary year; 1968 would see a red flag of the dispossessed return to be raised on barricades around the world.

The Chicago conference and protest had begun in earnest when the Yippies – the Youth International Party – nominated a pig called Pigasus for president and paraded it through the streets. Their founder Jerry Rubin described the protesters who gathered: 'We're going to be the news and everything we do will be sent out to living rooms from India to the Soviet Union …. We were motherfucking bad. We were dirty, smelly, grimy, foul, loud, dope-crazed,

hellbent and leather-jacketed. We are a public display of filth and shabbiness, living in-the-flesh rejects of middle-class standards.'[2]

Their movement was at once surrealist and serious, viewing the USA as a farce and a tragedy, and taking the opportunity that television news now provided to broadcast their message around the world. In the 1950s the red flag had been fractured between the communist, capitalist and postcolonial worlds. It meant different things in Moscow, in London and in Hanoi, but in 1968 this new movement and new media would see it come hurtling back together as a unified force ready to terrify middle America and shape the world. A new generation would see images and ideas move instantly between the streets of the US, the refugee camps of Palestine and the revolutionary movements in Cuba, China and Angola. Third World Marxism had arrived in the USA, and many there had realised that the First World was a lie, that most African-Americans, most Puerto Ricans, most working-class white Americans lived in the Third World too.[3] They were part of a new communist movement that hoped to create 'two, three, many Vietnams'.[4] In 1968 the world would see, perhaps for the first time since 1848, a truly global revolutionary moment. And, as in 1848, the revolution would be defined by, and would itself define, the red flag.

In Chicago the Yippies yelled:

Rise up and abandon the creeping meatball!
We see sex, rock'n'roll and dope as part of a Communist plot to take over Amerika.
We cry when we laugh and laugh when we cry.
The yippie idea of fun is overthrowing the government.
Yippies are Maoists.
Yippies are put-ons because we make our dreams public.
We will avenge the murder of Che.[5]

The Yippies demanded radical societal change. Their allies were Students for a Democratic Society, the peaceniks and black militants. Black Panther leader Eldridge Cleaver had a provocation for all those hippies and students who gathered in Chicago in August

1968, just months after race riots in which the city's mayor had ordered police to 'shoot to kill arsonists, shoot to maim looters'.[6] Cleaver wrote: 'The genie of black revolutionary violence is here, and it says that the oppressor has no rights which the oppressed are bound to respect. The genie also has a question for white Americans: which side do you choose? Do you side with the oppressor or with the oppressed? The time for decision is upon you.'[7]

As the convention commenced on one side of the fence, street fighting between police and protesters ebbed and flowed outside the venue and in neighbouring parks. The United States of America's internal enemies had gathered. Amidst teargas, the buzzing of police helicopters, and speeches against the war a young man climbed the flagpole at the centre of Chicago's Lincoln Park, surrounded by a crowd of thousands, and began to lower the US flag. Some claimed that he was trying to lower it to half-mast to honour injured protesters, whilst others yelled from the crowd: 'tear down the flag'. Evidence after the fact indicated that the man was in all probability an undercover cop seeking to provoke a riot. Whatever the intention, the result was that the Stars and Stripes was pulled to the ground and the crowd raised a red flag in its place. It didn't matter that it was barely a flag, just a piece of torn red cloth; its symbolic meanings at the heart of the battle for American politics were clear. This was a flag that rejected everything that was supposedly 'good' and 'American'; it was a flag of equality, liberation, subversion and anti-American revolution.

No further provocation was required for Chicago's police force. They removed their name badges, fixed their helmets and batons, and charged into the crowd, arresting the red flag-raisers, firing smoke bombs and beating their way through a crowd of some 10,000 protesters. One policeman recalled 'it was war'; another remembered shouting, 'Let's get the motherfuckers.' Another police officer said later, 'the guys were damn mad about the flag and some red commie rag going up; that really upset guys'.[8] By the time the police violence had subsided more than 400 protesters and 190 police officers were injured. For America's youth the images of young people beaten bloody on the streets of Chicago by

the police – whilst in the same month 1,000 American conscripts died in Vietnam – played its part in radicalising a generation. For older Americans the scenes of disorder, the long-hairs, the radicals, the militant young black men and the red flag raised in Chicago all moved them further into the arms of paranoid anti-communists. It has been suggested that news footage of the 1968 police riot in Chicago did as much to make Richard Nixon president as any other factor in the whole campaign.[9]

In the immediate aftermath of the riot, and in the trial that followed, few could agree even on what the offending flag had been. Witnesses who were certain that it was a Viet Cong flag that had been raised were then unable in court to state what colour a Viet Cong flag actually was.[10] Witnesses who claimed it was a red flag with some kind of symbol on it were then unable to confirm what the symbol had been; the writer Norman Mailer could only say that he had seen 'some kind of rebel flag',[11] and the *Chicago Sun-Times* stated that it was 'some kind of girl's red slip'.[12] And yet the red flag raised outside the Democratic Convention in that year of global revolution, 1968, was an iconic red flag taking its place in the torrid unrest at the heart of the so-called 'First World.' A First World where the red flag had developed symbiotically with the red flags of tyranny and utopia, insurgency and liberation; a world where the red flag was increasingly defined by the radical ideas of China, and the nations struggling against French and British imperialism. It was no accident that the Yippies called themselves Maoists and raised a red slip in Chicago. Nor was it an accident that Students for a Democratic Society flew red flags at their convention in June of that year, declaring a 'New Left'.[13] It was no accident either when Chicago's Black Panther leader Fred Hampton said: 'We don't think you fight fire with fire best; we think you fight fire with water best. We're going to fight racism not with racism, but we're going to fight with solidarity …. We're going to fight their reactions with all of us people getting together and having an international proletarian revolution.'[14]

The politics of the red flag had resurfaced in the heart of their greatest enemy: the United States of America. The red flag brought

together all those who wanted to subvert the current system, and across the world a great generational unrest was taking place. On campuses and in workplaces, in ghettos and in slums the red flag was the symbol of everything the establishment detested, a symbol that united situationist intellectuals with blue-collar workers, black radicals, middle-class students and urban guerrillas. For those taking up the red flag in the USA, Britain, France, Italy and West Germany in the middle of the twentieth century the symbol's power was fourfold. It was the trusty standard of labour, it was the flag of the Soviets and the capitalist world enemy, it was the out-there flag of the radicalised hippies and heads, and it was also the chic revolutionary symbol of a new global proletariat fighting in the cities and jungles of the colonised world. Maoism had swept into the West like a breath of fresh air, re-animating radical movements with a vital and complex philosophy of armed insurgency, mass mobilisation and strategic alliance, all embodied in ideas of rigorous self-criticism, righteous rebellion, anti-racism and individual political purity. This philosophy was communicated to the West in the person of an authentic revolutionary hero, Chairman Mao, and his ideas were synthesised in the Fluxus-like poem-aphorisms of his 'Little Red Book': *Quotations from Chairman Mao Tse-tung*. This book, itself a kind of pocket red flag, was by 1968 ubiquitous in the universities and factories of the West, with more than a billion copies distributed in over 100 countries.[15]

To understand how the red flag came to fly in the hands of the rebels of 1968 we must look at its journey in the West over the preceding decades. Since 1917 the red flag had functioned there as a symbol of an implicit threat of an alternative economic system. Emboldened by the revolution in Russia and radicalised by the experiences of the First World War, workers were able to vote for the first time in many countries. These workers in Western Europe used their votes to return their first socialist and labour governments in the interwar period. But the politicians they elected were in the main liberals and reformers, interested not in a red flag of revolution, but a flag of a progressive establishment. These parties, with the red flag as their symbol, worked to effect a moderate and

evolutionary – rather than revolutionary – transformation of their societies. This was the red flag of a '2½ International'.

In Britain the Labour Party briefly became the minority government in 1924 and won again in 1929, demonstrating that a democratic socialist party with an outwardly pacifist foreign policy and an agenda of mass housebuilding could govern a world power. The Labour Party in Britain flew the red flag of international socialism, but was hamstrung by its reliance on liberal MPs, and became heavily associated with its betrayal of trade unions as it sought to protect the interests of capital and break up strikes. It presented a conflicted visage for the red flag, as associated as it was with the provision of social housing as it was with the breaking of the general strike of 1926.

In addition, the red flag of the British Labour Party governed over a quarter of the world's population, through the British Empire. A population who were subjugated, without rights as workers or citizens. The contradictions of a red flag unable to effect liberatory change at home and unwilling to effect such a change in the colonies eventually brought it down. In the wake of the Wall Street Crash and the Labour Party's own betrayals and splits it was the Independent Labour Party, described by Aneurin Bevan as 'pure but impotent', and the Communist Party of Great Britain which increasingly were able to claim the red flag.[16]

In Italy a similar process took place with still more tragic results. The Italian Socialist Party, with its symbols of the red flag, the carnation and the hammer and sickle, attempted to bring together moderate and revolutionary, nationalist and internationalist factions and had won the largest number of seats in the 1919 election. But in the aftermath it was damaged by a split to its left which saw the emergence of the Italian Communist Party, and a threat from its right as its former member Benito Mussolini renounced Marxism and led the fascist blackshirts in street-fighting against the bearers of the red flag. The same process would be seen in Germany, where a divided socialist and communist movement would be ruthlessly crushed by Hitler's fascists. In Germany and Italy splits in the red flag movement left the road clear for fascists to take power.

Panicked communist parties across Europe now pivoted away from criticism of reformist socialists to a policy of popular fronts in which communists, socialists, liberals and even anti-fascist conservatives were to unite under any flag to stop fascists gaining power. Popular Fronts would now see the red flag subsumed by national flags in a last-ditch attempt to prevent the spread of violent nationalism. As the Second World War approached, the red flag and its politics were in power only in the Soviet Union and Mongolia, and the alternative mode of production and way of life that the flag represented seemed a distant hope for the millions in Europe about to descend into the nightmare of fascist occupation.

And yet in the years that followed it was the red flag that would eventually vanquish Hitler and Mussolini. Following the Second World War and the division of the world by the victorious powers the red flag was resurgent. In much of the world it was the symbol of radical government, and even in the capitalist countries its alternative system could now be glimpsed just metres away on the other side of the Iron Curtain. Where the red flag had previously flown in distant Moscow, it was now the symbol of ruling parties in Central Europe. In Korea and Germany the two systems would be tested in parallel. The power of the labour unions, the communist parties and the social democrats across Western Europe all sprung to a greater or lesser extent from that world on the other side of the Berlin Wall. In countries beyond Soviet influence the red flag was still able to demand and inspire significant concessions, as with Nordic social democracy or the British National Health Service. Both were won not just by workers and politicians at home, but by the implicit threat to the ruling class posed by the continued existence of communist societies: red flags no longer represented utopias, but realities. The victories won beneath the red flag in Moscow facilitated the compromises made with the red flag in London and Paris. In the capitalist world the people's flag instructed rulers to look at the fate that had met their cousins in the communist world.

The Labour Party took power in Britain at the end of the Second World War. When the British Parliament reconvened at the end of the Second World War, Conservative Party MPs, bruised from

a crushing electoral defeat, began to sing 'For He's a Jolly Good Fellow' to their returning leader Winston Churchill. They were drowned out by the opposition benches singing 'The Red Flag', the Labour Party's backbenchers leading the powerful chorus while the ministers on the front bench shifted uncomfortably and half-mouthed along.[17] Ownership of the song, like the flag itself, was contested in Britain between the Labour Party and the communists. In this moment two red flags were colliding in the ancient heart of British democracy. One was the flag of reformist, respectable, municipal socialism, the flag that had the new prime minister Clement Atlee quipping: 'the people's flag is palest pink, it's not red blood, but only ink'.[18] The other, veiled behind such reformism, was the red flag of communism, a flag that now flew in cities around the world and that promised a new dawn following the war. A young Denis Healey, still in army uniform and having recently switched allegiance from the Communist Party to the Labour Party, addressed the 1945 Labour Conference. He told them:

> The upper classes in every country are selfish, depraved, dissolute and decadent. The struggle for socialism in Europe has been hard, cruel, merciless and bloodyThe crucial principle of our foreign policy should be to protect, assist, encourage and aid in every way the socialist revolution wherever it appears The penalty for entertaining any hesitation about the support for the revolution would be that Labour would wake one day to find itself running with the Red Flag in front of the armoured car of Tory imperialism and counter-revolution.[19]

But this red flag of revolution would find no ally in the new Labour government. Despite the huge service the red flag had given Britain throughout the war, in peace the flag was to exist as both the symbol of the party of government and at the same time as that government's key enemy.

The Labour government embarked upon a massive programme of nationalisation and reform at home whilst focusing its energies abroad on fighting communism; two red flags were now in conflict.

Attlee, who was famed for nationalising the mines, founding the health service, building social housing and approving the swift withdrawal from India, had described the Russian Revolution of 1917 as 'rather appalling'.[20] His foreign minister Ernest Bevin was a firm anti-communist, sending British troops into Korea, helping to establish NATO and at one summit even lunging at the Soviet Foreign Minister, Vyacheslav Molotov while shouting, 'I've 'ad enough of this I 'ave!'[21] Healey, who had cautioned against allowing the red flag to become a cover for British capitalism, fell firmly in line with the government and spent his time promoting the Korean War and using British intelligence to attack Marxists in the trade union movement.[22] Even at the height of Labour's most radical government, and with many staunchly left members of parliament thought to be sympathetic to communism under observation by the secret services in a 'lost sheep' file, the red flag was too subversive to be permitted as a flag of government at home or abroad.[23] The British Labour Party began a slow divorce from the red flag that would see it removed as the party's symbol in the 1980s and replaced by a rose. The eponymous song would be dropped as the party's anthem in the 1990s under Tony Blair's New Labour. And decades after being symbolically defeated, the red flag in the Labour Party would be politically defeated with the destruction of Corbynism in 2019.

The association between the red flag and a moderate middle-ground socialism in Britain was always conflicted. Those who led the Labour Party struggled to reconcile the aspirations associated with the flag by many of their members with the realities of governing a capitalist nation. As Tony Benn reflected in a hustings in 1981 as the red flag began to be lowered over the British Labour Party: 'We have tried to make capitalism work with good and humane Labour governments and we haven't succeeded – because it can't work, it lives on inequalities. If you try to modify them they turn on you, cut back your gains and throw you back to where you started.'[24]

After 50 years in and out of government the red flag and the Labour Party became dislocated. The red flag maintained its

anti-establishment identity. There were too many international examples of the radical socialism that the flag pointed towards. The Labour Party re-made Britain in the 1940s, and it did so with the support of millions of voters and scores of politicians who hoped to build socialism. In 1948, when the National Health Service was founded, medical students flew the red flag from the roof of Glasgow Royal Infirmary.[25] But the government they put their faith in was not remaking Britain in the spirit of that red flag. Instead, it focused on building a mixed economy, acquiring the atomic bomb and forging a new place in the world as the key ally of the United States. The Labour Party deliberately left the class system, public schools, honours and peerages intact, attempting to create a hybrid, capitalist Britain, preserving the privileges of the elite whilst ameliorating the suffering of the poor. Such an offer would always lead to disillusionment. The red flag of municipal socialism in Britain, the flag of the Second International, was deeply anachronistic by the time Labour came to power again in the 1960s, with the flag's symbolism ceded to the militants of the trade union movement and the Communist Party who still looked toward Moscow for direction and inspiration.

The political identity of the red flag followed a similar pattern in other Western European countries, where the same global economic forces saw the red flag moving close to power following the Second World War before being forced out by the establishment in concert with business and US interests, to find itself once again the symbol not of governing socialists, but of militant and revolutionary outsiders.

In post-war France the red flag gained massively in popularity and prestige from its association with both resistance and liberation, and the Communist Party itself was nicknamed 'le parti des 75,000 fusillés' ('the party of the 75,000 executed'). This possibility of a patriotic left was capitalised on, and the French communists, more moderate than their sister parties across Europe, placed their red flag next to the national flag of France.[26] But despite the prestige of the radical left in France, shockwaves were sent around the capitalist world as communists won the greatest share of the French popular

vote in the 1946 election and formed the Tripartite government beneath the red flag. Tripartisme was a system in which the three broadly left parties united to form a government commanding 75 per cent of the vote in order to ensure a strong mandate for reconstruction and to guard against a return to political violence. Of the three parties that formed the government, the Popular Republican Movement, the Communist Party of France and the French Section of the Workers' International, the latter two had the red flag as their symbol. These flags represented, respectively, international communist revolution and French socialist reform. The tensions between these two red flags, moderated by the Catholic democrats of the Popular Republican Movement, would shape the Fourth Republic as it struggled to rebuild France. The party brought in sweeping reforms, including nationalisation and increased state power.

An analogous political situation emerged in Italy, where the Communist Party, equally emboldened by its role in defeating fascism, secured a large share of the vote and formed a left-wing coalition. While moderate socialists ruled Britain, in France and Italy communism looked capable of moving the Iron Curtain as far west as the English Channel,[27] even if the Italian communist leadership suggested that it might be tactically useful to roll up the red flag for a while and instead fly the red, white and green.[28] As 1946 progressed into 1947 the popularity of the communists in Italy and France only grew. They increased their organising and recruitment amongst agricultural workers and won new allies with their wide-ranging land reforms.[29] Membership of the Communist Party in France approached 1 million, and in Italy topped 2 million. In both countries one in four voters could be counted as a communist.[30] The red flag of the resistance had left a powerful organisational and cultural legacy that made it seem possible that two of Western Europe's great powers would soon follow Eastern Europe into the sphere of Marxist influence.

The rise of the red flag in Western Europe would be abruptly halted in both France and Italy in May 1947. The flag's sudden ejection from power would see it returned to its role in the West as

an enemy flag and a flag of revolution, and it would not be raised again in the government of Italy or France for decades.

The key to this shift was the collaboration of European capitalists with the USA. The US proposed a package of funding called the Marshall Plan, in which it would offer vast sums of money for the reconstruction of Europe in exchange for the removal of regulations and barriers to trade, and increased productivity targets.[31] An aim of the Marshall Plan, both explicitly and covertly, was to halt the westward march of the red flag. Explicitly, this would be achieved through a rise in living standards accompanying the delivery of more than $13 billion worth of aid. Covertly, more than $600 million of this aid would go to fund CIA activity combating left-wing movements in Europe.[32] All of this money would be contingent on the expulsion of communists from government in Italy and France.

The US Ambassador to France told the socialist French Premier Ramadier, 'no Communists in government or else'.[33] In response, a wave of strikes opposing the Marshall Plan broke out across France. Although the Communist Party did not officially support the strikes, which were led by anarchists and Trotskyists, the industrial unrest offered the socialists and republicans the chance to please their American allies. Rumours were spread of a plan for a communist coup on 1 May, and Ramadier referred to the communists as 'the conductor of a secret orchestra' in relation to the growing strike movement and factory occupations. On 5 May he expelled all communist ministers from government and was rewarded with vast state and private investment from the USA.[34] The red flag had been dragged from the corridors of power by a soft coup, but it was not just the communist red flag that was lowered. The symbol of the socialists in France too had long been the red flag, but henceforward it was firmly established as the three arrows representing the fight against fascism, conservatism *and* communism.

As in France, the US Ambassador had asked the Italian prime minister directly to dissolve parliament and expel the communists, and Secretary of State Marshall had informed Italy that anti-communism was a precondition of any US aid.[35] But in Italy the 1947 attack on the red flag was far more violent than it had been under

near-identical circumstances in France. In April a coalition of communists and socialists won a surprise regional election victory in Sicily and it looked possible that the Communist Party leader and resistance hero Palmiro Togliatti might soon bring Italy under democratic communist control. Twelve days after the election, on May Day 1947, 400 peasants marched beneath red flags and sang songs to celebrate the local communist leader Girolamo Li Causi's commitment to redistribute land and wealth on the island of Sicily.[36] As the May Day march passed through a mountain valley it came under machine gun fire from horsemen on the hills. In the massacre that ensued eleven people were killed, including four children. A further 27 people were injured. The murders caused outrage across the country. Speculation spread that it was orchestrated by a coalition of monarchists, landowners and the Mafia as punishment for the left election victory and as a deterrent for future voters.[37] The next day in parliament the Christian Democrat Minister for the Interior reported that the massacre had been non-political, a random act of banditry. The Sicilian communist Li Causi protested, claiming that it was clearly the work of the Mafia and the Uomo Qualunque Party, a right-wing populist group. The leader of the Qualunquists rose to protest, and Communist politicians shouted 'Assassin!' in reply. A brawl broke out in which 200 deputies of left and right exchanged blows as centrists frantically tried to untangle them.[38]

The General Confederation of Italian Labour announced a general strike in protest against the political massacre in Sicily, and some 6 million workers walked out as communist leaders raised the threat of civil war.[39] Despite mounting evidence implicating the Mafia, the Christian Democrats and an American intelligence network in the events in Sicily,[40] the general strike and talk of war were sufficient pretext for the Christian Democrats to remove all ministers from the Communist and Socialist Parties from government by the end of May. The general strike petered out with its political leadership now removed from power, and millions of dollars in American aid rolled in before the end of the year.[41] The

red flag had been successfully neutralised by a national and international bourgeoisie.

The Communist Party would continue to secure the largest share of the vote in France for another decade, and in Italy, after an assassination attempt on the Communist leader Togliatti in 1948, a further general strike, combined with tens of thousands of workers armed and bearing red flags seizing towns and factories in northern Italy, would demonstrate the continued strength of the movement despite capital's capture of Italian politics.[42] But such a show of force was merely a gesture, and both Italy and France would see the red flag locked out of power.

The red flag in Western Europe was keenly controlled by its enemies. Having been suppressed in France and Italy, the same tactics were now used to suppress it in Belgium and Luxembourg, and finally the Communist Party was banned outright in West Germany in 1956 in a decision that was upheld by the European Commission of Human Rights.[43]

A soft coup had been enacted across Europe that preserved liberal democracy as the dictatorship of the bourgeoisie. The final minuscule piece of the puzzle was completed in 1957 when the US and Italian states gave their support for regime change in San Marino. A provisional government had been formed to oppose the Sammarinese Communist Party which had ruled San Marino since 1945 when it had become the first democratically elected communist party in the world, nationalising the tiny landlocked state's two factories.[44] A single shot was fired in the strange and small coup that followed, and the last red flag flying over a national government in Western Europe was lowered.[45]

Excluded from power, persecuted by the United States and separated geopolitically from the support of the USSR, the red flag would slowly recede from view as a parliamentary political symbol in Western Europe and would instead find itself in the extra-parliamentary realms of the unions, the streets and domestic terrorism. Excluded from the democratic path to power it became a flag of dissidents and subversives.

The containment of a Soviet-style red flag by an alliance of the conservative European elite and the US establishment did not mean that there did not continue to be significant support for and allegiance to communism, nor attempts to promote a red flag divorced from revolution and bring euro-communism to the fore. But neither of these currents in Western communism returned the red flag to the political mainstream, and instead the flag moved to the fringes and the underbelly of society. With no hope of a democratic road to communism in Western Europe, those who wished to see the red flag fly over London, Paris or West Berlin could do so either by fermenting revolution at home or by supporting revolution abroad. Figures such as Kim Philby, Guy Burgess and Melita Norwood – apparent pillars of the British establishment – passed secrets to their Soviet counterparts, living secret lives of allegiance to the values of internationalism, peace, solidarity and equality embodied in the red flag, and rejecting their own national flag. In Norwood's case the knowledge that she passed to the KGB in her 40-year career as a Soviet spy embedded in the British Civil Service provided the scientific knowledge for the communists' atomic bomb. She believed that her work helped prevent the technological advantage of the USA and Britain that could have resulted in a Third World War.[46] Certainly such subversives – often themselves outsiders by dint of nationality and sexuality as well as politics – played a huge role in keeping the red flag flying in the East, though it had been successfully suppressed in their home nations of the West.

But whilst the red flag of Soviet-directed communism was suppressed in the West, the flag would also see a process of disillusionment within the system that upheld it. Following the revelations of Khrushchev's secret speech denouncing Stalin, the erosion of opposition within the Eastern Bloc and the invasion of Hungary, the red flag in Europe had increasingly become tied to a politics of tyranny, bureaucracy and conservatism – banning new music, opposing gay rights and enforcing cultural conformity. Military force in the name of the red flag had been used in Budapest, Prague and later in Kabul. And at home shortages of basic foodstuffs and consumer goods remained more common than in capitalist coun-

tries. Although the symbol remained the standard of the working class in Europe and represented a politics that had won real concessions and materially improved the lives of all workers, and although it still had a role with workers, intellectuals and marginalised groups, the flag had by the mid-1960s become to many a backward-looking and repressive symbol. Its retreat from public life to the west of the Iron Curtain was mirrored in a failure to deliver many of the red flag's key promises to the east; promises of peace, land and even bread were being broken.

Nowhere, though, was the red flag more zealously eradicated from public life than in the United States of America. In 1919 the US state had responded to the perceived threat of Bolshevism with violence and paranoia that became known as the First Red Scare. Facing a wave of strikes, and hoping to take advantage of them in order to be able to maintain the strict anti-sedition laws that had been passed during the war, Attorney General Palmer began a campaign of systematic government investigation targeting communists, socialists and anarchists. Palmer appointed a 24-year-old right-wing radical called J. Edgar Hoover to oversee what became known as the Palmer Raids, and some 10,000 arrests were made, particularly of Eastern Europeans, Italians and Jews. Thousands languished in jail, and more than 500 political leaders and party members were deported from the USA, including Emma Goldman and Alexander Berkman.[47] Hoping to use the Red Scare as a stepping-stone to the White House, Palmer reinforced the anti-communist and anti-immigrant rhetoric that would go on to define American politics. Palmer also helped J. Edgar Hoover on his way to the foundation of the FBI, which Hoover would lead for more than 50 years in a campaign of violent repression against progressives, and forced ideological conformity that would make him a quasi-dictator within the American deep state. The Red Scare of 1919 would, over time, transform anti-communism into a guiding political value of the USA.

Central to the rhetoric of this anti-communism was the idea that the red flag was an enemy flag, inherently un-American and incompatible with life in the United States. As the federal government

struggled to legally square the persecution of left-wing individuals with the Constitution, it fell increasingly to the actions of vigilantes and of individual states to suppress radicalism. In 1919 alone 29 states passed laws banning the display of the red flag. Across the country striking workers were beaten up, left-wing teachers were dismissed from their jobs, socialist meetings and newspapers were suppressed, and men and women suspected of political activity were assaulted, arrested and forced to kiss the US flag.[48] This was a public mass-panic that had as its fetish objects two supposedly opposing flags: the scarlet standard and the Stars and Stripes. The criminalisation of the red flag provided a powerful tool for the harassment of left-wing organisations and the political and social life of progressives in the USA. Right-wing groups were gifted with a legal tool for shutting down and rooting out communist and socialist activity across the USA. There was now no need to show evidence of seditious speech or action; the display of the red flag was enough. And with the flag criminalised, communists and socialists were not only subjected to harassment and arrest, they were further prevented from identifying themselves publicly and were legally divorced from a key tool in conveying their stance within a largely immigrant and multilingual society.

In 1929 anti-red flag laws were still on the books and an anti-communist surveillance organisation called the Better America Federation campaigned to enforce them. That summer they persuaded a sheriff to search a local communist-organised camp for working-class children in California. A 19-year-old teacher at the camp named Yetta Stromberg was arrested and given a prison sentence for displaying the red flag.[49] Described in the local newspaper as the 'tempestuous daughter of Russian immigrants', Stromberg had been responsible for the raising of the red flag at the summer camp each morning, around which the children had pledged allegiance to 'the workers' red flag, and to the cause for which it stands, one aim throughout our lives, freedom for the working class'.[50] Stromberg was by no means the only person to serve a jail sentence for contravening a red flag law, but she was the only one to appeal her conviction in the Supreme Court. In the case of *Stromb-*

erg v. California the Supreme Court found that the anti-red flag laws were unconstitutional as they were incompatible with the right of free speech and liberty. This conclusion was reached not on the grounds that a state could not ban a political symbol, but instead on the argument that the red flag was not inherently a form of expression which may incite violence, crime or the overthrow of organised government by unlawful means. Essentially, the meaning of the red flag was held to be not necessarily one of violence, despite Yetta Stromberg also being found to be in possession of a large quantity of communist literature 'of the most violent type'. The flag itself, the Supreme Court established in 1931, was not only a flag of revolution, but also a flag compatible with democracy.[51]

After a decade of suppression the constitutional right to display a red flag in the USA was established, though it would remain a focus of state violence and repression in the century that followed. Such repression was satirised in Charlie Chaplin's 1936 masterpiece *Modern Times*. In the film Chaplin, struggling against the inhumanity and alienation in a factory where he works, goes outside and picks up a red flag that has fallen from a passing truck. Chasing after the truck to return the flag, Chaplin unwittingly becomes the leader of a demonstration of workers bearing placards reading 'liberty or death' and *'unidad'*. He and his fellow protestors are brutally beaten by the police and Chaplin ends up in jail, begging to stay there because he prefers it to life on the outside.

In the United States, as in the rest of the world, the prestige of the red flag was dramatically raised by the Soviet contribution to the defeat of fascism. On May Day 1947, as part of an International Workers Day parade, American soldiers marched in uniform beneath the red flag in New York City and were criticised in the US Senate.[52] The years that followed would see feverish anti-communist policies take hold. Fear of civil and military government employees being loyal to the red flag spread across America and a new red scare emerged, with Senator McCarthy initiating witch-hunts for communists across all aspects of American society and President Eisenhower eventually criminalising membership of the Communist Party with the Communist Control Act of 1954.

William Z. Foster, the leader of the US Communist Party, told the House Un-American Activities Committee: 'The workers of this country and the workers of every country have only one flag and that is the red flag. That is the flag of the proletarian revolution.'[53] He was indicted for subversive activity.

These attempts to discredit and root out the red flag at home whilst mercilessly persecuting its adherents in Asia and Latin America served to establish the red flag as the anti-establishment symbol *par excellence*. Democratic communism, which had long been the key heir to the red flag across North America and Western Europe, now gave way under internal and external pressures to a younger, more insurgent, underground movement. The peaceful path to communism was now closed, and violence seemed, for many, to be justified. The red flag became the militant banner of the counterculture; it became their symbol specifically because it was taboo. It became a flag of the draft-dodging, the long-haired, the drop-outs because it was a direct threat to the status quo, to the generation in power. As the Yippies put it: 'Our strategy is to steal the children of the bourgeoisie right away from the parents. Dig it! Yesterday I was walking down the street. A car passed by, parents in the front seat and a young kid, about eight, in the back seat. The kid flashed me the clenched fist sign.'[54]

The youth of the USA and the West were, on paper, the most secure and successful young people the world had ever seen, but they experienced deep disquiet and alienation. This was the contradiction at the heart of the counterculture. A new society had been built in the post-war period, but community, identity, links to the land and traditional faith had all been disrupted. Many among the youth of the West looked to drugs, rock 'n' roll, Indian spirituality and the hippy trail for an escape from the suffocating boredom of post-war society. Others found the answers to both their malaise and their cultural and material poverty in the glamour and radicalism of figures like Che Guevara, Leila Khaled, Ho Chi Minh, and Chairman Mao. The counterculture that re-shaped much of the world between the mid 1960s and the end of the 1970s reframed the red flag of revolution as a symbol wrapped up in direct action,

experimental living and a New Left. Icons of the 1960s the Beatles had toyed with the provocative class politics of communism in their hit 'Back in the USSR' – its refrain a play on the political slogan 'I'm Backing Britain' – but in 1968, as the red flag dominated political events from Chicago to Paris to Beijing, they released their single 'Revolution' and John Lennon snarled the ambivalent:

> But when you talk about destruction
> Don't you know that you can count me out (in).

In the USA, fevered opponents of the counterculture sought to tie together all its contradictory revolutionary extremes into one conspiracy. Tens of thousands of copies of a pamphlet called *Communism, Hypnotism and Beatles* were produced claiming that youths made mentally ill by listening to beat music were destined to raise the red flag: 'Little wonder the Kremlin maintains it will not raise the red flag over America, the Americans will do it themselves. If the following scientific programme destined to make children sick is not exposed.'[55]

Communism was always just one small element of the swinging 60s, but the 60s themselves revolutionised the red flag, reframing it as a symbol of youth and participation. Communism was cool again. Mick Jagger sang 'the time is right for violent revolution' and figures like John Lennon wore Chairman Mao pin badges.[56] All over the world students read Marx, Lenin and most of all Chairman Mao's 'Little Red Book'. Mao's exhortation to 'bombard the headquarters!' and partake in a cultural revolution mapped directly onto the anti-authoritarian experimentation of the hippies, Yippies and militants. But their red flag was different to that of their parents, and even to that of Mao. In post-war society revolutions were no longer just a possible future, but a known past. Many nations had experienced national, political and cultural revolutions, often more than once in living memory. Soviet tanks, US-backed coups, liberal hypocrisy, racism, sexism and the continued failure of parliamentary politics to relieve poverty had betrayed them all and led this youth moment to seek a red flag that represented something wholly

new.[57] Experimentation, non-hierarchical organising, direct action, communal living and a rejection of societal norms made this a prefigurative politics that aimed to build the new world in the shell of the old. This was a red flag of personal as well as political liberation. It was a red flag that represented a new set of values, a new way of living, a new morality, and an internationalism that didn't just look to Moscow, but also to Havana, Hanoi and Beijing. A red flag that wanted to fight imperialism abroad by opening up a new front in the belly of the beast.

In May 1968 this new red flag was unleashed on the world. Occupations and demonstrations that had begun on the campuses of Paris's universities now spilled out into the city, where more than 60 barricades, countless fires, salvos of cobblestones and more than 10,000 students[58] halted police advances. Student-driven ambulances weaved between protesters, ferrying the injured to make-shift wards in university halls.[59] Students called up to local residents in the apartments above for bandages, lemons to treat teargas, shields against the water cannons and fuel for their fires. They were met with overwhelming help and support from a public who, despite the ceaseless street-fighting, were shown in poll after poll to support the student uprising.[60] The walls of Paris were plastered with posters of Guevara, Mao, Lenin and Trotsky and the slogans of the Situationist International: 'be realistic, demand the impossible', 'to be free in 1968 means to participate', 'the barricade blocks the street but opens the way', 'boredom is counter-revolutionary' and 'no replastering, the structure is rotten!' These posters, often printed in red ink by the Popular Workshop of the École des Beaux-Arts bore the revolutionary red flag flying from factory chimneys and barricades.

In the days that followed the red flag was flown by students across France, and in response millions of workers raised the red flag over the factories.[61] A one-day strike in solidarity with the students and against police brutality was called by the official trade unions, but workers took matters into their own hands and the one-day action spiralled into an open-ended general strike with workers downing tools across the country. General de Gaulle, who had ruled

France for a decade, withdrew to West Germany on 29 May.[62] An eyewitness wrote:

> This has undoubtedly been the greatest revolutionary upheaval in Western Europe since the days of the Paris Commune. Hundreds of thousands of students have fought pitched battles with the police. Nine million workers have been on strike. The red flag of revolt has flown over occupied factories, universities, building sites, shipyards, primary and secondary schools, pit heads, railway stations, department stores, docked transatlantic liners, theatres, hotels.[63]

As it had been in 1848 and in 1871, Paris was in the hands of the people, and their symbol was the red flag. A red flag that united the hopes of the students and their anti-capitalist counterculture with the workers and their socialist vision. Both took inspiration from the global anti-colonial insurgents who flew the red flag of revolution at the edge of empire. The often contradictory demands of communists and anarchists, old and young, students and workers, Trotskyists and Leninists, trade union rank and file and Maoist insurgents, white French and colonial subjects were synthesised in the red flag of the people. A shared language found in the iconography of communism – the raised fist, the barricade, the faces of Che Guevara and Chairman Mao and, above all, that call to action, the red flag – helped to overcome these different dialects of the struggle. The rising established again that it was possible to fly the red flag of revolution in an advanced capitalist nation at the imperial centre of the world.

But May 1968 in Paris did not blossom into a revolution. Despite millions on strike, and 20 per cent of the population saying in polls that they would support a revolution. Despite the fact that the police had publicly voiced their resentment at being used against the students. Despite half a million demonstrators gathering in Paris chanting 'Adieu, de Gaulle!' as the president left the country.[64] No provisional government was formed, and the French Communist Party instead supported immediate elections.[65] The possibility

of the red flag again flying over a government in Paris receded as workers returned to the factories and a fearful public delivered De Gaulle a huge majority in the election.

May 1968 failed to subvert power in France, but it shook the world, and its tremors continue to be felt. In France and elsewhere in Western Europe huge numbers of people were radicalised, movements for social, sexual, racial and gender liberation proliferated and a decade of militant trade unionism saw boss-nappings and factory occupations from Turin to the Clyde. In Copenhagen the wild subversive radicalism of the red flag reached a surreal apogee when in December 1974 100 men and women dressed as Santa marched through Copenhagen behind a huge red flag. The Red Father Christmases occupied the stock exchange, paraded through a car factory demanding it be given to the workers, and then entered a department store and began handing out the merchandise, declaring: 'Merry Christmas! Today, no one has to pay.' Children who witnessed scores of Santas being dragged out into the street and beaten by the Danish police knew which side they were on.[66] The red flag of the 1960s and 1970s belonged in the hands of the youth.

The flag's symbiotic relation with the red flag of the colonised world continued too. The events of 1968 were inspired by the revolutions of China, Vietnam, Russia and Cuba, but the ideas and energy of Paris would reverberate back out to the socialist world, with the Prague Spring seeking huge reforms to communism, and Tito telling the people of Yugoslavia: 'the students are right'.[67] The red flag would also travel again – as it had in the 1870s in the hands of the Communard Louise Michel – to the Kanak people of New Caledonia. Indigenous students who had participated in the Paris uprising returned to the islands radicalised; they wore red scarves around their necks, painted the words 'Free Caledonia' and 'The Whites came with the Bible to civilise us. We had the lands. Now they have the lands, and we still have the Bible' on colonial buildings, and founded the Party of Kanak Liberation.[68]

The events of 1968 also moved the red flag back into the hands of the internally colonised subjects of Europe and America. That winter activists scaled Notre-Dame and flew the red flag of Vietnam from

its spire.[69] The red flag of a global people's war flew at the spiritual heart of France. This was an intersectional, internationalist, radical symbol in the hands of a new generation – a generation drawn to the young black and brown men and women fighting and dying beneath the red flag. Many young people of colour in the USA began to view themselves as 'an internal colony'. Asian-Americans formed the Red Guard and paraded with red flags and berets.[70] The Black Panthers armed themselves, fed the children of their communities and began to 'support the revolutionary struggles of the world against imperialism and display the red flag', praising 'those who bled for freedom'.[71]

In the United States the government unleashed the war on drugs as cover for destroying the subversives who formed the student, anti-war and black power movements. John Ehrlichman, the Assistant to the President for Domestic Affairs, later said of the plan:

> The Nixon White House had two enemies: the antiwar left and black people. You understand what I'm saying? We knew we couldn't make it illegal to be either against the war or black, but by getting the public to associate the hippies with marijuana and blacks with heroin, and then criminalising both heavily, we could disrupt those communities. We could arrest their leaders, raid their homes, break up their meetings, and vilify them night after night on the evening news. Did we know we were lying about the drugs? Of course we did.[72]

The capitalist powers sought to crush black power at home just as they crushed revolutions in Asia and Latin America. The energy of May '68 stalled under state and media reaction in Europe. Whilst many of the liberatory ideas of 1968 became hegemonic, the symbol that had represented them, the red flag, began to recede. Huge societal gains were made following the popular rising in Paris and around the world, and millions of lives were improved, but only in compromise with capitalism. The culture of society was altered, but its base remained the same. The capitalist establishment subsumed and co-opted the ideas that it was able to, but stripped out the

economic and participatory elements of May 1968. Those radical demands for economic and social justice remained wrapped in a red flag and located firmly beyond the political pale. As many of the middle-class and upwardly mobile participants of the 1968 revolutions and counterculture began their 'long march through the institutions' they put down the red flag, and instead found their place within the establishment. Their intent had been to reshape the institutions of society, but instead they were themselves profoundly reshaped and deradicalised by the institutions they joined.[73] Often it was only those with the least to gain from liberal compromise who continued to fly the red flag. Black revolutionaries such as Stokely Carmichael (Kwame Ture) stayed true to the red flag as leader of the All-African People's Revolutionary Party (A-APRP, as did queer communists like Mark Ashton, who founded Lesbians and Gays Support the Miners (LGSM), or Leslie Feinberg, who wrote:

> Like racism and all forms of prejudice, bigotry toward transgendered people is a deadly carcinogen. We are pitted against each other in order to keep us from seeing each other as allies. Genuine bonds of solidarity can be forged between people who respect each other's differences and are willing to fight their enemy together. We are the class that does the work of the world, and can revolutionize it. We can win true liberation.[74]

The red flag is subversive both because it subverts the establishment and also because those subversive identities that the establishment cannot suffer to exist are pushed towards it. Black, Jewish and Queer people have always found and made meaning in the red flag. In modern Europe it is transgender people, black people and migrant workers who are the key targets of capitalist society's hate. These identities subvert the borders, boundaries and binaries that capitalism requires to function. It is these identities that often find and forge the liberatory potential of the flag.

But such identities, when removed from an economic context, have also sometimes served to distance the red flag from its popular appeal. On the one hand the red flag is the flag of the poorest,

the most disenfranchised, immigrants, people of colour and those incarcerated in prisons and asylums. And on the other hand it has at times become the flag of left-wing academics and commentators, who exist at a remove both from the oppressed and from power. In the 1970s and 1980s the red flag in the West underwent a period of radicalisation and demonisation, propelled by the forces of a conservative counter-revolution, an intellectual movement increasingly adrift from the masses, and the outbreak of a wave of radical left-wing terrorism. All three of these trends pushed the red flag further outwith the mainstream and created a distance between the symbol and the people it claimed to represent. Of these trends, the red terrorist would be the most divisive.

Italy's Red Brigades with their Anni di Piombo, and the Red Army Faction in West Germany would define the red flag for many in the 1970s. In both cases left-wing militant groups were formed by young people who had passed through the radicalism of 1968 and wished to take up arms against governments which they saw dominated by conservatives, Christians and former fascists. These red flag-flying militants were often middle-class and university-educated, disproportionately compared to most other violent organisations they were women, and many had met at Berlin's first film school. One early film by young guerrilla Holger Meins, *Die Rote Fahne* (1968) saw a series of people carrying an enormous red flag through the streets of West Berlin.[75] Such aesthetic work soon morphed into practical action. Groups such as those at the film school and the anti-psychiatry Socialist Patients Collective provided space for the discussion of suppressed communist ideas, and though they began by organising demonstrations, distributing leaflets and making experimental films, they were quickly confronted by the reality of an intransigent society and a police force that was willing to beat and kill unarmed protesters who flew the red flag.

A tipping point came with the murder of Benno Ohnesorg, who was shot in the head by the police and left for dead at a protest in West Berlin in 1968 as officers beat a nurse who went to his aid.[76] The student movement collapsed following this murder, and elements of the left in Germany moved towards support for armed

struggle. These urban guerrillas used small arms to engage in attacks on the state, big business and representatives of imperialism, beginning a wave of left-wing bombings, assassinations, kidnappings, bank robberies and shoot-outs. The German tabloid *Bild* wrote: 'Yesterday, malicious and misguided people tried for the first time to bring terror into the free part of the city …. They wave the red flag and believe the red flag. Here the fun ends … and democratic tolerance.'[77]

The Red Army Faction believed that their vanguard action would inspire brutal repression by the state and that that in turn would lead to a great proletarian backlash that would see the red flag of revolution fly across West Germany. A contemporary of the Red Army Faction, Stefan Aust, wrote:

> World War Two was only 20 years earlier. Those in charge of the police, the schools, the government – they were the same people who'd been in charge under Nazism. The chancellor, Kurt Georg Kiesinger, had been a Nazi …. The moment you see your own country as the continuation of a fascist state, you give yourself permission to do almost anything against it. You see your action as the resistance that your parents did not put up.[78]

In West Germany the reality of a state and legal system largely managed by former fascists proved fertile ground for red terrorists. More than a quarter of Germans under the age of 40 said they supported the Red Army Faction, and one in ten said that they would hide a member of the group from police.[79] When the first member of the group to be killed by police, Petra Schelm, was buried, 50 youths laid a giant red flag over her grave. The police quickly had it removed.[80]

But the increasing violence and growing death toll of the group's campaign led them to be identified less as martyrs and more as a criminal gang. By the end of the decade all of the original members of the Red Army Faction had been either killed by police or had died in prison; they left the red flag more firmly identified in Europe with violence than it had been even at the height of Stalinism.

In Italy the Red Brigades led the red flag on a similar trajectory. A study group at Trento University formed to discuss the works of Mao and Guevara enjoyed early public support as it began to engage in industrial sabotage, the kidnapping of industrialists and attacks on military targets. This support vanished as the violence of its campaign escalated and its targets became more controversial, including the murder of a former Christian Democrat prime minister, Aldo Moro, whom they had taken hostage in the hope of a prisoner exchange. The later killing of popular Communist Party member and trade unionist Guido Rossa, who had spoken to the police about the Red Brigades, disgusted even their own supporters. These crimes and others associated the red flag with arbitrary and revenge killings in Italy and framed the group as little more than a red mafia.[81] The lasting legacy of the Red Brigades – aside from some 12,000 arrests and 14,000 acts of violence[82] – was to end the historic compromise between the Italian Communist Party and the Christian Democrats that in the late 1970s was on the brink of returning communists to government in Italy after 30 years in opposition.

Similar red terrorist groups emerged elsewhere, The Weather Underground in America bombed the Capitol and used red flags to smash the windows of the Justice Department.[83] The Japanese Red Army hijacked planes and fired mortar rounds at embassies of imperialist states.[84] Bank robberies and bombings were carried out by the Communist Combatant Cells of Belgium, the Workers' Party of Scotland and Action Directe in France. All of them channelled the red flag of subversion. They were disaffected radicals dragging the hope of the 1960s into the desolation of the 1980s; they existed at the fringes of the academy, the arts and literature. They were defined by slogans rather than analysis, by the romance of street-fighting and the acceleratory logic of violence. In their hands the red flag often took on the form of a symbol not just seeking to change or subvert society, but to destroy it.

Inspired by Leninist and Maoist urban guerrillas, associated with the so-called 'evil empire' of the Soviet Union or divorced from power in the hands of students, academics and Trotskyist factions,

the subversives who flew the red flag after 1968 became increasingly separated from power and reviled by the media. Across Europe and America the radicals who flew the red flag in the 1960s and 1970s had by the 1980s either been defanged and accommodated into society or repositioned as the enemy within. In England in 1981, when David Blunkett's municipal socialist council flew the red flag over Sheffield town hall on May Day to 'recognise the dignity and solidarity of working people' it became a circus, with uproar in the newspapers and locals calling for the mayor to be deported to Russia.[85] The red flag had become both an extreme symbol and also an object of mockery and hypocrisy. The people's flag seemed divorced from the people; it was a flag of Russians, bank-robbers and militants. Its association with the dignity of working people had been subverted both by the flag's staunchest enemies and its most zealous adherents. And yet as anti-capitalist traditions waxed and waned in America and Western Europe, the glamour and violence of the Red Army Faction, the Red Brigades and the Weather Underground would surface repeatedly in the appeal of the red flag. In the World Trade Organization protests, the Occupy movement, the environmental and student movements and the anti-austerity campaigns around the turn of the millennium the red flag of 1968, the red flag of subversion, would fly repeatedly in the heart of the decadent West.

12
A Flag of the Peasants

The village of Naxalbari sits amidst the tea plantations of Northeast India. Its rolling hills are blue green against the misty clouds of the lower Himalayas. A small settlement, less than 50 miles from Darjeeling, Naxalbari is populated largely by Dalits and Adivasis, the most socio-economically disadvantaged castes and tribal people. The area is typical of much of rural India, worked by landless peasants and controlled by upper-caste landlords. But what makes the village distinct is that in India its name is synonymous with the red flag.

Naxalbari's rise to revolutionary significance began in March 1967, when a group of local peasants marked out an area of land with red flags and declared it their own. This was a small land raid, carried out by peasants struggling to pay rent. They were determined to take the land, to grow crops directly and to free themselves from their masters. On 23 May Bigul Kisan, a sharecropper from the village, began to harvest the appropriated land and was beaten by agents of the local landowner. Violent clashes ensued and armed militias of local peasants and tribal people took control of the village and its grain supplies, forming a peasants' council. Police arrived the next day and were beaten back by peasants waving red flags and firing a volley of arrows. One policeman was killed. The following day a large group of police tried to enter the village; the peasants' council, many of them women with children on their backs, blockaded the road into the village in order to defend their land. The police fired indiscriminately into the crowd and killed seven men and women and two children.[1] Police began raiding the villages around, and many locals fled to the forests and hills.

The Naxalbari rising could have been any one of thousands of peasant risings in India that decade, or in any decade. Indebted

and indentured low-caste labourers have frequently risen up, often killing their immediate oppressors, before being brutally suppressed by landlords or the state. The tribal people of India have fought in rebellions against the successive ruling classes of the Moghuls, the British and the Indian government, as each has sought to dispossess them. But at Naxalbari the uprising was not an isolated one; the peasant movement here was connected to a wider revolutionary cause. The red flags of the peasants of Naxalbari signified the beliefs of the dedicated Maoist revolutionaries in their ranks and united them with a global class struggle. The massacre in this instance would be a spark for a wider revolution. One that still sees red flags flying across the forests of India to this day.

Through the village's connection with Communist Party organisers, word of the brutality of the police response spread fast. A nascent student movement in the country's cities focused the eyes and ears of young people on Naxalbari. In the days that followed the massacre the Maoists of Naxalbari declared the start of a revolution, and across the region peasants rose up beneath the red flag, took control of their land and attacked their landlords. Young people flooded in to live amongst the peasants and tribal people and to join India's own communist revolution.[2] The farm labourers who had retreated to the hills now re-emerged as guerrilla fighters.

On 5 July 1967 the *People's Daily* – organ of the Chinese Communist Party – published an editorial entitled 'Spring Thunder over India' which echoed what the people of Naxalbari believed – that this was a revolutionary moment:

> A peal of spring thunder has crashed over the land of India. Revolutionary peasants in the Darjeeling area have risen in rebellion. Under the leadership of a revolutionary group of the Indian Communist Party, a red area of rural revolutionary armed struggle has been established in India. This is a development of tremendous significance for the Indian people's revolutionary struggle.[3]

The form and nature of what became known, after the name of the village, as the Naxalite movement could be seen in these first few

months. This was the red flag of the peasants leading the way for a national liberatory struggle, in line with the ideas of Mao Tse-tung. *People's Daily* continued: 'By integrating itself with peasants, the Indian proletariat will be able to bring about earth-shaking changes in the vast countryside of India and defeat any powerful enemy in a soul-stirring people's war.'[4]

The struggle that began in the foothills of the Himalayas in 1967 would begin a people's war that continues today, more than half a century later, across vast swathes of the Indian subcontinent. A struggle that sees the red flag fly in the hands of tens of thousands of fighters forming a red corridor of contested land that has stretched from Assam to Kerala. Across millions of acres of central India there are peasants and tribal people resisting the advances of the state, the army and the international mining companies that are intent on extracting the rare earths beneath the jungle. The red flag is the standard of the armed Naxalites, but also the wider peasant movement and India's many legal and illegal communist parties. In the hands of the peasants it is a flag transformed again, to find a new meaning in the daily struggles of the rural poor.

The idea that the red flag might become the symbol of the peasants and tribal people of India was a radical departure from some of the flag's past iterations. The red flag as it had emerged in the nineteenth century had been chiefly a flag of the urban proletariat. It flew amongst the smog and dirt of the industrial city and in the shadow of dark satanic mills. In Chicago, Paris and Berlin it was displayed in tenement windows and raised in slums and city squares. Its appearance in rural and agricultural work was rare. In the early decades of the twentieth century, from Moscow to Barcelona, the red flag maintained its association with steel, smoke and the factory floor. The world watched the red flag rise and fall in the hands of urban industrial workers.

But whilst the red flag may have been forged in the cities of Europe, it was the rural population of the world that would take it to its greatest heights. The peasants and indigenous and tribal people of Latin America, Africa, India, China and Central and Southeast Asia have been a defining force in both the history and

the future of the red flag. For the most part they were not factory workers, but farm labourers; not the proletariat, but the peasantry.

Peasants are small-scale agricultural workers engaged in subsistence farming and meeting obligations to their landlords. Historically they were not the focus of radical agitation, both because they were often a scattered and thinly spread population with low levels of literacy, making them hard to organise, and because their relation to subsistence, and even to money, was mediated by more ancient forms of exchange and modes of production. Even the peasants of Naxalbari in the 1960s paid their rent in rice, not rupees. For these reasons early bearers of the red flag believed that peasants would never emancipate themselves.

For Marx the red flag would need the support of the peasantry if it were to come to power, but the peasantry itself was made up of geographically disparate groupings, engaged in exchange with local power rather than with society as a whole. They were largely illiterate, geographically divided and not confronted by the full force of capital. When the red flag was raised in a peasant revolt it generally served as a symbol only of defiance against the local landowner, money-lender or policeman, rather than against the national or global ruling class. In Europe these peasants were often viewed by socialists as either a bucolic hangover from pre-capitalist times, a political blank space or as an untrustworthy element that aspired to landlordism.

But as the red flag spread forth from the Soviet Union in the twentieth century it found itself raised in societies where by far the largest and most oppressed class was not the proletariat, but the peasantry. Indeed, international communism arrived in societies where the urban proletariat was marginal or did not exist at all. The utopian and egalitarian ideas that the flag represented took hold far beyond the types of society in which its leading theorists had lived. How, then, was the people's flag to adapt to conditions in which the majority of the people were not the factory workers but the peasantry? In India, China and Southeast Asia this would become the question that would most dramatically shape the history of the red flag in modern times. Where in Soviet Russia a proletarian party

flying the red flag had sought to industrialise the peasantry out of existence, in Asia it was the peasants themselves who became the agents of history.

Nowhere in the world, and least of all in India and China, is the peasantry a homogenous group; it comprises sharecroppers, landless labourers, tenant farmers, collectively farming tribal groups and smallholders, all from a vast array of nations, cultures and castes. There are richer and poorer peasants, landed and landless peasants. What they have in common, though, is that they are the mass of agricultural workers whose productive lives are shaped by powerful outside forces. Their labour is expended on the production of food, but any surplus they produce is extracted, whether it be by way of tithes, rents, landowner profits or, in the case of smallholders, by wholesaler profits and markets which are rigged against them. They are distinguished from primitive cultivators in that they are engaged in a struggle to produce a fund that will allow their survival and reproduction under capitalism. Where primitive cultivators either retain their surplus or have it distributed among the tribe as a form of insurance, peasants continually have any surplus they produce extracted.

In the middle decades of the twentieth century a vast transformation in political agency took place. Whilst peasants had for centuries engaged in rebellions, the advent of political parties and political education among the peasants, brought on by improved means of communication, now transformed those rebellions into revolutions – revolutions that took place beneath the red flag. Still today peasants make up a vast swathe of the flag's adherents. It is these peasants who have kept the red flag flying from the Mekong to the Yangtze, and from West Bengal to Kerala.

The key moment in the red flag of the peasants' rise was the culmination of the Chinese revolution. In 1949, after a quarter of a century of political and military struggle, a predominantly peasant army fighting beneath the flag of the Chinese Communist Party (CCP) fought a final territorial war against the Kuomintang and raised the red flag over the second largest country in the world. The victory was dependent on the tens of millions of peasants who had

risen up first against the Japanese occupation and then against the nationalist Kuomintang. This largely illiterate mass of people had been introduced to politics through the visual symbol of the red flag, alongside the concrete propaganda of land redistribution and the access to news, theory and ideology that was now possible via communist radio broadcasts.[5] The CCP was not a peasant party, but instead a party that intended to build communism based on national unity. Through a protracted peoples' war led by the peasantry it had encircled the cities, driven out the colonisers and was now on the brink of transforming society. For Mao the peasants who made up a large part of his armies had two advantages as a revolutionary vanguard: they were the dispossessed, and they had no political history. He wrote: 'That may seem like a bad thing, but it is really a good thing. Poor people want change, want to do things, want revolution. A clean sheet of paper has no blotches, and so the newest and most beautiful words can be written on it, the newest and most beautiful pictures painted on it.'[6]

In China the utopian and revolutionary possibilities of the red flag were opened up, but the flag's power – as all the world could see – sprang not from the Great Helmsman, Chairman Mao, nor from the urban workers of China, but from the peasants. The Chinese Revolution of 1949 may in the grand sweep of history do more to shape the world, and the meaning of the red flag in particular, than even the Russian Revolution of 1917. Its undeniable and instant impact was to throw the red flag into the hands of the global peasantry, and to give them the example of the Chinese people's war. The Chinese Revolution's impact on the identity of the red flag will be dealt with in more detail in the next chapter, but its initial effect was to electrify the global peasantry and to place the red flag in their hands.

In India the red flag of the Communist Party held high prestige. The nation had seen it play a key role in securing independence, and many artists, intellectuals and academics supported it at a national and local level. But despite its significant unifying role in ending the British occupation of India and the strong organisational work that had taken place beneath the red flag, the role of the flag was a

conflicted one post-independence. Fomenting revolution within a newly forming nation was complex, and the communists themselves were caught between their revolutionary ideals and their support for Nehru. Communism in India was divided between reformist and revolutionary tendencies, as well as between an urban population who experienced rapid changes in their living standards and rural peasants for whom little had changed in a century.

It was this rural peasantry that most often rose up in armed resistance against the state. In the case of the Telangana Rebellion of 1946–1951 the red flag was the symbol both of the rural revolutionaries and of the centralised Communist Party which hoped to temper the revolution. Peasants across Telangana had risen up and taken control through guerrilla warfare. New recruits swore allegiance to the red flag:

> I ... pledge that I am joining the guerrilla force and I have pledged with determination to destroy the exploiters' rule and establish a people's raj. To fight and destroy the enemy and help the people is my only job. Weapons are more valuable than life. In getting weapons and protecting them, I am prepared to give my life. I shall never show cowardice nor submit to the enemy but shall emulate the example of glorious martyrs. I take this pledge in front of the red flag.[7]

In more than 4,000 villages the red flag of the peasants was raised.[8] The villages were organised into communes, and they outlawed rent, caste distinction, forced marriage and the exclusion of women from the workforce across the region.[9] Large-scale programmes of land redistribution and education were instigated, and the rebel communes reported that, for the first time, hundreds of thousands of people were able to eat two meals a day.[10] The militancy of the peasants had its mirror in mass strikes in the cities and on the railways; in this instance, urban workers took their lead from the countryside.[11] The combatants of Telangana raised the red flag over an ever-greater area, burning down the houses of their landlords.[12]

But in 1951 this red flag of the peasants, flying over central India, was crushed. The army of the Indian government marched in, and the Communist Party of India (CPI) ordered the rebels to put down their weapons. Stalin himself advised that such an insurgency could only ever be an isolated island, with no hinterland on which it could lean. The CPI agreed that the uprising could not be won, and in any event it had wanted to preserve the red flag as a potential democratic symbol and to extricate itself from what it considered to be an isolated peasant uprising; the flag of the electoral party diverged from the flag of the peasants.

Indeed, the 1950s saw huge electoral gains for the CPI. The party's vast agrarian base was firmly established, and whether peasants rose up with traditional weapons or at the ballot box, it was the red flag that they flew. Although Nehru's Congress Party dominated the Lok Sabha, the CPI frequently came second and formed the main opposition in the country's early general elections. In each of the elections of 1957, 1962 and 1967 communists secured over 10 million votes and established the red flag as the de facto symbol of challenge to the post-imperial establishment. The communists saw India as still economically colonised. Many beneath the red flag understood class relations as remaining semi-feudal, others understood it as backward capitalist, but for all on the left the red flag of rural India provided a crucial answer to the country's many oppressions.

At state level too the red flag was finding electoral success. In 1957 the communists came to power democratically in the newly formed state of Kerala. Uniquely in a liberal democracy, communists would continue to rule Kerala for most of the next 70 years, with a coalition of the Communist Party of India and the Communist Party of India (Marxist) winning 45 per cent of the vote in the 2021 elections. Communists also formed state governments across the 1960s, 1970s, 1980s, 1990s and 2000s in West Bengal and Tripura, and secured large shares of the vote in Andhra Pradesh and Tamil Nadu. In the 1990s, the 2000s and the 2020s communists formed the key support in popular fronts to prevent neo-liberal and fascist governments in India. The red flag of democratic com-

munism has repeatedly proven itself to be the force that can defend Indian democracy and has delivered huge material gains to many.

These victories were won in large part by peasant voters, alongside an increasing army of agricultural wage workers emerging as rural life came increasingly into the sphere of capitalism. At a fundamental level the success of the red flag in the south and east of India correlates with land ownership; by the 1970s the average size of a cultivated holding in Kerala was 1.8 acres (0.73 hectares), in Rajasthan it was 16 acres (6.47 hectares) and in the Punjab 13.8 acres (5.58 hectares). The red flag flew not in the most urban or industrial states, nor in states where larger-scale farms prevailed, but in those states where the peasants lived off smallholdings and where they had the most to gain from communist rule. Nationwide, three-quarters of all communist votes still come from outside the cities, and there are no greater predictors of communist vote share in India than landlessness and rural population density.[13] In areas where the people own little land and are crowded in large numbers they form an agrarian labour reserve army that can easily see the conditions of its own oppression.

In Kerala today the ruling Communist Party holds mass rallies in which thousands of people stand with red flags flying amongst the palm trees. The communists declare that they are 'building a dream state in fascist India' amidst chants of 'Long live the revolution'.[14] Whilst it may not truly be a dream state, beneath the red flag Kerala has the highest literacy rates and social welfare spending, the strongest healthcare system, the least communal violence, the most progressive protections of gay and transgender rights, and the second least impoverished population of any Indian state.[15] Just as in post-war France and Italy, the red flag of communism as flown by the CPI is both revolutionary in its genealogy and social democratic in its nature.

The class-consciousness of Keralan agricultural workers proceeded from their material conditions, and from seeing the gains won in the fields and in parliament by the red flag.[16] The red flag of the peasants has been raised where increased population density leads to alternating oversupply and shortages of labour and where

sharecroppers can see most clearly that their interests are shared with neighbouring peasants, and not with bigger landlords and buyers. In Kerala such factors meet with historically high and continually increasing literacy, as well as high-value crops and fertile land providing for agricultural workers who are above the basic subsistence level and are thus able to seek to improve their lot in a way which is less possible for illiterate peasants who may lack the resources and time to engage in political activity.

The same is true in China, Indonesia, the Philippines and Vietnam, where the density and landlessness of the rural population have been the greatest predictors of either communist voting or insurgency.[17] The red flag, though it formed as a symbol of Western, urban and industrial worker power, was through its storied association with land redistribution, education and direct action the obvious symbol of the landless peasants.

When in 1959 the Indian central government intervened – with the support of the CIA – and deposed the first communist government in Kerala,[18] it appeared that the red flag of the peasants would be suppressed as an electoral as well as a revolutionary symbol. But after a period of direct rule by the Indian presidency communists were again democratically elected and the red flag was raised over Trivandrum. As a symbol it was both utopian and practical, promising a better life for the poor than was offered by India's liberal parties.

In tandem with this democratic communism, the rising at Naxalbari continues to define the red flag of the peasants in India. That first rebellion evolved into the decades-long Naxalite insurgency in which the Communist Party of India (Maoist) continues to fight a vast guerrilla war, controlling 24,710,538 acres (10 million hectares) of India's forest across 16 states and defending the land of the local tribal Adivasi communities from which it draws its strength. When the Communist Party of India (Maoist) was briefly legal in 2004 more than a million people attended its rally in Warangal in Telangana.[19]

Funding the purchase of weaponry and the provision of public services through a combination of 'membership fees, levies, dona-

tions, taxes, penalties and wealth confiscated from enemies',[20] the Indian Maoists seek to create a state within a state. In response the Indian government has pursued a ruthless war against them, using their territory as a training ground for an increasingly militarised police force and excusing murder and rape of dissident thinkers and activists by naming them 'Maoist sympathisers'.

Where Naxalite control has been thus threatened, communists have responded with great violence against the brutality of the police, landlords, illegal loggers, international mining companies and the Indian army.[21] But although they continue to be considered India's greatest internal existential threat, their campaign has yet to grow into a mass movement. They have the support of many of the tribal and landless people of central India, as well as many artists and intellectuals, but their struggle has not found favour amongst urban workers or the wider population.[22] Their ceaseless war and the bloody associations of their flag win them powerful enemies in both the legitimate communist parties and the far-right supporters of the Bharatiya Janata Party government.

The Naxalites do, however, find themselves with an important ally, inspiration and hinterland on which to fall back: Nepal. There the Communist Party of Nepal (Maoist Centre) waged a ten-year insurgency before entering electoral politics in 2006 and winning a parliamentary majority in 2008. In 2022 it again formed the world's only democratically elected communist government and nominated the Maoist leader Pushpa Kamal Dahal as the country's prime minister. Kamal Dahal, popularly known as Prachanda ('fierce') was born into a poor agricultural family; he became a guerrilla fighter at a young age, eventually directing the Maoist insurgency in West Nepal throughout the civil war.[23] The violent revolution that began in the self-proclaimed rebel capital of Thabang, a small village in Rolpa, would eventually become the revolutionary war that redefined the country and placed the red flag at its centre.

What was remarkable about the Maoist revolution in Nepal across the 1990s and 2000s is not just that it succeeded in ending the 240-year rule of the Ghorka monarchy and bringing both democracy and communist government to Nepal, but that it did

so at a time when the red flag seemed to be in retreat. The fall of the Berlin Wall and the movement of the Chinese Communist Party towards capitalism provided the backdrop to a red flag-bearing army which criticised both the Soviet and Chinese communists as reactionary and revisionist. This people's army, like that in India, found its most crucial base among the peasantry. During the civil war it was rural peasants who provided the key strike force as well as the movement's leadership. In the peace process that followed, the movement won over urban workers and middle-class professionals and delivered a fully democratic government beneath the red flag. It was Nepal's armed peasants who had reshaped the nation. In a period in which India turned towards fascism, and China turned towards capitalism the Nepalese peasants have raised the red flag and led their country through a communist revolution.[24] For these people Maoism offered a means to counter both their immediate oppression by the landlords and their larger oppression by the king and the international bourgeoisie. The red flag provided the symbolic means for the peasants to expand their struggle nationwide and to unite it with the struggles of the workers in the cities, as well as with the educated middle classes, who all felt that they had something to gain from the revolution.

On the Nepalese revolution's tenth anniversary Prachanda landed by helicopter in the rural village of Thabang in the Rapti district of western Nepal, where the peasant uprisings had begun in the 1950s. The sounds of hundreds of red flags catching the wind and revolutionary songs blasting from loudspeakers were drowned out by his helicopter blades as the victorious Maoist leader returned from the capital. He was demonstrating that power in Nepal springs from the red flag of the villages.

Since 2007, the year of communist victory, the red flag of Nepalese Maoism has flown at the summit of Sagarmāthā, Mount Everest – the red flag flying on top of the world. It is a symbol of state, but equally it remains a double-edged banner, flown still by those who talk again of bringing the government down.

This double identity of the red flag as a symbol of respectable power and insurgent radicalism is evident too in communist Nepal's

relationship with its closest neighbour – India. Nepal shares an open border and most of its trade with India, and yet at the same time it serves as the key ally and strategic base for the Indian government's greatest internal threat – the Naxalite movement. The Naxalite territory stretches from Nepal down across India, reaching the states of Bihar, Chhattisgarh, Jharkhand, Andhra Pradesh, Odisha and Madhya Pradesh. The area is known as the Compact Revolutionary Zone and marks a contiguous area in which the red flag of the peasants is dominant, from Northern China to Central India.

The latest Naxalite insurgency reached its peak in the first decade of this century, when revolutionary violence affected nearly a tenth of India's administrative districts and Maoist organising took place in 22 of India's 28 states. The images of this time were of red flags emblazoned with white hammer, sickle and machine gun motifs flying above the villages of India. Defending them, battalions of women bearing assault rifles, and tribal people with bows and arrows wore red headbands and saluted red flags. Tens of thousands of armed cadres and further thousands in the Chetna Natya Manch, the cultural wing of the party, spread the message of the red flag. Around 100,000 Maoist women formed the Krantikari Adivasi Mahila Sangathan and organised against forced marriage, patriarchy and oppression.[25] The territory they defended constituted a revolutionary zone under the administrative and military control of peasant armies. These red flag-wielding armies helped local people to take control of their own land, to protect the forests and to resist the advances of international mining corporations, right-wing militias and government paramilitaries. As well as carrying out attacks on security forces, the Naxalite fighters performed daily community service: digging wells, providing healthcare and assisting the elderly. At night the fighters invited villagers to readings of revolutionary literature and screenings of films that dealt with land distribution and global revolution.[26] All this happened in parallel to the democratic communism pursued by millions of Indians who flew the red flag in every city in the country, at times critical, at times supportive of the insurgency.

The writer Arundhati Roy described a Naxalite festival where tribal people celebrated with the People's Liberation Guerrilla Army:

> There is a sea of people, the most wild, beautiful people, dressed in the most wild, beautiful ways. The men seem to have paid much more attention to themselves than the women. They have feathered headgear and painted tattoos on their faces. Many have eye make-up and white, powdered faces there's lots of militia, girls in saris of breathtaking colors with rifles slung carelessly over their shoulders. There are old people, children, and red bunting arcs across the sky ... the lines break up and re-form and the olive green is distributed among the swirling saris and flowers and drums and turbans. It surely is a Peoples' Army. For now, at least. And what Chairman Mao said about the guerillas being the fish, and people being the water they swim in, is, at this moment, literally true.[27]

In 2009 the Indian government responded to both the violence and the popularity of the Naxalites by initiating Operation Green Hunt: an all-out offensive by state police and paramilitaries designed to eliminate Naxalite territorial control. Since the operation began more than 2,000 Maoists and a further 2,000 civilians have been killed. Hundreds of thousands have been displaced. Security forces have been accused of atrocities, sexual assaults and mass violations of human rights, and one superintendent of police ordered his officers to shoot on sight any journalists reporting on the conflict.[28] The campaign of state violence continues today, with aerial bombing of tribal people by the Indian government reported in 2023.[29] Whilst some in the wider communist movement in India hope that the Maoists will follow the lead of their Nepalese allies and move into democratic politics, others think that the ferocity of the state response to peasant and tribal communists, coupled with a total failure to address the root causes of the unrest, will only lead to a continuation of the protracted war. In the 2020s, after a decade in retreat, the Naxalite movement is again gaining ground and influ-

ence. Its cadres continue to win safety and security for the people of the hills, its red flags continue to fly from the trees of the forest. The communist greeting continues to echo across India: 'lal salaam' ('red salute'). As Roy put it: 'India has a surviving Adivasi population of 100 million people, they alone are the ones who know the secret of sustainable living.'[30] They are fighting for that secret and that life beneath the red flag.

The many victories won by the red flag in India have been secured by diverse movements and parties. Unarmed resistance, democratic communists and Maoist guerrillas continue to pursue tactics and ideas specific to the slums, cities, plains and forests of India. More than 100 years ago the Indian Marxist revolutionary Bhagat Singh wrote: 'Let us declare that the state of war does exist and shall exist so long as the Indian toiling masses and the natural resources are being exploited by a handful of parasites. They may be purely British Capitalist or mixed British and Indian or even purely Indian.'[31]

As the exploiting and colonial class in India has morphed from British imperialists to Hindutva fascists, as the stolen land and wealth and hobbled democracy have continued to make hundreds of millions of lives miserable, this state of war has continued. The one authentic symbol that has defended the people in India is the red flag, and its power has always sprung from the peasants.

In Nepal since the 2008 democratic elections the government has been predominantly formed by varying coalitions built around the Communist party (Maoist Centre) and the Communist Party (Unified Marxist-Leninist). The subtleties of these parties' differing tactical and economic positions, however, have been dissolved in the symbol of the red flag. Across a vast heterogenous subcontinent with more than 400 languages the symbolic power of the red flag lies in its role as a demand for radical change – as a symbol associated as much with action as with theory, elections or protest.

More than perhaps any of these groupings the All India Kisan Sabha (All India Peasant's Union) flies the red flag for the rural dispossessed. It remains one of the key symbols in the struggle for life and dignity for Indian peasants and farmers. Whilst it may seem that the peasant movement represents some element of the red

flag's past or the tail of a twentieth-century revolution, it is, quite to the contrary, the red flag of the peasants that is at the head of any red flag movement in India and the world today. In 2022 peasant farming was still the principal or sole source of food for 70 per cent of the global population, despite being the productive force on less than one quarter of the world's agricultural land.[32] This majority contributor to life on earth, the peasantry, finds itself at the sharpest end of capitalist expansion, agro-chemical exploitation, and climate collapse. At the same time, amongst the 3 billion people on this planet who experience hunger and malnutrition, the majority of these are those living closest to food production. In India tens of thousands still die each year of malnutrition, the majority being peasants, Dalits and tribal people.[33] The brutality of their oppression cannot be ignored when more than 300,000 farmers have committed suicide in India since 1995.[34] Most of these deaths by suicide can be attributed to debt or drought. This is the blood that stains the flag of the peasants red. As Vijay Prashad puts it: 'Farmers' suicides in India are the dead canary in the coal mine – the noxious gases of capitalism snuffed them out. To take one's life is tragic, but there is a social meaning here: it is a cry from the darkness against a brutal world.'[35]

The flag of the peasants is on the front of line of a global battle that is not just revolutionary, but existential. When in March 2018 over 50,000 farmers and peasants marched from their homes into the centre of India's financial capital, Mumbai, they brought the peasants' struggle home to the political, economic and cultural rulers of India and lit a fuse that would see the peasants' and farmers' movement at the forefront of the challenge to India's far-right government. The red caps, red banners and huge red flags that bore the white hammers and sickles of Indian communism on them were inescapable. The editorial column of *People's Democracy* stated:

> The kisan march was unique in the way it was conducted with discipline, determination and a collective display of peasant power. The sight of a sea of red flags moving in a massive procession captured the attention of people everywhere and the national

and regional media took this visual message to all corners of the country. No mass protest in recent times has had the nationwide impact of the kisan march.³⁶

The red flags both united the movement and made their message abundantly clear to the ruling class. The protestors won a resounding victory, securing land rights, pensions, remunerative prices and an end to state land acquisition without consent. In front of a rally of tens of thousands of victorious peasants and farmers, one political leader shouted: 'Come here and see, this is a sea of red here. You think you can destroy the image of Lenin we carry in our hearts?'³⁷ In response hundreds of red flags began to wave. Ashok Dhawale in his account of the movement writes:

> One of the popular slogans is: Lal Bawte Ki – Jai! (Victory to the Red Flag!) The Communist Party (irrespective of which particular one it may be) is called Lal Bawta Party. The poorest farmers, tribals, Dalits, and women, the marginalized of the marginalized, owe their allegiance not to this or that leader, but to the lal bawta.

It is the red flag, the *lal bawta*, that stands above any party, faction or leader. The meaning and importance of the red flag is clear. Dhawale goes on to describe a young boy he finds picking up red flags after the rally. He asks him what he is doing, and the boy replies: 'Collecting flags so that people don't take them home.' 'Why?' Dhawale asks. And the boy replies: 'We need them for the future.'³⁸

The red flag of the peasants is needed for all our futures. The Kisan March began years of farmers' protests, culminating in the 2020 general strike which saw 250 million Indian workers down tools in solidarity with farmers and peasants in the largest strike in human history.³⁹ Again the red flag triumphed and the government conceded to the farmers' demands.

From Marx onwards many of the red flag's advocates have believed that peasants form a relic of feudal society, a reactionary and outdated class. And yet as market forces have swept through Asia, Africa and Latin America since the 1980s the peasant class has

in no way disappeared, but it has instead in every way found itself face-to-face with capitalist class, either having its surplus appropriated directly through the sale of its labour or indirectly through the unequal exchange of its produce. The agricultural workers and peasant farmers of India have been on the front line of the capitalist and climate crises, and their centrality in the struggle mirrors the continuing centrality of peasants to the meaning and future of the red flag. Though the flag of the peasants may be more advanced in India, it fights a battle that is global.

As in India, peasants and farm workers around the world find themselves increasingly in conflict not just with their own landlord or with their own state, but with an ever-expanding and ecocidal agro-industry. Their lives are meted out to them by vast multinational corporations that integrate and oversee debt, land management, technical development, distribution, marketing and consumption. When peasants find themselves fighting against patent-protected seed monopolies and where just three companies sell half the seeds in the world, those peasants become an increasingly international and political class.[40] It is small wonder, then, that the red flag maintains its influence and develops its meanings amidst such obviously dystopian capitalist conditions.

The red flag of the peasants has never been a reactive symbol, it has shaped and continues to shape the world for all of us. In 1959 guerrillas flying the red flag took control of Cuba in what was to be one of the most dramatic historical events ever to transpire in the Americas. Che Guevara wrote that it was the peasants of the Sierra Maestra who, through their love of the land and hatred of the landlords, had defended the revolution: 'The peasant class of Latin America, basing itself on the ideology of the working class whose great thinkers discovered the social laws governing us, will provide the great liberating army of the future – as it has already done in Cuba.'[41] This peasant-backed revolution would be perhaps the greatest provocation to the anti-communism of the United States, and would see the world come to the brink of nuclear war in the Cuban missile crisis of 1962. For the first two years of Fidel Castro's revolution the urban working class and even the Cuban commu-

nists were critical of his movement, which was seen to stem not from the workers, but from the urban intelligentsia. The peasants, however, saw the need to raise the red flag and support both a social revolution and a revolution of land tenure.[42]

The second half of the twentieth century would see the USA confronted again and again by the red flag of the peasants. In 1975, despite being the world's most powerful economic and military actor, the US was fought to a bitter defeat by a peasant army bearing the red flag of Vietnam. In the decades that followed, China emerged as the globe's most powerful trading power and manufacturer, commanding the world's largest navy.[43] This superpower of the future rose up to challenge American global supremacy beneath a red flag and at the head of a huge peasant army.

On the other side of the world Brazilian peasants also rise beneath a red flag. On encampments across the country the red flag of O Movimento dos Trabalhadores Rurais Sem Terra ('the Landless Workers' Movement') flies over tents and shacks on occupied farms. Emblazoned with a map of Brazil and an image of two peasants holding a machete, the red flag of the peasants is raised, not for state power as in Kerala, but for direct control of unproductive land. More than a million members of the organisation continue to take their land and rights by force, living under regular police attack and often defended by landless children clutching red flags and throwing stones.[44] Together they seize unproductive land, sabotage agricultural monopolies and live in democratic leaderless communities. Their mix of Marxism and liberation theology – the application of Christianity to the political realities of class and racial oppression – continues to enact a societal transformation that begins with land. The Landless Workers' Movement has, through occupation, secured first land rights and then education and services for hundreds of thousands of Brazilians. Above their encampments they fly the red flag. Their eventual goal is the socialist transformation of society, and they celebrate the heroes of the Cuban and Bolshevik revolutions. But they don't take up arms; instead, they seek to take over the governance of schools, to engage in radical self-education and to bring up generations of landless children who

will further the aims of the movement both within and outwith the state.[45] Their red flag is an experiment in utopia, and its power comes from the peasants.

Different tactical approaches – armed and unarmed struggle and electoral campaigns – continue to see the red flag fly above both the peasant movement and national governments around the world from Cuba to Laos. In Brazil, India, Tigray and Nepal the administrative and political vacuum that exists in many rural areas has seen Leninism, Maoism and the red flag of the peasants secure huge territorial victories. In the revolution at Naxalbari, in the government of the Communist Party of India (Marxist) in Kerala, in the vast influence of the Landless Workers' Movement in Brazil we see different paths for the red flag. In all three cases the red flag flies as a demand for a radical transformation of society, and a direct conflict between the oppressed and their oppressors. One is a Maoist insurgency where power comes from the gun, one is a Second International-style municipal government that emanates from liberal democratic elections, and the third is an anarchistic tradition in which power comes from direct action. The extent to which these tactical and circumstantial uses of the flag have liberated people varies, but in all three cases the red flag represents the most immediate symbol for the defence of landless people and for the possibility of their securing a better life. In each case the red flag represents the political will of millions of peasants – that population closest to the land, closest to food production and closest to the climate devastation wrought by capitalism.

The forms of politics and insurgencies that have sprung from peasant movements in the late twentieth and early twenty-first centuries and which have challenged the political and military hegemony of capitalism have imbued the red flag with a connectedness to the land – a new ecological and agricultural dimension that is itself a stand against alienation. Peasants have connected the people's flag to the fundamentals of sustaining and reproducing life. The tension between the red flag as an urban and European utopian symbol and its reality in the rural struggle of Asia has produced and continues to produce complex political questions about the nature of red

flag politics. It remains to be seen whether those peasants fighting beneath the red flag will develop as Che Guevara imagined: 'This army, created in the countryside where the subjective conditions for the taking of power mature, proceeds to take the cities, uniting with the working class and enriching itself ideologically.'[46]

This flag of urban and European conception now finds itself strongest in the rural global South; whether it can surround and control the cities, nations and ideas at the centre and connect with the red flag politics of French or Indian industrial workers is unclear. Yet what is incontestable is that the red flag has secured many of its greatest triumphs against imperialism and capitalism in the hands of the peasants and in the rural sphere. Karl Marx wrote that capitalism must always degrade its only two sources of wealth, the soil and the worker.[47] The red flag in the twenty-first century is in no small part the flag of the soil and the worker in their battle against capital. This relationship between the worker and the soil is crucial to the meaning of the red flag, and to our future on this planet.

13
A Flag with Chinese Characteristics

On 1 July 2021 Tiananmen Square was filled with thousands of red flags, some plain, some emblazoned with hammers and sickles, and some bearing five yellow stars representing the unity of the Chinese people. These are the red flags of a global superpower in the twenty-first century. President Xi Jinping addressed the crowd: 'Through tenacious struggle, the Party and the Chinese people showed the world that the Chinese people were capable of not only dismantling the old world, but also building a new one, that only socialism could save China, and that only socialism with Chinese characteristics could develop China'[1]

This celebration marking the centenary of the Chinese Communist Party also marked one of humanity's greatest achievements: the lifting of 800 million people out of absolute poverty. The red flag points towards a second century of Chinese communism which would see China's ascension to the world stage as a political and economic world power. These incredible feats of development have for a century carried the red flag as their symbol. A liberatory flag of Marxism-Leninism-Maoism, and at the same time the national symbol of an authoritarian superpower propelled by capitalism. The red flag saw Chinese communism overcome the Kuomintang and establish a new working-class state, and in the process it transformed itself.

Fidel Castro said that revolution is a struggle to the death between the future and the past. But that struggle does not end with taking power, it only triumphs with the total transformation of society. In China, as in all revolutionary states, the red flag of ideals metamorphosed into a red flag of the real. Seventy years after the Chinese Revolution it is inarguable that the red flag has brought the future to millions of Chinese people. Today China has a literacy rate and

life expectancy higher than that in the USA. The country has the largest high-speed rail network in the world and recently inaugurated the first maglev railway; its magnetically levitating trains are the fastest form of public transport on earth. China's inventors register more patents each year than any other country, and China is the world leader in the production of renewable energy, producing over three times the renewable capacity of its nearest competitor, the USA. Such successes represent the organisational and productive power of the Communist Party. And yet such progress has also left the promises of the red flag unfulfilled: class, money and inequality still proliferate, with a vast migrant workforce – subjugated by both state and private capital – busy constructing this future whilst living under grim oppression.

Across most of the world today the red flag maintains its identity as a flag of revolution and a demand for radical social change; a flag of protest and defiance. But the Chinese flag, more than any other iteration of the symbol today, is also synonymous with the suppression of protest and the crushing of dissidents. The red flag in China flies not as a symbol of protest, but of power. No red flag has a greater impact on the world nor shapes the lives of more people than does the red flag of China. And this power continues to be expanded, both through a military might that is able to challenge the dominant world order and also through President Xi's flagship Belt and Road Initiative, an economic megaproject that is increasing trade and transportation links across a staggering 151 countries[2] and which aims at dispersing over-capacity and over-accumulation in the Chinese economy whilst also increasing China's global market and soft power. The red flag of China flies over many of the world's largest development projects, projecting a vision of the future across Africa, Latin America and Eurasia. This red flag represents a socialism with Chinese characteristics that can at times seem obscure and distant from the flag's past, but which is inevitably playing an important part in defining its future. It is a contemporary embodiment of the collective and cooperative radical vision the flag has always represented, but with new and contra-

dictory connotations. It is an extension of and a deviation from the flag's past lives.

And yet those past lives all persist in the red flag of China: a flag with a direct and clear lineage. The Chinese Communist Party (CCP) in its early years adopted the flag of the Soviet Union, wishing to demonstrate its political allegiance and to make plain its ideology. By the 1940s the CCP had its own stylised yellow hammer and sickle on a red field which it maintains to this day. When the Communist Party won the revolutionary war in 1949 a different red flag was adopted as the symbol of the People's Republic of China. The flag was plain red with one large yellow five-pointed star, and four more yellow stars forming an arc in the canton. The largest star represents the communist party, and the four smaller stars represent the peasantry, the workers, the petit-bourgeoisie and the national bourgeoisie who formed the new democracy.[3] Inherent in its symbolism was the fact that this red flag was a revolutionary symbol that incorporated all Chinese classes in a national struggle against imperialism. It was from its outset both communist and nationalist. Whereas the Soviet Union explicitly strove to unite different nations and so disperse nationalism under its red flag, the Chinese communist state projected a single national identity, and as such explicitly adapted the meaning of the red flag to its own nationalism, at the same time maintaining the red flag with hammer and sickle as the flag of the party, and the red flag with the Chinese symbols for 8 and 1 – representing the date of the Nanchang uprising – as the flag of the People's Liberation Army: three red flags representing the state, the party and the armed forces.

The red of these new Chinese flags stood for communism and for 'revolutionary enthusiasm', but at its inception the colour also spoke to the nationalist identity of the flag. It was still the red flag of international communism, and more specifically Bolshevism – the Chinese constitution itself borrowed heavily from the Soviet constitution of 1936 – but the red of the new flag was also culturally and politically Chinese. In fact, the shade of red itself is known often as 'Chinese red', not because of the flag, but rather from the history of Chinese lacquerware and the dark, rich red that Chinese

artisans coated their exports in. A lighter synthetic red is known in China as a 'foreign red'.[4]

The modern associations of red in China with state, revolution and the goal of communism are helpfully supplemented by older concepts linked to the colour: the red of luck, popularity, beauty and devotion. Phrases such as *hong xing* (literally, 'red star'; metaphorically, 'a favourite'), *zou hong* ('get red', 'get lucky' or 'become popular very suddenly') and *chidan zhong xin* ('red-bellied loyalty', 'utter devotion') have all seeped into the red of the red flag of China.[5] That the red flag carries with it ideas of beauty, luck and celebration is a fact that is also present, if veiled, in European nations where traditions of cutting red ribbons, raising red curtains or rolling out red carpets maintain these ideas of a joyful rather than a vengeful red. Such associations are far more alive in places where the red flag remains the flag of government: in China and Vietnam, where red envelopes contain gifts for births, graduations and all other celebrations and in India, where the bride wears red on her wedding day. In much of Asia the positive associations of red remain strong, and these associations colour the flag.

National unity, imperial history, luck and loyalty are all woven into this new red flag, and placed alongside martyrdom and class struggle. In China, where red is a colour associated with fortune and happiness, where rising stocks are shown in red on the Chinese Stock Exchange and falling prices appear in green,[6] it has perhaps been easier for the red flag to reconcile its ideas of death and sacrifice with its meanings of life and hope. Placed next to the bright red flag of China, the flag of the USSR was a notably dull and sombre red.

That is not to say, however, that the red flag in China did not also foreground ideas of blood, sacrifice and even revenge. Maoism, the form of Marxism that secured the victory of the red flag in the Chinese Revolution, is a convulsive ideology that created one of the most significant breaches of the capitalist world order in history, and it did so through armed struggle. Maoism is a development of Marxist-Leninism with a focus on anti-imperialism and peasant mobilisation. Mao saw China as having experienced semi-feudal,

semi-capitalist and semi-colonial subjugation, and declared open war on the landlord, the capitalist and the imperialist occupier; he promoted a combination of agrarian revolution, guerrilla war and national liberation, with a people's army taking the countryside and encircling the cities.

The red flag that was raised over China in 1949 was already the flag of 30 years of bloody revolution, of the brutal sacrifice of the military retreat known as the Long March in which 90 per cent of the communist army perished. The Chinese flag was the red flag that had secured the final triumphant defeat of both the Japanese imperial invaders and the nationalist Kuomintang.

Whereas the triumph of the Russian Revolution began a violent civil war and terror, the Chinese Revolution was triumphant at the end of a civil war. The character of a red flag that fights a civil war in power and that of a red flag that fights a civil war in opposition cannot help but be contrasted; people of all classes are likely to blame those in office for the death and destruction. In contrast, it was the red flag of China that ended the nationalist devastation. Although the bitter class war continued after the civil war, the red flag of China was a flag of peace, a flag of liberation and a flag of reconstruction. Chinese communists immediately began the processes of collectivisation, electrification and industrialisation that had been enacted in Russia under Stalin in the 1920 and 1930s and set about constructing a new socialist China in the 1950s.

But whilst the red flag represented solidarity and ideological unity between China and the Soviet Union from the 1920s to the 1950s, this unity was shaken by the death of Stalin. In 1956 Nikita Khrushchev, the new first secretary of the Soviet Communist Party, denounced Stalin and began the de-Stalinisation of Russia. In his speech 'On the Cult of Personality and Its Consequences' Khrushchev repudiated Stalin's deformation of Soviet collective leadership, censuring the songs, cities and socialist realism that celebrated him, and criticising his paranoid purges. While Khrushchev tried to assert the idea that Stalinism had been a deviation from Marxist-Leninism, Chairman Mao and the Chinese Communist Party declared the opposite, denouncing Khrushchev as a reformist who was aban-

doning the revolution. In particular, Maoist China objected to the new USSR policy of peaceful coexistence with capitalist nations. The Sino–Soviet split saw the red flag of international communism cleaved in two: a Soviet flag and a flag of Chinese socialism. As a result of this divide the red flag of China underwent a process of indigenisation, with the flag's associations with the Russian struggle for socialism replaced with ideas and images of Chinese revolution and martyrdom.[7] The Sino–Soviet split saw a further step in the process of the red flag of China becoming a national rather than a communistic emblem.

But like all national red flags the Chinese flag existed in a place of tension between the state and the movement. This was still a red flag that looked outwards to a world revolution, even though it now rejected its key global ally and emphasised instead the achievements and ideas of the Chinese nation. From its earliest existence the red flag of China served to remind the Chinese people both of the liberatory struggle that had formed the people's republic and of the radical goals of that republic. The red flag represented a hope for a future China that would be prosperous, egalitarian and a leader of global revolution – replacing the role of the now inward-looking USSR. The Chinese flag, it was hoped, would be a standard of revolution across Asia and beyond.

At home as well the red flag took on a central organising role. The lives of Chinese citizens in the middle of the twentieth century were not just dominated by the red flag flying above them, but also by the miniaturised red flags that pervaded their lives. Mao's 'Little Red Book' of quotations served as a red flag in every hand, to be brandished at others or kept close to one's heart. The red scarves of children and young people were wearable red flags that framed faces in a flash of scarlet, emblems of revolution, markers of ideological loyalty and reminders of blood.

And certainly the blood red of the Chinese flag was central in its early years. In the 1950s all of China's landless peasants received land, and between 200,000 and 2 million landlords died at their hands.[8] Death on an even greater scale followed as the collectivisation and industrialisation of the Great Leap Forward (one of

China's Three Red Banners which were intended to usher in socialism) turned into the last great Chinese famine of the twentieth century. The number of people who died in the famine is wildly contested, with estimates ranging from 1 million to 55 million dead.[9] But what is certain, and what was conceded at the time by the Chinese president Liu Shaoqi, is that the disaster was in part man-made, as the push towards industrialisation and modern farming caused huge food shortages.[10] But even as violence shook the countryside and policies failed, the red flag carried its other significance, not of blood, but of hope. It served as an assurance that such terrors and failures were in the name of a greater good, the cause of communism. In the light of policy failures and the famine Mao stepped back from state leadership and ceded control of policy to moderates such as Liu Shaoqi and Deng Xiaoping. A period of stabilisation, self-criticism and a move away from the cult of personality followed.

But in 1966 Chairman Mao began the Cultural Revolution: a power struggle which would divide the red flag of China against itself. The red armbands and lapels of Mao's newly formed paramilitary Red Guards signified a radical sweeping away of the party establishment in this new revolution. This was a further upheaval of Chinese society, and one that would both lend the red flag of Maoism a defining role in the global 1960s and at the same time spread terror through China itself.

The Cultural Revolution was an attempt not just to return Mao to power, but also to modernise society. The Red Guard that led and enforced the Cultural Revolution shook the nation and the world with an eruption of social and political violence; they were made up largely of students and radicals, analogous to the '68 risings in Chicago, Paris and Prague, spilling forth from the universities and encompassing the peasantry and lumpenproletariat. Endorsed by Mao, the Cultural Revolution proclaimed that 'to rebel is justified' and that the people must 'bombard the headquarters'. It was an anarchistic attempt by Mao to clear out agents of reform and traditionalism in the party and to empower and radicalise Chinese youth. The Cultural Revolution proclaimed that there was a danger

that the Communist Party of China would transform into an agent of capitalism unless a profound transformation in the mentality of its members took place.[11] Red Guards took control of local Communist Party branches, denounced revisionists and ransacked historical and religious sites in a popular purge of the country, led not by the army or by the state, but by young people empowered by Chairman Mao. As Mao endorsed the anger against his reformist enemies, they in turn redirected it towards intellectual and historical figures. The apparatus of the party and government were seized by Red Guards across the country, but lacking central coordination it became unclear who was following Mao and who was simply taking advantage of the violence for their own gain. Perhaps emblematic of the zealous passion and confusion were attempts by the Red Guards to redirect traffic so that red lights meant go and green lights meant stop.[12]

The Cultural Revolution would last a decade, and amidst the turmoil loyalty to Maoism and to the red flag itself would become increasingly central to political and social life in China. The central edict was to 'raise high the great red flag of Mao Zedong Thought',[13] and everywhere banners proclaimed that 'Chairman Mao is the reddest sun of the east.' As political life became more unpredictable, the necessity of revering the red flag became more absolute. The Cultural Revolution was, in part, a power struggle in which Mao strove to reassert himself, in part an ideological struggle over the meaning and ideology of Chinese socialism, but more than either of these things, it was an attempt to culturally and socially radicalise China, to produce the same revolutionary change in society that had already taken place in land ownership, the military and the economy in the 20 years prior.[14] Within this process the red flag was the talismanic banner of shared radical identity.

In many ways it was the flag of the Cultural Revolution that propelled the red flag to the forefront of the global risings of 1968. Whilst the red flag of Soviet communists or of the European Labour movement had belonged to an earlier generation, the red flag of the Cultural Revolution belonged to the youth of the 1960s. In China the flag had been re-sanctified with revolutionary zeal.

This Chinese flag of global revolution would inspire guerrilla wars that would sweep through Latin America and Asia for more than half a century, reshaping the global class struggle and reinforcing the red flag as the universal symbol of the workers and peasants against the propertied class. From the Peruvian Communist Party – Shining Path's protracted war in Peru – to Nepali Maoists' eventual victory in forming Nepal's democratic government, the red flag of the Chinese revolution had many unpredictable international heirs.

However, in China itself the flag moved in a contrary direction. Following Mao's death in 1976 and the end of the Cultural Revolution a new leader rose to power – Deng Xiaoping. Though still professedly committed to Marxism and Maoism, Deng began a vast programme of market economy reforms, opening up China to the world and introducing massive foreign investment in Chinese industries. Having seen the status quo smashed by the Cultural Revolution, the CCP seized the opportunity to again build a new China.[15] Emphasising the importance of productive forces and the benefits of cooperation and competition under capitalism, Dengist China proclaimed that it was harnessing capitalism in order to develop the country towards socialism, and alongside foreign capital and the toleration of a new domestic bourgeoisie state-owned enterprises would continue to provide the capitalisation of the majority of the Chinese economy.

Deng's programme emphasised economic and political pragmatism in order to modernise the Chinese economy and place it on a level footing with the West. State-controlled capitalisation would be the engine that propelled China forward. And yet unlike in other contemporary socialist economies in which economic liberalisation was matched by social liberalisation and the eventual lowering of the red flag and destruction of the planned economy, the Chinese government has maintained tight control over both the economy and its citizens.

In 1989, in the same year that the red flag of the communist nations of Eastern Europe was brought down by the people, a student movement emerged in China, demanding freedom of the press, freedom of expression and market reforms. The protestors

rallied around ideas of liberalisation, but also anger against inflation, corruption, immigration and the relative improvement in the quality of life of peasants compared to the urban elite.[16] Occupying the centre of Beijing and flying red flags emblazoned with words like 'Give Me Democracy or Give Me Death' and 'Long Live the People', students and workers occupied Beijing's central public space for a month, escalating their action first to hunger strikes and then riots. On 3 June 1989 the protest collapsed amidst violent confrontations with the army. The Chinese Communist Party asserted that whilst economic reform would continue, political power would remain solely in the hands of the Communist Party.

In Tiananmen Square in 1989 the red flags of the protestors were defeated by those of the party and the military. Here was a conflict between flags all claiming to represent the people, the nation and the spirit of 'true socialism'. In their folds were revolutionary and counter-revolutionary ideas; demands for personal liberty, democratic freedom and elite privilege; appeals to national and class unity; and the assertion of state power. Blood was shed, and the flag of the party prevailed.

However, the red flag of protest continues to emerge in China as a symbol of dissent both from the left and right. In 2014 50,000 migrant workers at the Dongguan shoe factories struck beneath red banners, and in 2023 alone there were hundreds of strikes against local officials and bosses. In these industrial disputes the red flag often plays a complex role, both asserting the cause of the workers and also highlighting that this is a localised struggle and that protestors remain loyal to the project of the Chinese state, and are indeed appealing to that state to intervene on behalf of the socialist project. The symbol of both 1989 and 1949, the red flag in China remains a call for radical social change in the hands of the state, the people, the workers and the army.

In the twenty-first century this change is coming as quickly as it ever has. The majority of the capitalisation and opening up of the Chinese economy took place after the suppression of the 1989 student movement, and Deng's reforms have succeeded in creating a multi-polar world in which China is an economic and political

superpower. The next steps for China are those being taken towards world leadership: the first time a red flag has ever represented the dominant world power may be approaching. China's latest leader, President Xi, has again transformed China and its relation to the world. Though the economy is capitalised, the majority of the means of production remain in state hands, and even those private companies that do operate do so under significant control by the party. Both economic and personal freedoms remain scant. Under Xi a return to some of the rhetoric of Maoism and the iconography of the red flag has also taken place. The primacy of the political red of China is being asserted. At military parades the red flag of the party – with its hammer and sickle – processes ahead of the red flag of the nation and the red flag of the army. In Xinjang red banners fly over every mosque, declaring and demanding 'Love the Party, Love the Country'. Though red flags represent different facets of society in China, it seems that the red flag of communism is once again being moved to the foreground.

In the city of Xiongan red flags flutter around the high-speed rail station that is now the largest rail hub in the world. The city is President Xi's showpiece development: a new urban mega-development that Xi calls a '1,000 Year Plan of National Significance'. A supercity encompassing the latest developments in social, technological and ecological science and thought in order to produce millions of homes in a liveable city of five-minute neighbourhoods amidst reforested land, expanded lakes and state-of-the-art renewable energy, smart transport and waste recycling systems.

Whether you understand the programme of President Xi as technologically deterministic Marxism or totalitarian state capitalism that retains merely the visage of revolutionary ideals, the red flag is the symbol of this new vast social and economic experiment. Over the 40 years since Deng's reforms began millions have been lifted out of poverty and universal healthcare and unemployment insurance have been achieved.[17] Nearly three-quarters of all the people lifted out of poverty in the world over this period were lifted out of poverty by China.[18] China's gross domestic product over the last 40 years has grown on average by nearly 9 per cent a year. Fuelled

by the engine of capitalism, these incredible achievements, unparalleled in history, have taken place in the name of Marxism and under the symbol of the red flag. Xi is heralded around the world as a politician synonymous with progress, and seen by many as a bulwark against Western imperialism. While it may be the Maoist red flag that still travels the world, it is the visions of Deng and Xi that have most recently transformed China. These transformations rely on the radical and revolutionary ideals of the red flag. It is the world turned upside down by the economic, industrial and cultural revolution of Mao that allowed these staggering developments. The Great Leap Forward may have entailed great suffering, but it also did industrialise and modernise the economy and open the door to later transformations. China today is a nation of high-rises, high finance and billionaires. The official state car manufacturer, Hongqi (meaning 'red flag'), now produces limousines that retail at £580,000 each. Originally designed for Communist Party officials, Hongqi today caters for entrepreneurs and celebrities. Almost every facet of Chinese society has been transformed by capital since market reforms began: 40 per cent of the economy is now in private hands, and wealth is evident across China's cities, where consumable goods and enterprises dominated by the profit model are visible everywhere.

And yet the symbols and language of revolution remain at the nation's head. The red flag of China continues to fly as a flag of socialism; albeit a socialism with Chinese characteristics, a socialism with the party idealised as the agent of change. Marxist-Leninism and dialectical materialism continue to be central to state ideology under Xi Jinping. Thought, and the current primary stage of socialism as developed in China is anticipated to engage in a long struggle with the global capitalism that is dominant around the world. The red flag of China still asserts that capitalism will come to an end and that the triumph of socialism is inevitable. Though it does not promote world revolution, the Chinese Communist Party's position is still that the red flag is the symbol of the next stage of world history.

However, as the post-Mao era has developed, socialist symbols, rituals and language foregrounding workers and revolution have

been devalued, and the flag has become associated primarily with the nation and ruling party. The language and rituals of socialism and popular meanings of the red flag have reappeared in times of stress for the system, such as the massacre of protestors around Tiananmen Square in 1989,[19] when the red flag was affirmed by the state as a flag of Marxist revolution belonging to the people, rather than the army, the party or the protestors.

The red flag as a symbol of national unity was further asserted in the process of subsuming the former British colony of Hong Kong into the People's Republic of China. In 2019, as the struggle for Hong Kong's distinct democratic freedoms within China intensified, pro-Hong Kong democracy activists climbed flag poles in Kowloon and threw red flags into the sea; they were arrested for desecrating the national flag, and the Chinese state began a media campaign called '1.4 Billion Flag Guards', in which vast numbers of national figures and ordinary citizens pledged to guard the flag. However, the language of revolution and Maoism was absent this time. Instead, flag guards declared that they were defending a flag that symbolises the sacrifices of Chinese people during wartime, and which, as prominent flag guard Jackie Chan put it, stands for 'peace, security and stability'.[20]

Domestically, the red flag of China has a meaning that is able to morph with the changes of the Chinese Communist Party, placing the security and prosperity of the nation and party first, and yet being able to rely on the powerful symbolism of revolution and the equally powerful promise of economic liberation that the flag's history contains. China's unparalleled technological and economic progress and its vast system of repression and coerced loyalty continue to reproduce key elements of Stalinist society. In President Xi the world has, for the first time since perhaps Mao or Khrushchev, an international actor in command of a globally significant economy and military, beneath the red flag. The meaning and direction of Xi's red flag may be apparent in his return to Maoist self-criticism sessions, in his own history of exile during the cultural revolution or in his balancing of state and market in the economy. But it may be decades before his own impact on the red flag of

China is clear. The Xi era does not seem to represent a turning away from the history and ideals of the red flag; instead it presents a particular political vision of that flag, one which embraces both common prosperity and state control.

The red flag of the global communist movement and the red flag of China exist as separate but related symbols. The Chinese flag remains both a symbol of socialism and of nationalism. But nevertheless the achievements of the Chinese Communist Party – its state control of the world's largest manufacturing economy, its defiance of a Western imperialist order, its vast investment in renewable energy and its ongoing verbal commitments to Marxism and Maoism – all ensure that aspects of the national Chinese experience confirm the prestige and meaning of the red flag abroad. The Chinese red flag exists sometimes in tension with and sometimes in tandem with the wider red flag.

Just as the Paris Commune and the 1917 Russian Revolution were defining and inciting moments for many of the red flag's meanings, so too is it possible that in the future the Chinese Revolution of 1949 may be taken to be the key moment in the history of the red flag. A red flag that remains a flag of international communism and of the workers against the propertied class, but which now comes imbued with the powerful story of Chinese communism. Such associations may grow as China's global influence continues to expand. Whether it is the lessons of guerrilla warfare, peasant agency and the need to bombard the headquarters that persists in Maoist thought around the world or the example of economic and productive transformation of Dengist government or China's coming of age as a global leader under Xi, China may offer the most powerful manifestation of the red flag in the world today, but it remains just that: a single expression of the multi-faceted international flag of the working class. Some communists in Britain, France, India and Nepal may look to China when they raise their red flags, but their red flags remain their own.

When it comes to the red flag's Chinese characteristics two things seem certain. One is that even a global superpower cannot divorce the red flag from its centuries-old association with revolution, and

the other is that this revolutionary red flag will remain the symbol of China whether it builds socialism or not. The red flag serves the Chinese Communist Party well; no other flag can command such forceful ideas of martyrdom and transformation, loyalty and common wealth. And yet it must also be an object of respect and apprehension for China's government. Many times in the twentieth century the red flag was turned on China's rulers, and such a possibility remains inherent in their co-option of a revolutionary symbol. The Chinese red flag may seem fixed as the symbol of an authoritarian party, but the same flag could at any moment become again the standard of a people's revolution. Across China Marxists loyal to the red flag meet to bitterly criticise the Chinese state. Elsewhere workers rally beneath the red flag and appeal to that state to deliver rights and wages. The red flag remains a strange and unstable totem, caught between high-minded ideals and brutal realities. The Chinese Communist Party keeps the red flag flying, stretching its colours between political opportunism and repressive reality, kitsch sentimentality and grassroots faith in a political vision. The red flag represents a powerful, egalitarian China standing up to the United States of America just as much as it represents a state-capitalist one-party empire.

In 2024 China became the longest-lasting communist nation on earth, overtaking the Soviet Union. No other government has flown the red flag for so long, nor taken it so far. Sixty years after the Soviet Union's first victories in the space race China has planted a red flag on the moon. Thirty-five years after the Red Army ground to a halt in Afghanistan, China has raised the red flag over a sphere of economic influence that includes not just Central Asia, but Pakistan, Africa, and increasingly Western Asia and Eastern Europe. The power of the Chinese red flag cannot be overestimated. It remains the flag of a people engaged in a process of revolutionary transformation. Perhaps nowhere on earth do the potentialities of utopia, tyranny and rapid human development seem more immediately present. On building sites across the global South the red flag of China flies as a symbol of progress. The Chinese working class and the global dispossessed continue to look to the red flag in

the hope that it will fulfil its radical promise, and in trepidation at the further betrayals that may yet be ahead. As the million state-owned solar panels of the photovoltaic plant in the futuristic city of Xiongan begin to power its world-leading trains, factories and hospitals and as its young students pledge 'red patriotic' allegiance, the red flag over China continues to project its own power into an uncertain future.

14
A Flag of the Present

On the banks of the River Lin in Eastern China a series of large 1990s buildings house the factory of Linhai C&S Arts & Crafts Co. Ltd. Decorated at each corner with red flags, and flying three large red flags over its door, the factory is one of the official manufacturers of the state flag of China. Across multiple floors of printing, dyeing and sewing machines, hundreds of workers colour, cut, sew, fold and pack red flags in their tens of thousands. Each year these flags are shipped out from Linhai and across China, to be flown at sporting events, military rallies, cultural occasions and in schools, hospitals and government buildings. But these flags are not just symbols of socialism, nor are they merely national emblems; they are also commodities, produced and sold for a profit. This is market socialism manufacturing the symbol of revolution whilst extracting surplus value from the workers who make it; these red flags exist subject to market conditions. Production of red flags may suddenly halt when, say, a British royal has died and all workers need to be switched to urgent orders for union jacks. Or the sewing of red flags may experience a planned stoppage, as happens in the months before the football World Cup finals, when all production is focused on the flags of the qualifying teams. The many flags made in Linhai all have their own distinct – and sometimes opposing – meanings and histories, but they are united in their purpose of production: the movement of capital. The red flag in this context is no different; it is a product of raw materials and labour, produced to communicate an identity and commodified for the enrichment of the business owner.

Such a fate is a new one for the red flag. For centuries it was produced only to be used, not sold. The red flag of revolution and defiance was most often improvised in the moment of violence or

A FLAG OF THE PRESENT

societal demand. It was the countless flags run up from curtains and clothes in the days of the Paris Commune; the sheet dipped in calf's blood at Merthyr Tydfil in 1831; the portion of a sari raised in Madras in 1923. Red flags were objects urgently fashioned from what lay at hand, produced in the moment to communicate a sudden cry of mutiny or class war. The red flag was a plain red flag in part because any more complex design would have been ill-suited to the urgency of the riot, the strike or the revolution. Red flags were rarely mass-produced or bought or sold. They were objects with an immediate purpose, made by the people who wished to raise them.

In the twentieth century this changed; as worker governments took power across the world – with the red flag as the symbol of the ruling party, if not the state – red flags began to be produced in state-owned factories. The flags underwent a process of alienation, as it were. No longer made by the person who intended to signal with them, they were sewn alongside millions of army uniforms, mass-produced and shipped to every corner of Russia, China, Indonesia or Vietnam. Their signification was subtly altered by their mode of production. The production of the flags represented a portion of the total social labour of a society as directed by the ruling party. These red flags were industrially produced, but they were not made for profit. In communist countries these state-produced flags were used to project political power both abroad and at home.

In the twenty-first century, whilst many red flags are still fashioned with urgency for the barricade or the picket line, or sewn in workshops and tenement flats, the majority are subject to the creep of commodification, made by capitalists, wringing surplus value out of the scarlet standard. The flags of the Chinese People's Army, the flags of the Indian farmers, the flags of the French workers who block trains and airports at times of national crisis are made in the factories of capitalists. The pessimist might say that the capitalist tentacles of commodification and alienation now demonstrate such total world control that they exploit the workers in the creation of their own symbol. This is true even at the heart of the largest communist-ruled country on earth where the red flag is made by exploited workers. The optimist though might counter by quoting

Lenin: 'the capitalist is always working on the preparation of their own suicide'.[1] No matter how or where it is made, the red flag is still a banner of equality, the anathema to the capitalist system it is produced under.

But it is not just in the realm of production that the capitalist stands over the red flag. Today a flag is just as likely to be a symbol on a mobile phone screen as it is a material object. And such screens are almost wholly controlled by capitalists. Across social media, electronic messaging and email, emojis increasingly form one of the most prominent uses of flags. But here, on the computer and smartphone, the red flag is notable not for its provenance, but for its absence. The red flag does not appear in this new digital vexillological language.

A vast array of flag emojis are accessible at the touch of a button to signify identity, nationality and politics. The flags of Tuvalu, Vatican City and San Marino appear alongside the UN, EU, trans and gay pride flags. The black flag, the pirate flag, the flag of surrender and the chequered flag are all lined up for instant, language-free communication. In an increasingly global and visual world the flag has a renewed role as a signifier of identity. But of the 259 flag emojis available to smartphone users, just one is not flag-shaped; the red flag can be deployed only as a triangle. Searching for it on your phone, you won't find it tagged as socialist or communist; the red triangle is not a flag of the workers, but a golf flag, as if floating above a virtual hole. The Unicode Consortium – a Silicon Valley non-profit that determines the standard for text and emoji presentation on all modern software – decreed that a standard red flag should not be included; instead, the emoji known as 'triangular flag' stands in its place. *Emojipedia* informs us that 'while it [the triangular red flag] is most commonly used to reference golf, it can also be used to denote danger, or a problem'. No mention at all is made of its common use to denote socialism, trade union activity or revolution. The red triangle flag is the most-used flag emoji in the world, ahead of the Stars and Stripes.[2] Across the internet, along with the red rose, a loaf of bread, a hammer and the flags of Cuba, China, North Korea, Angola and Vietnam, the triangular flag is

used to denote socialist and communist politics. But it is a cipher: a golf flag, not a red flag. The language of digital capitalism does not allow the red flag of revolution to be expressed as itself. The very language with which workers are able to discuss and identify their politics online is limited by the capitalists who produce the means of communication. Red roses and golf flags stand in for a galaxy of socialist signification.

Such a capitalist erasure of the language and imagery on the internet is mirrored in the real world too, where the red flag has faced new suppressions and subversions. The red flag of the Soviet Union was raised by the separatist Russian nationalists in eastern Ukraine after 2014, and then adopted by the invading Russian army in 2022. This nationalist revision of the red flag is endorsed by the Russian government and denounced by those in the West. Both sides of the conflict reduce the red flag to a symbol of war. And yet its ideological meaning still in part persists, as Ukraine suppresses and imprisons communists, and Russia relies on a memory and a legend of the red flag as a defeater of fascism to justify its war. Again, it is a red flag alienated from its own meaning: an anti-fascist icon turned to a symbol of occupation. And yet the flag of the Soviet Union is still flown by radical internationalists in Ukraine, Russia and beyond, where the flag's meaning persists.

Since 25 December 1991, when the Soviet flag was lowered at the Kremlin and the pre-revolutionary Russian imperial tricolour was raised in its place, the red flag has continued to bear its soviet history. Over 70 years the red flag had presided over liberation, violence, glory, grinding oppression and, in its final years, a loss of direction, ideology, status and hope. Yet even as it was lowered over Russia, the state newspaper cautioned that the destruction of the Soviet project would be long and difficult, and that its symbol had 'a force equal to nationalism, and in certain conditions, it is also capable of uniting millions of fanatic supporters'.[3]

The collapse of the Soviet Bloc and the marketisation of communist China caused the red flag to be lowered from government flagpoles around the globe. The final years of the twentieth century brought the broad expectation that without the support of a super-

power the red flag's time in power had passed. The 1990s were believed to have ushered in a state of permanent liberal democracy and the death of the red flag; stable centrism was expected to reign. But the opposite has occurred; the victory of capitalism in the Cold War has seen Marx's ideas vindicated. Capitalist hegemony has seen the continuing degradation of workers and of the earth, the continued polarisation between the ruling and working classes, and a continuing cycle of financial crises. The period we now live in is not one of stability and centrism, but of radicalism of the left and right. Political life continues to be defined by division, and class remains at the heart of this: the worker against the capitalist. The global population today is more polarised than ever between increasingly unequal classes. The Covid pandemic, the climate crisis and each deepening recession only make this reality more stark; the rich appropriate ever more of the wealth created by the poor. The red flag today remains the demand for an alternate world, one that can offer the stability and safety that liberal democracy has failed to deliver.

In the first quarter of the twenty-first century extreme right-wing governments flourished around the world, in the USA, India, Italy, Brazil, Argentina, Britain, the Philippines and Hungary, and radically conservative demagogues were elected, backed by a combination of bigotry and the support of the billionaire-owned media. Yet even in the era of Donald Trump more than a third of US millennials had a positive view of communism – five times as many as had sympathies with the red flag in their parents' generation.[4] And in those same years millennials and Gen Z voters flocked towards the red flag-waving electoral projects of Jeremy Corbyn and Jean-Luc Mélenchon. We should not make the mistake of imagining that these millennials were children or students either. These were the people born in the 1980s and 1990s who came of age as the red flag was being consigned to history by many, and who had by the late 2010s become the largest section of the workforce. As capitalist crises eroded their job security, their housing security, their purchasing power and their opportunity to explore the world, this new generation of workers looked towards the red flag. In 2020, a survey

by the Edelman Trust Barometer found that most people around the world (56 per cent) agreed with the statement 'capitalism does more harm than good'. In France this figure was 69 per cent and in India it was 74 per cent – nearly three-quarters of the population of the second most populous country on earth are anti-capitalist.[5]

Movements such as Corbyn's and Mélanchon's were crushed by a hostile media and a centrist political class, but their legacy remains in the mass mobilisation of young people. From the Black Lives Matters protests to the 2022 wave of strikes, the French pension unrest of 2023 and the ongoing demonstrations against Israeli genocide in Palestine, the red flag can again be seen in the hands of young workers. They have demonstrated that a mainstream desire for the socialism and anti-colonialism of the red flag still exists at the centre of the capitalist world.

The red flags flown by members of the social democratic movements of Britain, France and the USA represent an electoral expression of the red flags that continue to fly on picket lines across Europe and worldwide. Trade unionism is also resurgent in the twenty-first century. As working conditions and job security continue to deteriorate in many developed nations, new businesses such as Apple, Amazon, Uber and Starbucks have seen workers unionise for the first time, and overall numbers of trade union members have increased around the world. The red flag in its most simple incarnation, as the symbol of a strike or mutiny – a direct conflict between worker and boss – is still redolent with the histories and potentials of the workers' movements of the last two centuries, and so it continues to be embraced by trade unions, both radical and moderate.

For most people who came of age after the 1990s the exploration of the red flag's promise has been an auto-didactic adventure: its parties and institutions largely absent from mainstream life, its histories and ideas written out of the textbooks. These generations have explored the recesses of libraries and social media to re-evaluate anti-colonial struggles, civil rights figures and anti-communist propaganda. Re-engagement with red flag politics may in places be semi-ironic: online exploration of Posadism, Hoxhaism, Gonzalism and Ostalgie generates an oscillating mass of content ranging

from darkly comic memes to rose-tinted celebrations of extreme sects and totalitarian states. Whilst these memes function in thrall to what Jodi Dean called Communicative Capitalism – they are a sort of interpassive phenomenon, where strongly held and emotional representations of the self online take the place of political action in the real world – they are at the same time a real expression and exploration of radical education. The sharing of online images depicting red flags of terror and tyranny against the bourgeoisie in part allows technology to function as a fetish covering over the impotence of the people posting and allowing them to convince themselves they are politically active, but at the same time they provide the nursery slopes of real political engagement and action.[6] The digital use of the red flag mimics the use of the red flag in real life, it is a symbol to gather around and find one's identity and history in – even within the capitalist-controlled zones of the internet. The digital red flag is still both a demand and a threat. In the propaganda videos made by Houthi rebels and the Palestinian resistance a small red triangle can often be seen hovering above their Israeli targets – a virtual red flag of both vengeance and liberation.

These red memes and emojis are a utilisation of the red flag to cry out against the current dominant forms of control. The red flag is a symbol of resistance within the virtual world, fighting against new ways in which we experience the alienation and oppression created by capitalism. In each era and each locale capitalism exists not just on a material level, but a psychological one; it is possessed of affects that control and demoralise individuals and allow the system of exploitation to persist. Misery, boredom, hopelessness and anxiety perpetuate the international, national and personal political experience. A feeling of being constantly watched and controlled by our work, the state and our peers diminishes our lives and inhibits our personal expression. The red flag both in material and digital form offers some shelter from these feelings. As a symbol it is a rejection of misery. Even in the virtual world the red flag can be used to signal dissent, to come together to resist, to organise and to endorse the one response to alienation that cannot be co-opted and sold

back to us by the ruling class: the revolutionary destruction of capitalism itself. It is a symbol that remains as effective and efficient as ever in calling for a different future.

Today the Democratic People's Republic of Korea (DPRK) continues to provide a strange and enigmatic totem for such a desire for an alternative future. Though the red flag there has been transformed to a symbol not of Marxist-Leninism, social democracy or anarchism, but to one of Juche, a syncretic ethno-nationalist pseudo-communist ideology, it nevertheless holds out as an astonishing exception to the homogenous global rule. Amidst a cult of personality and labour camps, the Korean Workers' Party keep the red flag flying and has been credited even by the CIA with a radical improvement in the status of women, free housing, free healthcare and health statistics, particularly in life expectancy and infant mortality, that are the envy of any low-income nation in the world.[7] The DPRK has more doctors per capita than the United Kingdom, the United States, France or South Korea.[8] Besieged by the world, the DPRK almost uniquely manages to maintain an alternative economic and social system; it is the hermit kingdom that has fully withstood neo-liberalism and Americanisation. Its scientific and military achievements have allowed it to do what Iraq did not, and develop weapons of mass destruction. Undoubtedly it is not its prison camps or its nuclear weapons, though, that make the DPRK global enemy number one: it is hated and feared in the West not because of its tyranny, but because of the alternative economic system it represents, its commitment to the red flag,

In every country in the world today there are people looking eagerly for an alternative to the world they live in. North Korea may not be the dream of many. And yet even still it is evidence that another world is possible. Millions wish to see that world shaped in line with the values of the red flag: the demand for dignity, justice, equality and the transformation of society. In many countries the red flag is the flag of established, democratic socialism. The parties of Italy, France or South Africa that fly the red flag may move between radical and reformist politics, but their identification with the flag signals to their members and voters an abiding connection

to revolutionary and utopian ideals. In other countries the red flag represents a politics that is not on the ballot box, but instead can be found in communal life, in the streets or in the armed struggle. Around the world a thousand red flags bloom.

In recent years the flag has found its most fertile ground in Latin America. Across the continent parties and politicians that fly the red flag have won and retained power in what has become known as the 'turn to the left' or the 'socialism of the twenty-first century'. In the 2020s the Marxist Free Peru Party brought President Castillo to office; in Chile President Boric was elected at the head of a coalition that included the Communist Party and the libertarian left; in Venezuela Maduro maintained his position as president and head of the United Socialist Party of Venezuela; in Colombia Gustavo Petro, a former socialist guerrilla, became the country's first left-wing president; and in Brazil Lula was freed from jail and elected to the presidency as head of the Workers Party in what may be the most remarkable political journey since Nelson Mandela. All of these leaders were democratically elected with the red flag as either their symbol or a symbol of their political platform. Their victories signal a new life for the left in Latin America and a new role for the red flag on the front lines of the economy, self-determination and the climate crisis. These leaders propose that both capitalist and undemocratic socialist governments have failed to deliver better lives for the people and that mass-democratic, labour-controlled economies hold the answer. This is a tradition of the red flag that looks back to Allende, the Spanish Republic and the Second International, but which proposes decentralised and culturally specific answers as to how Marxism and socialism should be applied. Such a promise and the electoral victories it secures are built upon the utopian hopes and the traditions of resistance that the red flag embodies.

These red flags in Latin America also represent a radical re-engagement with environmentalism – a new relationship between the state and the natural world, and an understanding of the inter-relation between social and environmental justice. The Bolivian socialist government passed the Law of the Rights of Mother Earth, which

recognises humans as merely a part of a complex and dynamic community of plants, animals, micro-organisms and other beings. On his election Lula, the socialist president of Brazil, declared: 'There is no planetary security without a protected Amazon. We will do whatever it takes to have zero deforestation and degradations of our biomes. For this reason, I would like to announce that efforts to fight climate change will have the highest priority in my next government.'[9] The turn to the left in South America sees the red flag resurgent at the ballot box, in defence of the Amazon rainforest.

The flag continues to fly elsewhere as both a symbol of revolution and of armed insurgency. In India, Turkey, Syria, Iran, Iraq, Palestine, Peru, Colombia and the Philippines anarchist, socialist, Marxist, Leninist and Maoist armed groups continue the armed struggle beneath the red flag. In Nepal such an insurgency has won and has placed the red flag as the symbol of government. Red flag-bearing rebel armies range from those pursuing a people's war uniting the claims of indigenous people with those of peasants and environmentalists to paramilitary resistance cells fighting against occupying armies to armed cartels espousing radical propaganda as they fund their war though drug production, kidnap and smuggling. The red flag has many lives in the modern world.

In the Philippines the red flag has been flying as a symbol of resistance for 50 years. The communist rebels there fly the red flag against the threat of death in their struggle to remove US neo-colonialism from their islands. In 2021 President Duterte told the Filipino army to destroy the communists: 'Just make sure to return their bodies to their respective families. Forget about human rights. That's my order. I'm willing to go to jail, that's not a problem.'[10]

In face of such threats the Communist Party of the Philippines continued its insurgency into its sixth decade, with fighting on more than a hundred guerrilla fronts. The party's 150,000 members fly a red flag that stood as the most profound opposition to the Marcos dictatorship, a family which again returned to power in 2022.[11] While Filipino cities suffer from some of the most persistent and widespread poverty and hunger in South East Asia,[12] in the liberated zones of the jungles a different reality can be seen. Beneath red

flags and defended by the New People's Army (NPA), people's democratic governments oversee collective farming and distribution of food, enact land reform and collect revolutionary taxes for community and healthcare projects. In contrast to the capitalist state, these people's governments defend the rights of minorities and LGBT people, even officiating over the first ever gay and lesbian marriages in the Philippines, with newly married men kissing beneath the red flag, and brides placing bullets in each other's hands as they declare their love. These are rituals that affirm both love and revolutionary zeal.[13] NPA fighters have also travelled to India to help train Naxalites who govern liberated zones in their own protracted people's war.[14] Thousands of miles apart, deep in the jungles of the Filipino archipelago and in the Indian subcontinent the red flag's twin associations – with armed resistance and with the promise of equality – continue to thrust it into the hands of people in search of a better life.

In few places can this better life seem more distant than in the camps and cities of occupied Palestine. But nevertheless the red flag continues to fly above the resistance in Gaza, the West Bank and the Israeli territories. The red flag is the only political symbol in the protracted and brutal occupation of Palestine that has adherents in both the Palestinian and Israeli parliaments, as well as amongst the armed fighters of Palestine. To what extent the flag manages to bridge the divide between the Palestinian People's Party, the Popular Front for the Liberation of Palestine (PFLP) and Maki – the Israeli Communist Party – may be debatable, but what is beyond doubt is that the red flag inspires defiance and insurrection in Palestine, just as it inspires hope for a free and equal society within Israel. In Gaza, when men and women don red keffiyehs and raise the red flags of the PFLP and the Palestinian People's Party they are espousing the same desire for social and economic freedom as are those Israelis who raise the red flag on the other side of the wall. When the red flag is raised at protests in Gaza, Ramallah or Haifa its message is the same, one of a continued revolutionary struggle against class oppression and settler-colonialism. The red flag in Palestine provides a unifying and galvanising

symbol that cuts across the theoretical and tactical differences of the country's many left parties. Particularly in ethnically and religiously mixed refugee camps and villages it unites local, national and international struggles.[15] In 2001 the leader of the PFLP, Abu Ali Mustafa, was assassinated by Israeli forces. Since 2010 his successor, Ahmad Sa'adat, has been in an Israeli jail. Their most famous member, Leila Khaled, lives in exile. Those members of the Palestinian resistance who fly a red flag have a perhaps unique ability to garner support from outside of Palestine, and for this reason their suppression by Israel is near total. Israel would far rather show the world a fight against Islamists than one against communists. From Jenin to Jerusalem the occupying Israeli army seeks daily to arrest and kill red flag militants.

Across the Middle East the red flag continues to stand in opposition to the currents of authoritarianism and Islamism that have continued to prevail since the Arab Spring. In Kurdistan, crossed as it is by the borders of Turkey, Syria, Iran and Iraq, the red flag flies as a promise of a new and better society. The armed fighters of the Kurdish mountains and Syrian plains have not only begun a huge multi-ethnic, feminist, democratic and decentralised revolution, they have done it whilst fighting on the front lines against ISIS and Turkey. The Women's and People's Protection Units of the Kurdistan Workers' Party (PKK) have raised the red flag in the face of the most merciless and feared armies on earth. They have done so with the support of international fighters drawn from every corner of the world. These fighters are mobilised by the ideals of this new revolution, which unites socialist and anarchist adherents to the red flag. In the midst of a national liberation struggle the new ideas and ideology of the Kurdish revolution are reinvigorating the flag and providing a focal point for the international working-class movement. Beneath red flags Kurdish and international fighters have helped to defend areas of Syria and Iraq from ISIS; they then set up independent cantons and began a transformation of society. Based on the theory of PKK leader Abdullah Öcalan's 'new paradigm' the revolution declared that a free, dignified, socialist and feminist society would not be won by purely Leninist means, but

rather by a new non-state formulation of socialism. Rojava – the Autonomous Administration of North and East Syria – strived to build on the theoretical gains of revolutionary Leninism and anarchism, taking inspiration from the work of Murray Bookchin; Kurdish revolutionaries hope to break with the state and instead to use grassroot democracies to give the people sovereignty over their economic, political and social lives. This is the red flag at the head of a democratic confederalism that fights to guarantee democracy, freedom, ecology and women's liberation for all. It is both a new political direction for the red flag and also an old one, returning to the questions of the First International and seeking to address the rift that followed the defeat of the Paris Commune. Although initially appealing to libertarian communists critical of twentieth-century socialism and even of the Leninist positions of the PKK, the Rojava experiment has increasingly attracted communists and socialists of all traditions, such as the Marxist-Leninist Communist Party of Turkey which sends cadres to the front lines to defend Rojava, and even the Bob Crow Brigade which came from Britain to fight alongside the PKK.

The Rojava revolution also brings the red flag to the front lines of the climate emergency, declaring that people who are alienated from nature are alienated from themselves and are therefore self-destructive. The Kurdish fighters maintain that the red flag can only liberate people by recognising that the social, economic and ecological crises of our time are intimately linked.[16] Such a politics has won huge support internationally.

These experiments have their antecedents in the Zapatista-controlled regions of the southern Mexican state of Chiapas where Centres of Autonomous Resistance and Zapatista Rebellion (CRAREZ) administer radical governments led by the people. These governments are known as *'caracoles'*, meaning snails, the name emblematic of the slow revolution against capital and globalisation. These *caracoles* distribute education and healthcare while promoting indigenous language and art, and fighting to secure land and housing rights and answer the fundamentally ecological question of who owns the land and what should they do with

it. Although these free territories were secured from the Mexican state by the forces of the EZLN in the uprising of 1994, the Zapatista army does not hold any power in the autonomous districts. Although their communities and demonstrations have red flags flying, emblazoned with hammers and sickles and pictures of Che Guevara, the Zapatista revolution distances itself from the red of past revolutions and embraces Marxist and communist ideas whilst trying to hand power directly to the people. Their flag is a red star on a black background, representing a unification of the red and black flags and the five-pointed star of communism.

The people of Rojava and Chiapas are not alone in re-forging the links between anarchism and Marxism. In South Africa the shack-dwellers' organisation Abahlali baseMjondolo is a militant, progressive political group trying to re-create the commons and to separate housing from the markets. Its tens of thousands of members march in red shirts and beneath red flags. They aim to build an ethics of living communism and to take back what belongs to the people: land, housing and dignity, blocking roads, occupying land and defending migrants. As in the liberated zones of the Philippines, the Zapatista-controlled regions in Chiapas and the cantons of Rojava, the red flag stands here as a banner of radical experiments in lived democracy and socialism. At the same time it faces the condemnation of the South African Communist Party which rules as part of the Tripartite government.

Therein lies a common tension of the red flag in the twenty-first century. It is flown in parallel by radical movements and by established parties, in many cases parties of government. Abahlali baseMjondolo stands in conflict with the South African Communist Party. The Naxalites' tactics are opposed by the Communist Party of India. The Workers' Party of Kurdistan is engaged in a civil war with a Syrian government that includes the Syrian Communists as a junior party. In Colombia, Argentina, Peru, Venezuela, Nepal, Cuba, Vietnam and Brazil political parties fly the red flag over different types of socialist and communist governments, whilst in each country other socialist, communist and anarchist factions fly the red flag against them. The red flag represents today, as it

always has, dissent and diversity. It embodies the struggle between organised workers, official governments, armed insurgencies, dispossessed masses and vanguardists, sometimes in conflict, sometimes in concert, as they strive to build a world in which wealth is shared by those who create it. All flying the red flag. A flag with immediate demands and diverse tactics.

In 2022 the *International Meeting of Communist and Workers' Parties* took place in Havana. Representing communist and workers' parties from more than 70 countries around the world, delegates debated the major political and economic crises of the day. The parties gathered at the conference represented over 100 million members and came from every continent on earth. They declared: 'Solidarity with Cuba and all the struggling peoples. United we are stronger in the anti-imperialist struggle, together with social and popular movements, in the face of capitalism and its policies, the threat of fascism and war; in defence of peace, the environment, workers' rights, solidarity and socialism.'[17]

In Havana they met in the capital city of a small island that holds out as a beacon of unbelievable human dignity, a small island synonymous with the politics of the red flag. In Communist Cuba there may be many problems, but the abolition of homelessness and hunger, the advent of full employment, universal healthcare and education, and the brigades of doctors that minister to the poor of the world all keep the flame of revolution alive. Since 1959 Cuba has flown the red flag in support of the world's oppressed. In part through necessity and in part through political vision, Cuba has become one of the only ecologically sustainable economies in the world, pushing urban agriculture, organic farming, renewables, recycling and biodiversity to the front of the political agenda. The red flag in Cuba remains not just as a defiant stand against the aggression and imperialism of the United States, but as a symbol of social and environmental hope – a red flag of dignity and equality besieged by American imperialism.

The workers' movement have suffered major defeats in recent decades. But as Engels said, 'history does not progress in a straight line, it moves by jumps and zigs and zags'.[18] Today the red flag

is battered but undefeated, still zigging and zagging through history, resurgent in the hands of countless millions around the world. Increasingly it is a symbol uniting the struggles of human and non-human life on this planet. Across political parties, armed insurgencies, revolutions both democratic and violent, mass movements and trade unions the red flag continues to be the symbol of radical popular mobilisation in the twenty-first century. It remains the flag of the workers against the propertied class, the dispossessed against the usurper, the oppressed against the coloniser. The ideologies and tactics the flag embraces continue to adapt. But its promise remains the same.

15
A Flag of the Future

The morning I began writing this book, in May 2021, I looked out of the window of my Glasgow flat and saw two men being dragged out of the tenement across the street. They were forced into a van by uniformed officers. They had been abducted by the UK Border Agency. Within minutes neighbours were out blocking the street and demanding the men's release. As Police Scotland escalated the situation and the crowds swelled, a seven-hour standoff between the people of my neighbourhood and the police began. By the time the two detainees, Sumit Sehdev and Lakhvir Singh, were freed by the crowd that evening flags were flying over a crowd of thousands. Among them were two red flags in the hands of local communists, and a large banner showing the red flag raised in the city 100 years before, in 1919 when the British Army occupied Glasgow to crush a general strike. Here in the twenty-first century was a microcosm of the red flag's meanings. Just metres from my window the flag was raised in defiance as a symbol of the people against the powerful, as a demand for justice and as a link with the living tradition of a workers' movement that stretches back more than a century and unites people around the world. This was a small insurrection, an act of spontaneous community-based resistance, but the red flag connected its meaning to a wider struggle. As the two men were freed the crowd that packed the street began to chant 'the people, united, will never be defeated'. This chant itself is a translation of the Chilean song 'El Pueblo Unido Jamás Será Vencido': the anthem of Salvador Allende's socialist government in Chile. In these words and in the red flag traditions of resistance united those acting in the moment with those who have fought for justice throughout history.

This is the power of the red flag. It forms an unbroken link between all those who fight against oppression. It represents the

power of unity over division. It allows struggling people everywhere to see their direct connection with the heroes of the Palestinian resistance, the Bolshevik revolution and the Paris Commune. The red flag declares that the working class will never be defeated, that the dispossessed will always force history and society onwards. The red flag is a symbol that can never be finally suppressed because the demands it makes are human and universal. It is a symbol that re-emerges in the face of every injustice because that is its most essential role, as a symbol that stands against every injustice.

Anti-communism in our media, education and history demonises the red flag and paints it as a flag of violence and failure. Yet this lie is communicated by a system that millions know to be failing. The capitalist parties of liberal democracy can do nothing but perpetuate the conditions that the red flag exists to defeat.

As capitalist politicians fail to deliver on promises of better lives, as corporations continue to destroy the environment, as the logic of profit continues to guarantee poverty, the red flag becomes a rallying point again and again. Each overlapping injustice moves more people towards an understanding that the current organisation of society cannot work for them. With each generation capitalism's relentless war against the people and the planet becomes more desperate and the red flag's stand against that war becomes more essential.

The red flag is a signal that another world is possible. The project of the ruling class has always been to make their system and their rule seem natural and inescapable. The red flag is a beacon that illuminates that lie. It is a red curtain that can be lifted by the curious to reveal a thrilling array of alternate societies, both historical and present. Even when the ruling class seeks to extinguish hope and red flags recede from the present, a thousand red flags from the past can still be seen at the head of every kind of strike, riot and revolution. Although these red flags have many shades and many histories, what they share is their ability to point to a society beyond this one. The red flag stands for realties in our own time and place that are built upon solidarity and community rather than on exploitation and division. It stands for traditions in our history in which the pos-

sibility of greater human development, happiness and equality were the guiding principles. As Eugene Debs wrote: 'It is an emblem of hope, a bow of promise to all the oppressed and downtrodden of the earth.'[1] It is this hope and promise that means the red flag continues to point to the future.

The red flag is not only a means of communication through time, but also through space. It is a system by which solidarity, affinity and hope can be transmitted. And such solidarity is never unidirectional. When workers in London or Turin fly the red flag in solidarity with comrades in Palestine they will always gain more in return from the Palestinian resistance. As Abdaljawad Omar writes: 'the Palestinian struggle uncovers the institutional, economic, and structural realities for those in the global north, the Arab world, and global south ... it exposes truths, reveals fascisms, and emboldens trajectories of change'. The red flag provides the symbolic unity that allows us to understand our interconnected struggles.

The Scottish revolutionary John Maclean wrote of his demands beneath the red flag: 'we are out for life, and all that life can give us'. The flag, at its best and simplest, is a call for life. But it is a call that comes laden with peril. In Marc Chagall's 1937 painting *Revolution* he puts the red flag centre stage, balanced between the rushing, building force of the revolutionaries on one side and the freely expressed images of life, lovers, animals, musicians, clowns and gravity-defying dancers on the other. Bridging these two worlds is Lenin, as an acrobat, balancing on one hand. Lenin the acrobat shows us the dizzying possibilities of liberation and freedom. The painting seeks to glorify all that is life-giving about the red flag whilst also carrying with it the warning against all that can be stultifying in it too. It presents us with a red flag that is the banner of the festival of the oppressed, but cautions us not to lose ourselves in the struggle. For Chagall Lenin presides as the acrobatic ringleader, able to marshal these possibilities, able to balance, upside down and on one hand, between the forces of life and death; the guiding ideas of the red flag.

The red flag has not remained a static symbol. It is mutable, and as it has changed it has played a role in moulding the movement

and history itself. The social anthropologist Anthony Cohen suggested that: 'In the face of variability of meaning, the consciousness of community has to be kept alive through manipulation of its symbols. The reality and efficacy of the community's boundary – and, therefore, of community itself – depends upon its symbolic construction and embellishment.'[2]

The manipulation, construction and embellishment of the red flag have helped to create the boundaries of the movement. For progressive politics the role of the red flag has always been both to state outwardly 'what we want', but also to preserve and to alter a knowledge inwardly of 'who we are'. The red flag has itself defined and altered the radical communities that have created it. In each conflict the material forces acting upon society have led communities to take up and to change the flag and its meaning, and these changes and manipulations have in turn altered society. As a symbol of dissent, a demand for change, history has seen the red flag repeatedly repositioned as more radical and revolutionary in the face of each co-option and compromise. The red flag continues to answer new societal calls and to bring the theory and tactics of the past to bear on the struggles of the future.

Che Guevara is often quoted as saying:

> At the risk of seeming ridiculous, let me say that the true revolutionary is guided by a great feeling of love. It is impossible to think of a genuine revolutionary lacking this quality We must strive every day so that this love of living humanity is transformed into actual deeds, into acts that serve as examples, as a moving force.[3]

That moving force of love, driving towards a better future for humanity, is central to the red flag. But so too is death, the darker side of that transition to the future. The red flag is a symbol of love and hope to humanity, but also of violence and tyranny towards those who hold humanity back. The red of the flag has at its core a dialectic synthesis of the red of life and the red of death, one that

expands to encompass the contradictions of solidarity and freedom, love and hate.

Less frequently quoted than the words above are Guevara's comments in the ellipsis. He writes of the loving revolutionary that: 'she must combine a passionate spirit with a cold intelligence and make painful decisions without flinching'. We are invited to be entirely unalienated from great feelings of love, and of anger and hatred. Not to flinch. Painful decisions and violence must surely come in the train of the red flag.

This idea is echoed in perhaps the most famous of Mao's aphorisms:

> A revolution is not a dinner party, or writing an essay, or painting a picture, or doing embroidery; it cannot be so refined, so leisurely and gentle, so temperate, kind, courteous, restrained and magnanimous. A revolution is an insurrection, an act of violence by which one class overthrows another.[4]

The red flag persists both because of its hopeful promise and also because of the necessity of its act of violence: because the underclass must continually respond to the violence of the ruling class. The symbol of this response is the red flag. From the time when it was first flown by pirates and mutineers through its symbiotic growth with the proletariat, that new dispossessed class, to its place in the national liberation struggles of the colonised world, the red flag has been the symbol of the emergency, the demand for change, the necessity of violence in defence of the workers. The red flag first gained its modern meaning in the battle with emerging capitalism when it was raised on the barricades in Paris in 1848 and 1871, St Petersburg in 1917 and in Berlin and Turin in 1919. As capitalism mutated into imperialism and decayed into fascism the red flag found itself confronted with ever more deformed enemies. Over the next hundred years and more it has continued to be met with the brutality of the ruling class. Revealed by the brightness of a flag that flew above the defeat of Nazism is the shadow of the terrible

violence that was done to innocent people and to fellow workers in the name of that red flag and its utopian aims.

In the early nineteenth century the red flag opposed emerging capitalism in the hope of preserving a way of life. It defended the commons, pastoral knowledge and a clean and unfettered existence away from the factories. It failed in this, and in every corner of the world the emergence of capitalism resulted in a sudden and precipitous fall in life expectancy, quality of life and infant survival. In Manchester, at the centre of the Industrial Revolution, life expectancy fell to just 25 years.[5] Such unprecedented reductions in quality of life were repeated around the world as capitalism spread. This is unsurprising given the vast dispossession, enslavement and exploitation inherent in capitalism's birth. In some areas, such as the most exploited nations of South Asia, Latin America and Sub-Saharan Africa, these metrics of humanity are only now beginning to recover to their pre-capitalist levels.[6] However, in most of the world around a century after capitalism emerged – the 1900s in the centre, the 1950s in the colonised world – these statistics began to rapidly transform, with life expectancy and levels of public health far outstripping that of any pre-capitalist society. In no small part the red flag of the workers, the red flag of the peasants, helped bring about this transformation. The formation of an unrelenting bourgeoisie beneath the banner of capital found its reaction in a vast proletariat who took up the red flag and, through campaigns for restricted working hours, an end to child labour, weekends, health care and housing, secured the lives of untold millions of people.

In the twentieth century the world was twice consumed by world wars. Twice those wars were ended by the forces of the red flag. In 1918 it brought Europe to the brink of revolution and dethroned the crowned heads of state. In a shattered world after 1945 it built new institutions, flawed but capable of providing housing, healthcare and dignity for all. But the red flag's spread was ruthlessly combated by the agents of global capital in the form of the British and French Empires, the US military and the CIA. Frequently the enemies of the red flag achieved a near total break between one generation of revolutionaries and the next. But even in its defeats

the flag has never ceased to mitigate and to combat the degradation of humanity. The red flag was hunted nearly to extinction in the last century and yet still it rises.

For 200 years the red flag of life has been locked in a struggle with the death drive of capital. And yet each open grave has been a furrow for the red flag to take root in. In China in 1949 the red flag ruptured the fabric of capitalism entirely and secured incredible gains for the people.

Now in the twenty-first century the red flag stands against capitalism in its latest form, but this time it is a capitalism poised to destroy life itself. A necro-capitalism that through oil and plastic is strangling the planet. Capitalism is a mode of production that is committed not just to the degradation of our humanity, but to the destruction of our world. The red flag is deployed to defend both. If, as Walter Benjamin suggested, the red flag is the system by which humanity can apply the brakes, to stage a revolution that stops history, then the flag has never been more urgently required.

Just as the red flag was the symbol that ended the slaughter of the trenches and the holocaust, it must today be the symbol of a movement that ends the destruction of the world. It is the red of correction, the red pen that scores through a mistake, that teaches us that everything that is made can be unmade: that another world is possible.

It is clear that capitalism today is incompatible not just with tolerable human life, but with any kind of life at all. Without an economic and social revolution the forces that oppose the red flag will degrade both the earth and the workers to the point of destruction. The cause of this destruction is not mysterious, and the people preparing the apocalypse are not unknown to us. A society organised around the pursuit of profit must eventually destroy itself and its world. The red flag defending the Amazon, the red flag opposing oil pipelines, the red flag protecting rare earths in central India – these are the key sites of the struggle against this destruction. Jean Jaurès said: 'capitalism carries war within it just as clouds carry storms'. Capitalism today carries the war that sets fire to the world.

Red is, of course, the colour of socialists and of firefighters.

Today the downtrodden of the earth are more likely than they were even half a century ago to be insecurely housed, to be living from hand to mouth and to be compelled to sell their labour in order to survive. The ameliorative gains of the welfare state have been destroyed in the wake of 1989: contrary to the claims of liberals, mass healthcare and housing were nothing without the red flag, and as actually existing socialism has retreated, so too have the palliative measures taken for those suffering in the capitalist world. The working class is larger and more precarious now than it has ever been. The need to achieve its shared goal, as symbolised in the red flag, has never been so urgent.

We must comprehend the flag's past in order to envision its future. The First World War presented a caesura in which the old modes of socialist organising were proved to be wanting. The anti-colonial struggle revealed again that new identities, tactics and values were needed to carry the flag into the future. Today the climate emergency presents the same teleological challenge. As Fidel Castro said: 'throughout history, it has been demonstrated that great crises give rise to great solutions'.[7] The red flag continues to symbolise these solutions, and to constitute a solid lineage between eras of insurrection. It is able to encompass a movement, and to allow it to remake itself. How we remake it now is up to us.

The red flag continues to be the emblem of the workers, the peasants, the dispossessed; it is the flag of the Republic of Labour, emblazoned with the words 'La Liberté ou la Mort'. It flies as it always has, as a threat of death and a demand for life. Always forced on to a more radical meaning by the failures of compromise and co-option. Its revolutionary meanings continue to resonate because the material conditions we find ourselves in, though altered, are inherently and systemically identical to those that workers experienced when they first raised the flag two centuries ago. It remains to be seen whether it is in the end a flag of martyrdom or a flag of the future, a flag of utopia or a flag of tyranny. What is certain is that it remains the flag of the people. A flag that calls the people to action because we have not won, but we are not yet defeated.

Rosa Luxemburg wrote:

> The whole road of socialism – so far as revolutionary struggles are concerned – is paved with nothing but thunderous defeats. Yet, at the same time, history marches inexorably, step by step, toward final victory! Where would we be today without those 'defeats', from which we draw historical experience, understanding, power and idealism? Today, as we advance into the final battle of the proletarian class war, we stand on the foundation of those very defeats; and we can't do without any of them, because each one contributes to our strength and understanding.[8]

The red flag was born from these defeats, but it remains a flag of the future, to be flown until we reach that final victory. As the Filipina revolutionary Salud Algabre said: 'No uprising fails. Each one is a step in the right direction. In a long march to final victory, every step counts, every individual matters, every organization forms part of the whole.'

The red flag is not a symbol of victory, it is a symbol of struggle. It is the handing down of possibility, the often glimpsed alternative to oppression and degradation.

Marx called the Paris Commune an attempt at 'storming heaven'.[9] The glimpses of that heaven as it has been desperately pulled into the present are what give the red flag its power and its force. In every failed attempt to storm heaven we gain a greater view of the other world that is possible, and these defeats form a red thread that runs through history, a red thread embodied in the symbol of the red flag.

Why is the red flag red? The question can be answered historically: it is the heir to the red flags of French kings and mutinous sailors. It can be answered practically: red is the colour that is easiest to see amongst the smoke of revolution or the smog of the factory. It can be answered materially: at the moment when the proletarian class was born the same technological advances that brought about their subjugation introduced cheap bright red dyes to the masses. It can be answered culturally: the colour red symbolises passion,

anger, love, luck, beauty and sacrifice. But the strongest answer is the most universal: the red flag is red because human blood is red. It is a blood flag. It represents our shared humanity, our shared debt to the martyrs who have died so that we might have better lives. And it represents a threat to all those who would live by stealing the lifeblood of the workers.

The red flag's values are universal: equality, freedom, liberation – and so too is its symbolism: it is stained with the blood of past and future revolutionaries, the same blood that flows through all of us.

The red flag represents a continuity, a line that takes us back through time and joins every struggle together. This is the flag's power. To raise the red flag is to take a stand in the moment, but it is also to travel through time and connect with the tradition of generations of fighters before us. The red flag is a demand from the dead to the living. It represents one united struggle, a movement that has toppled kings and tsars, defeated fascism and given life and dignity to millions of workers. There is no more powerful symbol in terms of what it has achieved for humanity, and what it still can achieve.

As the world heads into the middle of another century of capitalism the people of the earth are dogged by deprivation, exploitation, alienation and mass extinction. As this battle between death and life, between the exploiting class and the people and earth, rages on, the red flag continues to be picked up by all those that demand a different future. The red flag is the signal of the emergency, and the hope for the future. A future in which no person is lessened by another. Amidst the grief and fury, the love and hate, two roads again show themselves: one is a promise of death, meted out slowly for the profit of the few; its symbol is the dollar bill. The other is a promise of life, shared and lived to its fullest; its symbol is the red flag.

Acknowledgements

All work is a collective endeavour and this book is no exception. Its existence is due to the ideas and labour of countless comrades, friends and family. Foremost amongst them are Livi Crook, Tom Coles, Kieran Hurley, Julia Taudevin, Lily Einhorn, Alex Swift, Nick Bell, Suryashekhar Biswas, Christopher Silver, Sara Shaarawi, Kate Connelly, Jo Shaw, Hannes Hellström, David Bloomfield, Tom Baxter, Katherine MacKinnon, David Lees, Hussein Mitha, John Bennett, Sebastian Bustamante, Joey Simons, Abdaljawad Omar, Mariam Alexander Baby, Felipe Bustos Sierra, Josie Giles, Kate MacLeary, David Castle, Pedro Martinez Pirez, Lou Dear, Tessa Cook, Dai Lâm Tait, Lauren Pyott, Kelly Bornshlegel, and all the staff of Pollokshields library, Isobel Neviazsky, Roberto Bastidas, Ralph Hartley, Ben White, Raph Cormack, Andrea Brazzoduro, Mark Porubcansky, Josie Long, Ewan Gibbs, Bayan Haddad, Red Sunday School, Clydeside IWW, Noam Chomsky, Leila Khaled and, above all, Karl Marx. My thanks also to Alan Bett and Viccy Adams, and everyone at Creative Scotland for funding the writing of this book. And also to the organisers and delegates of the *International Meeting of Communist and Workers' Parties*.

Notes

INTRODUCTION

1. Lissagaray, Prosper-Olivier, *Histoire de la Commune de 1871* (Paris, France: La Découverte, 2000) p.383
2. Michel, Louise, *Red Virgin* (Tuscaloosa, AL: University of Alabama Press, 1981) p.112
3. Bullard, Alice, *Primitivism, the Paris Commune of 1871 and the Making of Nineteenth-century French National Identity* (Berkeley, CA: University of California Press, 1994) p.217
4. Eichner, Carolyn J., 'Civilization vs Solidarity: Louise Michel and the Kanaks', *Salvage*, no. 4 (2017) pp.84–97
5. Avrich, Paul, *The Haymarket Tragedy* (Princeton, NJ: Princeton University Press, 1984) pp.186–190
6. Parsons, Albert R., *Life of Albert R. Parsons: With Brief History of the Labor Movement in America* (Chicago, IL: Lucy E. Parsons, 1889) p.6
7. Parsons, Lucy, 'I Am an Anarchist', *Kansas City Journal*, 21 December 1886
8. *Chicago Tribune*, 27 June 1886, quoted in Avrich, *The Haymarket Tragedy*, p.209
9. Parsons, Albert R., 'To Our Readers', *The Alarm*, vol. 1, no. 1 (1887) p.2
10. Avrich, *The Haymarket Tragedy*, p.393
11. Ibid., p.396
12. Hemingway, Ernest, quoted in *Pravda*, 23 February 1942, p.4
13. Chomsky, Noam, email to the author, 19 September 2020
14. Marx, Karl, *The Class Struggles in France 1848 to 1850* (Moscow, Russia: Progress Publishers, 1979) p.189
15. Benjamin, Walter, *Walter Benjamin: Selected Writings, 1938–1940*, ed. Marcus Bullock and Michael W. Jennings (Cambridge, MA: Harvard University Press, 1996), p.402
16. Benjamin, Walter, 'Theses on the Philosophy of History', in *Illuminations*, trans. Harry Zohn (New York: Schocken Books, 1969) p.249
17. Boylan, Henry, *A Dictionary of Irish Biography* (Dublin, Ireland: Gill & Macmillan, 1998) p.76

18. Marx, Karl, 'The Civil War in France', in *Capital, the Communist Manifesto, and Other Writings* (New York: Modern Library, 1959) p.409

CHAPTER 1

1. Corcoran, Michael, *For Which It Stands: An Anecdotal Biography of the American Flag* (New York: Simon and Schuster, 2002) pp.5–6
2. Ibid., p.8
3. Sidonius Apollinaris, *Carmina*, verse 409
4. Dennis, George T., 'Byzantine Battle Flags', *Byzantinische Forschungen*, no. 8 (1981) pp.51–60
5. Jain, Jagdish Chandra, *Life in Ancient India as Depicted in the Jain Canons* (Jalandhar, India: New Book Company, 1947) p.75
6. Pastoureau, Michel, *Red: The History of a Color* (Princeton, NJ: Princeton University Press, 2017) p.6
7. Deutscher, Guy, *Through the Language Glass: Why the World Looks Different in Other Languages* (New York: Random House, 2016) p.56
8. Tennyson, Alfred, *The Works of Alfred Lord Tennyson, Poet Laureate* (London: Macmillan, 1887) p.261
9. Amar, Z., Gottlieb, Hugo, Varshavsky, Lucy and Iluz, David, 'The Scarlet Dye of the Holy Land', *BioScience*, vol. 55, no. 12 (2005) pp.1,080–1,083
10. Bradley, Mark, *Colour and Meaning in Ancient Rome* (Cambridge, UK: Cambridge University Press, 2010) pp.194–195
11. Jacoby, David (2004) 'Silk Economics and Cross-cultural Artistic Interaction: Byzantium, the Muslim World, and the Christian West', *Dumbarton Oaks Papers* 58 (Washington, DC: Dumbarton Oaks Research Library and Collection, 2004) pp.197–240, at p.210
12. Yarshater, Ehsan, *The Cambridge History of Iran, Volume 2* (Cambridge, UK: Cambridge University Press, 1983) p.1,008
13. Konda-Kun, M., 'Красное знамя (символ революц. борьбы)' ['Red Banner (Symbol of Revolutionary Struggle)'], in Prokhorov, Alexander (ed.), *The Great Soviet Encyclopedia, Volume 13* (Moscow, Russia: Sovetskaya Entsiklopediya, 1973)
14. Pastoureau, *Red*, p.102
15. Von Querfurth, Curt O., *Kritisches Wörterbuch der heraldischen Terminologie* (Nördlingen, Germany: Verlag der C.H. Beck'schen Buchhandlung, 1872) p.118
16. Engels, Frederick, *Dialectics of Nature* [1883] (Moscow, Russia: Progress Publishers, 1964) p.20
17. Tuchman, Barbara, *A Distant Mirror* (London: Penguin, 1978) p.148

18. Southey, Robert, *Poetical Works* (Boston, MA: Little, Brown, 1864) p.181
19. Heebøll-Holm, Thomas, *Ports, Piracy and Maritime War* (Boston, MA: Brill, 2013) p.110
20. Contamine, Philippe, 'L'Oriflamme de Saint-Denis aux XIVe et XVe Siècles', *Annales de l'Est* (Nancy, France: Faculté des lettres de Nancy, 1975) pp.195–196
21. Hippolyte Taine describes a red flag above the Globe theatre in his *History of English Literature* (New York: Henry Holt, 1879). Contemporary images such as the Visscher panorama of 1616 show flags flying above the Globe and other theatres.
22. Frykman, Niklas, *Mutiny and Maritime Radicalism in the Age of Revolution: A Global Survey, International Review of Social History*, vol. 58, Special Issue S21 (2013) pp.87–107
23. Perrin, William Gordon, *British Flags* (Cambridge, UK: Cambridge University Press, 1992) p.175
24. Millington, Ellen J., *Heraldry in History, Poetry and Romance* (London: Chapman & Hall, 1858) p.27
25. Atkinson, Charles Francis, 'Fronde, The', in Chisholm, Hugh (ed.), *Encyclopædia Britannica*, vol. 11 (11th edn, Cambridge, UK: Cambridge University Press, 1911) pp. 247–249
26. Konstam, Angus, *Pirates: 1660–1730* (Oxford, UK: Osprey Publishing, 1998) p.706
27. Johnson, Captain Charles, *A General History of the Robberies and Murders of the Most Notorious Pirates – from Their First Rise and Settlement in the Island of Providence to the Present Year* (Oxford, UK: Taylor & Francis, 2013) p.482
28. Hobsbawm, Eric, *Bandits* (New York: The New Press, 2000)
29. Clifford, Barry and Kinkor, Kenneth, *Real Pirates: The Untold Story of the Whydah from Slave Ship to Pirate Ship* (Washington, DC: National Geographic, 2007) pp.80–81
30. Webster, Jane, 'Slave Ships and Maritime Archaeology: An Overview', *International Journal of Historical Archaeology*, vol. 12, no. 1 (2008) pp.6–19
31. Truly, Hans, *Rum, Sodomy, and the Lash* (New York: New York University Press, 1999) p.2
32. Frykman, *Mutiny and Maritime Radicalism in the Age of Revolution*
33. Spence, Thomas, 'The Restorer of Society to Its Natural State', in Dickinson, H.T. (ed.), *The Political Works of Thomas Spence* (Newcastle, UK: Avero, 1983) pp.69–92
34. Frykman, Niklas, *The Bloody Flag: Mutiny in the Age of Atlantic Revolution* (Berkeley, CA: University of California Press, 2020)

35. Williams, Gomer, *History of the Liverpool Privateers and Letters of Marque: With an Account of the Liverpool Slave Trade, 1744–1812* (Liverpool, UK: Liverpool University Press, 2004) pp.554–557
36. Frykman, *Mutiny and Maritime Radicalism in the Age of Revolution*
37. Williams, *History of the Liverpool Privateers and Letters of Marque*, p.557
38. *Moniteur*, 22 October 1789
39. Carlisle, Thomas, *The French Revolution: A History, Volume 1* (London: Chapman & Hall, 1894) p.15
40. Wordsworth, William, *Collected Poems* (Ware, UK: Wordsworth Editions, 1994) p.615
41. Andress, David, *Massacre at the Champ de Mars* (Woodbridge, UK: Boydell and Brewer, 2013)
42. Ibid., p.5
43. Ibid., p.193
44. *Les Révolutions de Paris*, no. 106 (1791) pp.53–55
45. Woodward, W.E., *Lafayette* (New York: Farrar & Rinehart, 1938)
46. Lamartine, Alphonse, *Memoirs* (London: George Bell & Sons, 1890) p.285
47. Adolphus, John, *The History of France from the Year 1790 to the Peace Concluded at Amiens in 1802* (London: George Kearsley, 1803) p.417
48. Jaurès, Jean, *A Socialist History of the French Revolution* (London: Left Book Club, 2022) p.97
49. Ibid., p.98
50. *Le Parisien*, 11 July 2011
51. Jaurès, *A Socialist History of the French Revolution*, p.98
52. Dommanget, Maurice (ed.), *Histoire du Drapeau Rouge* (Marseille, France: Le Mot et Le Reste, 2006) p.18
53. Collins, James B., *La Bretagne dans l'État Royal: Classes Sociales, États Provinciaux et Ordre Public de l'Édit d'Union à la Révolte des Bonnets Rouges* (Rennes, France: Presses Universitaires de Rennes 2006)
54. Albert Mathiez, *Les Origines des Cultures Révolutionnaires, 1789–1792* (Paris, France: G. Bellais, 1904) p.34
55. Fleischman, Hector, *Robespierre and the Women He Loved* (London: John Long, 1913) p.329. Robespierre suggested that the red cap would be taken by enemies of liberty to be a sign of frivolity and factionalism in the republican movement.
56. Mosse, George L., *The Nationalization of the Masses: Political Symbolism and Mass Movements in Germany from the Napoleonic Wars through the Third Reich* (New York, Howard Fertig, 1975)
57. Elgenius, Gabriella, 'Expressions of Nationhood: National Symbols and Ceremonies in Contemporary Europe', thesis submitted for the

degree of Doctor of Philosophy, London School of Economics and Political Science, University of London, 2005, p.25

58. Cohen, Anthony P., *The Symbolic Construction of Community* (London: Routledge, 1995) p.19
59. Knowlton, Stephen A., 'Contested Symbolism in the Flags of New World Slave Risings', *Raven*, no. 21 (2014) p.76
60. Postgate, Raymond, *1796: The Story of a Year* (New York: Harcourt, Brace & World, 1969) p.62
61. *Hull Packet*, 5 September 1815
62. *Suffolk Chronicle*, 9 September 1815
63. *Dublin Evening Post*, 3 August 1830
64. Frykman, *Mutiny and Maritime Radicalism in the Age of Revolution*
65. Coats, Anne Veronica, *The Naval Mutinies of 1797* (London: Boydell Press, 2011) p.1
66. Frykman, *The Bloody Flag*, p.10
67. Coats, *The Naval Mutinies of 1797*, pp.2–5
68. Frykman, *Mutiny and Maritime Radicalism in the Age of Revolution*
69. Gill, Conrad, *The Naval Mutinies of 1797* (Manchester, UK: Manchester University Press, 1913) p.13
70. Coats, *The Naval Mutinies of 1797*, p.10
71. Bates, Iain M., *Champion of the Quarterdeck: Admiral Sir Erasmus Gower (1742–1814)* (Pomona, Australia: SAGE Old Books, 2017) pp.231–243
72. Hawkins, Anne and Watt, Helen, '"Now Is Our Time, the Ship Is Our Own, Huzza for the Red Flag": Mutiny on the Inspector, 1797', *The Mariner's Mirror*, vol. 93 (2007) pp.156–179
73. Perrin, *British Flags*, p.175
74. Frykman, *Mutiny and Maritime Radicalism in the Age of Revolution*
75. Ibid., pp.87–107
76. Frykman, Niklas, 'The Mutiny on the Hermione: Warfare, Revolution, and Treason in the Royal Navy', *Journal of Social History*, vol. 44, no. 1 (2010) pp.159–187
77. *The Monthly Mirror Reflecting Men and Morals*, vol. IV (1797) p.18
78. Pfaff, Steven et al., 'The Problem of Solidarity in Insurgent Collective Action', *Social Science History*, vol. 40, no. 2 (2016) pp. 247–270
79. Jaurès, Jean, 'Les Drapeaux', in Dommanget, *Histoire du Drapeau Rouge*, pp.496–498

CHAPTER 2

1. Silby, Joe, *The Trial Complete of Richard Parker, President of the Delegates, for Mutiny* (London: John Fairburn, 1797) p.14

2. *Bell's Weekly Messenger*, 24 December 1797
3. Foster, John, *Class Struggle and the Industrial Revolution* (Abingdon, UK: Taylor & Francis, 2003) p.36
4. Ibid., p.38
5. Ibid.
6. *Champion* (London), 28 December 1818
7. *Champion* (London), 8 March 1819
8. Stott, France, *Looking Back at Royton* (Oldham, UK: Oldham Arts and Heritage, 1994)
9. Rogers, Nicholas, *Crowds, Culture, and Politics in Georgian Britain* (Oxford, UK: Clarendon Press, 1998) p.242
10. *Caledonian Mercury*, 23 August 1819
11. Demson, Michael (ed.), *Commemorating Peterloo* (Edinburgh, UK: Edinburgh University Press, 2019)
12. *London Morning Herald*, 3 September 1819
13. *Glasgow Herald*, 21 August 1820
14. Stevenson, John, *A True Narrative of the Radical Rising* (Glasgow, UK: W. & W. Miller, 1835)
15. *The Chartist Circular* (Glasgow), May 1838
16. McCombes, Alan and Paterson, Roz, *Restless Land* (Glasgow, UK: Calton Books, 2014) pp.189–204
17. Donnachie, Ian and Lavin, Carmen, *From Enlightenment to Romanticism, Anthology One* (Manchester, UK: Manchester University Press, 2003) pp.184–202
18. Bloom, Clive, *Riot City, Protest and Rebellion in the Capital* (London: Palgrave Macmillan, 2012) p.156
19. Roberts, Tom and Iles, Anthony, *All Knees and Elbows of Susceptibility and Refusal: Reading History from Below* (Glasgow, UK: Transmission Gallery, 2012) p.176
20. Hoyle, Martin, *The Axe Laid to the Root: The Story of Robert Wedderburn* (Watton at Stone, UK: Hansib, 2016) p.61
21. Sperber, Jonathon, *Rhineland Radicals* (Princeton, NJ: Princeton University Press, 2021) p.161
22. Williams, Gwyn A. *The Merthyr Rising* (Abingdon, UK: Taylor & Francis, 2021) p.26
23. *Bristol Times and Mirror*, 15 October 1831
24. Williams, *The Merthyr Rising*, p.18
25. Williams, Gwyn A., 'Lewis, Richard [Known as Dic Penderyn]', in Goldman, Lawrence (ed.), *Oxford Dictionary of National Biography* (Oxford, UK: Oxford University Press, 2004)
26. *Northern Star and Leeds General Advertiser*, 11 September 1841, explicitly references a red flag with the motto. Countless news reports

over the preceding decade note flags daubed 'bread or blood', but don't note their colour.
27. *True Sun*, 9 April 1835
28. Marvin, C. and Ingle, D.W., *Blood Sacrifice and the Nation: Totem Rituals and the American Flag* (New York: Cambridge University Press, 1999) p.63
29. Horkheimer, Max and Adorno, Theodor, *Dialectic of Enlightenment* (Redwood City, CA: Stanford University Press, 2002)

CHAPTER 3

1. Forbes, Amy Wiese, *The Satiric Decade: Satire and the Rise of Republican Political Culture in France, 1830–1840* (Lanham, MD: Lexington Books, 2010) p.32
2. Harsin, Jill, *Barricades: The War of the Streets in Revolutionary Paris, 1830–1848* (New York: Palgrave, 2002) p.58
3. Hugo, Victor, *Les Misérables* (New York: T.Y. Crowell, 1887) p.221
4. Houssaye, Arsène, *Man about Paris* (New York: Morrow, 1970) pp.18–19
5. House, Jonathan M., *Controlling Paris* (New York: New York University Press, 2014) p.44
6. Sarrans, Bernard, *Lafayette, Louis-Philippe, and the Revolution of 1830* (London: Effingham Wilson, 1832) p.281
7. Heine, Heinrich, *Selected Works* (New York: Vintage Books, 2010) p.94
8. *Le National*, 9 June 1832
9. Forbes, *The Satiric Decade*, p.32
10. Mansel, Philip, *Paris between Empires: Monarchy and Revolution, 1814–1852* (New York: St. Martin's Press, 2003) p.285
11. Heine, *Selected Works*, p.94
12. Nedd, Andrew M. and Goldstein, Robert Justin, *Political Censorship of the Visual Arts in Nineteenth-century Europe* (New York: Palgrave Macmillan, 2015) p.77
13. Harsin, *Barricades*, p.61
14. Sarrans, *Lafayette, Louis-Philippe, and the Revolution of 1830*, p.282
15. Corcoran, Paul E. and Fuchs, Christian, *Before Marx: Socialism and Communism in France 1830–1848* (London: Palgrave Macmillan, 1983) pp.3–4
16. Hugo, Victor, *Choses Vues: Souvenirs, Journaux, Cahiers, 1830–1885* (Paris, France: Editions Gallimard, 2002) p.76
17. Behrent, Megan, 'The Enduring Relevance of Victor Hugo', *International Socialist Review*, no. 89 (2013)

18. Robb, Graham, *Victor Hugo: A Biography* (New York: W.W. Norton, 1997) p.377
19. Ibid., p.378
20. Hugo, *Les Misérables*, p.36
21. Ibid., p.767
22. *Moniteur*, 15 April 1834
23. Kropotkin, Peter, *Words of A Rebel* (Oakland, CA: PM Press, 2022) p.295
24. Olsen, James, S. and Roberts, Randy, *A Line in the Sand: The Alamo in Blood and Memory* (New York: Free Press, 2001) p.124
25. Pécout, Gilles, *Il Lungo Risorgimento: La Nascita Dell'italia Contemporanea (1770–1922)* (Rome, Italy: Mondadori, 1999) p.173
26. *The Charter*, 16 June 1839
27. Harsin, *Barricades*, p.139
28. Marx, Karl, 'Critical Notes on the King of Prussia', *Vorwarts!*, no.64, 10 August 1844
29. Pasolini, Pier Paulo, 'Alla Bandiera Rossa' (1982)
30. Marx, Karl, 'The Class Struggles in France', in *Karl Marx: Selected Writings* (Oxford, UK: Oxford University Press, 2000) p.231
31. Marx, Karl, 'The Economic and Philosophical Manuscripts of 1844, Third Manuscript', in *Karl Marx: Early Writings* (London: C.A. Watts, 1963) p.176
32. Fernbach, David, 'Introduction', in Marx, Karl, *The Revolutions of 1848* (New York: Random House, 1973) pp.23–24
33. Hobsbawm, E.J., *The Age of Revolution 1789–1848* (London: Abacus, 1994) p.359
34. Engels, Frederick, 'The Reform Movement in France', *The Northern Star*, 20 November 1847
35. Ibid.
36. Marx, Karl, *The Class Struggles in France 1848 to 1850* (Moscow, Russia: Progress Publishers, 1979) p.27
37. Dommanget, Maurice (ed.), *Histoire du Drapeau Rouge* (Marseille, France: Le Mot et Le Reste, 2006) p.76
38. Bakunin, Mikhail, *The Confession*, trans. Robert C. Howes (Ithaca, NY: Cornell University Press, 1977), pp 54–57
39. Perreux, Gabriel, *Les Origines du Drapeau Rouge en France* (Paris, France: Presses Universitaires de France, 1930) p.76
40. Lamartine, Alphonse, *Memoirs* (London: George Bell & Sons, 1890) p.XVII
41. Lamartine, Alphonse, *History of the French Revolution of 1848, Volumes 1–2* (Boston, MA: Philips, Sampson, 1854) pp.198–199
42. Ibid.

43. Bookchin, Murray, *The Third Revolution: Popular Movements in the Revolutionary Era, Volume 2* (London: Cassell, 1998) pp.102–105
44. Marx, Karl, 'The Class Struggles in France', in *Karl Marx: A Reader* (Cambridge, UK: Cambridge University Press, 1986) p.251
45. Proudhon, Pierre-Joseph, 'Dilemma: Red or White, 1850', in McKay, Iain (ed.), *Property Is Theft! A Pierre-Joseph Proudhon Anthology* (Oakland, CA: AK Press, 2010) pp.257–258
46. Hazan, Eric, *A History of the Barricade* (London: Verso, 2015) p.77
47. Chase, William, S., *1848, a Year of Revolutions* (London: H.E. Robbins, 1850) p.253
48. Ibid., p.204
49. Thayer, William Roscow, *The Dawn of Italian Independence* (Boston, MA: Houghton Mifflin, 1893) p.389
50. Harney, George Julian, *The Northern Star*, 30 September 1848, p.3
51. Sperber, Jonathan, *The European Revolutions 1848–1851* (Cambridge, UK: Cambridge University Press, 2005) p.80
52. Marx, Karl and Engels, Frederick, 'The Communist Manifesto', in *Selected Works in One Volume* (London: Lawrence & Wishart, 1968) p.63
53. Moss, Bernard H., 'Marx and the Permanent Revolution in France: Background to the Communist Manifesto', *Socialist Register*, vol. 34 (1998) pp.158–160
54. Carver, Terrel, *The Life and Thought of Friedrich Engels* (New York: Springer International, 2020) p.221
55. Sperber, Jonathan, *Rhineland Radicals* (Princeton, NJ: Princeton University Press, 2021) p.359
56. Engels, Frederick, 'The Uprising in Frankfurt', *Neue Rheinische Zeitung*, no. 108 (1848)
57. Engels, Frederick, 'The Campaign for the German Imperial Constitution', in *Marx and Engels: Collected Works, Volume 10* (London: Lawrence & Wishart, 1978) p.173
58. Hazan, *A History of the Barricade*, pp.86–87
59. Boime, Albert, *Art in an Age of Civil Struggle, 1848–1871* (Chicago, IL: University of Chicago Press, 2008) p.532
60. Hazan, *A History of the Barricade*, p.90
61. Ibid., p.95
62. Marx, Karl, 'The Eighteenth Brumaire of Louis Bonaparte', in *Marx and Engels: Selected Works in One Volume* (London: Lawrence & Wishart, 1968) p.104
63. Marx, Karl, 'The Class Struggles in France', in *Marx and Engels: Collected Works, Volume 10* (London: Lawrence & Wishart, 1978) p.79
64. Proudhon, *Dilemma*

65. Marx, 'The Eighteenth Brumaire of Louis Bonaparte'
66. Marx, 'The Class Struggles in France', p.126
67. Hayward, Jack, *After the French Revolution: Six Critics of Democracy and Nationalism* (London: Harvester Wheatsheaf, 1991) pp.245–246
68. Schurz, Carl, *The Reminiscences of Carl Schurz* (New York: McClure, 1908) p.402
69. Fleche, Andre, M., *The Revolution of 1861: The American Civil War in the Age of Nationalist Conflict* (Chapel Hill, NC: University of North Carolina Press, 2012) p.24
70. Whitman, Walt, 'Resurgemus', *New York Daily Tribune*, 21 June 1850, p.3

CHAPTER 4

1. Jaurès, Jean, 'Les Drapeaux', in Dommanget, Maurice (ed.), *Histoire du Drapeau Rouge* (Marseille, France: Le Mot et Le Reste, 2006) pp.496–498
2. Traverso, Enzo, *Revolution: An Intellectual History* (London: Verso: 2021) p.200
3. Marx, Karl and Engels, Frederick, *Collected Works of Karl Marx and Frederick Engels, Volume 12* (New York: International Publishers, 1979) pp.669–670
4. Karl Marx, *The Karl Marx Library, Volume 3: On the First International*, trans. Padover, Saul K. (New York: McGraw-Hill, 1971) p.xiv
5. Babel, Antony, *La Première Internationale, Ses Débuts et Son Activité à Genève de 1864 à 1870* ['The First International, Its Early Days and Its Activities in Geneva from 1864 to 1870'], (Geneva, Switzerland: Georg & Co., 1944) p.256
6. Fribourg, E.E., *L'Association Internationale des Travailleurs* (Paris, France: Armand Le Chevalier, 1871) p.164
7. Marx, Karl, *Capital, Volume 1* (London: Laurence & Wishart, 1970) pp.264–265
8. Ibid., p.301
9. *Christian Observer*, vol. 68 (1868) p.457
10. Fribourg, *L'Association Internationale des Travailleurs*, p.101
11. Hübner, Hans, *Aus der Geschichte der roten Fahne* (Berlin, Germany: Dietz Verlag, 1962) pp.22–23
12. Bebel, A., *Aus Meinem Leben* (Berlin, Germany: Dietz Verlag, 1961) p.394
13. Tchernoff, Jo, *Dans le Creuset des Civilisations* (Paris, France: Rieder, 1936) p.122

NOTES

14. Taylor, A.J.P., *Bismarck: The Man and the Statesman* (London: Hamish Hamilton, 1955) p.133

CHAPTER 5

1. Milza, Pierre, *L'Année Terrible: La Commune (Mars–Juin 1871)* (Paris, France: Perrin, 2009), p.65
2. Hutton, Patrick F., *The Cult of the Revolutionary Tradition: The Blanquists in French Politics, 1864–1893* (Oakland, CA: University of California Press, 1981) p.31
3. Von Waldersee, Alfred, *A Field Marshal's Memoirs* (Burke, VA: Borodino Books, 2019) p.20
4. Milza, *L'Année Terrible*, pp.143–145
5. Ibid., p.421
6. Ibid., pp.9–18
7. Ibid., p.77
8. *The Economist*, 25 March 1871
9. Bookchin, Murray, *The Third Revolution: Popular Movements in the Revolutionary Era, Volume 2* (London: Cassell, 1998) p.246
10. Hazan, Eric, *A History of the Barricade* (London: Verso, 2016) p.109
11. Bookchin, *The Third Revolution*, p.223
12. Ibid., pp.228–229
13. Marx, Karl, *The Civil War in France* (Peking, China: Foreign Languages Press, 1977) pp.74–77
14. Lenin, V.I., 'In Memory of the Commune', *Rabochaya Gazeta*, 28 April 1911
15. Marx, *The Civil War in France*, p.84
16. Traverso, Enzo, *Revolution: An Intellectual History* (London: Verso, 2021) p.200
17. Morris, William, 'Socialism from the Root Up', *Commonweal*, vol. 2, no. 38 (1886) p.210
18. Benham, George, B., *The Story of the Red Flag: Its Origin, Ancient and Present Place in the History of the World* (New York: Socialistic Cooperative Publishing Association, 1897) p.16
19. Edwards, Stewart, *Communards of Paris* (Ithaca, NY: Cornell University Press, 1973) p.140
20. Castagnary, Jules-Antoine, *Gustave Courbet et la Colonne Vendôme* (Paris, France: E. Dentu, 1883) p.27
21. Horne, Alistair, *The Fall of Paris: The Siege and the Commune 1870–71* (New York: St. Martin's Press, 1965) p.351
22. Milza, *L'Année Terrible*, pp. 294–296

23. Ross, Kristin, *Communal Luxury: The Political Imaginary of the Paris Commune* (London: Verso Books, 2016) p.23
24. Horne, *The Fall of Paris*, pp.340–350
25. Ibid., pp.340–350
26. *The Economist*, 11 March 1871
27. Horne, *The Fall of Paris*, pp.340–350
28. Fetridge, W. Pembroke, *The Rise and Fall of the Paris Commune in 1871* (New York: Harper & Brothers, 1871) pp.78–80
29. Lissagaray, Prosper-Olivier, *History of the Commune of 1871* (London: Reeves and Turner, 1886) pp.278–280
30. Marx, *The Civil War in France*, p.94
31. In his *Instruction for an Armed Uprising* in 1868 Blanqui implored the Parisian working class 'above all, not to become shut up, each in his quartier, as all uprisings have never failed to do'; quoted in Bookchin, *The Third Revolution*, p.247
32. Dommanget, Maurice (ed.), *Histoire du Drapeau Rouge* (Marseille, France: Le Mote et le Reste, 2006) p.174
33. Bookchin, *The Third Revolution*, p.247
34. Lissagaray, *History of the Commune of 1871*
35. Bookchin suggests 30,000 casualties, Lissagray, Lenin and others claim 20,000, whereas Jacques Rougerie and Robert Tombs say that at least 10,000 can be evidenced. The true number will never be known, but the immensity of the slaughter is indisputable.
36. Milza, *L'Année Terrible*, pp.431–432
37. Bookchin, *The Third Revolution*, p.249
38. Zola, Émile, 'Notes Parisiennes', *Le Sémaphore de Marseille*, 3 June 1871
39. Fetridge, *The Rise and Fall of the Paris Commune in 1871*, pp.296 and 318
40. Marforio (pseudym of Lacroix, Louise), *Les Echarpes Rouges, Souvenirs de la Commune*, (Paris, France: Libraire Centrale, 1872) pp.8–9
41. Ramsay, Raylene L., *French Women in Politics: Writing Power, Paternal Legitimization, and Maternal Legacies* (Berlin, Germany: Berghahn Books, 2003) p.31
42. Thomas, Edith, *The Women Incendiaries*, trans. Atkinson, James and Atkinson, Starr (London: Secker & Warburg, 1967) p.170
43. Institute of Marxism-Leninism of the C.C., C.P.S.U. (ed.), *Documents of the First International, Volume V: 1871–1872* (London: Lawrence & Wishart, 1964) p.144
44. Trotsky, Leon, 'Lessons of the Paris Commune', *New International*, vol. 2, no. 2 (1935) pp.43–47

45. Harrison, Royden, 'Marx, Engels, and the British Response to the Commune', *The Massachusetts Review*, vol. 12, no. 3 (1971) pp.463–477
46. Engels, Frederick, 'The Program of the Blanquist Fugitives from the Paris Commune', *Der Volksstaat*, no.73, 26 June 1874
47. *Documents of the First International, 1871–1872*, p.32
48. Interview with Karl Marx in *New York World*, 18 July 1871
49. Engels, 'The Program of the Blanquist Fugitives from the Paris Commune'
50. Gallice, Guy and Zamensky, Pierre, *Sous les Plis du Drapeau Rouge* (Paris, France: Edition de Rouergue, 2010) p.10. No better book exists than this if you want a catalogue of red flags through history.
51. Niven, John, *Years of Turmoil: Civil War and Reconstruction* (Boston, MA: Addison-Wesley, 1969) p.160
52. Messer-Kruse, Timothy, *The Yankee International: Marxism and the American Reform Tradition, 1848–1876* (Chapel Hill, NC: University of North Carolina Press, 2000) p.120
53. Ibid., pp.1–2
54. Ibid., p.101
55. Hutton, *The Cult of the Revolutionary Tradition*, pp.121–122
56. Morris, William, 'The Pilgrims of Hope', *Commonweal*, 3 July 1886
57. Holland, Owen, *Literature and Revolution: British Responses to the Paris Commune of 1871* (New Brunswick, NJ: Rutgers University Press, 2022) p.140
58. Traverso, Enzo, *Left-wing Melancholia: Marxism, History, and Memory* (New York: Columbia University Press, 2016) p.34
59. Michel, Louise, *Red Virgin* (Tuscaloosa, AL: University of Alabama Press, 1981) p.68
60. Hobsbawm, Eric, *Introduction to the Communist Manifesto* (London: Verso, 2012)
61. Leipziger Hochverratsprozess, 11–26 March 1872, pp.287–288
62. Ibid.

CHAPTER 6

1. Locomotive Act 1865 (Red Flag Act)
2. Bookchin, Murray, *The Third Revolution: Popular Movements in the Revolutionary Era, Volume 2* (London: Cassell, 1998) p.259
3. Robertson, Ann, 'The Philosophical Roots of the Marx–Bakunin Conflict', *What Next?*, December 2003
4. Bakunin, Michael, *Marxism, Freedom and the State* (London: Freedom Press, 1950) p.43

5. Marx, Karl and Engels, Frederick, *Selected Works in One Volume* (New York, 1968) p.323
6. Ely, Richard T., *The Labor Movement in America* (London: Macmillan, 1905) p.100
7. Marx, Karl, *Capital, Volume One* (London: Laurence & Wishart, 1970) pp.759–769
8. Ibid., p.301
9. Du Bois, W.E.B., *The World and Africa: An Inquiry into the Part Which Africa Has Played in World History* (New York: International Publishers, 1965) pp.18–21
10. Roediger, David, R., *Towards the Abolition of Whiteness* (London: Verso, 1994) p.27
11. Smith, Shannon M., '"They Met Force with Force": African American Protests and Social Status in Louisville's 1877 Strike', *Register of the Kentucky Historical Society*, vol. 115, no. 1 (2017) pp.1–37
12. McCabe, James D., *The History of the Great Riots* (Philadelphia, PA: Philadelphia National Publishing Company, 1877)
13. Taylor, Nikki, M., *America's First Black Socialist* (Lexington, KY: University Press of Kentucky, 2013) pp.146–148
14. Johnson, Oakley, *Marxism in United States History before the Russian Revolution* (New York: Humanities Press, 1974) p.77
15. McInnis, Maurie D., *Slaves Waiting for Sale: Abolitionist Art and the American Slave Trade* (Chicago, IL: University of Chicago Press, 2011) pp.85–86
16. Contemporary article in the *New York Daily Tribune*, quoted in 'The End of The Slave Trade', *New York Times*, 27 March 2015
17. Morgan, A.A., *Precarious Lives: Black Seminoles and Other Freedom Seekers in Florida before the US Civil War* (self-published by author, 2020) p.48
18. Shilliam, Robbie, 'In Recognition of the Abyssinian General', in Hayden, Patrick and Schick, Kate (eds), *Recognition and Global Politics: Critical Encounters between State and World* (Manchester, UK: Manchester University Press, 2016) pp.121–138
19. Rasmussen, Daniel, *American Uprising: The Untold Story of America's Largest Slave Revolt* (New York: Harper, 2011) p.26
20. Shilliam, 'In Recognition of the Abyssinian General'
21. Kaufman, Jason, '"Rise and Fall of a Nation of Joiners": The Knights of Labor Revisited', *Journal of Interdisciplinary History*, vol. 31, no. 4 (2001) pp. 553–579
22. Powderly, Terence Vincent, *Thirty Years of Labor, 1859–1889* (Columbus, OH: Excelsior Publishing, 1889) p.556

23. Goldman, Emma, *Living My Life*, vols 1 and 2 (New York: Dover Publications, 1970) p.80
24. Ibid., p.245
25. Falk, Candice, *Love, Anarchy and Emma Goldman* (New Brunswick, NJ: Rutgers University Press, 2019)
26. *Detroit Journal*, 16 November 1897, quoted in Kowal, Donna M., *Tongue of Fire: Emma Goldman, Public Womanhood, and the Sex Question* (New York: New York University Press, 2016) p.106
27. *New York World*, 17 September 1893, quoted in Kowal, *Tongue of Fire*, p.97
28. Ferguson, Kathy E., *Emma Goldman: Political Thinking in the Streets* (Lanham, MD: Rowman & Littlefield, 2011) p.218
29. David, Henry, *The History of the Haymarket Affair* (New York: Collier Books, 1963) pp.21–35
30. US Bureau of the Census, *Historical Statistics of the United States, Colonial Times to 1970* (Washington, DC: US Bureau of the Census, 1975)
31. Halker, Bucky, *For Democracy, Workers, and God: Labor Song-poems and Labor Protest* (Chicago, IL: University of Illinois Press, 1991) p.35
32. Schaack, Michael J., *Anarchy and Anarchists* (Chicago, IL: F.J. Schulte, 1889) p.364
33. Foner, Philip, S., *Our Own Time: A History of American Labor and the Working Day* (London: Verso, 1989) p.140
34. Foner, Philip S., *May Day: A Short History of the International Workers' Holiday, 1886–1986* (New York: International Publishers, 1986) pp.27–28
35. Green, James R., *Death in the Haymarket: A Story of Chicago, the First Labor Movement and the Bombing That Divided Gilded Age America* (New York: Pantheon Books, 2006) pp.162–173
36. Austin, H. Russel, *The Wisconsin Story: The Building of a Vanguard State* (Milwaukee, WI: The Milwaukee Journal, 1969) p.250
37. Foner, *Our Own Time*, pp.140–141
38. Haymarket Trial witness statements, quoted in Schaack, *Anarchy and Anarchists*, pp.480–490
39. *Chicago Tribune*, 27 June 1886
40. Schaack, *Anarchy and Anarchists*, p.377
41. Foner, *Our Own Time*, p.143
42. Parsons, Albert, *Anarchism* (Chicago, IL: Mrs Parsons, 1887) p.86
43. Ibid., p.66
44. Ibid., pp.73–74
45. Ibid., p.83

46. Ibid., p.103
47. Avrich, Paul, *The Haymarket Tragedy, Volume 2* (Princeton, NJ: Princeton University Press, 1984) p.395
48. Haymarket trial witness statements, quoted in Schaack, *Anarchy and Anarchists*, pp.648–649
49. Thompson, E.P., *William Morris: Romantic to Revolutionary* (New York: Pantheon Books, 1976) p.507
50. Foner, *May Day*, p.43
51. Ibid., pp.44–45
52. Peterson, Abby et al., *The Ritual of May Day in Western Europe* (London: Taylor & Francis, 2016) p.134
53. Worley, Matthew (ed.), *The Foundations of the British Labour Party* (Farnham, UK: Ashgate, 2009) p.84
54. Connell, Jim, *Confessions of a Poacher* (London: Lilliput Press, 2004) p.154
55. Mann, Tom, *Tom Mann's Memoirs* (Nottingham, UK: Spokesman, 2008) p.68
56. Ibid., p.68
57. Dommanget Maurice, *Histoire du Drapeau Rouge* (Marseille, France: Le Mote et le Reste, 2006) p.197
58. Larson, Sean, 'The Rise and Fall of the Second International', *Jacobin*, 14 July 2017
59. Ibid.
60. Lenin, V.I., 'The International Socialist Congress in Stuttgart', *Kalendar Dlya Vsekh* (1908)
61. Khudekov N.S., *Riot in Kandeevka in 1861: The End of Serfdom in Russia* (Moscow, Russia: Moscow State University, 1994)
62. Dommanget, *Histoire du Drapeau Rouge*, p.194
63. Kropotkin, Peter, *Kropotkin: 'The Conquest of Bread' and Other Writings* (Cambridge, UK: Cambridge University Press, 1995) p.218
64. Taber, Mike (ed.), *Under the Socialist Banner: Resolutions of the Second International, 1889–1912* (Chicago, IL: Haymarket Books, 2021)
65. Chisholm, Hugh (ed.), 'Burns, John', in *Encyclopædia Britannica* (Cambridge, UK: Cambridge University Press, 1911)
66. Cockcroft, James, D., *Mexico's Revolution Then and Now* (New York: Monthly Review Press, 2012) p.26
67. Bascomb, Neal, *Red Mutiny: Eleven Fateful Days on the Battleship Potemkin* (Boston, MA: Houghton Mifflin, 2007) pp.55–60 and 112–127
68. Lenin, V.I., *Complete Works, Volume Eleven* (Moscow, Russia: Progress Press, 1972) p.175
69. Bascomb, *Red Mutiny*, p.185

70. Work, Clemens P., *Darkest before Dawn: Sedition and Free Speech in the American West* (Albuquerque, NM: University of New Mexico Press, 2006) p.34
71. Smith, Gibbs, *Joe Hill* (Salt Lake City, UT: Gibbs Smith, 2009) p.154
72. Cornell, Andrew, *Unruly Equality: U.S. Anarchism in the Twentieth Century* (Oakland, CA: University of California Press, 2016) p.23
73. From *The IWW's Killed Project* at the University of Washington, Seattle, WA
74. Cornell, *Unruly Equality*, p.24
75. 'The Contemptible Red Flag', *New York Times*, 21 September 1912
76. Bowen Raddeker, Helene, *Treacherous Women of Imperial Japan* (Abingdon, UK: Routledge, 1997) p.6
77. Kautsky, Karl, *Socialism and Colonial Policy, 1907)* (London, Athol Books, 1975) p.7

CHAPTER 7

1. Gallacher, W., *Revolt on the Clyde* (London: Lawrence & Wishart, 1936) p.18
2. Shor, Francis, 'The IWW and Oppositional Politics in World War I: Pushing the System beyond Its Limits', *Radical History Review*, no. 64 (1996) pp.75–94
3. Connolly, James, 'Labour in the New Irish Parliament', *Forward*, 4 July 1914
4. Barekat, Houman and Gonzalez, Mike (eds), *Arms and the People* (London: Pluto Press, 2013) p.63
5. Trotsky, Leon, *History of the Russian Revolution* (Chicago, IL: Haymarket, 2008) p.76
6. Häikiö, Martti, *A Brief History of Modern Finland* (Helsinki, Finland: University of Helsinki, 1992) p.18
7. Gerwarth, Robert, *November 1918: The German Revolution* (Oxford, UK: Oxford University Press, 2020) p.87
8. Bell, Christopher and Elleman, Bruce, *Naval Mutinies of the Twentieth Century: An International Perspective* (London: Frank Cass, 2003) p.99
9. Ibid.
10. Gerwarth, *November 1918*, p.97
11. Ibid., p.119
12. Ibid., p.99
13. Rothstein, Andrew, *The Soldiers' Strikes of 1919* (New York: Springer, 1980) pp.73–81

14. Carew, Anthony, *The Lower Deck of the Royal Navy 1900–39* (Manchester, UK: Manchester University Press, 1981) p.104
15. Kershaw, Ian, *Hitler 1889–1936: Hubris* (New York: W.W. Norton, 1999) pp.112–116
16. 'Winston Churchill's Shocking Use of Chemical Weapons', *The Guardian*, 1 September 2013
17. Perry, Matt, 'During the Black Sea Mutiny, French Sailors Rejected France's War on Soviet Russia', *Jacobin*, 27 December 2020
18. Montefiore, Dora, 'Impressions of the Reception of John Maclean', *The Call*, 12 December 1918, p.6
19. Bell, Henry, *John Maclean: Hero of Red Clydeside* (London: Pluto Press, 2018) pp.132–135
20. Evans, Raymond, 'Agitation, Ceaseless Agitation: Russian Radicals in Australia and the Red Flag Riots', in McNair, John and Poole, Thomas (eds), *Russia and the Fifth Continent* (Brisbane, Australia: University of Queensland Press, 1992) pp. 126–171
21. Cannistraro, Philip V. and Meyer, Gerald, *The Lost World of Italian American Radicalism* (Westport, CT: Praeger, 2003) p.17
22. Hughes, Langston, *Scotsboro Limited* (New York: Golden Stair Press, 1932) p.19
23. Battista, Santhià, *Con Gramsci all'Ordine Nuovo* (Firenze, Italy: Editori Riuniti, 1956) p.99
24. Muehlebach, Andrea, *The Moral Neoliberal: Welfare and Citizenship in Italy* (Chicago, IL: University of Chicago Press, 2012) p.189
25. Ebner, Michael, R., *Ordinary Violence in Mussolini's Italy* (Cambridge, UK: Cambridge University Press, 2011) p.28
26. Ibid., pp.29–30
27. Luxemburg, Rosa, 'What Does the Spartacus League Want?', *Rote Fahne*, 12 December 1918
28. Dillon, Christopher, 'The German Revolution of 1918/19', in Rossol, Nadine and Ziemann, Benjamin (eds), *The Oxford Handbook of the Weimar Republic* (Oxford, UK: Oxford University Press, 2022) p.38
29. Luxemburg, Rosa et al., 'A Call to the Workers of the World', *Rote Fahne*, 25 November 1918
30. Lloyd George, David, *A Diary* (London: Harper & Row, 1971) p.309

CHAPTER 8

1. Dralyuk, Boris (ed.), *Stories and Poems from the Russian Revolution* (London: Pushkin Press, 2016) pp.15–25
2. Prashad, Vijay, *Red Star Over the Third World* (New Delhi, India: LeftWord Books, 2017) p.21

NOTES

3. McCaffray, Susan, *The Winter Palace and the People* (DeKalb, IL: Northern Illinois University Press, 2018) p.204
4. Orlovsky, Daniel, *A Companion to the Russian Revolution* (Hoboken, NJ: John Wiley and Sons, 2020) p.179
5. Ibid.
6. Pastoureau, Michel, *Red* (Princeton, NJ: Princeton University Press, 2017) p.172
7. Regulations on the State Flag of the Union of Soviet Socialist Republics, date of adoption: 19 August 1955
8. Liebowitz, Ronald, *Education and Literacy Data in Russian and Soviet Censuses* (Ithaca, NY: Cornell University Press, 1986) pp.155–170
9. Mace, David R., 'The Employed Mother in the U.S.S.R.', *Marriage and Family Living*, vol. 23, no. 4 (1961) pp.330–333
10. Podolsky, Edward, 'Some Achievements of Soviet Medical Research', *The Russian Review*, vol. 6, no. 1 (1946) pp.77–83
11. Einstein, Albert, *What Russia Means to Us* (New York: Jewish Council for Russian War Relief, 1942) p.1
12. Chaterjee, S., 'Science in Soviet Russia', *The Hindu*, 6 December 2017
13. S.L., 'Iron and Steel in the Soviet Union' *The World Today*, vol. 8, no. 5 (1952) pp. 210–222
14. Mayakovsky, Vladimir, *The Bedbug and Selected Poetry* (Bloomington, IN: Indiana University Press, 1975) p.229
15. Pearl, Deborah, L., 'Tsar and Religion in Russian Revolutionary Propaganda', *Festschrift for Nicholas Valentine Riasanovsky*, *Russian History*, vol. 20, no. 1/4 (1993) pp.81–107
16. Von Geldern, James, *Bolshevik Festivals 1917–21* (Berkeley, CA: University of California Press, 1993) p.178
17. James, C.L.R., *Modern Politics* (New York: PM Press, 2013) p.36
18. Mayer, Arno, *The Persistence of the Old Regime* (New York: Pantheon Books, 1981)
19. Kollontai, Aleksandra, 'Novaia Zhenshchina', in *Novaia Moral i Rabochii Klas* (Moscow, Russia, 1918), p. 29
20. Kollontai, Alexandra. 'Tezisy o kommunisticheskoimorali v oblastibrachnykhotnoshenii', *Kommunistka*, vols 12–13 (1921) p.34
21. Ibid., p.29
22. From the author's interview with Leila Khaled in Amman, June 2012.
23. Sharlin, Shifra, 'Marc Chagall and the People's Art School in Vitebsk Reunion', *The Tablet*, 3 December 2018
24. George-Graves, Nadine (ed.), *The Oxford Handbook of Dance and Theatre* (Oxford, UK: Oxford University Press, 2015) p.753
25. Von Geldern, *Bolshevik Festivals 1917–21*, p.2

26. Ibid., pp.205–206
27. Trotsky, Leon, 'The Family and Ceremony', *Pravda*, 14 July 1923
28. Baiburin, Albert, 'Rituals of Identity: The Soviet Passport', in Baiburin, Albert, Kelly, Catriona et al., *Soviet and Post-Soviet Identities* (Cambridge, UK: Cambridge University Press, 2012) p.93
29. Trotsky, 'The Family and Ceremony'
30. Socialist Sunday Schools archive collection (ORG/SSS) of the Working Class Movement Library
31. Poole, Edward, 'Troublesome Priests: Christianity and Marxism in the Church of England, 1906–1969', MPhil. thesis, University of Manchester, UK, 2014
32. Masing-Delic, Irene, *Abolishing Death* (Redwood City, CA: Stanford University Press) pp.88–89
33. 'Deklarativnaia Rezolyutsiia', *Biokosmist*, vol. 1 (1922), quoted in Groys, Boris, *Russian Cosmism* (New York: Eflux, 2018) p.9
34. Andres, James, T., *Red Cosmos: K.E. Tsiolkovskii, Grandfather of Soviet Rocketry* (College Station, TX: Texas A&M University Press, 2009)
35. Andres, *Red Cosmos*, pp.9–10
36. Channel, David, F., *A History of Technoscience* (Abingdon, UK: Taylor & Francis, 2017) p.194

CHAPTER 9

1. Glantz, David M., *When Titans Clashed: How the Red Army Stopped Hitler* (Lawrence, KS: University Press of Kansas, 1998) p.271
2. Wagner, Ray, *The Soviet Air Force in World War II: The Official History* (New York: Doubleday, 1973) p.359
3. Griffin, Michael 'The Great War Photographs: Constructing Myths of History and Photojournalism', in Brennen, Bonnie and Hardt, Hanno (eds), *Picturing the Past: Media, History and Photography* (Urbana, IL: University of Illinois Press, 1999) p. 144
4. Obituary in *The Times*, 2 June 2010
5. 'Iconic Red Army Reichstag Photo Faked', *Der Spiegel*, 1 March 2010
6. 'Red Army Soldier Who Helped Raise Russian Flag over Hitler's Reichstag Dies', *The Times*, 18 February 2010
7. Rodney, Walter, *The Groundings with My Brothers* (London: Verso, 2019) p.16
8. Benjamin, Walter, *Toward the Critique of Violence* (Redwood City, CA: Stanford University Press, 2021)
9. Trotsky, Leon, *Terrorism and Communism* (Abingdon, UK: Taylor & Francis, 2014) p.47

NOTES

10. Marx, Karl, *The Civil War in France* (Peking, China: Foreign Language Press, 1977) p.99
11. Orlovsky, Daniel, *A Companion to the Russian Revolution* (Hoboken, NJ: John Wiley and Sons, 2020) p.179
12. Figes, Orlando, *A People's Tragedy* (London: Penguin, 1998) p.754
13. Avrich, Paul, *Kronstadt 1921* (Princeton, NJ: Princeton University Press, 1991) p.60
14. Davies, Sarah, *Popular Opinion in Stalin's Russia* (Cambridge, UK: Cambridge University Press, 1997) p.104
15. Avrich, *Kronstadt 1921*, pp.80–81
16. Degras, Jane, *The Communist International Documents 1919–1943, Volume 1* (London: Routledge, 1971) pp.212–215
17. Avrich, *Kronstadt 1921*, p.146
18. Ibid., pp.210–211
19. Goldman, Emma, *Trotsky Protests Too Much* (Glasgow, UK: Anarchist Communist Federation, 1938)
20. Stone, Bailey, *The Anatomy of Revolution Revisited: A Comparative Analysis of England, France, and Russia* (Cambridge, UK: Cambridge University Press, 2013) p.335
21. Trotsky, *Terrorism and Communism*, p.89
22. Reed, John, *Ten Days That Shook the World* (New York: Dover Publications, 2012) p.293
23. Steinberg, Isaac, *Spiridonova: Revolutionary Terrorist* (London: Methuen, 1935) pp.234–238
24. Smith, S.A., *The Russian Revolution: A Very Short Introduction* (Oxford, UK: Oxford University Press, 2002) p.64
25. Serge, Victor, *Year One of the Russian Revolution* (London: Pluto Press, 1992)
26. Graves, William S., *America's Siberian Adventure, 1918–1920* (New York: Arno Press. 1971) p.108
27. Gramsci, A., *Quaderni dal Carcere* (Turin, Italy: Einaudi, 2001) p.311
28. Hoffman, David, L., *The Stalinist Era* (Cambridge, UK: Cambridge University Press, 2018) p.55
29. Ibid., pp.54–55
30. Parker, Stephen, *Bertolt Brecht: A Literary Life* (London: Bloomsbury, 2014) p.383
31. Meyer, Arno J., *The Furies: Violence and Terror in the French and Russian Revolutions* (Princeton, NJ: Princeton University Press) p.607
32. Fitzpatrick, Sheila, *Stalin's Peasants* (Oxford, UK: Oxford University Press, 1994) pp.50–54

33. Wheatcroft, Stephen G., 'Victims of Stalinism and the Soviet Secret Police: The Comparability and Reliability of the Archival Data: Not the Last Word', *Europe-Asia Studies*, vol. 51, no. 2 (1999) pp.315–345
34. Trotsky, *Terrorism and Communism*, p.60
35. Debs, Eugene, 'The Crimson Standard', *Appeal to Reason*, 27 April 1907, p.1
36. Thomas, Hugh, *The Spanish Civil War* (London: Penguin, 2001) p.637
37. Orwell, George, *Homage to Catalonia* (London: Secker & Warburg, 1938) pp.3–4
38. Costello, John and Tsarev, Oleg, *Deadly Illusions: The KGB Orlov Dossier* (New York: Crown, 1993)
39. Orwell, *Homage to Catalonia*, pp.190–210
40. Paz, Abel, *Durruti and the Spanish Revolution* (Oakland, CA: AK Press, 2006) p.206
41. Michel, Louise, *Red Virgin* (Tuscaloosa, AL: University of Alabama Press, 1981) pp.193–194
42. Hodges, Donald C., *Intellectual Foundations of the Nicaraguan Revolution* (Austin, TX: University of Texas Press, 1988) p.49
43. Cappelletti, Angel, *Anarchism in Latin America* (Oakland, CA: AK Press, 2018)
44. Applebaum, Anne, *Gulag: A History* (New York: Doubleday, 2003) pp.89–90
45. Adler, Nanci, 'Communism's "Bright Past": Loyalty to the Party Despite the Gulag', *Culture & History Digital Journal*, vol. 3, no. 4 (2014)
46. Carter, Peter, *Mao* (Oxford, UK: Oxford University Press, 1962) p.62
47. Lovel, Julia, *Global Maoism* (London: Vintage, 2020) pp.28–29
48. Hitler, Adolf, *Mein Kampf* (Berlin, Germany: Angriff, 1942) p.270
49. Megargee, Geoffrey P., *Encyclopaedia of Camps and Ghettoes 1933–1945, Volume 1* (Bloomington, IN: Indiana University Press, 2009) p.84
50. White, Joseph Robert, 'Introduction to the Early Camps', *Encyclopedia of Camps and Ghettos, 1933–1945, Volume 1* (Bloomington, IN: Indiana University Press, 2009) pp.3–16
51. Langbein, Herman, *People in Auschwitz* (Chapel Hill, NC: University of North Carolina Press, 2005) p.215
52. Ibid.
53. Ibid., p.158
54. Ibid., p.147
55. Hubner, Hans, *Aus der Geschichte der roten Fahne* (Berlin, Germany: Dietz Verlag, 1962) p.48

56. Mandel, Ernest, 'Trotskyists and the Resistance in World War Two', talk given in London in 1976
57. Turbett, Colin, *The Anglo-Soviet Alliance: Comrades and Allies During WW2* (London: Pen & Sword, 2021) pp.50–65
58. Cacciatore, Nicola, 'Working with the Enemy: Relations between Italian Partisans and the British Forces (1943–1945)', PhD thesis, University of Strathclyde, Glasgow, 2019, pp.89 and 257
59. Lopez, Jean et al., *World War II Infographics* (London: Thames & Hudson, 2019) p.146
60. Pieck, Wilhelm, *Mansfeld – Kriwoi Rog, 1929–1989: Die Fahne von Kriwoi Rog – Symbol unserer Freundschaft* (Berlin, Germany: Neues Deutschland, 1989)
61. 'Berlin Bans Russian and Ukrainian Flags During WWII Commemoration', *Politico*, 6 May 2022
62. 'Open Letter to the Working Class', *Pravda*, 31 August 1918
63. Su, Yang, *Collective Killings in Rural China During the Cultural Revolution* (Cambridge, UK: Cambridge University Press, 2011) p.286
64. Corbin, Alain, *The Village of Cannibals: Rage and Murder in France, 1870* (Cambridge, MA: Harvard University Press, 1993)
65. Ali, Tariq, *The Dilemmas of Lenin* (London: Verso, 2017) p.57
66. Twain, Mark, *A Yankee at the Court of King Arthur* (London: Chatto & Windus, 1899) p.133
67. Losurdo, Domenico, *Stalin: History and Critique of a Black Legend* (London: Iskra Books, 2023) p.40

CHAPTER 10

1. Blackburn, Robin, *The American Crucible: Slavery, Emancipation and Human Rights* (London: Verso, 2011) p.438
2. Craton, Michael, *Testing the Chains: Resistance to Slavery in the British West Indies* (Ithaca, NY: Cornell University Press, 2009) p.329
3. Rodney, Walter, *How Europe Underdeveloped Africa* (Nairobi, Kenya: Pambazuka Press, 2012) p.20
4. Sankara, Thomas, speech before the General Assembly of the United Nations, New York, 4 October 1984
5. Marx, Karl, *Capital, Volume One* (London: Laurence & Wishart, 1970) p.751
6. Trotsky, Leon, 'A Letter to Comrade McKay', in *The First Five Years of the Comintern, Volume II* (New York: Pioneer Publishers, 1953) pp.355–356
7. Lenin, V.I., *Collected Works, Volume 42* (Moscow, Russia: Progress Publishers, 1971) p.196

8. Young, Robert J.C., *Postcolonialism: An Historical Introduction* (Hoboken, NJ: Wiley, 2016) p.136
9. Degras, Jane (ed.), *The Communist International 1919–1943: Documents, Volume One* (London: Oxford University Press, 1956) p.105
10. Isono, Fujiko, 'The Mongolian Revolution of 1921', *Modern Asian Studies*, vol. 10, no. 3 (1976) pp.375–394
11. Prashad, Vijay (ed.), *Red Star over the Third World* (New Delhi, India: LeftWord Books, 2017) p.39
12. Nehru, Jawaharlal, in Prashad, *Red Star over the Third World*, p.42
13. Gandhi, M.K., in Prashad, *Red Star over the Third World*, p.35
14. 'Workers and Kishans May Day Celebration', *The Hindu*, 2 May 1923
15. I am indebted to Mariam Alexander Baby, Politburo member of the Communist Party of India (Marxist), for this and other information in this chapter, taken from an interview with him which I conducted in Havana in October 2022.
16. Gerlach, Christian and Six, Clemens (eds), *The Palgrave Handbook of Anti-Communist Persecutions* (New York: Springer International, 2020) p.128
17. Ibid.
18. Mohanan, Kalesh, *The Royal Indian Navy: Trajectories, Transformations and the Transfer of Power* (Abingdon, UK: Taylor & Francis, 2019) p.208
19. Ervin, Charles Wesley, *Tomorrow Is Ours: The Trotskyist Movement in India and Ceylon* (Colombo, Sri Lanka: Social Scientists' Association, 2006) p.182
20. Lenin, V.I. *Selected Works, Volume 15* (Moscow, Russia: Progress Publishers, 1977) pp.185–186
21. Satia, Priya, *Spies in Arabia: The Great War and the Cultural Foundations of Britain's Covert Empire in the Middle East* (Oxford, UK: Oxford University Press, 2008) p.208
22. Tamari, Salim, 'Najati Sadqi (1905–79): The Enigmatic Jerusalem Bolshevik', *Journal of Palestine Studies*, vol. 32, no. 2 (2003) pp.79–94
23. Kabha, Mustafa, 'The Spanish Civil War as Reflected in Contemporary Palestinian Press', in Gershoni, Israel (ed.), *Arab Responses to Fascism and Nazism: Attraction and Repulsion* (Austin, TX: University of Texas Press, 2014) p.133
24. Tamari, 'Najati Sadqi (1905–79)', pp.79–94
25. Franzen, Johan, 'Communism in the Arab World and Iran', in Naimark, Norman, Pons, Silvio and Quinn-Judge, Sophie (eds), *The Cambridge History of Communism, Volume 2: The Socialist Camp and*

World Power 1941–1960s (Cambridge, UK: Cambridge University Press, 2017) pp.518–543
26. Spenser, Daniela, in Racine, Karen et al., *Strange Pilgrimages* (Wilmington, NC: Jaguar Books, 2000) p.148
27. Castro, Fidel, *My Life: A Spoken Autobiography* (New York: Scribner, 2009) p.100
28. Biao, Lin, *Long Live the Victory of People's War!* (Beijing, China: Foreign Languages Press, 1965)
29. Birtle, Andrew James, *The Korean War: Years of Stalemate, July 1951–July 1953* (Washington, DC: US Army Center of Military History, 2008) p.35
30. Ford, Derek R., *Education and the Production of Space* (Abingdon, UK: Taylor & Francis, 2016) p.48
31. Kohn, Richard, H. and Harahan, Joseph P. (eds), *Strategic Air Warfare: An Interview with Generals Curtis E. LeMay, Leon W. Johnson, David A. Burchinal, and Jack J. Catton* (Washington, DC: Office of Air Force History, 1988) p.88
32. Adams, Clarence, *An American Dream* (Amherst, MA: University of Massachusetts Press, 2007) pp.34–55
33. Ibid., p.104
34. Brazinsky, Gregg, *Winning the Third World: Sino–American Rivalry during the Cold War* (Chapel Hill, NC: University of North Carolina Press, 2017) p.154
35. 'Chin Peng Obituary', *The Guardian*, 22 September 2013
36. Leary, John D., *Violence and the Dream People: The Orang Asli in the Malayan Emergency 1948–1960* (Athens, OH: Ohio University Center for International Studies, 1995) pp.42–43
37. Peng, Chin, *In Everlasting Memory: Dare to Struggle, Dare to Sacrifice*, memorial booklet (2013)
38. Immerman, Richard H., *The CIA in Guatemala: The Foreign Policy of Intervention* (Austin, TX: University of Texas Press, 1982) pp.75–82
39. Ibid., pp.161–170
40. Castañeda, Jorge G., *Compañero: The Life and Death of Che Guevara* (New York: Knopf, 1997) p.62
41. Bevins, Vincent, *The Jakarta Method* (London: Left Book Club, 2021) p.48
42. Law no.27/1999, Laws Regarding Crimes against National Security, on Communism and Marxism-Leninism
43. Bevins, *The Jakarta Method*, p.72
44. Ibid., p.124
45. Anderson, Benedict R. and McVey, Ruth, 'What Happened in Indonesia?', *New York Review of Books*, 1 June 1978

46. Sukarno's speech of 17 August 1964: 'Tahun Vivere Pericoloso'
47. Bevins, *The Jakarta Method*, p.133
48. 'Covert Support of Violence Will Return to Haunt Us', *The Guardian*, 6 October 2005
49. Curtis, Mark, 'US and British Complicity in the 1965 Slaughters in Indonesia', *Third World Resurgence*, no. 137 (2002)
50. Anderson and McVey, 'What Happened in Indonesia?'
51. Ho Chi Minh, *Selected Writings* (New Delhi, India: LeftWord Books, 2022) p.32
52. Bevins, *The Jakarta Method*, pp.164–165
53. Ibid., p.194
54. Ibid., p.196
55. Bergman, Ronen, *Rise and Kill First: The Secret History of Israel's Targeted Assassinations* (London: Random House, 2018) pp. 86–94
56. Cabral, Amílcar, 'The Weapon of Theory', address delivered to the *First Tricontinental Conference of the Peoples of Asia, Africa and Latin America*, Havana, January 1966
57. *The Telegraph*, 15 February 1966
58. *The Red Flag in South Africa: A Popular History of the Communist Party* (Cape Town, South Africa: South African Communist Party, 1990) p.64
59. 'SACP Statement on the Passing Away of Madiba', South African Communist Party, 6 December 2013
60. Meredith, Martin, *Mandela: A Biography* (New York: Public Affairs, 2010) pp.197–201
61. Mandela, Nelson, *Long Walk to Freedom* (London: Abacus, 2013) p.138
62. Okoth, Kevin Ochieng, 'The Flatness of Blackness: Afro-pessimism and the Erasure of Anti-colonial Thought', *Salvage*, no. 7 (2020) pp.79–116
63. 'Burkina Faso's Revolutionary Hero Thomas Sankara to Be Exhumed', *The Guardian*, 6 March 2015
64. Lei Constitucional da República Popular de Angola, 1975, Article 54, vs Lei Constitucional da República de Angola 1992, Article 162
65. Kiernan, Ben, *The Pol Pot Regime: Race, Power, and Genocide in Cambodia under the Khmer Rouge, 1975–1979* (New Haven, CT: Yale University Press, 2008) pp.16–19
66. Tyner, James A., *The Killing of Cambodia: Geography, Genocide and the Unmaking of Space* (London: Routledge, 2017)
67. Laban Hinton, Alexander, *Why Did They Kill? Cambodia in the Shadow of Genocide* (Oakland, CA: University of California Press, 2004) p.1

68. Bevins, *The Jakarta Method*, p.220
69. Mahler, D.G. et al., *World Economic Poverty Trends, 1990–2022* (Washington, DC: Development Initiatives, 2022)
70. Bevins, *The Jakarta Method*, p.238

CHAPTER 11

1. Kusch, Frank, *Battleground Chicago: The Police and the 1968 Democratic National Convention* (Chicago, IL: University of Chicago Press, 2008)
2. DeGroot, Gerard, *The Sixties Unplugged* (London: Pan Macmillan, 2013) p.265
3. Elbaum, Max, *Revolution in the Air* (London: Verso, 2002) pp.2–6
4. Guevara, Che, *Message to the Tricontinental Conference* (Havana, Cuba: OSPAAAL, 1967)
5. Rubin, Jerry, *Do It* (New York: Simon & Schuster, 1970) pp.83–85
6. Kusch, Frank, *Battleground Chicago: The Police and the 1968 Democratic National Convention* (Chicago, IL: University of Chicago Press, 2008) p.35
7. Cleaver, Eldridge, *Post-prison Writings and Speeches* (New York: Random House, 1969) p.38
8. Kusch, *Battleground Chicago*, p.95
9. Taylor, D. and Morris, S., 'The Whole World Is Watching: How the 1968 Chicago "Police Riot" Shocked America and Divided the Nation', *The Guardian*, 19 August 2018
10. 'Vietcong Flag Is Chicago Trial Issue', *New York Times*, 4 February 1970
11. Mailer, Norman, *Miami and the Siege of Chicago* (London: Penguin, 2018) pp.160–161
12. Kusch, *Battleground Chicago*, p.95
13. 'Students Unfurl Flags of Protest', *New York Times*, 14 June 1968
14. Guzman, Richard, *Black Writing from Chicago* (Chicago, IL: Southern Illinois University Press, 2006) p.241
15. Kent, Allen, Lancour, Harold and Daily, Jay E., *Encyclopaedia of Library and Information Science, Volume 22* (Boca Raton, FL: CRC Press, 1977, p.31
16. Hollis, Patricia, *Jennie Lee: A Life* (Oxford, UK: Oxford University Press,1998) p.64
17. Bew, John, *Clement Attlee: The Man Who Made Modern Britain* (Oxford, UK: Oxford University Press, 2017) pp.11–12; Jefferys, Kevin, *The Attlee Governments 1945–1951* (Abingdon, UK: Taylor & Francis, 2014) p.14

18. Bew, *Clement Attlee*, p.229
19. Zilliacus, Konni, *I Choose Peace* (London: Penguin, 1949) p.103
20. Bew, *Clement Attlee*, p.92
21. Woods, Randal Bennett, *A Changing of the Guard* (Chapel Hill, NC: University of North Carolina Press, 1990) p.288
22. Lashmar, Paul and Oliver, James, *Britain's Secret Propaganda War 1948–1977* (Stroud, UK: Sutton Publishing, 1988) p.86
23. Lilleker, Darren Graham, 'Against the Cold War: The Nature and Traditions of Pro-Soviet Sentiment in the British Labour Party 1945–89', PhD thesis, University of Sheffield, 2001
24. Benn, Tony, quoted in 'Understanding the Corbyn Campaign: An Interview with Max Shanly', *Revolutionary Socialism in the 21st Century*, 13 July 2015
25. Brown, Gordon, *Labour List*, 5 July 2018
26. Cossart, Paul, *From Deliberation to Demonstration: Political Rallies in France, 1868–1939* (Colchester, UK: ECPR Press, 2013) p.240
27. Jenkins, Philip, *A Global History of the Cold War, 1945–1991* (New York: Springer, 2021) pp.28–29
28. 'Italy: Caesar with Palm Branch', *Time Magazine*, May 5, 1947
29. Ginsborg, Paul, *A History of Contemporary Italy: Society and Politics, 1943–1988* (London: Palgrave Macmillan, 2003) pp.106–113
30. Chiocchetti, Paolo, *The Radical Left Party Family in Western Europe, 1989–2015* (Abingdon, UK: Taylor & Francis, 2013) pp.43–44
31. Carew, Anthony, *Labour Under the Marshall Plan: The Politics of Productivity and the Marketing of Management Science* (Manchester, UK: Manchester University Press, 1987)
32. Weiner, Tim, *Legacy of Ashes: History of the CIA* (New York: Doubleday, 2007) pp.40–41
33. Prashad, Vijay, *Washington Bullets* (New York: Monthly Review Press, 2020) p.48
34. Grogin, Robert C., *Natural Enemies* (Blue Ridge Summit, PA: Lexington Books, 2001) p.121
35. Corke, Sarah-Jane, *US Covert Operations and Cold War Strategy: Truman, Secret Warfare and the CIA, 1945–53* (London: Routledge, 2007) pp.47–48
36. 'Italy: Caesar with Palm Branch'
37. 'Italy: Battle of the Inkpots', *Time Magazine*, 12 May 1947
38. Ibid.
39. 'Italian Strikers Talk of Civil War', *New York Times*, 5 May 1947
40. Valentine, Douglas, *The Strength of the Wolf: The Secret History of America's War on Drugs* (London: Verso, 2013) p.76
41. Ginsborg, *A History of Contemporary Italy*, pp. 106–113

42. Jenkins, *A Global History of the Cold War*, p.37
43. Decision 250/57, European Commission of Human Rights
44. Wouter, Veenendaal, *Politics and Democracy in Microstates* (London: Routledge, 2014) p.74
45. 'San Marino: World's Smallest Crisis', *Time Magazine*, 14 October 1957
46. Meddick, Simon, Payne, Liz and Katz, Phil, *Red Lives: Communists and the Struggle for Socialism* (London: Manifesto Press Co-operative, 2020) p.144
47. Finkelman, Paul (ed.), *Encyclopaedia of American Civil Liberties* (Abingdon, UK: Taylor & Francis, 2013) pp.1,280–1,282
48. Heale, M.J., *American Anti-Communism: Combating the Enemy Within, 1830–1970* (Baltimore, MD: John Hopkins University Press, 1990) pp.60 and 73
49. Ibid., p.101
50. 'Yetta Fights against Term in San Quentin', *San Bernardino Sun*, 16 April 1931
51. *Stromberg v. California*, 283 US 359 (1931)
52. 'U.S. Soldiers Accused of March under Red Flag on May Day', *New York Times*, 4 May 1947
53. Hearings before the Committee on Un-American Activities, House of Representatives, Seventy-ninth Congress, First Session, on H. Res. 5, to Investigate, Investigation of Un-American Propaganda Activities in the United States
54. Rubin, *Do It*, p.94
55. Noebel, David A., *Communism, Hypnotism and the Beatles* (Tulsa, OK: Christian Crusade Publications, 1965) p.1
56. 'Lennon Remembers', *Rolling Stone*, 4 February 1971
57. Mohandesi, Salar et al., *Voices of 1968* (London: Pluto Press, 2018) p.25
58. 'The Night of the Barricades', *Le Monde*, 12 May 1968
59. 'Paris in May', *The Beacon*, June 1968
60. Mohandesi et al., *Voices of 1968*, pp.179–182
61. Statement of the Jeunesse Communiste Revolutionnaire, 21 May 1968
62. Mohandesi et al., *Voices of 1968*, pp.179–182
63. *Paris: May 1968 Non à la Bureaucratie*, Solidarity Pamphlet 30
64. Dogan, Mattei, 'How Civil War Was Avoided in France', *International Political Science Review*, no. 5 (1984) pp.245–277
65. Mendel, Arthur P., 'Why the French Communists Stopped the Revolution', *Review of Politics*, no. 31 (1969) pp.3–27
66. 'Santa Gets Busted in Copenhagen', *Mother Jones*, December 1977

67. Vučetić, Radina, *Coca-Cola Socialism: Americanization of Yugoslav Culture in the Sixties* (Budapest, Hungary: Central European University Press, 2018) p.12
68. Chappell, Dave, *The Kanak Awakening* (Honolulu, HI: University of Hawaii Press, 2014) pp.86–116
69. 'Vietcong Flag Put atop Notre Dame', *New York Times*, 20 January 1969
70. Maeda, Daryl J., 'Black Panthers, Red Guards, and Chinamen: Constructing Asian American Identity through Performing Blackness, 1969–1972', *American Quarterly*, vol. 57, no. 4 (2005) pp.1,079–1,103
71. *Black Panther Party Hearings*, Ninety-first Congress, Second Session, United States, Congress,. House Committee on Internal Security (1970) p.5,032
72. Mohandesi et al., *Voices of 1968*, p.28
73. Ibid., p.26
74. Feinberg, Leslie, in Stryker, Susan and Whittle, Stephen (eds), *The Transgender Reader* (New York: Routledge, 2006) p.220
75. Meyer, James Simpson, *The Art of Return: The Sixties and Contemporary Culture* (Chicago, IL: University of Chicago Press, 2019) p.105
76. Carter, April, *Direct Action and Liberal Democracy* (Abingdon, UK: Taylor & Francis, 2014) p.12
77. *Bild*, 3 June 1967
78. 'A Match That Burned the Germans', *New York Times*, 12 August 2009
79. Ibid.
80. Becker, Jill, *Hitler's Children: The Story of the Baader-Meinhof Terrorist Gang* (London: Pickwick Books, 1989) p.241
81. Brannan, David, 'Left- and Right-wing Political Terrorism', in Tan, Andrew T.H. (ed.), *Politics of Terrorism: A Survey* (London: Routledge) p.60
82. Das, Satya P., *Economics of Terrorism and Counter-Terrorism Measures* (New York: Springer, 2022) pp.53–54
83. Varon, Jeremy, *Bringing the War Home: The Weather Underground, the Red Army Faction, and Revolutionary Violence in the Sixties and Seventies* (Berkeley, CA: University of California Press, 2004) pp.128 and 184
84. 'Red Army's Reign of Terror', *BBC News*, 8 November 2000
85. Payling, Daisy, 'You Have to Start Where You're At: Politics and Reputation in 1980s Sheffield', in Smith, Evan (ed.), *Waiting for the Revolution: The British Far Left from 1956* (Manchester, UK: Manchester University Press, 2017) pp.144–162

CHAPTER 12

1. Kundu, Amitabh et al., *India's New Economic Policy: A Critical Analysis* (Abingdon, UK: Taylor & Francis, 2010) p.283
2. 'Naxalbari Revisited', *Times of India*, 25 April 2015
3. 'Spring Thunder over India', *People's Daily*, 5 July 1967
4. Ibid.
5. Ou, Susan and Xiong, Heyu, 'Mass Persuasion and the Ideological Origins of the Chinese Cultural Revolution', *Journal of Development Economics*, vol. 153 (2021)
6. Mao, in *Hung Ch'i*, 6 January 1958
7. Sundarayya, Puchalapalli, *Telangana People's Struggle and Its Lessons* (New Delhi, India: Foundation Books, 1972) p.48
8. Elliott, Carolyn M., 'Decline of a Patrimonial Regime: The Telengana Rebellion in India, 1946–51', *Journal of Asian Studies*, vol. 34, no. 1 (1974) pp.27–47
9. Gupta, Akhil, 'Revolution in Telengana 1946–1951 (Part One)', *Comparative Studies of South Asia, Africa and the Middle East*, vol. 4, no. 1 (1984) pp.1–26
10. Roosa, John, 'Passive Revolution Meets Peasant Revolution: Indian Nationalism and the Telangana Revolt', *Journal of Peasant Studies*, vol. 28, no. 4 (2001) pp.57–94
11. Sundarayya, *Telangana People's Struggle and Its Lessons*, pp.230–233
12. Ibid., p.154
13. Zagoria, David S., 'The Ecology of Peasant Communism in India', *American Political Science Review*, vol. 65, no. 1 (1971) pp.144–160
14. 'One of the Few Places Where a Communist Can Still Dream', *Washington Post*, 27 October 2017
15. 'Kerala Becomes First State to Unveil Transgender Policy', *Indian Express*, 12 November 2015'; Indian Census, 2011
16. 'One of the Few Places Where a Communist Can Still Dream'
17. Zagoria, 'The Ecology of Peasant Communism in India', pp.144–160
18. Indian Parliamentary Debate, *Official Report*, vol. 195, no. 36 (2002) p.218
19. Roy, Arundhati, *Broken Republic* (London: Penguin, 2011) p.6
20. Singh, Ajit Kumar, 'Red Money', *Outlook*, 3 February 2022
21. Roy, Kaushik and Gates, Scott, *Unconventional Warfare in South Asia: Shadow Warriors and Counterinsurgency* (Abingdon, UK: Taylor & Francis, 2016) pp.75–77
22. Ibid., p.82
23. 'Maoist Leader Pushpa Kamal Dahal "Prachanda" Takes Oath as Nepal's Prime Minister', *Outlook*, 26 December 2022

24. Paudel, Dinesh, 'The Double Life of Development: Peasants, Agrarian Livelihoods, and the Prehistory of Nepal's Maoist Revolution', dissertation submitted to the Faculty of the Graduate School of the University of Minnesota, 2012
25. Pandita, Rahul, *Hello, Bastar: The Untold Story of India's Maoist Movement* (Chennai, India: Tranquebar Press, 2011) p.96
26. 'Life in an Indian Maoist Jungle Camp', *BBC*, 7 March 2011
27. Roy, *Broken Republic*, p.141
28. Ibid., p.81
29. 'Andhra-Telangana Human Rights Forum Alleges Aerial Bombings on Maoists', *Indian Express*, 3 February 2023
30. Roy, *Broken Republic*, p.213
31. Bhagat Singh's Last Petition (1931), Bhagat Singh Research Committee
32. ETC Group, *With Climate Chaos: Who Will Feed Us? The Industrial Food Chain or the Peasant Food Web?* (3rd edn, Montreal, Canada: ETC Group, 2016) p.6
33. 'No State Has Reported Starvation Deaths, Centre Tells Supreme Court', *The Hindu*, 12 May 2022
34. 'Thousands of Farmer Suicides Prompt India to Set Up $1.3bn Crop Insurance Scheme', *The Guardian*, 14 January 2016
35. Dhawale, Ashok, *The Kisan Long March in Maharashtra* (New Delhi, India: LeftWord Books, 2018) p.7
36. Ibid., p.17
37. Ibid., p.48
38. Ibid., p.63
39. 'This Is a Revolution, Sir', *Jacobin*, 1 December 2020
40. 'Fighting the Seed Monopoly', *The Guardian*, 2 May 2014
41. Guevara, Ernesto 'Che', *A New Society: Reflections for Today's World* (London: Ocean Press, 1991) p.96
42. 'Cuba: A Peasant Revolution', *The World Today*, vol. 15, no. 5 (1959) pp.183–195
43. 'The Risks of Relying on Superpowers to Protect Global Trade', *Financial Times*, 19 July 2021
44. Green, Duncan, *From Poverty to Power: How Active Citizens and Effective States Can Change the World* (Rugby, UK: Practical Action Publishing, 2012) p.48
45. Tarlau, Rebecca, *Occupying Schools, Occupying Land: How the Landless Workers Movement Transformed Brazilian Education* (Oxford, UK: Oxford University Press, 2019) pp.1–10
46. Guevara, *A New Society*, p.96

47. Marx, Karl, *Capital, Volume 1* (London: Lawrence & Wishart, 1970) p.507

CHAPTER 13

1. President Xi Jinping's speech at Beijing's Tiananmen Square to mark the 100th anniversary of the founding of the Chinese Communist Party. Official English-language translation provided by the CCP via Xinhua News Agency.
2. Nedopil, Christoph, 'Countries of the Belt and Road Initiative' (Shanghai, China: Green Finance & Development Center, FISF Fudan University, 2022)
3. Dillon, Michael, *Contemporary China* (Abingdon, UK: Taylor & Francis, 2008) p.138
4. Tang, Wai Hung, Choy, Eric and Cheng, Maria, *Essential Terms of Chinese Painting* (Hong Kong: City University of Hong Kong Press, 2018) p.334
5. Link, Eugene Perry, *An Anatomy of Chinese: Rhythm, Metaphor, Politics* (Cambridge, MA: Harvard University Press, 2013) pp.135–136
6. Cao, Deborah, *Chinese Language in Law: Code Red* (Washington, DC: Lexington Books, 2017) p.4
7. Levine, Steven I., 'China and the Socialist Community: Symbolic Unity', paper presented at *Conference on China's Quest for National Identity*, 25 January 1990, Princeton University, pp.28–29
8. Roberts, J.A.G., *A History of China* (London: Palgrave Macmillan, 2006) p.257
9. Gao, Mobo, *Constructing China* (London: Pluto Press, 2018) p.11
10. Ashton, Basil, Hill, Kenneth, Piazza, Alan and Zeitz, Robin, 'Famine in China, 1958–61', *Population and Development Review*, no. 10 (1984) pp.613–645
11. Gao, *Constructing China*, p.138
12. ' Revolutionary Chinese Guards Say Red Is the Colour of Revolution and Should Be the New Green Light', *The Guardian*, 25 August 1966
13. Jiaqi, Yan and Gao, Gao, *Turbulent Decade: A History of the Cultural Revolution* (Honolulu, HI: University of Hawaii Press, 1996) p.60
14. Dittmer, Lowell, 'Thought Reform and Cultural Revolution: An Analysis of the Symbolism of Chinese Polemics', *American Political Science Review*, vol. 71, no. 1 (1977) pp.67–85
15. Gao, *Constructing China*, p.142
16. Feiyang, Sun and Day, Roderic, 'Another View of Tiananmen', *Red Sails.org*, 2021

17. Bachelet, Michelle, 'Statement by UN High Commissioner for Human Rights Michelle Bachelet after Official Visit to China', 28 May 2022
18. World Bank, *Four Decades of Poverty Reduction in China* (Washington, DC: World Bank, 2022) p.xi
19. Levine, Steven I., 'China and the Socialist Community: Symbolic Unity', paper presented at *Conference on China's Quest for National Identity*, 25 January 1990, Princeton University, p.43
20. '"1.4 Billion Flag Bearer" Receives 5 Billion Hits on Chinese Social Media', *China Global Television Network*, 16 August 2019

CHAPTER 14

1. Lenin, V.I., quoted by Annenkov, I.U. in 'Remembrances of Lenin', *Novyi Zhurnal*, September 1961, p.147
2. 'The Most Frequently Used Emoji of 2021', *Unicode Emoji Mirror Project* (2021)
3. 'End of the Soviet Union; The Soviet State, Born of a Dream, Dies', *New York Times*, 26 December 1991
4. 'More Than a Third of Millennials Approve of Communism, YouGov Poll Indicates', *The Independent*, 7 November 2019
5. Hickel, Jason, *Less Is More* (London: Left Book Club, 2023) p.25
6. Dean, Jodi, 'Communicative Capitalism: Circulation and Foreclosure in Politics', *Cultural Politics*, vol. 1, no. 1 (2005) pp.51–74
7. Cumings, Bruce, *North Korea: Another Country* (New York: The New Press, 2011) pp.8–9
8. *World Health Statistics 2015* (Luxembourg City, Luxembourg: World Health Organization, 2015)
9. 'Lula Vows to Undo Environmental Degradation and Halt Deforestation', *The Guardian*, 16 November 2022
10. '"Kill Them": Duterte Wants to "Finish Off" Communist Rebels', *Al Jazeera*, 6 March 2021
11. Sison, Jose Ma, 'The People Will Intensify the Revolution as Crisis of the Ruling System Will Worsen', *Philippine Revolution Web Central*, 1 January 2022
12. 'The Philippines Has the Most Persistent Poverty in South-East Asia', *The Economist*, 25 November 2017
13. Alburo, Kaira, 'Brothers, Lovers, and Revolution: Negotiating Military Masculinity and Homosexual Identity in a Revolutionary Movement in the Philippines', *Asia-Pacific Social Science Review*, vol. 11, no. 2 (2011) pp.27–42

NOTES

14. 'Philippine Reds Export Armed Struggle', *Asia Times Online*, 22 April 2010
15. These points are from the author's correspondence with Abdaljawad Omar at Birzeit University, Palestine.
16. Internationalist Commune of Rojava, *Make Rojava Green Again* (London: Dog Section Press, 2018) p.27
17. Statement of the *International Meeting of Communist and Workers' Parties*, Havana, 29 October 2022
18. Engels, Friedrich, 'Karl Marx, "A Contribution to the Critique of Political Economy"', *Das Volk*, no. 16 (1859)

CHAPTER 15

1. Debs, Eugene, 'The Crimson Standard', *Appeal to Reason*, 27 April 1907, p.1
2. Cohen, Anthony, *The Symbolic Construction of Community* (London: Taylor & Francis, 1995) p.15
3. Guevara, Che, 'From Algiers, for *Marcha*: The Cuban Revolution Today', in Deutschmann, David (ed.), *The Che Reader: Writings on Politics and Revolution* (2nd edn, New York: Ocean Press, 2005) p.212
4. Mao Tse-tung, 'Report on an Investigation of the Peasant Movement in Hunan', in *Collected Works of Mao Tse-tung, Volume 1* (Peking, China: Foreign Languages Press, 1977) p.18
5. Hickel, Jason, *Less Is More* (London: Left Book Club, 2023) p.50
6. Sullivan, Dylan and Hickel, Jason, 'Capitalism and Extreme Poverty: A Global Analysis of Real Wages, Human Height, and Mortality Since the Long 16th Century', *World Development*, vol. 161 (2023)
7. Speech given by Fidel Castro Ruz, President of the Republic of Cuba, at the closing of the *International Conference for World Balance*, Havana, Cuba, 29 January 2003
8. Luxemburg, Rosa, 'Order Reigns in Berlin', *Rote Fahne*, 14 January 1919
9. Karl Marx's letter to Dr Kugelmann, 'Concerning the Paris Commune', 12–17 April 1871

Index

Aachen Revolt of 1830 41
Abahlali baseMjondolo 279
Abu Ali Mustafa 277
Action Directe (France) 227
Adams, Clarence 183
Adivasi, the 240, 242
Adorno, Theodor W. 43
African National Congress (South Africa) 194
Afro-Marxism 195–6
Albert Hall 164
Algabre, Salud 290
alienation 53, 217–18, 248–9, 267, 271–2, 291
Alizarin, red dye 82
All India Kisan Sabha 243–6
All India Muslim League 177
All-African People's Revolutionary Party 224
Allende, Salvador 189, 274, 282
Alsace 74
American Civil War 70, 98, 102
American Revolution 21
Amritsar Massacre of 1919 (Jallianwala Bagh Massacre) 179
anarchism 1–2, 7–9, 58, 92–110, 113, 115–17, 149–51, 156–9, 167, 211, 248, 256, 277–8
Andhra Pradesh 236
'Angelus Novus' by Paul Klee 6, 10
Anni di Piombo 225–8
anti-colonialism 1–2, 40–1, 171–99, 284, 289
anti-communism 123, 127, 153, 159–60, 185–91, 196–9, 203, 208, 211–12, 215–18, 246, 283
Antoinette, Marie, *Queen of France* 24
Arab Revolt of 1916 179
Argus, (French Brig) 38

Argyle and Sutherland Highland Regiment 42
Ashton, Mark 224
al-Assad, Bashar 9
Assam 231
Atlantic Mutinies of the 18th Century 21–3
Atlee, Clement 207–8
Aurora (Russian Battleship) 150
Auschwitz 162–4
Aust, Stefan 226
Azad, Ram Mohammad Singh 178

Babeuf, François-Noël 29
Baden 64
Baghdad 178
Bakunin, Mikhail 58, 70, 82, 93–4
Baltimore 98
'Bandiera Rossa' (song) 126
Bandung Conference 190–1
Bastille, the 46, 73, 81, 110
Bath 42
baucans, the 18–21
'Beat the Whites with the Red Wedge', by El Lissitzky 139, Plate 12
Beatles, the 219
Bebel, August 73, 90
Beijing 183, 187, 192, 199, 219, 220, 259
Beirut 178
Bejamin, Walter 5–6, 10, 147, 288
Belgrade 87
Bellamy, Samuel 19–20
Belle Epoque, the 92–3
Belt and Road Initiative 251
Ben Barka, Mehdi 191
Berkman, Alexander 101, 215

INDEX

Berlin 3–4. 63, 110, 117, 122, 145–6, 178, 214, 225–6
Berlin, battle of 145–6
Berlin Wall 4, 167
Better America Federation 216
Bevan, Aneurin 205
Bevin, Ernest 208
Bharatiya Janata Party (India) 239
Biennio Rosso 125–6
Bild (Newspaper) 226
Bismarck, Otto von 73, 83, 90
Black Panthers 201–3
blackshirts (Italy) 126, 205
Blair, Tony 208
Blanqui, Louis Auguste 52, 60–1, 67, 70, 76, 78, 82, 110, 148
Bloedvlag, the 19
'Blood of the Revolutionary Martyrs Fertilising the Earth' by Diego Riviera 114
bloody week, semaine sanglante, 1871 83–6
Blunkett, David 228
Blutfahne, the 16, 17
Bob Crow Brigade 278
Bolshevik-Leninist Party of India 177
Bolsheviks (Russian Social Democratic Labour Party) 119, 121, 123, 130–58, 174–5, 180, 215
Bombay (Mumbai) 176, 177, 244
Bonnets rouge 27
Bordeaux 27, 72
Boric, Gabriel 274
Brandenburg Gate 4
Brecht, Bertolt 155
Brest-Litovsk Treaty 120
Breton rising of 1675, revolt of the Bonnets rouges 27
Bristol 42
British Empire, the 31–2, 171–2, 174–7, 184–5
Britsh Broadcasting Corporation 187
Brooklyn Bridge 125
Brosowksi, Minna 165
Brosowski, Otto 165

Brusilov, Aleksei 126
Buchenwald Resistance 163–4
Budapest 87, 108, 123, 167, 214
Burgess, Guy 214

Cabral, Amilcar 191–2, 195, Plate 18
Café du Croissant 118
Cain 16
Cairo 178–9
Calcutta (Kolkata) 176
Cambridge 141
Canut Revolt of 1834 50
Carlisle, Richard 38
Carlisle, Thomas 24
Carlos the Jackal 193
Carmichael, Stokely (Kwame Ture) 224
Castillo, Pedro 274
Castro, Fidel 158, 166, 180–1, 185, 247–7, 250, 289, Plate 18
Cato Street Conspiracy 40
Cavignac, Louis-Eugène 65
Central Intelligence Agency 185–9, 199, 211–12, 238, 273, 287
Chagall, Marc 138, 284, Plate 24
Champ de Mars Massacre 24–26
Chan, Jackie 262
Chaplin, Charlie 217
Chaplin, Ralph 115
Charlemagne 17
Charleston 99
Chartism 61, 63
Chavez, Hugo 196
Cheka 150, 166
Chennai (Madras) 175–6
Chetna Natya Manch 241
Chiang Kai-shek 159
Chiapas 136, 278–9
Chicago 2–3, 87, 96, 102–10, 200–3, 219, 231, 256
Chin Peng 184
Chinese People's Army 177, 180, 240, 252–4, 267
Chinese Revolution 233–4, 250, 252, 263

Cholera 45–6, 85
Chomsky, Noam 5
Christian Democrats (Italy) 212–13, 227
Churchill, Winston 123, 207
Church of England 141
Cincinatti 104
civil service (United Kingdom) 214
Clark, Peter H. 98
Cleaver, Eldridge 201–2
Clerkenwell Green 87
climate emergency 6, 243–6, 248, 270, 274–5, 278–9, 280, 283, 288–90
Clyde Workers Committee 120
Cohen, Anthony 285
Cold war, the 182–93, 199, 207–8, 270
collectivisation (China) 254
collectivisation (Russia) 155–6, 159
Combination Acts (United Kingdom) 36
Comintern (Third International) 129, 174
commodification 266–9
communism 3, 55, 57, 120–1, 126, 128, 137–8, 142–3, 159, 167, 168–9, 182, 191, 207, 210–15, 218, 234–41, 250–3, 279
Communism, Hypnotism and Beatles 219
Communist Combatant Cells (Belgium) 227
Communist League, the (1847) 56
Communist Manifesto, the by Karl Marx and Frederick Engels 63, 66–7, 90
Commmunist Party of Brazil 190
Communist Party of Chile 274
Communist Party of China 177, 181, 230, 236, 233–4, 250–65, 266
Communist Party of France 180, 209–11, 221–2
Communist Party of Germany 165
Communist Party of Great Britain 205, 209

Communist Party of India 176, 230, 236–8, 279
Communist Party of India (Maoist) 238–9
Communist Party of India (Marxist) 236–8, 248
Communist Party of Indonesia 185–8
Communist Party of Iraq 178
Communist Party of Israel (Maki) 276
Communist Party of Italy 205, 210–12, 227
Communist Party of Kampuchea 196–8
Communist Party of Malaysia 184
Communist Party of Nepal (Maoist Centre) 239–41, 258
Communist Party of Nepal (Unified Marxist-Leninist) 243
Communist Party of Palestine 179
Communist Party of Peru (Shining Path) 258
Communist Party of San Marino 213
Communist Party of South Africa 193–5, 279, Plate 17
Communist Party of Syria 279
Communist Party of the Phillipines 275–6
Communist Party of the Soviet Union *See* Bolsheviks
Communist Party of the United States of America 217–18
Communist Party of Turkey 278
Communist University for Toilers of the Orient 178
concentration camps 161–4, 184–5
Confederation Riots of 1876 171–2
Connell, Jim 7, 109–10
Connolly, James 115, 119
Conservative Party (United Kingdom) 206–7
Copenhagen 222
Corbyn, Jeremy 262
Corn Laws (United Kingdom) 43
cosmism 142–4

Courbet, Gustave 80–1, 140
Crosby, Bing 186
Crowe, Eyre 98
crusades, the 13, 17
Cuban Missile Crisis 246
Cuban Revolution 4, 185, 199, 246–7
Cultural Revolution 166–7, 256–8
Czoglosz, Leon 102

Dachau 162–3
Dalits 229, 244–5
Darboy, Georges 148
Darjeeling 230
de Gaulle, Charles 220–3
De Leon, Daniel 105, 115
de-Stalinisation 167–8, 254
Dean, Jodi 272
Debs, Eugene 115, 284
Delhi 175
Demerara 99
Democratic Party (USA) 200
Democratic Party Convention of 1968 200–3
Democratic Party of Struggle (Indonesia) 186
Deng Xiaoping 256–9
Detroit 104
Dongguan 259
Du Bois, W.E.B. 97–8
Dublin 119
Duterte, Rodrigo 275

Easter Rising of 1916 119
Ebert, Friedrich 127
École des Beaux-Arts 220
Egypt, pre-dynastic 12
eight hour movement 71–2, 102–3
Einstein, Albert 134
Eisenhower, Dwight D. 217
Elberfeld Rising of 1849 64
Elizabeth II, Queen of England 193
Emojipedia 268
Engel, George 105–8
Engels, Frederick 16, 57, 63–4, 71, 87, 112, 280

Etaples Mutiny of 1917 122
European Commission on Human Rights 213
European Parliament 168

Fanon, Frantz 192
fascism 126, 160, 205
Faucher, Léon 70
Federal Bureau of Investigation 215
Federation of Organised Trades and Labor Unions (USA) 102–3
Feinberg, Leslie 224
Fejkiel, Wladyslaw 162
Ferré, Théophile 88
Fielden, Samuel 105–8
Finnish Civil War 121
Finnish Socialist Workers Republic 121
First World War 118–23, 139, 173–4, 289
Fischer, Adolph 105–8
Foster, William Z. 218
Fourth International, the 177
France (French Battleship) 123
Franco, Francisco 156
Frankfurt 64
Free Peru Party 274
Free Syrian Army 9
Freikorp 127
French Revolution of 1789 21, 24–30
French Revolution of 1848 57–68, 169
French Section of the Workers' International 210–11
Froissart, Jean 18
Fronde, the 27

Gagarin, Yuri 143
Gallacher, Willie 118–19
Gandhi, Mohandas Karamchand 175, 176
Garibaldi, Giuseppe 51
Gaughan, Dick 109
Gaza 4, 276
Geoffrey, Michael 47

George V (King of England) 128
Gerbstedt 165
Géricault, Théodore 38
German Imperial Navy Office 122
German Revolution of 1918 122, 128, 160
Ghorka Monarchy 239
Giza pyramids 178
Glasgow 39, 51, 108, 109, 119, 124, 141, 209, 282
Glasgow Rent Strike of 1915 120
Globe Theatre, the 17
Goethe, Johann Wolfgang von 13
Goldman, Emma 101–2, 151, 215
Gonzalism 271
Gorgon Uprising 15
Gotteszell Prison 161
Gower, Erasmus 31
Grafton 98
Gramsci, Antonio 125–6
Graves, William S. 153
Great Leap Forward (China) 255–6, 261
Great Purge (Russia) 155–6, 166–7
Guatemala City 189
Guatemalan Civil War 185
Guevara, Ernesto 'Che' 185, 192, 201, 218, 220, 221, 246, 249, 285–6
Gulags 158–9

Hague, the 188
Haifa 276
Haitian Revolution of 1791 21, 28, 99, 171
Hamburg 119
Hamdi, Aziz 178
hammer and sickle (symbol) 132, 143
Hanoi 187, 199, 201, 220
Harlem 125
Harney, Julian 63
Harrison, Frederic 96
Hautefaye 166
Havana 186, 191–2, 220, 280
Haxthausen, August 56
Haymarket Bombing 102–10, Plate 8

Haywood, Bill 115
Healey, Denis 207–8
Heine, Heinrich 46
Hemingway, Ernest 3
Hill, Joe 115–16
Hitler Youth 145
Hitler, Adolf 160–4, 205, 206
HMS Hermoine (British gunship) 32
HMS Inflexible (British sloop of war) 32
HMS Kilbride (British gunboat) 123
HMS Sandwich (British ship of the line) 30, 32
Ho Chi Minh 178, 180, 218
Hobsbawm, Eric 20
Holy Roman Empire 16
Hongqi (car manufacturer) 9, 261
Hoover, Edgar J. 215
Houthi Movement (Yemen) 272
Hoxhaism 271
Hughes, Langston 125
Hugo, Victor 45, 48–50
Hunt, Henry 38

Ibárruri, Dolores 138, 179
Indian National Congress 177, 236
Indian Workers' Association 179
Industrial Revolution, the 35, 55
Industrial Workers of the World (IWW) 100, 115–16, 119
International Brigades, the 156–7, 179
International Criminal Court 188
International Meeting of Communist and Workers Parties 280
International Working Women's Day 120
International Workingman's Association (First International) 7, 70–5, 84, 88, 93–4
Irish Land League 110
Iron Curtain 4, 167, 206–15
Islamic State 4, 277
Ismailov, Abduhlkhakim 146, Plate 15
Italian Socialist Party 205

INDEX

Iwo Jima 146

Jacobins 26, 27, 28, 36, 41, 57, 63, 99, 148, 168
Jagger, Mick 219
Jakarta 186–9
Jaurès, Jean 26, 33, 69–70, 118, 208
Jean Bart (French Battleship) 123
Jenin 277
Jerusalem (al-Quds) 277
Jharkhand 179
Jolly Roger 19, 41
Jones, Mother 115
Juche 273
Judas Iscariot 16, Plate 1
Julian, John 20
July Monarchy 46, 47, 54

Kabul 214
Kahlo, Frida 113–14
Kalashnikov rifle 191
Kamenev, Lev 156
Kanafani, Ghassan 193
Kanak, the 1, 173–4, 222
Kandievka Uprising of 1861 111
Kathmandu 199
Kazan Square 111
Keisinger, Kurt Georg 226
Kenmure Street 282
Kennedy, Robert F. 200
Kentish Town 87
Kerala 231, 233, 237–8
Kerensky, Alexander 131, 134
Kermes, red dye 14–15
KGB 152, 167–8, 214
Khaled, Leila 138, 193, 218, 277
Khaledi, Yevgeny 145–6, Plate 15
Khmer Rouge 196–8
Kiel Mutiny 121–2
King, Martin Luther 183, 200
Kisan March 243–5, Plate 22
Klee, Paul 6
Knights of Labor 100
Kollontai, Aleksandra 137
König (German Battleship) 121

Korean War 182–3
Korean Workers Party (DPRK) 273
Krantikari Adivasi Mahila Sangathan 241
Kremlin, the 120, 142, 269
Krivoy Rog 165–6
Kronstadt 8, 149–51, 157
Kropotkin, Peter 112, 167
Kruschev, Nikita 167, 214, 254, 262
Kun, Béla 123
Kuomintang 234, 254
Kurdistan Workers Party (PKK) 4, 9, 277–8, 279

L'Ouverture, Touissant 41
Labour Church 141
Labour Party (United Kingdom) 113, 117, 118, 132, 177, 205–9
Lafargue, Paul 109, 110–11, 118
Lafayette, Gilbert du Motier 25, 27, 46
Lahore 175
Lamarque, Jean Maximilien (funeral of) 45–48
Lamartine, Alphonse de 59–60, Plate 6
Langbein, Hermann 162–4
Law, Harriet 71
League of the Just, the 56
Lehr und Wehr Verin 104
LeMay, Curtis 182
Lenin, Vladimir Ilyich Ulyanov 115, 120, 130, 131, 136, 139, 149, 152, 156, 159, 166, 167, 174–5, 178, 219, 220, 268, 284
Leninism 195, 208, 210–12, 221, 227, 248, 273, 278
Lennon, John 219
Leroux, Pierre 48
Li Causi, Girolamo 212
Liberal Party (Mexico) 113
liberation theology 247
Lichtenburg 165
Liebknecht, Karl 122, 127
Liebknecht, Wilhelm 73, 90–1

Lin Biao 181
Lincoln Park 202
Lingg, Louis 105–8
Linhai 266
Lissitzky, El 138–9, Plate 12
Liu Shaoqi 256
Liverpool 21–3, 109
Liverpool Seaman's Revolt of 1775 21–3, 28
Lok Sabha 236
London 30, 34, 70, 72, 108, 113, 117, 141, 177, 193, 201, 206, 214
Lorraine 74
Losurdo, Domenico 170
Louis Napoléon III (Emperor of the French) 66, 73, 75
Louis Philippe (King of the French) 46, 57
Louis XVI (King of France) 24
Lubeck Rising of 1408 16
Lula da Silva, Luiz Inácio 274
Lumumba, Patrice 191
Luxembourg Commission 61
Luxemburg, Rosa 119, 126–7, 138, 290
Lyon 26, 50, 82

MacDiarmid, Hugh 51
Machel, Samora 195
Maclean, John 119, 124, 284
Madikizela-Mandela, Winnie 194
Madras (Chennai) 175–6
Madrid 87
Maduro, Nicolás 274
Mailer, Norman 203
Malevich, Kazimir 138
Manchester 37–8
Mandela, Nelson 194–5
Manet, Édouard 88
Mao Tse-tung 159–60, 166, 177, 179, 180, 204, 218, 219, 220, 234, 253–65, 286
Maoism 159, 181, 184, 201, 204, 227, 229–44, 250, 258, 250–65
Marat, Jean-Paul 27

Marcos family 266–7
Markievicz, Constance 138
'Marseillaise, La' (Song) 29, 72
Marseille 82, 119
Marshall Plan 210–12
Marx, Eleanor 105
Marx, Karl 5, 8, 63–4, 67, 70–4, 87, 89, 93–5, 111–12, 117, 135, 219, 245, 290
 On capital 74
 On colonialism 172
 On communists 55–6
 On Emperor Louis-Napoléon III 66
 On King Louis Phillipe 57
 On the destruction of the Commune 83
 On the French Revolution of 1848 61, 66
 On the metabolic rift 249
 On the Paris Commune 78–9, 148
 On the Silesian weavers 53
 On the Split of the First International 7
Marxism 7–9, 94–5, 99, 112, 125, 132, 134–7, 167, 178, 180, 186, 190, 194–5, 208, 210, 236, 243, 247, 260, 264, 274, 279
Marxism-Leninism See Leninism
Marxism-Leninism-Maoism See Maoism
May Day 3, 208–9, 175, 178, 212, 217, 228
Mayakovsky, Vladimir 135
Mazzini, Giuseppe 63
McCarthy, Joseph 217
McKinley, William 102
Meins, Holger 225
Melbourne 125
Mélenchon, Jean-Luc 270–1
Merthyr Rising of 1831 41–3, Plate 5
Methodism 40
Mexican Revolution of 1910 113–15
MI5 208
MI6 185–9

Michel, Louise 1–2, 85–6, 89, 138, 158, 174
Middleton 36, 37
Milwaukee 105
Misérables, Les (novel) 48–50
Misérables, Les (stage musical) 50
Modern Times (film) 217
Mohl, Moritz von 65
Molotov, Vyacheslav 208
Mongolian People's Republic 175
Montefiore, Dora 124
Montmartre 76, 85, 86
Morant Bay Rebellion of 1865 171
Mordred 16
Morice, Humphrey 20
Moro, Aldo 227
Morris, William 89, 105
Moscow 119, 130, 134, 192, 201, 206, 209, 220
Most, Johann 101
Movimento dos Trabalhadores Ruras Sem Terra, O 247–8
Movimiento 26 de Julio (Cuba) 158
Munich Soviet Republic 123
Murex (red dye) 15
Musolini, Benito 99, 205, 206

Nagy, Imre 167
Nantes 72
Napoleonic Wars 35–6
Nasser, Gamal Abdel 186, 190
National Health Service (United Kingdom) 206, 209
National Workshops of 1848 61, 64–5
Naxalbari 229–32
Naxalism 229–32, 238–9, 241–3, 279, Plate 21
Nazi Party (Germany) 160
Nazism 127, 146, 164–5, 168, 226
necro-capitalism 288–90
Neebe, Oscar 105–8
Nehru, Jawaharlal 175, 186, 190, 236
Nepalese Civil War of 1996–2006 239–41
Neto, Augustinho 195

Neumeuer, Hans 162–3
New Caledonia 1, 173–4
New Left, the 203–4, 218–20
New People's Army 276
New York 67, 87–8, 104, 125, 217
Nicholas I (Russian Tsar) 58
Nicholas II (Russian Tsar) 120, 130, 131, 136
Niemöller, Martin 164
Nihilism 32, 109, 111
Nixon, Richard 203, 223
Noel, Conrad 141
Non-Aligned Movement 190–2
Nore Mutiny of 1797 30–2, 34
North Atlantic Treaty Organization, the 188, 208
Norwood, Melita 214
Notre-Dame Cathedral 29, 222–3

O'Dwyer, Michael 179
Öcalan, Abdullah 277–8
Odessa 114
Ohnesorg, Benno 225
Omar, Abaljawad 284
On the Cult of Personality and its Consequences by Nikita Kruschev 167, 214, 254
Operação Jacarta 189
Operation Green Hunt 242
Operation Red Flag 188
Operation Rolling Thunder 188
Oriflamme, the 16–19, 23–4, 34
Orlov, Alexander 157
Ormée parliament 27
Orthodox Christianity 137, 139
Orwell, George 157, 186
Owen, Robert 48, 49, 70

Paine, Thomas 41
Palais Garnier 81
Palestinian People's Party 277
Palmer Raids, the 214–15
Palmer, Alexander Mitchell 215
Panic of 1857 70
Pantheon, the 81

Paris 1, 2, 8, 17, 23–6, 30, 45–53, 55, 57, 58–63, 65–7, 72–4, 75–89, 91, 108, 110, 117, 138, 148, 173, 180, 206, 214, 219, 220–2
Paris Commune, the 1–2, 7, 75–91, 108, 136, 140, 143, 148, 169, 173–4, 290, Plate 7
Parker, Richard 30–2, 34
Parsons, Albert 2–3, 105–8
Parsons, Lucy 2–3, 108, 115
Partido Obrero de Unificación Marxista (Spain) 157
Party of Order (France) 64–5
Pasolini, Pier Paulo 54
Penderyn, Dic 43
People's Art School of Vitebsk 138–9
People's Liberation Guerrilla Army 242–3
Peterloo Massacre of 1819 37–8, Plate 3
Petro, Gustavo 274
Philby, Kim 214
Phnom Penh 187
Phrygian cap 27
Pinochet, Augusto 189
Pitt, William 'The Younger' 36
Pittsburgh 98
Pol Pot 197
political violence 147–9, 191–2
political banquets in Paris 57
Poor Law (United Kingdom) 43
Popular Front for the Liberation of Palestine 193, 276–7
Popular Republican Movement (France) 210–11
Posadism 143, 271
Potapov, Jakov 111–12
Potato failure in Europe 56
Potemkin (Russian Battleship) 114
Prachanda 239–40
Prague 214, 222, 256
Prashad, Vijay 190, 244
Proudhon, Pierre-Joseph 61–2, 70, 78
Punjab 179, 237
Pyongyang 187

pyramids 135, 178

Qualunque Party (Italy) 212
Quintor, Hendrick 20
Quotations from Chairman Mao Tse-tung 204, 255, Plate 23

Radek, Karl 156, 174
Radical war of 1820 (Scotland) 39–40
Radio Australia 187
'Raft of the Medusa' by Théodore Géricault 38, Plate 4
al Rahuhl, Husayn 178
Rajasthan 237
Ramallah 277
Rapti 240
Red Army Faction 225–8
Red Army, the 2, 123, 124, 145–7, 150, 164–5, 168, 264
Red Brigades (Italy) 225–8
'Red Flag, the' (Song) 7, 109–10
Red Guard (China) 256–8, Plate 23
Red Guard (Germany) 126–7
Red Guard (Italy) 125–6
Red Guard (United States) 223
Red Scare (United States) 215–18
Red Square 134, 136
Red Terror of 1918–1922 151–5, 159, 166–7
Redcoats 18
Reed, John 152
Reichstag, the 145–6, 165, Plate 15
Repin, Ilya 88
Riga 114
Rivera, Diego 113–14
Robespierre, Maximilien 27, 78
Rochefort, Victor Henri 89
Rodney, Walter 147, 172
Rogers, John G. 105
Rojava 9, 277–8
Romadier, Paul 211
Roman Empire, the 13–15
Rosbecq, battle of 18
Rosenthal, Joseph 178–9
Rossa, Guido 227

Rote Fahne (Film) 225
Rote Fahne (Newspaper) 126
Roy, Arundhati 242–3
Royal Indian Navy Mutiny of 1946 177
Royal Palace (Berlin) 122
Royton 37
Rubin, Jerry 200–1
Russian Civil War 123, 149–54, 169, 179
Russian Revolution of 1905 114–15, 152
Russian Revolution of 1917 120–1, 130–3, 136, 148, 152
Russo-Japanese War 114

Sa'adat, Ahmad 277
Sadqi, Najati 179
Sagarmāthā (Mount Everest) 240
Saint Denis Basillica 16–17, 34, 52
Saint Etienne 82
Saklatvala, Shapurji 179
San, Aung 184
Sandanistas 158
Sankara, Thomas 172, 195–6
Santa Anna, Antonio Lopez de 51
Saqqara Pyramids 136
Schelm, Petra 226
Schurz, Carl 67
Schwab, Michaek 105–8
Second International, the 94–6, 110–12, 118–19, 158, 173, 209, 274
Second World War 145–6, 154, 159, 164, 177, 184, 206, 209
Sehdev, Sumit 282
Senones, Richer de 17
Serge, Victor 153
Shaack, Michael J. 103–4
Shakespeare, William 17
Shanghai 159
Shaw, George Bernard 89, 105
Sheffield 228
Shilliam, Robbie 99
Siberia 112, 114, 154

Sicily 56, 212
Sierra Maestra 246
Sihanouk, Norodom 184
Silesian Weavers Revolt of 1844 53
Silk road, the 12
Singapore 186
Singaravelu, Malayapuram 175–6
Singh, Bhagat 176
Singh, Lakhvir 282
Sino-Soviet split 254–5
Situationist International, the 220
Skull and Cross Bones See Jolly Roger
Slovak Soviet State 123
Slovo, Joe 193, 194
Smolny Institute 136
Social Democratic Party (Germany) 112, 117, 118, 127
Social Democratic Workers' Party of Germany 73
Socialism 48, 62, 91, 95–6, 110, 127, 128, 130, 153, 169, 179–80, 195, 205, 207–9, 273–4, 278–9, 290
Socialism with Chinese Characteristics 250–65
Socialist Left Revolutionaries (Russia) 152–3
Socialist Party (France) 113, 118
Socialist Patients Collective 225
Socialist Sunday School 141
Soho, London 40
Southey, robert 17
Soviet Republic of Iran on the Caspian Sea 175
Spanish Civil War, the 156–9, 162, 169, 179, Plate 14
Spartacists 122
Spies, August 105–8
Spiridonova, Maria 152–3
Springtime of the Peoples, 1848 revolutions 53–68
St Petersburg (Petrograd) 111–12, 114, 120, 130–3, 139
Stalin, Joseph 142, 145, 154–6, 166–9, 179, 180, 185, 214, 254, Plate 13

Stalingrad 146
Stalinism 154–7, 158, 166, 168–9, 262
Stars and Stripes, the 107, 146, 202, 216, 218
Stasi 167
Stevens, Shakin 109
Stony Gut 171
Strathaven 39
Stromberg, Yetta 216–17
Students for a Democratic Society 201, 203
Sukarno 184, 186
Sumatra 188
Syndicalism 95, 100, 107, 115–16, 125, 158

Tambov Rebellion of 1920 149
Tamil Nadu 236
Telangana Rebellion of 1946 235–6, Plate 16
Tennyson, Alfred 14
Thabang 240
Thaxted 141
Thiers, Adolph 77, 85, 148
Third World Marxism 201
Third World War 214
Thiruvananthapuram 199
Tiananmen Square 250, 258–9, 262
Togliatti, Palmiro 212–13
Toulouse 72, 82
Tower Hamlets Militia 34
Trento University 227
Tricolour (French) 26, 29, 50–1, 58–61, 63, 64, 66, 110
Tricolour (Russian) 130–1
Tricontinental Conference of 1966 191–2
Trincomalee 32
Tripura 236
Trotskyism 157, 158, 177, 210–11, 227
Trotsky, Leon 86, 120, 123, 141, 148, 150, 152, 156, 173, 220
Tsarism 111, 114, 123, 136, 175
Tsiolkovsky, Konstantin 142
Tuileries Palace, 1792 storming of 26

Tuileries Palace, 1848 storming of 57–8
Twain, Mark 92, 168

Ukraine-Russia war of 2022 166, 269
Ulaanbaatar 175
Um Nyobè, Ruben 191
uMkhonto we Sizwe (South Africa) 193
Unicode Consortium 268
United Kingdom Border Agency 282
United Nations, the 197
United Socialist Party of Venezuela 274
United States Air Force 182, 185, 188, 196

Varlin, Eugene 84
Vendôme Column, destruction of 80–1, 83–6, 140
Venice 63
Versailles 80, 85
Versaillese (French Government) 80–91
Vienna 63
Viet Cong 203
Vietnamese Resistance War Against America 188–9
Voice of America 187
Volkssturm 145
Vorwärts (Newspaper) 112
Voshkod rocket 142

Waffen-SS 145, 161–4
Wage labour 35, 39, 53, 55, 65, 70, 79, 97, 114, 130, 172, 264
Waldi, Orli 162
War Communism 149–51
Warsaw 114
Washington 87
Waterloo, Battle of 29
Weather Underground, the 227
Wedderburn, Robert 40–1
Weimar Republic 165
West Bengal 223, 236

INDEX

White House, the 223
White Russians, the 123
White Terror (China) 159
White Terror (Russia) 153–4
Whitman, Walt 67–8
Wilde, Oscar 105
Wilhelm II (German Kaiser) 121
Winter Palace (St Petersburg) 114, 120, 130, 140
Wordsworth, William 24
Workers' and Peasants' Party of Turkey 178
Workers' Party (Brazil) 274
Workers' Party of Scotland 227

Wyatt, Robert 109
Wydah Galley 20

Xi Jinping 250, 251, 260–5
Xiongan 260, 265

Youth International Party (Yippies) 200–3, 218, Plate 20

Zapatistas (EZLN) 158, 278–9
Zaragoza 179
Zhou Enlai 190
Zinoviev, Grigory 156, 174
Zola, Emile

The Pluto Press Newsletter

Hello friend of Pluto!

Want to stay on top of the best radical books we publish?

Then sign up to be the first to hear about our new books, as well as special events, podcasts and videos.

You'll also get 50% off your first order with us when you sign up.

Come and join us!

Go to bit.ly/PlutoNewsletter

Thanks to our Patreon subscriber:

Ciaran Kane

Who has shown generosity and comradeship in support of our publishing.

Check out the other perks you get by subscribing to our Patreon – visit patreon.com/plutopress. Subscriptions start from £3 a month.